Monuments
AND THE MILLENNIUM

PROCEEDINGS OF A JOINT CONFERENCE ORGANISED BY ENGLISH HERITAGE AND THE UNITED KINGDOM INSTITUTE FOR CONSERVATION

John Dinkle - May 2011

ENGLISH HERITAGE

Monuments and the Millennium:
The Victoria & Albert Museum, London, 20–22 May 1998

Edited by Jeanne-Marie Teutonico and John Fidler
Consultant editor: Kate Macdonald

First published by James & James (Science Publishers) Ltd,
35-37 William Road, London NW1 3ER, UK

A catalogue record for this book is available from the British Library

ISBN 1 873936 97 4

Printed in the UK by Hobbs the Printers

Contents

Preface

In the winter of 1997, Colin Schlapobersky, then Chairman of the Stone Section of the United Kingdom Institute for Conservation of Historic and Artistic Works (UKIC), contacted English Heritage and proposed the running of a joint international conference on conservation issues surrounding public sculpture and monuments. The two organisations had already collaborated successfully in running an international symposium entitled *Architectural Ceramics: Their History, Manufacture and Conservation* which had taken place in 1994. The conference proceedings of the same name, published in 1996, had proved to be extremely popular, recognised to be the largest source of new information on the subject to have been issued for many years.

The time felt right to repeat the exercise but dealing this time with multi-media materials in a particular environmental and managerial context. A working party was formed, involving Mr Schlapobersky, Russell Turner and Angus Lawrence from UKIC's Metals Section, and staff from English Heritage's Building Conservation and Research team: Sasha Chapman, Jeanne-Marie Teutonico and myself. The Public Monuments and Sculpture Association (PMSA) was invited to participate and Jo Darke became its representative.

At the time, national interest was growing over the fate of public monuments, particularly war memorials and sculpture maintained by the shrinking budgets of municipalities. Regarded as constant and enduring features of the built environment and ranging from the everyday to the spectacular, these objects continue to be regarded as of great historic, artistic and social value. With the re-evaluation and rescue of many public spaces being seen as a catalyst for, or the crowning glory to, urban regeneration projects throughout the land, the time had come to reassess the conservation response and look to better standards of practice for the coming millennium.

The international conference, *Public Monuments and the Millennium* took place at the Victoria and Albert Museum in London in May 1998. Thirty one speakers and tour guides from six countries on three continents discussed a wide range of associated topics over the six-session, three-day event. The first session provided a context for the debate and illustrated some approaches which have been taken towards the art-historical and conservation assessment and inventorying of public monuments. The second session was devoted to some of the philosophical and political issues which public monuments bring to the fore.

Day two commenced with a series of papers on general technical issues and methods for the conservation and repair of monuments. The fourth session allowed delegates out of the museum halls to view London's extraordinary variety of public monuments and sculpture at first hand, ably guided by the experts. On the last day specific case studies were presented to illustrate philosophical approaches and technical challenges as applied for the diversity of building materials. The final session then rose to the challenge of debating the future of public monuments and of issues related to the commissioning of new public sculpture.

Only the participants and readers of this volume will be able to judge whether the conference met all its aims and objectives and provided useful information and experience for those engaged in the field. As monuments to despots continue to topple in the Balkans, Latin America and South East Asia and vandalism by graffiti attacks continue to soil and scar statuary and memorials closer to home, the messages conveyed by the papers presented here offer hope and guidance for the enormous challenges of the millennium ahead.

John Fidler RIBA
Head of Building Conservation and Research
English Heritage

Introduction to the conference

Robert White

Chairman,
United Kingdom Institute for Conservation,
109 The Chandlery, 50 Westminster Bridge Rd
London SE1 7QY, England, UK
Tel.: 020 7721 872 Fax: 020 7721 8722

Minister, distinguished guests, ladies and gentlemen, good morning and welcome. It's a great pleasure to be invited to present this opening address at such a prestigious and well-organised event, and I'm sure you would all join me in congratulating the organising bodies.

Monuments and the Millennium has a daunting and imposing feel about it. It contains words which conjure the kind of images and issues which touch everybody's lives in one way or another. They promote a feeling of longevity, of spanning generations. But, while the certainty and reliability of the arrival of the millennium, along with our excitement and trepidation of what it might bring, is unarguable, are we able to give the same unambiguous assurance to future generations that their environment will be as culturally rewarding as they might expect it to be? Will subsequent generations be able to thank us for a legacy of cultural integrity, or will they bemoan an environment populated by deteriorating monuments or unsympathetic replicas? It is our level of professionalism and integrity as practitioners in the sector and as curators of the heritage, which will largely determine the answers to such questions.

My involvement here, as already mentioned, is as chairman of one of the organising groups, UKIC. On a rather selfish note, as this year marks the 40th anniversary of that organisation, this conference forms a significant contribution to the portfolio of events commemorating the anniversary. However, on a less selfish note, I hope I can provide an overview of the kind of events which have been taking place in recent years which we in the

professional bodies might hold up as legitimate developments in professional best practice in heritage conservation, and what further maturation we might reasonably expect to ease us gently towards the next millennium.

I'm an antiquities conservator and I know little of the specifics of architectural conservation. Some might thus reasonably question the validity of my addressing an event such as this. However, it is my firm belief that the meaningful elements of professional behaviour and best practice all transcend material specific considerations, and can be harmonized in order to provide, primarily, greater protection for the beneficiaries of conservation services, be they in the built or moveable heritage. We are firstly professional conservators who must abide by the same or comparable codes of conduct. Whether we specialise in the protection of antiquities, grass skirts or cathedrals, whether we are independent or employed by institutions, these are secondary issues. If we do not have synergy and speak the same professional language we do not have a true profession, and ultimately we will have a heritage with little or no integrity. As the chairman of the largest of the current swathe of professional conservation groups I consider this to be our main objective, and I am convinced that by meeting it the profile and credibility of the profession as a whole will be considerably enhanced.

In order to set our progress in context I would firstly like to take a small step back in time to UKIC's 30th anniversary. At the conference held to mark that occasion Mike Corfield, now Chief Scientist at English Heritage, presented a paper entitled

Towards a conservation profession which dealt with a range of professional development issues, and which made specific reference to the formation of UKIC's Ethics Committee back in the early 1980s. In my view the formation of that committee was one of the most significant benchmarks in the development of the professional conservation practitioner in the UK. It would also, as would be seen later, act as a catalyst in the consolidation of what had become a rather fragmented professional conservation arena. The Ethics Committee came up with a number of important conclusions in its early deliberations. These included:

- the fact that large numbers of practising conservators did not appear to have a professional approach to their work
- that many did not appear able to maintain their professional principles in the face of pressure from clients or employers;
- that there existed no single body representing all conservators with sufficient power to back individuals on professional matters, and;
- that there existed no single body with sufficient status to enforce a code of professional conduct by excluding or reprimanding transgressors.

These were strong criticisms indeed but, in my view, a fair and accurate representation of the prevailing professional climate.

So what have we done to address these criticisms? Well, happily, I am able to report several significant professional 'leg-ups' for the sector. Given my time restriction I would like to briefly outline three areas which I think already have, and will continue to, redress this professional imbalance and provide a solid platform for future development.

Firstly, we do not yet have that truly all-embracing professional body capable of representing all conservation practitioners on an individual level. But what we do have, thanks largely to UKIC whose idea it was, and to the Museums and Galleries Commission, whose support expedited it, is the Conservation Forum. This initially began as a very informal grouping of all the UK bodies which had practising conservators as a proportion of their membership. It is now on the verge of attaining a firm constitution as a true federal grouping of conservation organisations within the UK and Ireland,

something which had hitherto not existed. This has enabled some rather disparate agendas to begin to be harmonized, and the progress and potential it represents in terms of the unification of standards and competencies across the sector is significant.

Secondly, we are guiding our members through the pitfalls of the current marketplace via the provision of regulatory documentation. Such projects, wherever possible, are undertaken as partnership initiatives either with each other under the Conservation Forum's federal umbrella, or in association with other major heritage sector conservation players. One of the best examples of such a project is that regarding the formulation of guidelines for conservators on the commissioning and undertaking of conservation work and specifically competitive tendering, of direct relevance to both those who commission and those who undertake conservation projects. This was initiated by UKIC but has been sanctioned by all member organisations of the Conservation Forum, giving it a strong sector-wide mandate. Pivotal to its success has been its endorsement by the UK's major conservation commissioning bodies such as English Heritage, Historic Royal Palaces, Council for the Care of Churches, architects' and surveyors' organisations. All these groups have recognised the growing need for, and have been prepared to contribute to, this kind of regulatory document. As a corollary to this we are now well underway with the production of a standard contract for conservation work, in respect of both small studio-based activities and the more complex site-related projects.

These documents may complement the work currently being undertaken by DCMS in the preparation of its *Procurement Manual* on which we have been consulted. Certainly the opportunity to dovetail such initiatives is welcome.

From my own viewpoint as an antiquities conservator the excellent *Management of Archaeological Projects* guidelines produced by English Heritage in 1991 has had a major impact on professional practice. It has successfully provided a framework within which the disparate specialists involved in the execution of archaeological projects are able to communicate with one another in the same professional language, levelling that hitherto considerably bumpier playing field. And, of course, we must not forget UKIC's own *Code of Ethics*, the

benchmark to which we expect our professional members to adhere.

Finally, key to the successful implementation of such regulatory mechanisms is the ability to access lists of competent practitioners who would be invited to tender for conservation projects. Clearly those who commission the services of a conservator will benefit enormously from the production of the type of documentation I have mentioned, but they still need assurance that the work they commission will be carried out to an acceptable standard by practitioners whose competence has been measured and approved by their peers, in other words accreditation. UKIC is now on the brink of implementing an accreditation system which will provide the majority of conserving practitioners, for the first time, with the means to aspire to a widely recognised level of full professional accreditation, which embraces all of the strands of competency currently contributing to defining the fully rounded professional.

So I would like to offer this conference this tangible evidence of professional development as a platform for its deliberations over the next three days, and as an assurance that, as the clock ticks towards the year 2000, major strides forward are being taken by the professional bodies with the specific objective of clearly delineating the boundaries between hobbyist and professional, in order to finally deliver accountable quality control and consumer protection.

Before I take my seat it is my pleasure to introduce our next speaker, Sir Jocelyn Stevens. Sir Jocelyn, who probably needs little by way of introduction to many of you, is currently Chairman of English Heritage, a position he has held since 1992. During his reign Sir Jocelyn[1] has made a very significant contribution to raising the profile of English Heritage, both nationally and internationally, which comes as no surprise when one considers his extensive media experience. On behalf of UKIC, and in particular my colleagues in that organisation Colin Schlapobersky and Russell Turner who have done so much hard work in devising and preparing this conference, I would like to offer thanks to Sir Jocelyn for enabling English Heritage to act in partnership with the profession. Without that kind of vision and support we would not be sitting here now and we would certainly not be able to make the kind of progress we have in our professional institute.

ENDNOTES

1. Sir Jocelyn Stevens retired as Chairman of English Heritage on 31st March 2000 to be replaced by Sir Neil Cossons.

AUTHOR

Robert White trained in archaeological conservation at University College London's Institute of Archaeology and has worked for the last eighteen years as an antiquities conservator. He worked initially for excavating units in Lincolnshire but for the last eight years have been Head of Conservation at Lincolnshire's Museum Services, within the local authority's Education and Cultural Services Directorate. He has been associated with UKIC for the past ten years, initially as chairman of its Archaeology Section, and now as chairman of the organisation. During 1994-7 he served as chairman of the Conservation Forum, an umbrella grouping of all of the professional conservation organisations within the UK.

Foreword

At the opening of the conference the Chairman of English Heritage addressed the delegates.

Minister, distinguished guests, ladies and gentlemen, I want to thank Robert White for his introductory remarks and would like to join with him in welcoming you all to this conference on *Monuments and the Millennium*. I must give an especially warm word of welcome to our many overseas speakers who have travelled from Australia, America, Germany, Italy and the Irish Republic to be with us today.

This is the second international event that has been jointly organised by English Heritage and the United Kingdom Institute for Conservation, the first being held on the subject of architectural ceramics at Ironbridge in Shropshire in 1994. These ventures have been exceedingly fruitful in bringing together the established body of technical knowledge and current trends at pertinent moments in time. The ceramics event led to the publication of conference proceedings which subsequently helped to set the agenda for research and standards of practice in the years ahead. It is hoped that this week's discussions will also fulfill a similar role for the chosen field of study and I look forward to reading the post-conference proceedings and conclusions.

I must start my talk by adding my congratulations to those already proffered to UKIC on the occasion of its fortieth anniversary. Its progress towards higher standards of professionalism and practice is supported by English Heritage. Our collaboration on technical conferences and publications with UKIC's ceramics, stone and metals sections has

been mutually rewarding, I feel, and long may this association continue. Thanks must go to Colin Schlapobersky and his team from the stone and metals sections for helping to organise today's event. I must also acknowledge the cooperation and assistance of the Public Monuments and Sculpture Association for its help, through Jo Darke, in arranging speakers and visits to sites of interest around the capital. Finally I must also thank the management of the Victoria & Albert Museum for hosting this conference: English Heritage and its collaborators are most grateful.

Ladies and gentlemen, I should like to spend a few moments in giving a context to the discussions ahead. The title of this conference is *Monuments and the Millennium* – a topic which evokes thoughts of public memorials past, present and future. In Eastern Europe, since the collapse of communism, we have witnessed the wholesale tearing down of monuments and the re-erection and restoration of sculptures to newly-discovered older heroes. In the United Kingdom, reading newspapers recently, it is obvious that the subject of public monuments is currently riding high in the British public's and the government's consciousness: celebrations of lives past and of futures to come are finding tangible outputs in several ambitious enterprises currently underway or under consideration. It has been gratifying to read, for example, of the distinct and affectionate place held in the heart of this still civilised country for public works of art, war memorials and monuments.

Adorning civic spaces from the grandeur of city squares to humble village greens, monuments are

generally cherished but rarely now well maintained. Information about their welfare is variable, knowledge of their state of repair and treatment needs is scarce, and responsibilities for them are often confused or lost in the mists of time. Besides this, thoughtless neglect and well-meaning but ill-informed care are both seriously damaging to the future of our forefathers' legacy. There are lessons for us here too in the public and private sector patronage of new public art – who pays for long-term maintenance after the blue ribbons are cut and Time and Nature take command?

So it is heartening to see the gathering alliance overseas, and in this country too, of like-minded spirits to address these issues as we approach the new millennium. In this audience here today, ladies and gentlemen, besides those groups already mentioned in running the event, are experts and enthusiasts from the UK's Friends of War Memorials; the Mausolea and Monuments Trust; the Folly Fellowship; the Commonwealth War Graves Commission; the Royal Commission on Historical Monuments for England; the Imperial War Museum; and last, but not least, the newly-formed National Graffiti and Vandalism (Counter Measures) Association.

English Heritage, UKIC and the PMSA all hope that a degree of consensus, coordination and planned action can be established at this conference to help set national and international standards of care and patronage for the century ahead. In this English Heritage stands ready to play its part. In fact, several aspects of our current work will feature in this conference by way of example: notably the repairs and conservation of the Albert Memorial which Alasdair Glass will describe in a paper and which many of you will be visiting on the PMSA's tours. I am exceptionally proud of the thoroughly professional way we have treated this outstanding example of High Victorian building over the past few years. At a cost of £11.2 million (£2.8 million under budget) and 12 months ahead of schedule, my staff, consultants and contractors have achieved a most sensitive, technically ingenious and lifesaving operation which all of London will be able to enjoy after its opening in the autumn. Our painstaking work will be published in detail in book form shortly, and a summary of certain interesting technical aspects will be highlighted within these conference proceedings.

A significant contribution to many aspects of English Heritage's conservation work comes from its technical publications programme. And it is with very great pleasure that we launch today at this international conference, our own *Research Transactions* series – the product of the first five years of strategic technical research from our cathedrals grants programme. This entirely new venture seeks to draw together and to make publicly available the very considerable body of scientific and technical knowledge that is being produced from our work in conserving the nation's historic buildings and monuments. For too long our chief assets, the brains and skills of a dedicated and highly experienced workforce, have lacked a credible platform to corporately exhibit their discoveries and conclusions in conservation for the public good. Now at last, we can share our ideas and move forward with our peers to develop new standards of practice for the coming century ahead.

It is hoped that the *Transactions* will make the primary findings from our research and case work more accessible to other scientists and testing engineers. Expert architects, structural engineers, surveyors, conservators and policy-makers will find the reports useful too: though these are not text books for the novice or the layman. They will underpin the technical advice and published guidance that English Heritage gives to government, local authorities and the public on conservation matters generally. They are a record of our current understanding: helping to develop policies and standards of practice at the cutting edge of conservation.

Volume One, on the conservation of metals, will be found in your delegate packs and features several peer-reviewed scientific papers pertinent to this gathering of experts on public sculpture and monuments. Another four volumes are currently being prepared for publication during the next twelve months. Two volumes will deal with a variety of subjects covering studies of the performance and treatment of porous building materials; one volume will be dedicated to a study of earthen construction; and the fourth volume brings together reports on certain aspects of timber decay and its treatment. Further volumes will follow as the growing programme of research gathers momentum and new projects are concluded.

English Heritage is one of the few conservation bodies world-wide in the fortunate and highly influential position to be able to develop applied research needs from its own case-work and can collaborate with others, not only to deliver practical research results, but also to interpret and disseminate the findings through policy, guidance and practice to those concerned with conservation in the field. I commend the series and this first volume on *Metals* to an informed international audience and look forward to the scientific feedback and dialogue they should stimulate.

To conclude this marketing announcement for English Heritage publications I should also mention that we will also be publishing an *Advisory Note on the Conservation of Ferrous Metalwork*, to be followed by others of the conservation of lead and other metals used in an architectural environment. These are being produced to set basic national standards of practice and have been devised in consultation with UKIC, the Society for the Protection of Ancient Buildings (SPAB) and with industry. We are also planning an advisory note on counter-measures for graffiti damage to historic buildings and monuments. This will be a precursor to our technical contribution towards a new British Standard code of practice on the subject which English Heritage has been instrumental in setting up.

We stand ready at English Heritage to help conserve nationally important historic public monuments and sculpture across the country, in whatever way we can – be it through grant aid or by giving technical advice – as do our sister organisations in Scotland, Wales and Northern Ireland. In this respect, I note with interest a report recently published in the North American journal of the Association for Preservation Technology. The APT Bulletin records a report from the BBC World Service on radio that in northern China recently two thieves found guilty of stealing heads from antique statues have been sentenced to death. While this form of sanction may be seen as somewhat extreme, I am sure there are many in this audience here today that would wish for a heightened level of civic pride and of care in their own countries, perhaps not as severe as that found in China, but which would be commensurate with the cultural importance of public monuments and their place in time and space.

Finally, ladies and gentlemen, I should offer a few words on the subject of the patronage of new works of art, since this forms an important aspect of the conference this week. Contrary to popular belief, English Heritage is not just concerned with conserving old public sculptures and monuments. We have an interest in the commissioning of new, well-designed public sculpture in old settings, for this can lead to enhanced local pride and a sense of place, and a catalyst for urban regeneration and the revitalization of building plots and city centres.

We ourselves hosted an exhibition of new works of art in association with Northern Arts and the Crafts Council at Belsay Hall, one of our properties in the north-east of England. We believe that the old and the very new can live together without friction if all parties cooperate in a positive creative spirit. Speaking in the V&A, of course, I cannot forget that English Heritage approved the radical Daniel Libeskind project here for the spiralling, Cubist extension to the museum: an exciting urban contribution to space planning – a sculptured public building for the new millennium ahead, English Heritage is moving away from the negative culture of the past (where nothing was possible) to a creative new approach to development in historic settings. Conservation for us, in design terms, is not a way of preserving objects in aspic. Conservation controls change and uses it to best advantage for the common good.

In conclusion ladies and gentlemen, can I wish you every success in your endeavours here at the Victoria and Albert Museum, and out on site, over the next three days? May your deliberations stimulate determined collaborative action to improve national and international standards of care, welfare and sponsorship of public monuments and sculpture for the future. We owe it to the past and to current and subsequent generations' interest and enjoyment. The judgement of the millennium awaits us! Thank you.

Sir Jocelyn Stevens CVO
Chairman
English Heritage
May 1998

Part 1

Context and Inventory

1 Monuments and dilemmas
The Public Monuments and Sculpture Association National Recording Project

Johanna Darke
Public Monuments and Sculpture Association
72 Lissenden Mansions
Lissenden Gardens
London NW5 1PR, England, UK.
Tel.: 020 7485 0566
Fax: 020 7267 1742
jo.darke@inted.demon.co.uk

Abstract

This paper introduces Britain's heritage of public sculpture and monuments as part of a continuing impulse to commemorate, celebrate or innovate. From its beginnings, mainly based in the Stuart period, the present movement has provided town and country with a great variety of open-air art, as well as political symbols and vivid visual repositories of national, local, social and environmental history. With new work appearing in ever more exciting materials and forms, the PMSA, through its unique National Recording Project, is identifying these historical objects, precious either as symbols or as works of art, and discovering the challenges they hold for artists, custodians, educationalists, academics, local authority and government agencies, conservators and the ubiquitous enthusiast.

Key words

Sculpture, public, PMSA, NRP, monuments

Coinciding with the Millennium, rather than being specifically timed, the National Recording Project of the Public Monuments and Sculpture Association (PMSA) seems to be happening at an appropriate moment in the field of public art. The project aims to survey all the monuments and sculptures in Britain, incorporating objects of varying quality and scale from the stone-carved Eleanor Crosses of the thirteenth century to contemporary work in varying media.

In the context of the May 1998 conference, therefore, this overview of the National Recording Project (NRP) sets the scene for what is to come. The title *Monuments and the Millennium* reaches forward from a solid tradition that can either be grand in scale, and sometimes of undeniable artistry,

or else small-scale, local and domestic, equally appealing. The familiar image is of the local worthy immortalized in bronze, set up in his town at some time between the 1860s and the First World War (Fig 1). Another typical image is the portrait bronze of the ageing Queen Victoria, mostly appearing at her Jubilees or after her death in 1901, which still imposes Victoria's matriarchal presence on the northern industrial cities. Some of these elaborate monuments include in their design bronze statues of allegorical figures or personifications, such as *Motherhood* shown full-length in bronze at the back of Queen Victoria's splendid statue by Onslow Ford in Manchester (Fig 2). Motherhood stands with her baby in an alcove tiled with blue mosaic (sorely neglected when the photograph was taken in the

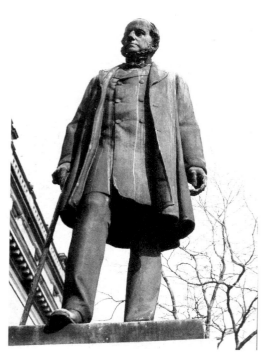

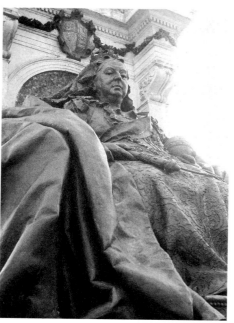

Figure 2 *Queen Victoria* (1819–1901) by Onslow Ford. Bronze, on stone representation of Imperial Throne. Manchester, 1901. (The Conway Library, Courtauld Institute of Art)

Figure 1 *William Henry Hornby* (1805–84) by Albert Bruce-Joy. Bronze. Blackburn, 1912. (Johanna Darke)

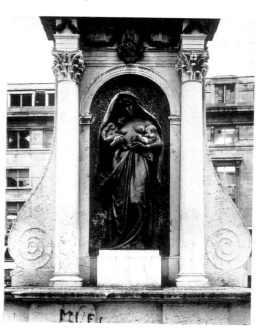

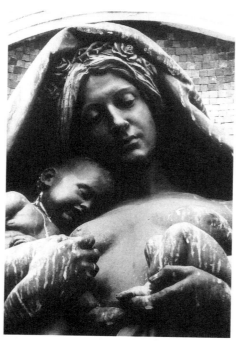

Figures 3 and 4 *Motherhood* by Onslow Ford. Bronze, in mosaic alcove at back of Victoria Memorial, Manchester, 1901. (The Conway Library, Courtauld Institute of Art)

Figure 5 *Albert Memorial*, monument to Albert, Prince Consort (1819–61) by Thomas Worthington (architect) and Matthew Noble (sculptor). Gothic canopy York stone, statue Sicilian Marble. Manchester, 1867. (Johanna Darke)

1980s, Figs 3 and 4). Commemorative works of Victoria's consort, Prince Albert contribute, among many others, the great Gothic-style monuments in London, inaugurated 1872, and Manchester, 1867 (Fig 5).

Beyond the Millennium, we can see a continuation of today's new concepts and patrons, new materials, and increasingly flexible artistic boundaries. In the associated fields of caring for a historical, and growing, national collection, new challenges arise through developing care and conservation methods, and through the untested nature of new materials. The National Recording Project was set up to define and evaluate the extent of the nation's public art, so that people who work in the field will recognise not only the objects that are surveyed, but the resulting

Figure 6 *Train* by David Mach. Brick. Darlington, 1997. (Jeremy Beach)

archive, as an invaluable working resource. Then the PMSA can start to campaign in earnest for a concerted approach to its promotion and care.

Despite the recent trend towards installing public art, as exemplified by David Mach's large-scale brick *Train* in Darlington, 1997 (Fig 6), and the ceramic, wood, steel and glass *Dolphin Mooring Post* (1993) in South Shields by the Northern Freeform Collective (Fig 7), public perception seems loyal on the whole

Figure 7 *Dolphin Mooring Post* by the Northern Freeform Collective. Ceramic, wood, steel, glass. South Shields, 1993. (Jeremy Beach)

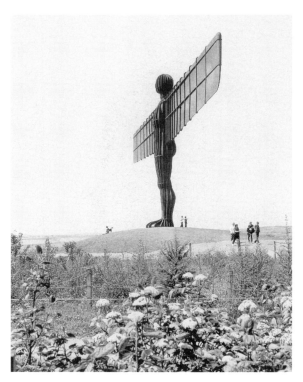

Figure 8 *Angel of the North* by Anthony Gormley, Gateshead (1994). (Paul Usherwood)

to the predominantly Victorian image in bronze or stone of a man on a pedestal, often sheltered under a Gothic canopy or surmounted by a winged figure. Even so, one can detect a continuum.

Figure 8, among other things, is rooted in a formerly industrial landscape. Not a lot of people know that Gateshead has at least two Angels, although most have heard of Antony Gormley's

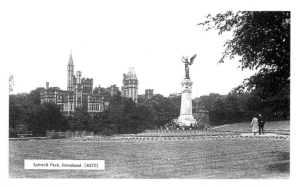

Figure 9 Monument to commemorate the South African War, F W Doyle (1905). Saltwell Park, Gateshead. (PMSA)

Angel, *The Angel of the North* (Fig 8). The other angel (Fig 9) stands in Saltwell public park, and might be called 'an Angel of the North'. Apart from Gateshead, the towns of Sunderland and Newcastle both have similar images: winged Victories, elevated on classical columns, to mark the sombre losses of the First World War. In other northern towns, and indeed in towns throughout England, this is one of the many recurring sculptural and monumental images used through the 1920s to commemorate the 'war to end all wars'. While there are obvious dissimilarities in period, style and intent, Gormley's *Angel* and the *Victories* can still be seen as part of the same continuing tradition. Both kinds of Angel are sculpture, after all, both mark out the past, and both, as one of Gateshead's recent publicity sheets for the Gormley *Angel* claims, 'make a space a place'. Gormley's *Angel*, erected with unprecedented accompanying publicity, has undeniably put Gateshead's public sculpture on the map.

The PMSA's National Recording Project was originally based on the National Inventory of War Memorials (NIWM), set up in 1989 for the Imperial War Museum and the (then) Royal Commission on the Historical Monuments of England (RCHME). The NRP survey was instigated in 1992, supported by a grant from the Henry Moore Foundation, and by 1995 had established five Regional Archive Centres (RACs) working with volunteer data gatherers and research students, in cities from Bristol to Glasgow, to survey and record on database all the statues and monuments within those cities. The eventual electronic archive covering Britain, created at the University of Northumbria at Newcastle (UNN), will be disseminated through the Web (www.gofast.to/pmsa) and also on CD ROM, and from on-site terminals in selected archive centres.

In 1995 the NRP, on behalf of its five working RACs, applied for a Heritage Lottery Fund grant (HLF), and in November 1996 the project was awarded £470,000 to cover a substantial area of Britain. The HLF-funded NRP eventually started in November 1997, and now has twelve archive centres based in host institutions in England, Wales and Scotland. Meanwhile, funds are still being urgently sought to augment the generous HLF grant and to complete the map.

In its early days the NRP was fortunate to attract two regional projects, which provided a vital starting

point for the national scheme. One of these was a planned update by Leicester University of the 1970s Walker Art Gallery survey of Liverpool public sculptures carried out by the Manpower Services Commission, and later undertaken as a pilot for the PMSA NRP from 1993–97. This was funded by Leicester with other generous contributions from the National Museums and Galleries on Merseyside and a private source. The other, almost complete, survey was the Birmingham Sculpture Project based at the University of Central England from 1986. This has been updated, and will be digitized for the NRP.

Both city surveys have been published as part of a series produced by Liverpool University Press, *Public Sculpture of Liverpool* (1997) and *Public Sculpture of Birmingham* (1998). Biographies of artists, included in each volume, have been extracted and compiled as a separate document to be carried on the NRP's website. Volume III, *Public Sculpture of North-East England*, will be launched in May 2000 at the University of Northumbria at Newcastle, Glasgow (Glasgow School of Art), Leicester (University of Leicester) and others are in the pipeline. The readership, like users of the electronic database, will be drawn from professionals in the field such as sculptors, scholars and historians, planning, listings and conservation officers, schools, universities and environmentalists and the ever-knowledgeable enthusiast.

Writing the catalogues, as with the survey and the creation of the database, helps to focus not only on general issues in public art but also on specific problems of the work in hand. The NRP's first dilemma was to determine what kind of objects might be brought by the survey under the same criteria. This inflammatory subject, the question of eligibility, has long been banned from PMSA meetings and gatherings, since it uses up time and passion, can never be fully resolved, and is often in any case determined by regional trends in monuments and sculptures. Apart from the Eleanor Crosses, an agreed starting date is the Stuart period, from which Hubert le Sueur's equestrian statue of Charles I survives (Fig 10). Put up at London's Charing Cross by Charles II in 1675 on the site where the Martyr King's executioners were themselves executed, it was restored in 1996 for the then Department of National Heritage.

From this early period to the present, kings and princes, Field-Marshals and Admirals, reformers such

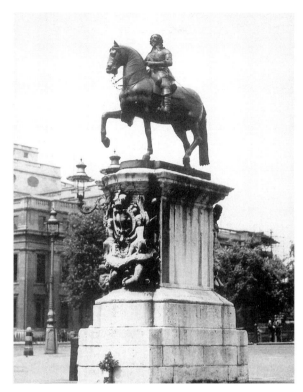

Figure 10 *Charles I* by Hubert le Sueur. Bronze. Facing down Whitehall, London, 1675. (The Conway Library, Courtauld Institute of Art)

as the blind Liberal Postmaster General, Henry Fawcett who is portrayed in bronze relief (1886) by Mary Grant on London's Embankment (Fig 11) and local characters like Blind Joe of Oldham (Fig 12), are equal with each other in the eyes of NRP recorders, and equal too with the innovative work of contemporary artists creating landscape, or mixed-media, and other contemporary public art. The survey inevitably focuses on the eclectic body of earlier work, however, and, broadly speaking, the directive is that we should record anything commemorative and/or sculptural that falls within the public eye.

Under these conditions the project has had to decide, for example, whether to count architectural sculpture, and if it does, where does this start or stop? An obviously eligible example is that of Charles Holden's London Transport Headquarters at 55 Broadway (1927–9), carrying carved reliefs by sculptors whose work typifies sculpture in the early

Figure 11 *Henry Fawcett (1833–1884), Postmaster General* by Mary Grant. Bronze relief, part of fountain ensemble by Basil Champneys. Victoria Embankment Gardens, London, 1886. (The Conway Library, Courtauld Institute of Art)

Figure 12 *Blind Joe the Bellman.* Sculptor not known. Sandstone. Alexandra Park, Oldham, nineteenth century. Blind Joe's bell and cane can be seen in the museum at Oldham. (Johanna Darke)

and mid-twentieth century, the best-known being Eric Gill and Henry Moore, as well as the two main figures of *Day* and *Night* (Fig 13) by Jacob Epstein. Not so obvious will be the numerous buildings, Victorian in the main, whose sculptural embellishments in terracotta or stone could fall either side of 'art' or 'ornament'.

Furthermore, should a complete building count, so long as it is purely monumental and commemorative? The NRP says 'yes' to the Penshaw Hill monument (Fig 14), a blackened Doric temple erected from 1844 to immortalize the 1st Earl of Durham, but 'no' to memorial libraries or hospitals. We will record the 'Jelly Mould' (local Lancaster terminology), according to Pevsner 'the grandest monument in England', a huge white structure commemorating the second wife of Lancaster's Lino

King Lord Ashton (by John Belcher, completed in 1909); and in the same breath, as it were, a sad headstone in Burwell, Cambridgeshire (1727) marking the death of 78 villagers and children burnt in a fire while watching a puppet show in a barn.

We are having to consider what in fact counts as 'public': overall, the churchyards and cemeteries are discounted (there are too many), but monuments erected by public subscription that happen to be sited in a churchyard can count. And we are asking what, in any period, counts as sculpture, or for that matter, as art? What is worth recording, and, perhaps by this criterion, what is worth preserving? The NRP *Data Gatherers' Guidelines*, Sheet 2 ('What Counts'), anticipates researchers' objectivity problems: 'ironically, contemporary public art is often the least documented and it is important to maintain an

Figure 13 *Night* by Jacob Epstein. Portland stone. London Transport Headquarters, 1927–29, by Charles Holden. (Johanna Darke)

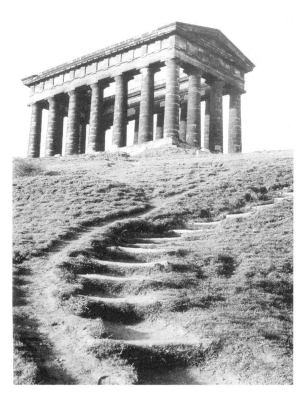

Figure 14 *Penshaw Monument: to the 1st Earl of Durham (1792–1840) – 'Radical Jack'.* Architects John & Benjamin Green. Penshaw Hill (National Trust), County Durham. Foundation stone laid 1844. (Johanna Darke)

objective attitude to work which, whatever its merits, will come to reflect our own time'. This hints at the difficulties within the art world of accepting today's exploratory approach to art as 'art', or, in the case of conventional works of figurative sculpture, even now being commissioned and erected, as showing a lack of basic skills which, on the whole, are no longer taught.

The PMSA in taking on the national survey has had to learn some basic skills. These include devising a survey form that can encompass the broad range of objects to be surveyed, and then training the volunteer data gatherers to fill in the form and to describe a complex piece in its entirety. The bust of Lord Lister in Portland Place, for example, has in front of its high stone pedestal a bronze sculpture of a woman and child; to either side of the pedestal is a large bronze cartouche carrying the sign of Mercury

(a caduceus, or winged staff entwined by two serpents). This emblem also appears at the base of the bust's bronze support, at the back. Faced with all this, it would be easy for any data gatherer to overlook the oblong Portland stone-paved platform on which the monument stands, with bollards and lamps in the same green-stained bronze as the bust itself, all of which, paving, bollards and lamps, are arguably an integral part of the overall design. Much information about this monument is carried in inscriptions and signatures *in situ*; the rest is the subject of archival research for which the NRP has compiled a source list and has established a practical means of logging the sources used and the extent to which each particular source has been used. This ensures that future researchers will not have to cover the same ground. In all this, the PMSA has benefited from the invaluable encouragement and

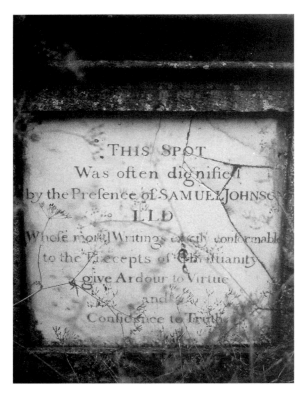

Figure 15 *Monument to Dr Johnson* (1709–1784), detail of inscription. Near Denbigh, Wales, *c* 1775. (Johanna Darke)

Figure 16 Detail of figure in architectural frieze, *The Awakening of Africa*, by Gilbert Ledward. Portland stone. Erected on Barclay's Bank, Old Broad Street, City of London 1960; removed 1995. (The Conway Library, Courtauld Institute of Art)

guidance of the Data Standards section at the National Monuments Record.

One of the great joys of the NRP survey is that its records deal not only in art history but in social, domestic or local history. Some monuments, like the *Charles I*, are artistically, nationally and locally important in equal measure. The recorded information, mainly core data, is entered either from site or from archival sources on to the NRP Survey Form, SF1. The data gatherers are also likely, as is hoped, to find substantial regional-specific information which, while not being entered on the database, will be flagged in the 'Sources' or the 'Myth and Legend' sections on the survey form.

The most important, basic details (core data) include, where possible, the names of artists, designers, architects and all associated assistants or craftspeople; dates of installing and unveiling, physical description, estimated size, materials and exact location, with grid references even in towns.

All inscriptions must be transcribed verbatim (Fig 15) with all the line breaks, and upper and lower case, and missing or displaced letters recorded. The listing status of the object, whether grades I, II*, or II, or not listed, or status 'not known', is seen as one of the most important sections on the survey form, particularly as it is felt in the PMSA that modern public art fares badly within the present listing system, generally being categorized with buildings and structures, rather than as art with all the frailty and delicacy that this can entail.

A recent case is Gilbert Ledward's stone relief sculpture (Figure 16) part of an architectural frieze completed in 1960, the year of the artist's death. This sculpture was saved by enlightened architects who notified the PMSA just as the demolition of the building was approaching the first storey, where the 20-ton Portland stone frieze was installed. The

listing system would have been helpless in this situation since the sculpture's location, a London city bank, would not have been considered for listing despite the presence of a work that should have been eligible at least for consideration, given its quality of preservation, and the artist's minutely-recorded details of research and approach. However it seems that sculpture cannot ordinarily be considered if it is part of an otherwise indifferent building.

The NRP survey form also includes a condition report. This should serve to record the various materials and the condition of our public art, and to focus on its vulnerability through being out of doors and in the public domain. One of the main issues is that of care: in the first place, whether we can or should care for public sculpture and monuments as a national collection, in a concerted way. Some would say, including artists themselves, that the works should be neglected, thereby creating their own history of natural deterioration and even of vandalism rather than a history of maintenance and/or repairs and restorations. The PMSA, on the other hand, feels that the national corpus of public art deserves to be cared for by accredited conservators so that maintenance and repair work need not put the piece at risk while costing the earth, as can too often be the case. The PMSA's leaflet *Conservation Strategy* was produced to offer cash-strapped local councils a practical system that might help this forward.

Some artists regret the lack of interest that can be shown, once a piece is installed with great fanfare, in caring for it or even logging information about the materials used, or in their requisite treatment. The sculptor Lillian Lijn described in the magazine *Woman's Art* (January/February 1995) her mobile sculpture *Circle of Light*, made of 23 copper wound aluminium tubes, forming a curved circular plane like a solar disc. When the sculpture was hung above Milton Keynes Shopping Centre, Lijn explained how 'in motion, and lit, the entire surface was alive with a shimmering rippling movement' (Lijn 1995, 7). Later, at a spring lecture given for the Lanscape and Art Network and the PMSA in 1995, the artist described how this piece of kinetic art, when permanently hung, had been wrongly positioned, wrongly lit and subsequently immobilized. Recently Lijn reported that after ten years of neglect, 'the Circle of Light will be restored and rehung, and properly lit' (letter to the author). She is at present

in correspondence with the new owners of her sculpture *Split Spiral Spin*, commissioned in 1982 by the Warrington Development Corporation, and installed in Birdwood Science Park. The new owners propose to recreate that part of the park as a car park, complete with sculpture. Perhaps this will set a precedent for all car parks to contain costly pieces of art.

Numerous pieces of artwork set up in the post-war new towns and during regeneration in the 1960s and 1970s, have posed serious problems through lack of, sometimes despite, provision for after-care. Works in Harlow have been badly vandalised. Coventry sculptures, part of the New Town 'Phoenix' built over the ashes of the 1940s Blitz, are now at serious risk. Milton Keynes's estimable public collection, built up over three decades as part of the new town planning, presented an awkward challenge when the Development Corporation was disbanded in 1992.

Displayed across Milton Keynes, this open air art gallery includes works by Bernard Schottlander, Elisabeth Frink, David Mach and many other leading contemporary sculptors as well as examples by local artists. Some work was specially commissioned, some (rather like the elements of the new town itself) 'parachuted in'. As is so often true, the resources in people and skills that could focus on setting up these new sculptures did not survive beyond the life of their governing organisation. The collection, like the Development Corporation, was disbanded, individual works of art being distributed to the owners of the land they happened to occupy. This somewhat ad hoc solution has produced a similarly ad hoc approach to their care: some can and do, some can't, and some don't. Recently the town council set up a part-time post for a Public Art Development Officer to address the problems not only of after-care for the existing collection, but in planning for new works and their future maintenance.

New materials, too, are already presenting conservation challenges beyond those of marble and bronze. Artists may fail to use the proper undercoat on painted steel, or to understand the rapidly-deleterious effects metal reinforcements can have on concrete. Owners may fail to safely record precise construction details of complex works in glass or fabric or neon so that they can be repaired, or parts replaced, after damage or deterioration or change of ownership. These details, or at least the

sources of available information, will be logged in the PMSA's National Recording Project survey, and should be available on the database.

To finish on an optimistic note, the PMSA is involved in various other projects including the thirtieth congress of the Comité International d'Histoire de l'Art (CIHA) in September 2000, and the Trafalgar Square Fourth Plinth Project, organised by the Royal Society of Arts. The steering committee recently selected from a shortlist three specifically designed proposals by the sculptors Mark Wallinger, Rachel Whiteread and William Woodrow, for temporary display on the empty plinth. Wallinger's diminutive but powerful figure of Christ (a marble composite body cast) was unveiled in July 1999. Woodrow's design is scheduled for February 2000. The project organisers will set up a public information post so that the concepts behind today's public art, its commissioning, installation and care, can be conveyed to people who view it in everyday circumstances, the public.

The PMSA welcomes this unique opportunity for public dialogue to flourish, just as this Millennium conference can inspire debate and provide an international perspective on important issues concerning public sculpture and monuments.

REFERENCES

Cavanagh T, 1997 *The Public Sculpture of Liverpool*, Liverpool, Liverpool University Press.
Lijn L, 1995 Light matters, in *Woman's Art*, **62**, 6–9.
Noszlopy G, 1998 *The Public Sculpture of Birmingham*, ed J Beach, Liverpool, Liverpool University Press.

AUTHOR

Johanna Darke is a founder member of the Public Monuments and Sculpture Association, founded in 1991, and is its Chief Executive and Coordinator of the PMSA's National Recording Project. She has been a writer and publisher on English landscapes, and English public monuments.

2

The National Inventory of War Memorials

Profile of a national recording project

Nick Hewitt

The National Inventory of War
Memorials, Imperial War Museum,
Lambeth Road,
London SE1 6HZ, England, UK.
Tel.: 020 7416 5353,
Fax: 020 7416 5379,
nhewitt@iwm.org.uk

Abstract

Little attempt was made to monitor or record the mass of post-First World War memorial construction, leading to fears for the condition of memorials during the 1980s. A letter to *The Times* by Dr Alan Borg led to the establishment of The National Inventory of War Memorials in 1989. This chapter describes the funding, staffing, recruitment of volunteers, aims and participating organisations; the development of the standard recording form and dedicated computer database. The contents of the archive at June 1998 are summarized. Examples are given from the 1000 inquiries and 200 visitors received by the Inventory during 1997–98.

Key words

National, inventory, war memorial, Imperial War Museum
recording, conservation, database, volunteers

ORIGINS OF THE NATIONAL INVENTORY OF WAR MEMORIALS

Approximately three quarters of a million British subjects died in the First World War. Most were buried in 'some corner of a foreign field' (Brooke 1914) by the Imperial (later Commonwealth) War Graves Commission due to an understandable official refusal to allow the repatriation of so many dead (Fig 1). At the end of the war, millions of bereaved Britons were consequently left with no physical focus for their grief. The result was the largest public arts project the country had ever seen, as British communities erected memorials to their fallen. Probably the best known is the Cenotaph in Whitehall, London, a tribute to all the fallen of the Empire and now the focus of British commemoration (Fig 2). However, few villages or towns lack some sort of memorial, and more can be found within a wide range of institutions, including churches, workplaces, sports clubs and schools (Fig 3).

Although in 1921 the Imperial War Museum appealed for photographs of memorials, little attempt was made to record the unparalleled programme of construction, since communities largely acted without central guidance. Over the years, as time and the elements took their course, it became apparent that some memorials could disappear unnoticed and that no comprehensive record existed (Fig 4).

In March 1988 the then Director General of the Imperial War Museum, Dr Alan Borg, wrote to *The Times*, arguing that there was 'an urgent national

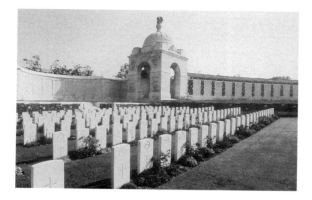

Figure 1 Commonwealth War Graves Commission cemetery and memorial at Tyne Cot, near Passchendaele, Belgium. (Marcus Taylor/ Commonwealth War Graves Commission)

requirement for an inventory of war memorials', as many were 'suffering from the ravages of time and pollution, with inscriptions becoming illegible and details of sculpture destroyed' (Borg 1988). The letter generated an enthusiastic response, and in June Dr Borg held a meeting at the Imperial War Museum to discuss his proposal. Attending were representatives from organisations which shared his concerns, among them the Federation of Family History Societies, the Western Front Association, the Royal British Legion, the Royal Commission on the Historical Monuments of England (RCHME, now merged with English Heritage) and the Victoria Cross and George Cross Association. The result of this meeting was the founding of the National Inventory of War Memorials project.

Based at and administered by the Imperial War Museum, the project was independently funded. The participating organisations provided senior representatives to form a supervisory committee, and a network of volunteers to carry out fieldwork. A full-time Project Coordinator was appointed in June 1989. For the first five years the project was financed by the Leverhulme Trust; subsequent sponsors have included the Rufford Foundation, the Manifold Trust and most recently the National Heritage Memorial Fund.

The aim was to record all physical objects in the United Kingdom created or installed to commemorate those killed in or as a result of military service. (This did not include graves, a memorial being defined as 'reuniting those who

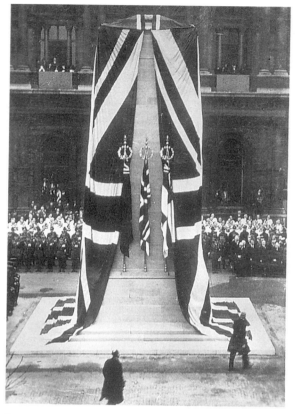

Figure 2 The Cenotaph in Whitehall, shortly before its unveiling on 11 November 1920. (Carter Collection/ NIWM)

were separated by a conflict'.) Information was seen as the key to successful preservation, and a primary aim was to record the geographical location, physical appearance and condition of memorials. In addition, the intention was to make the operational database available as a research tool to as wide a public as possible. The Inventory therefore set out to uncover the historical background; how memorials were funded, who unveiled or dedicated them and who designed, sculpted or manufactured them.

THE FIRST SEVEN YEARS

Drawing on the experience of RCHME when necessary, the Project Coordinator devised a standard recording form (Fig 5) to structure the input of a diverse range of volunteer field workers. Work also began on the development of a computer database tailored to the Inventory's requirements. The merits

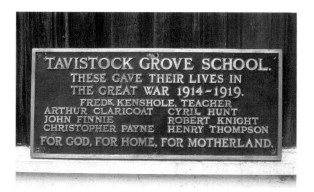

Figure 3 Plaque commemorating former pupils of Tavistock Grove School, Croydon. (Ron Cox/NIWM)

of various different software packages were assessed by Imperial War Museum and RCHME computing and curatorial staff, who eventually selected Oracle. This was primarily because it was and remains industry-standard software and as a relational database a series of reference tables could be used instead of entering a common attribute many times for many memorials.

By the end of May 1990 the database was functional. As far as possible, the screens mirrored the recording forms, which were now being returned by the box-load, often accompanied by ephemera such as photographs, postcards, and newspaper cuttings. The Inventory was also presented with a number of free-standing collections, including independent county surveys and two fine collections of contemporary postcards.

At the time this paper was given at the conference (May 1998), the Inventory contained records relating to around 28,000 memorials, estimated at roughly half of those in existence. They ranged from significant works of art by prominent artists, such as Sir William Goscombe John's memorial to the fallen of Lever Brothers Ltd at Port Sunlight (Fig 6) and Charles Sargeant Jagger's Royal Artillery Memorial at Hyde Park (Fig 7), to simple crosses by unknown village stonemasons (Fig 8).

As well as free-standing monuments, the Inventory records internal plaques commemorating both groups and individuals (Fig 9), Rolls of Honour inscribed on parchment (Fig 10), stained glass windows (Fig 11), utilitarian memorials such as community halls (Fig 12), fountains, avenues of trees, and church fittings and furnishings such as

Figure 4 Badly vandalised Second World War memorial in North Wales. (NIWM)

bells, pews, lecterns and altars. Perhaps the most unusual commemorative object recorded so far is Piel Island in Barrow-in-Furness, Cumbria, presented to the people of Barrow by the Duke of Buccleugh as a war memorial in 1920 (Fig 13).

Although most memorials were constructed to commemorate the First World War and have been added to, smaller numbers relate solely to earlier or later conflicts. An early decision was taken to include these in the Inventory, because although few in number they provide a valuable resource for wider historical comparisons. Around 1,000 memorials were erected after the Boer War of 1899–1902, and the form, style and content of these often gave a preview of what was to come in 1919 (Fig 14). Memorials have been recorded commemorating the Indian Mutiny, the Crimean War and the Napoleonic Wars (Fig 15) Among the earliest is a tablet commemorating Captain Philip Bacon, killed in command of the frigate Bristol while fighting the

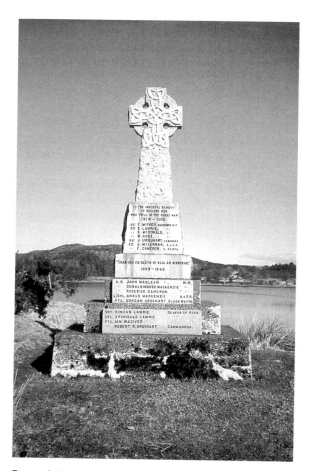

Figure 7 Royal Artillery War Memorial, Hyde Park, London. (Carter Collection/NIWM)

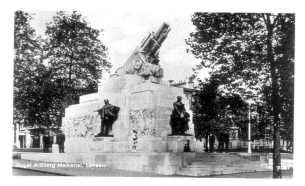

Figure 5 National Inventory of War Memorials recording form.

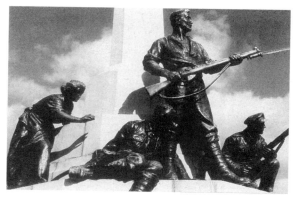

Figure 6 Lever Brothers Ltd and Port Sunlight War Memorial, Merseyside. (NIWM)

Figure 8 Celtic cross at Poolewe, in the Scottish Highlands. (NIWM)

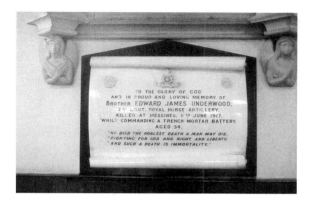

Figure 9 Marble tablet commemorating 2nd Lieutenant E J Underwood, in All Saints Church, Sanderstead, Croydon. (Ron Cox/NIWM)

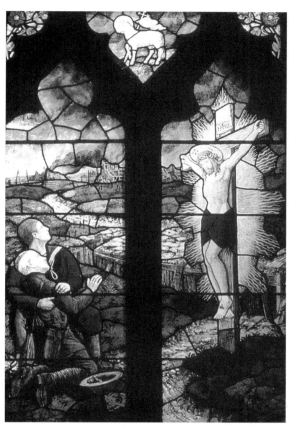

Figure 11 Memorial window from St Michael and All Angels' Church, Bugbrooke, Northamptonshire. (Tony Haylock/NIWM)

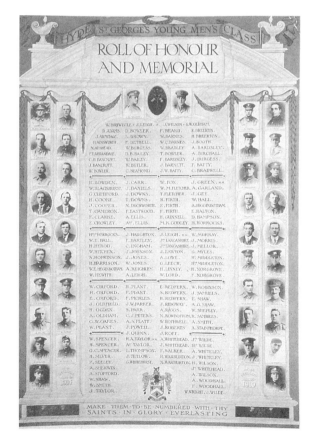

Figure 10 Unidentified Roll of Honour from the NIWM postcard collection; the project gazetteer lists nine communities called Hyde. (Carter Collection/NIWM)

Figure 12 Kenley Memorial Hall, Croydon. (Ron Cox/ NIWM)

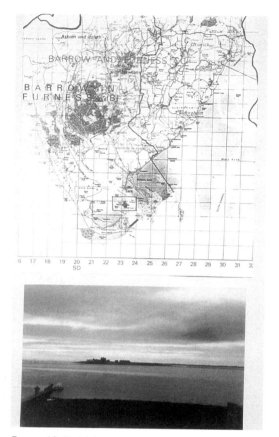

Figure 13 Piel Island, Barrow-in-Furness, Cumbria. (NIWM)

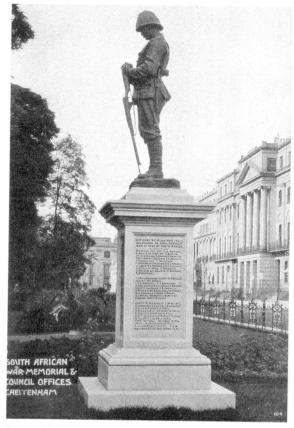

Figure 14 Cheltenham Boer War memorial, Gloucestershire. (Farthing Collection/NIWM)

Dutch in 1666 (Fig 16). However, the earliest casualties referred to are undoubtedly the Roman units which served on Hadrian's Wall, and have recently been listed on a retrospective plaque at Vindolanda Roman fort, Northumberland (Fig 17).

RESEARCH AND PUBLICATIONS

The Inventory's ability to respond to research inquiries remains limited while data-gathering continues. However, the project enjoys a growing reputation, and the development of the Imperial War Museum website, www.iwm.org.uk, has led to inquiries about the Inventory from as far afield as Asia and South America. Interest has grown in recent years, thanks to the fiftieth anniversary of the end of the Second World War, in 1995, and the eightieth anniversary of the Armistice which ended the First World War, in 1998. Without active

advertisement the project received more than 1000 inquiries and around 200 visitors during 1997–98, including:

- local historians interested in specific geographic areas, such as work on commemoration in the Wirral carried out by a Liverpool University student and similar studies of commemoration in Oxfordshire, Hampshire and Manchester.
- social historians looking at railway company memorials and memorials erected by a broad cross section of commercial institutions.
- art historians examining the use of Arthurian and mediaeval iconography in war memorials; Crusade imagery as part of a study of nineteenth- and twentieth-century art (Fig 18); and the works of Charles Sargeant Jagger. The Inventory has also developed good relations with more specific art historical bodies such as the Public Monuments

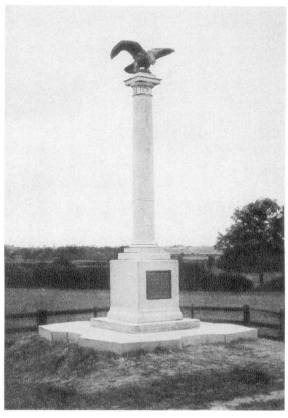

Figure 15 Bronze eagle erected at Norman Cross, Cambridgeshire by the Entente Cordiale Society in 1914. It commemorates 1,770 French prisoners from the Napoleonic Wars who died at a nearby military depot. The memorial has recently been demolished and the eagle stolen. (Carter Collection/NIWM)

Figure 16 Marble tablet commemorating Captain Philip Bacon, in the parish church at Coddenham, Suffolk. (Gwyn Thomas/NIWM)

and Sculpture Association (PMSA)

- military historians such as the Western Front Association, frequent visitors to the Inventory, and inquiries have been received regarding aviation memorials in Wiltshire, and UK memorials commemorating Canadian servicemen (Fig 19).
- students from Winchester College of Art, King's School, Peterborough and Queen Mary & Westfield College. In addition, both De Montfort and Middlesex Universities teach courses specifically relating to commemoration and staff and students regularly use the Inventory as a resource.

The Inventory is becoming a recognised reference point for the media, particularly at accepted times of commemoration such as Remembrance Sunday. During 1997, the Inventory contributed to national newspapers and local and national radio, and advised a number of television production companies.

Assisting conservators by providing detailed information has always been viewed as a significant role of the Inventory, providing the key to successful conservation. Local authorities, government departments, the Royal British Legion and conservation groups, such as the charity Friends of War Memorials, have all approached the Inventory for advice. In 1997 the Inventory published *The Conservation of War Memorials*, authoritative guidelines on devising a proper conservation strategy and where to seek advice. Funding from the Dulverton Trust enabled the production of this free booklet, although donations are always invited.

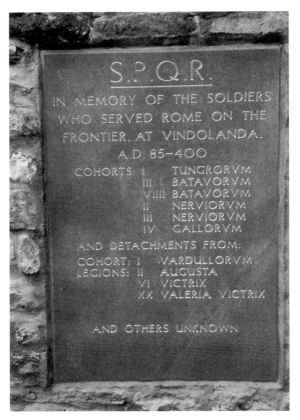

Figure 17 Memorial plaque at Vindolanda Roman Fort, Northumberland. (Andy Hamnett/NIWM)

Figure 18 Stained glass window depicting Richard the Lionheart, in the parish church at Higham St Mary, Suffolk. (Eric Hardie/NIWM)

The names recorded on memorials can offer a wealth of information to the family historian but the sheer volume of information involved meant that an early decision was taken not to add them to the database in the first phase of its compilation. Lists are always requested as part of the recording procedure, and if researchers can indicate where to look, by providing such evidence as place of birth, enlistment, etc, then the manual files can be searched, sometimes successfully.

However, it is important to realise that memorials are an imprecise resource which need to be interpreted carefully. Local commemoration was never an exact science and memorials can contain errors such as misspellings or mistakes with military units and ranks. Moreover, the same individual could be duplicated on several memorials, for example at his place of birth and workplace. Many memorials record only names, and it is hard to prove that the 'J Smith' recorded is the 'J Smith' sought.

Figure 19 Boulevard of maple trees planted at Pier Head, Liverpool, to commemorate Canadian participation in the Battle of the Atlantic during the Second World War. (George Donnison/NIWM)

A significant section of the Inventory's potential users would like to be able to search for names of servicemen, and we are working to address this issue. Current development plans include the addition of a name table, but the addition of the names themselves would take a great deal of time and effort, and is still not practical in this first phase.

TOWARDS THE MILLENNIUM

The Inventory has been a remarkably successful partnership between major public institutions and a network of dedicated volunteers. The incredible efforts made by these volunteers over the last nine years have now necessitated the expansion of the professional side in order to process the recorded information. This has been made possible by a generous three-year grant from the National Heritage Memorial Fund, announced in November 1997 (*The Times* 1997). By 2001 we should have a fully operational database of the estimated 50 to 60 thousand war memorials in the United Kingdom.

The existing Oracle database will be expanded from a single user platform using a stand-alone personal computer to a three-user network with its own file server, to increase the rate of cataloguing. To extend access to the collection as far as possible, public search terminals will be installed in the two busiest Imperial War Museum visitor research facilities as well as the project office. Refinements are planned to the existing structure of the database, aimed at making it as 'user friendly' as possible. Seven new report formats are planned, and visitors will eventually be able to search and obtain printouts under the following headings:

Geographical location
Previous locations if moved
Artists, manufacturers, etc
Public figures connected with ceremonies
Conflicts commemorated
Denomination
Memorial type
Materials
Ceremony date
Condition
References

Where available, references to personalities will contain concise biographies, and references to conflicts will contain short historical summaries. Memorial types and materials used will be supported by a brief definition. The existing detailed reports for individual memorials will be enhanced, and tables will be added for photographs and an index of the names of those commemorated. However, the actual addition of the photographs and names themselves still lies outside the scope of the existing budget and time-scale.

The final structure of the National Inventory of War Memorials at the end of Phase 1 will thus be a five-user Oracle network holding a database of 50–60,000 entries, easily accessible to Imperial War Museum staff and visitors. It is hoped that the database will be disseminated as widely as possible.

As far as possible, the Inventory will be cross-referenced to related collections, such as the war memorial prints held by the Imperial War Museum Photograph Archive, the unveiling programmes, orders of service and other ephemera held by the Imperial War Museum Department of Printed Books, and the Listed Buildings Database at RCHME. It should then be possible to use the database to carry out sophisticated research inquiries, including mapping the commemorative work of particular artists, or examining the popularity of certain designs and relating them to specific geographical areas. Memorials will provide invaluable information about national and local identity, and information about ceremonies and planning will give an insight into community organisation.

CONCLUSIONS

As for the future, after 2001 it is hoped that this valuable resource will made as widely available as possible. There would be opportunities for both conventional publication and electronic access. However, it is plain that the entire national collection of up to 60,000 records is not suitable for conventional publication, as it would result in a 100,000-page publication equal in size to several telephone directories. The approach taken by the PMSA National Recording Project, which aims to record all public sculpture, has been to adopt a regional approach to publication, with books covering Liverpool and Birmingham currently available. It may be that a similar approach would be appropriate for the NIWM. The entire database could be produced as a

CD-ROM, made available through the Internet, or through some combination of the two.

For the present, these remain only abstract concepts, and for them to become reality would require a great deal of additional time and further funding. Setting them to one side, we are still confident that by the end of 2001 we will have created a unique resource, invaluable to professional and amateur researchers both now and in the future; a resource of which all those involved will be able to feel justly proud.

REFERENCES

Brooke R, 1914 *The Soldier*.
Borg A, 1988 As though they had never been, letter to *The Times* (5 March).
The Times, 1997 We will remember them, 8 November, 2.

ACKNOWLEDGEMENTS

The author would like to thank his colleagues at the Imperial War Museum for their support and advice in the preparation of this paper, in particular the staff of the Photograph Archive for producing such excellent slides and Jane Carmichael, the Assistant Director, Collections, for patiently proof-reading. Thanks also to Dr Catherine Moriarty, my predecessor at the NIWM without whom the collection would not exist and who was always happy to offer advice about the project's history, and Dr Angela Gaffney of the National Museums and Galleries of Wales, for her constant moral support. Finally, thanks to Viv, Andy and Tamsin, for living with my nervous anticipation.

AUTHOR

Nick Hewitt is Project Coordinator of the National Inventory of War Memorials, based at the Imperial War Museum. He has degrees in history and War Studies, specialising in naval history. He joined the Museum in 1995, working first as an exhibition research assistant and then as the compiler of an inventory for HMS Belfast.

3 From here to eternity
Save outdoor sculpture for the next century

Susan K Nichols

1730 K Street NW, Suite 566,
Washington, DC 20006, USA.
Fax: 202-634-1422, 202-634-1435
snichols@heritagepreservation.org

Abstract

In the United States, Save Outdoor Sculpture! (SOS!) has completed a national inventory of all publicly accessible outdoor sculpture and for the millennium is offering grants for assessment, treatment and maintenance. An array of programmes heightens awareness of the value of outdoor sculpture and monuments and the need to preserve local artworks as a lasting gift for the next generation.

Key words

Sculpture, preservation, USA, SOS!, assessment, treatment, maintenance

In the United States, public sculpture is a marvellous and dizzying mix of style and stone, brain and bronze, fibreglass and ephemera, at once public and personal. Most stand in town squares, but some are submerged or subterranean. Since 1989, nearly 7000 volunteers have reported on the location, history, ownership and condition of this 'national collection' of 32,000 publicly accessible outdoor sculptures.

Analysis of that inventory is revealing. Nearly 48% of the sculptures are owned by public agencies; the balance is the responsibility of private individuals, corporations, religious bodies, museums and other non-profit-making organisations (Fig 1). Approximately 50% of America's collection is adequately cared for. The other 50% needs care, 10% needs it urgently (Fig 2). Since 1996, with the inventory essentially completed, that needy 50% has become the primary focus of SOS! The looming millennium adds impetus to the effort, providing an

incentive to communities and funders to save an outdoor sculpture as a gift to the next generation.

Recognising that the process to preserve is an integrated package of assessment, treatment and maintenance, in 1997, with an updated project

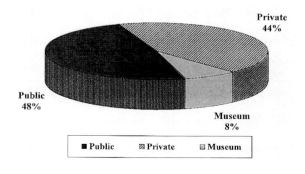

Figure 1 Distribution by owner of publicly accessible outdoor sculpture in the USA.

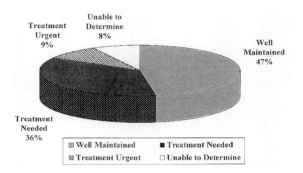

Figure 2 Distribution by condition of publicly accessible outdoor sculpture in the USA, indicating that 50% needs attention and that at least 9% is in urgent need of care.

name and logo, SOS!2000 made 27 awards of $1,500 each to assess 81 eligible artworks. In 1998, an additional $70,000 was set aside for assessments. Also that year SOS! began to address the maintenance piece of the puzzle with a pilot programme in four sites. Save Outdoor Sculpture! Tender Loving Care, dubbed SOS!TLC, brought a conservator of outdoor sculpture into each community three times, over 18 months, to train and monitor paid and unpaid people in low-tech maintenance procedures. A proposal to expand SOS!TLC to an additional dozen sites was funded for implementation in 1998 by the National Endowment for the Arts.

Several cities took responsibility prior to moves by SOS!. In the 1980s, in Baltimore, Boston, New York and Philadelphia, agencies and non-profit-making organisations addressed their deferred maintenance of public sculpture with inventories, assessments and treatment. In Dallas, Texas, for example, a law firm funded the city-wide inventory and assessment. Other states and cities have approached their maintenance of public sculpture in several creative ways. Some have legislated a municipal code change. In Buffalo, New York, money that was earmarked for the commissioning of new sculpture has been reallocated for care of existing artworks. In Baltimore, Maryland, residents living around a park with eight outdoor sculpture made annual pledges for five years to match the city's budget to ensure regular maintenance.

Children and youth have a role to play in preserving public sculpture as well. In Dallas, Texas, during the summers since 1996, youth at risk, trained by a conservator, assisted city parks' staff in low-tech

maintenance. In Houston, Texas, fifth graders have raised money to help their city maintain the city's landmark monument, *Sam Houston Memorial* (Ernesto Cerrachio, 1925); Exxon Company matches the children's contributions three to one.

Between assessment and maintenance is treatment, the key and most costly missing piece necessary to complete the preservation puzzle. Since the 1980s, creative and responsible bureaucrats and citizens have secured funding for conservation treatments in the United States. At the centre of every successful effort to save outdoor sculpture is a single individual, private or official, who pulls strings, prods, cheerleads, even sells root beer and a personal library as in Charlottesville, Virginia. There a housewife sold her library to pay for the costs of professional assessments of three significant public sculptures which have since been conserved. In Des Moines, Iowa, a pipe layer and Civil War buff spearheaded a campaign that raised nearly $200,000 for the professional assessment and treatment of the *Iowa Soldiers and Sailors Monument* (Harriet Ketcham, 1898). Among the special fund-raising events was the sale of root beer at military re-enactments.

In addition to special events and corporate or foundation support, a limited assortment of government funding sources can be tapped. In Texas and Tennessee, some cities with sculptures along highways or on roundabouts followed a tangled bureaucratic road to secure up to 80% of their costs from the federal highway law. In Tennessee, the *Peace Monument* (Giuseppe Moretti, 1926), the only monument erected in memory of both armies fighting against each other in the American Civil War, was badly damaged by storms and time and strangled for decades by highway interchanges. Citizens successfully matched their 20% share for its relocation and restoration. The State of Vermont was awarded federal highway money to train personnel in low-tech maintenance of sculpture in roadside parks. Officials in Denver, Colorado, and Portland, Oregon, set up interagency agreements, to conserve and maintain public sculptures. In addition, in Colorado, funds from the state's gaming fund have been used to preserve historic sculpture.

The millennium has boosted interest in the United States. A White House millennium project is 'Save America's Treasures' and public sculpture is a significant part of those treasures. In July 1998, the

White House announced the SOS!2000 Awards for treatment, available for cities and non-collecting, non-profit organisations with outdoor sculpture and monuments, made possible with the support of Target Stores and the National Endowment for the Arts. That announcement generated additional corporate inquiries about 'good citizen' projects.

Electronically, the SOS! website (www.heritagepreservation.org)includes illustrated updates of local projects to show how citizens of all ages are preserving their home town monuments, a tutorial that walks through the steps of assessment, treatment, maintenance and public awareness and interdisciplinary activities for elementary school children. In addition there is an on-line 'catalogue raisonne' of artworks in need of treatment and those whose conservation is underway.

For 2000, SOS! will form a partnership with several Girl Scout councils to offer an SOS! badge and plans to produce a low-security travelling exhibition, 'In Praise of America's Sculpture'. One goal of the travelling exhibition is to show the many faces of SOS!, local citizens who helped with the inventory, fund-raising and public awareness programmes. Other ways in which those people are honoured include nominal cash achievement awards for adults and children and Monumental Defender Certificates to those individuals and corporations that help save public sculpture in their home towns.

Americans feel strongly about their historical and contemporary public monuments, although they typically know very little of the origins of the artworks or artists' inspirations. Once alerted to that history and the preservation needs, the proponents are generous with their time and are enthusiastic fund-raisers. Millennium fever is feeding that zeal.

AUTHOR

Susan K Nichols is founding director of Save Outdoor Sculpture!, a project of Heritage Preservation, USA, initiating SOS! in 1989. She has 25 years experience with museums and other cultural institutions as educator, administrator, writer, editor and lecturer. Her most recent article appeared in the *Journal of International Cemetery & Funeral Management*. Ms Nichols earned an undergraduate degree in art from the University of Wisconsin and a graduate degree in museum education from The George Washington University.

4 Leeds: patronising the arts and encouraging the sciences

Dorcas Taylor

Deputy Curator
Yorkshire Sculpture Park,
Bretton Hall, Wakefield WF4 4CG,
England, UK.
Tel.: 01924 830302
Fax: 01924 830044

Samantha Sportun

Conservation Centre
National Museums and Galleries on Merseyside
Whitechapel, Liverpool, L16 HZ, England, UK.
Tel.: 0151 478 4903
sculpture@nmgmcc3.demon.co.uk

Abstract

The lintel relief that sits above the entrance of Leeds Town Hall, *Leeds Patronising the Arts and Encouraging the Sciences* (John Thomas, 1858), epitomises the aims of this paper; to explore the relationship between curators and conservators and their respective and combined interests in art and science.

Recognising the need to re-evaluate the city's public sculpture which, apart from interest from graffiti artists and over-excited students, has been overlooked in recent years, Leeds Museums & Galleries has been able to demonstrate its commitment to preserving the public sculpture of Leeds by commissioning a conservation audit in collaboration with the Liverpool Conservation Centre.

This chapter explores the issues of taking on the problems associated with the city's collection of public sculpture, determining the action needed to begin to rectify these problems and future developments. The second half of the paper examines the structure of the conservation audit, from the initial communication between Leeds and the Liverpool Conservation Centre through to the realisation of the project.

Key words

Leeds, survey, audit, public sculpture, collaboration, Leeds City Council, Liverpool Conservation Centre

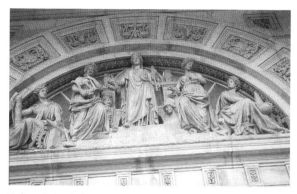

Figure 1 *Leeds Patronising the Arts and Encouraging the Sciences* by John Thomas (1858). (Leeds City Council)

THE CONTEXT

Dorcas Taylor

The title of this paper, *Leeds Patronising the Arts and Encouraging the Sciences*, refers to the pedimental relief of the same name by the sculptor John Thomas, completed in 1858, that sits above the entrance to Leeds Town Hall (Fig 1). As an emblem of civic pride, the sculpture, according to the Leeds Mercury in 1858, represented Leeds 'in its commercial and industrial character, fostering and encouraging the arts and sciences' (*The Leeds Mercury*, 7th September 1858). The central figure, representing *Leeds*, is located in front of the seat of *Justice*. On the right of the main figure is the figure of *Poetry and Music* and a figure representing *Industry*. To the left is the representative of the *Fine Arts*, incorporating painting, architecture and sculpture, who is placed alongside *Science*. With such noble sentiments behind its creation, it is ironic that it is only now that Leeds is able to direct this commitment towards those very sculptures which were produced to celebrate the creative and scientific achievements of Leeds a century or so before.

On Monday 27th November 1905, the people of Leeds witnessed the unveiling of the Leeds *Queen Victoria Monument* by George Frampton outside Leeds Town Hall in Victoria Square (Fig 2). Rising over 30 feet in height and at a cost of nearly £8000, with funds raised by public subscription the monument was described by the Yorkshire Evening Post as 'one of the finest pieces of modern sculpture in the world'.

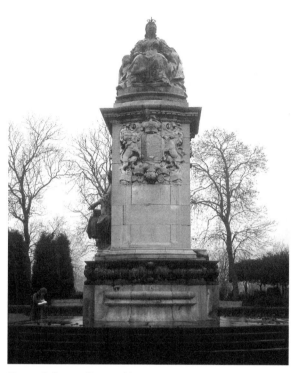

Figure 2 *Queen Victoria Monument* by George Frampton (1905). (Leeds City Council)

Amid a roar of cheering from the assembled thousands, Alderman Lawson, the chairman of the Memorial Committee, stepped forward to ask the Lord Mayor to accept and unveil the statue ... There was a further burst of cheering when the Lord Mayor came forward, and in well-chosen phraseology declared his acceptance on behalf of the citizens of Leeds. It was only right, his Lordship went on to say, that Leeds should provide its own memorial, a memorial which, he was told, was the finest that had been erected to the memory of our great, good Queen Victoria. (*The Yorkshire Evening Post*, 27th November 1905).

On the night of the 22nd November 1995, almost 90 years to the day later, the *Queen Victoria Monument*, now situated on Woodhouse Moor, a public park near the university and approximately one and a half miles from Leeds city centre, was vandalised. The bronze figure of *Industry*, which sat in a niche on the pedestal below and to the right of Queen Victoria as a partner to the figure of *Peace*, had fallen onto the stone steps leading up to the statue and

Figure 3 *Circe* by Alfred Drury (1894) installed in Leeds City Art Gallery (no date). (University of Leeds)

was balanced precariously on the top step. Not only was the sculpture obviously quite severely damaged, but it was also posing a danger to the public because with a weight of about ¾ of a ton, it could have easily toppled further down the steps. The damage that the statue had sustained was considerable in terms of accentuating problems inherent in the statue which had been the result of a similar accident a few years earlier. The head of the figure was severely dented and the knees and right hand had also incurred dents. The right arm was cracked to such an extent that it was very loose and could easily be snapped off. The join around the waist of the figure was also severely weakened.

It was likely that students coming out of a nearby pub had decided to use the sculpture as a climbing frame and were unaware that the sculpture was not fixed in its niche. This event acted as the catalyst to prompt Leeds City Council to reconsider its responsibilities towards public sculpture. The incident highlighted the fact that there was no clear line of responsibility within the council to oversee such emergencies and no obvious budget to pay for the restoration of the sculpture. It also highlighted the problem of long-term neglect. The monument had been relocated to a corner of Woodhouse Moor in the 1930s, when, at least to the councillors of Leeds, Victorian sculpture was unfashionable. This was to make way for the repaving of the square in front of the Town Hall. The sculpture was not relocated and remained on Woodhouse Moor.

The most important result emerging from the crisis from within the council was the recognition that public sculpture did actually exist in Leeds, but also that the

public sculpture *belonged* to Leeds. This dual recognition prompted councillors to commit funds to enable the first steps to be taken to pro-actively, rather than reactively, address the needs of Leeds' public sculpture.

Leeds Museums & Galleries agreed that this first step should be a conservation audit of public sculpture. The first task, however, before putting the work out to tender, was to establish how many examples of public sculpture Leeds possessed. To do this it was necessary to define 'public sculpture'. There were difficulties in establishing the criteria. While many cities and towns share similarities in the types of public sculpture they possess, the way in which 'public sculpture' is defined is, to some extent, unique to each situation and is dependent on and affected by specific historical and logistical constraints. A list of 'public sculpture' was therefore put together that made sense within the context of the audit (a publicly-funded exercise) and to Leeds itself (all the sculptures were readily accessible to the public).

Leeds is particularly fortunate to have a substantial body of information relating to publicly-sited sculpture in Leeds and the surrounding areas, useful for the audit because it includes evidence of ownership, and whether a piece of sculpture had been commissioned by public subscription or donated to the city. Using those guidelines 40 or so examples of works were identified as 'public sculpture'. Not all these works were necessarily sited outdoors and some 'public' sculptures were located in independent sites, notably *Henry Hall* by William Behnes (1852) and *Dr William Hey* by Francis Chantry (1826), which are in the main entrance of Leeds General Infirmary. Sculptures which were incorporated into the facades of public buildings, such as Herman Cawthra's two groups of putti with animals (1933), *Putto with Goat* and *Putto with Turkey*, were also included. Inconsistent accessioning of some outdoor pieces into the collection of what is now Leeds Museums & Galleries prompted the inclusion of these sculptures within the audit's remit.

One such work, *Circe*, by Alfred Drury, had been purchased by the Corporation Fund in 1895 from the Leeds Spring Art Exhibition and had originally been located in the City Art Gallery (Fig 3). It was 'lent' to the Parks Department in 1951 for installation in Park Square, an upmarket, commercial area of Leeds, and is still located there (Fig 4). Attempts were made some years later to move it to a less attractive

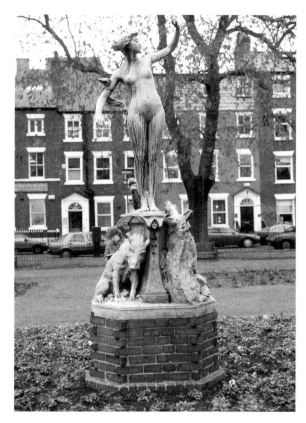

Figure 4 *Circe* by Alfred Drury (1894) current location in Park Square, Leeds. (Leeds City Council)

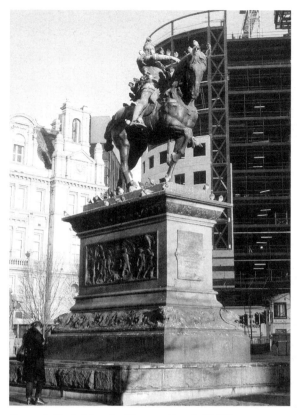

Figure 5 *Black Prince* by Thomas Brock (1903). (Sculpture Conservation Centre, Liverpool)

part of Leeds. In response to this proposition, from an undated article entitled 'What does a nice girl like you think?' in the Yorkshire Evening Post, the sculpture 'herself' responded to the suggestion:

> What do I think about moving? What do I think about leaving this lovely little garden where everybody respects me? Not likely … Nice fellow [the Parks Director] … Best thing he did was pulling me out of the Art Gallery. I nearly froze to death in those vaults. (*The Yorkshire Evening Post*, nd)

This somewhat flippant response shows the lack of understanding of public sculpture that goes some way to explain the deep-rooted, misinformed perceptions that needed to be overcome to enable Leeds to make some headway in developing a sense of responsibility towards its public sculpture.

Having decided on a core group of sculptures, it was necessary to establish the aims of the audit. A brief was compiled focusing on four main tasks:

- to provide an up-to-date condition report on each piece of sculpture
- to recommend and provide costings for necessary treatment
- to prioritise those works most urgently in need of treatment
- to put together a realistic programme of maintenance.

The aims of the Leeds audit were to gain an informed overview of the current state of its public sculpture, to highlight its needs and to find manageable, *realisable*, solutions to its problems. These aims echo the goals realised in a recent conservation audit of the Leeds Museums & Galleries sculpture collection itself.

The task of completing the audit was put out to tender and the Liverpool Conservation Centre, part of National Museums and Galleries on Merseyside, was appointed to undertake the job.

Figure 6 Evidence of serious corrosion on statue of *John Harrison* by Charles Henry Fehr (1903). (Sculpture Conservation Centre, Liverpool)

Figure 7 Lightly soiled bust of *Reverend Hook* by William Day Keyworth Jnr (1844). (Sculpture Conservation Centre, Liverpool)

THE SURVEY

Samantha Sportun

The list of about 40 sculptures along with directions for a conservation audit was forwarded to the Liverpool Conservation Centre in August 1996. An estimate for the time taken to examine these sculptures along with other costs was then calculated and submitted.

The actual survey was undertaken in January/February of 1997 by three staff from the Conservation Centre. The first day was spent familiarising themselves with the more accessible sculpture, taking photographs and noting the general condition of these sculptures and bases. To realistically examine some sculptures, such as the *Black Prince* by Thomas Brock (Fig 5), the workers required lifts, and sometimes a cherry-picker to access the elevated sculpture.

The condition survey assessed the individual problems associated with each piece of sculpture and prioritised the most urgent cases. By doing this a programme for conservation could be drawn up and practical solutions suggested for the aftercare of the sculptures.

The types of conservation problems that the sculptures exhibited are likely to be fairly representative of many public sculpture collections around the country. Almost all the sculptures needed some form of conservation treatment (some needing major intervention to stabilise them, while others only requiring light cleaning, see Figs 6 and 7). The worst affected had suffered from long periods of neglect and at other times perhaps too much attention, in the form of aggressive cleaning techniques or inappropriate filling and consolidation. Some of the sculptures had suffered from the regular attention from vandals, including the statue of *Robert Peel*, by William Behnes (Fig 8) which is attacked with paint almost monthly, the *Queen Victoria* monument by Frampton (Fig 2) and the *Lion fighting a snake* (anon 1883, Fig 10).

A contributing factor to this vandalism of this group of sculptures (apart from whom the sculptures represent) is that they are all relatively isolated in Woodhouse Moor park and away from the passing public for most of the time. The *Queen Victoria* monument has suffered serious physical damage on more than one occasion. The stonework has lost much of its detail and is very badly stained by

Figure 8 Paint-covered statue of *Robert Peel* by William Behnes (1852). (Sculpture Conservation Centre, Liverpool)

Figure 9 Decorative plaque suffering from serious bronze corrosion which is causing structural damage and straining. (Sculpture Conservation Centre, Liverpool)

bronze corrosion, and the bronze figures and decorative plaques also have serious corrosion problems (Fig 9).

The placement and siting of sculpture also has a profound effect on the way that it is regarded. *The Lion fighting a snake* (Fig 10) is a traditional piece of late Victorian stone carving in a corner of Woodhouse Moor. It is a small piece 3' by 4'8" (1m by 1.5m) situated on the ground near a playground. It was not raised on any from of pedestal or plinth or protected by any form of barrier. When it was examined in February 1997 every inch of it had been covered in paint and melted plastic, so that it resembled playground equipment. It is likely to have been regularly climbed upon and the inevitable happened two days after we examined it, when the lion was broken away from its base, causing serious

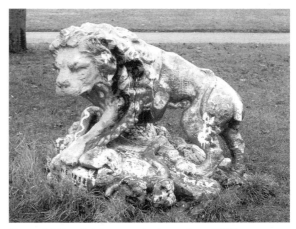

Figure 10 *Lion fighting a snake* (anon June 1883) vandalised with paint. (Sculpture Conservation Centre, Liverpool)

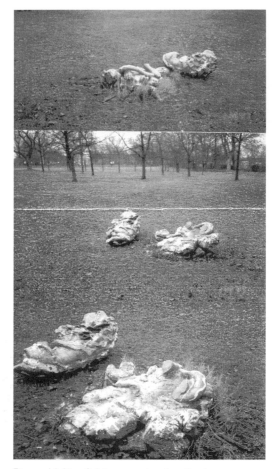

Figure 11 *Lion fighting a snake* after further vandalism, when the body of the sculpture was broken away from its base. (Sculpture Conservation Centre, Liverpool)

Figure 12 Base of the *Black Prince* suffering from salt damage. (Sculpture Conservation Centre, Liverpool)

damage to the leg area (Fig 11) The piece now requires much more interventive forms of treatment such as doweling to stabilise it. The combination of neglect and unsympathetic positioning turned this piece of sculpture into a target for vandalism.

Lack of consideration for the physical and chemical natures of sculptures also leads to an accelerated deterioration. The Alfred Drury *Circe*, the *Queen Victoria* monument and the *Black Prince* have all been placed on soil or have soil surrounding their plinths. This has resulted in water being transported up into the plinth and soaking up inside the sculpture. This transports salts and creates corrosion in areas of the sculpture where it may not have necessarily

occurred. Simple measures such as removing the soil, inserting an appropriate damp-proof course and maintaining the grout around the bases and plinths may have saved the internal pins from corroding and prevented the stone splitting in some instances (Fig 12).

The *Circe* is a special case in that it appears to have been made for indoor display. It is known that sculptors of the time, such as Alfred Gilbert and Alfred Drury, were very concerned with the fine patinas that they could achieve on their metal sculptures. Any evidence of the patina on Circe is likely to have been destroyed after years of outdoor exposure, with the result that it has changed the aesthetic appearance of the object quite dramatically.

Another example of inappropriate siting has been the display of a fine pair of decorative ceramic

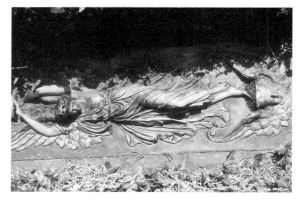

Figure 13 Ceramic panels (nineteenth century) within a hedge in Armley Park, Leeds. (Sculpture Conservation Centre, Liverpool)

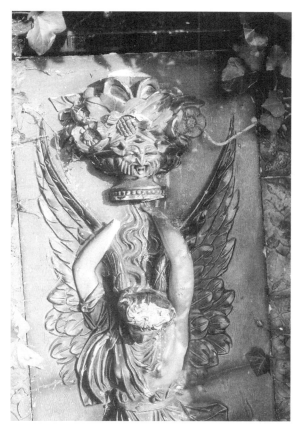

Figure 14 Cracks spanning the width of the panels.
(Sculpture Conservation Centre, Liverpool)

Figure 15 *Henry Marsden* by John Throp (1878) suffering
from advanced weathering. (Sculpture Conservation
Centre, Liverpool)

panels which have been displayed in a hedge in
Armley Park (Fig 13). It is not known how long they
were on this site, however they are reaching a
critical stage in their lifespan when a number of
factors could very swiftly combine to destroy
them. These relatively brittle objects have a
number of running cracks spanning their width
(Fig 14) as well as a number of losses to the
decorative surface. Their lower sections have also
been embedded into the soil. They have been
secured at an angle to a concrete backing which
could in turn cause salt damage and increase the
stress to the panels.

For other sculptures, particularly some of the
external stone pieces, it is not simply a question of
cleaning and stabilising the surface. Severe
weathering of the surface has occurred and eroded
much of their detail. This has been caused by siting

in an exposed position and suspected overcleaning
(with the use of acids and abrasives) (Fig 15). Those
of a similar period and marble that have been
displayed indoors have survived very well in
comparison and require only light cleaning for
conservation (Fig 16). The difference in condition is
to be expected but nevertheless is quite shocking.

A report has been produced as a tangible record
of a moment in the lifetime of these sculptures.
Material was gathered on each sculpture in the form
of photographs and written notes, standard
conservation practice, but to assess the extent of
conservation needed in some instances further
investigation would be needed, involving dismantling
and examining the internal armatures of the bronzes,
as well as some preliminary cleaning. Bases and
plinths also need to be carefully looked at to ensure
that they are structurally sound.

Figure 16 *Dr W. Hey* by Sir F Chantry (1826). (Sculpture Conservation Centre, Liverpool)

The initial funds required to stabilise and clean these types of large sculpture are usually quite substantial; however, once treated, the sculptures would only require a simple maintenance programme to ensure longevity.

Conservation practices change constantly as new methods of cleaning and consolidation are introduced. What was good practice 10 years ago may now be known to damage sculpture; however, these methods are still available, often cheaper than newer technology and may still be chosen when public bodies are forced to take the cheapest option.

A number of other options should be considered, such as resiting and renewing plinths, removing soil from around bases and moving sculptures away from the close proximity to the road. Perhaps the most radical solution would be to remove the deteriorated stone sculptures (such as the Keyworth lions in front of the Town Hall (Fig 17) to safety and replace them with carved copies. The originals

would be moved to a safer environment and the newly carved lions would restore a sense of civic pride to the building and also stimulate debate about personal sculpture.

CONCLUSION

Dorcas Taylor

The rigorous survey by the Liverpool Conservation Centre has provided Leeds with the necessary information to apply for funds from the National Lottery to act upon the findings of the audit, if the council is so minded. The audit was paid for by the City Council's Development Group and a briefing paper, based on the findings of the survey, was prepared by the Director of Museums & Galleries in collaboration with the Director of Leisure Services. As yet, the proposals outlined in the audit to address the needs of public sculpture have not been presented to any political committee within the council. However, as an exercise in its own right, the audit has offered a number of useful insights for Leeds.

As a collaborative venture, the audit provided an opportunity to share specialist knowledge between sculpture conservators and gallery curators, and the Development Department of Leeds Leisure Services provided their practical knowledge to facilitate the audit. The audit also highlighted the relationship that other departments in the council have with public sculpture in Leeds, notably the Parks Department and the Anti-Graffiti team. In response to this the audit has also highlighted an awareness within the council itself about who to approach for advice about public sculpture.

In the past, occasional and unfocused attempts had been made to at least keep the public sculpture presentable (this usually involved cleaning off paint and removing graffitti) and decisions made about public sculpture, such as the relocation of Drury's *Circe*, were made on an unregulated, ad hoc basis by a variety of unconnected individuals. With a developing sense of ownership towards its public sculpture, this audit has succeeded in gaining the recognition that these artworks form a public sculpture *collection* and as such need to be maintained and preserved collectively, in a structured and organised way.

Figure 17 *Lion* by W D Keyworth (1867) in an advanced stage of weathering. (Sculpture Conservation Centre, Liverpool)

ACKNOWLEDGMENTS

Thanks to Melanie Hall, now at Nottingham Trent University, and Terry Friedman, for their work on producing a list of public sculpture in Leeds; Ben Read for guidance on donated or commissioned sculptures; and Martin Wright from the Development Office, Leeds City Council, for organising access and equipment for sculpture inspection.

AUTHORS

Dorcas Taylor is Deputy Curator at the Yorkshire Sculpture Park, and former Assistant Curator (Sculpture) with Leeds Museums & Galleries, based at the Henry Moore Institute, Leeds. There she worked predominantly with the collection of twentieth-century British Sculpture in Leeds City Art Gallery. She is currently undertaking postgraduate research at the University of Manchester.

Samantha Sportun, Sculpture Conservator, graduated in Fine Art (Sculpture) from Staffordshire. University and became a practising sculptor for a number of years. She later graduated with an MA in conservation from Durham University. Since that time she has worked in the sculpture conservation department of the National Museums & Galleries on Merseyside, developing an interest in the restoration techniques of eighteenth-century sculptors and has been involved in research on the laser cleaning of parchment.

Part 2

History and Interpretation

5 Do monuments still speak in Picasso's Vallauris from museum, courtyard, park and street?

Helen E Beale

Department of French,
The University of Stirling, Stirling,
FK9 4LA Scotland, UK.
heb1@stir.ac.uk

Abstract

Public monuments in the pottery town of Vallauris Golfe–Juan in France are examined: their sites, the behavioural responses they elicit and their diversity, from civic monuments to the street furniture of monumentally large emblematic pots lining the main thoroughfare leading to galleries and potters' workshops. Four tropes are identified: wholly bounded, circular enclosure, partly open and quite open. Public appropriation and assimilation of the monuments is encouraged by the variety of site, the individual scale of the monuments and the town's character. The inherited benefits of Picasso's democratizing influence are noted. The generous provision of pedestrian space and the tidy management of the town favour perambulation. Being so protean, Vallauris should adapt well to 2000.

Keywords

Vallauris, Picasso, public sculpture

There are three main reasons for choosing the monuments of the French provençal town of Vallauris, on the Côte d'Azur, when considering the conservation and care of public monuments and sculpture on the eve of the Millennium. Firstly, for many, Vallauris is synonymous with Picasso, and the visitor may be led to Vallauris primarily to see where the master became a disciple of ceramics. But Picasso also gifted one of the town's public sculptures, and had a significant influence on the town's attitude towards openness of access to works of art.

Secondly, if making an assessment of towns against the watershed of the Millennium means assessing their hold on the past and their adaptability

to cope with the new, Vallauris Golfe-Juan is, to those who know it, an obvious choice of a place capable of constantly reinventing itself. It is a town which made its reputation on the production of the useful, in this case domestic pottery and culinary ware, objects which people bought regularly. However, its fortunes have fluctuated widely, and it has had to overcome economic vicissitudes such as competition from aluminium for cooking vessels. In its struggles, Vallauris has shown considerable resourcefulness and turned, inventively and effectively, towards lustre, tableware and design for its artistic and economic survival. This spirited character is still much in evidence in the town.

Thirdly, Vallauris, a survivor, likes to count survival by the millennia: in its current publicity material it lays claim to two thousand years of pottery tradition, and in its official history (Méjean 1975), it vaunts three thousand years. It was a dwelling place, apparently producing a form of unturned pottery, in the Iron Age; it has been a major pottery-producing town since the sixteenth century, and it celebrated in 1998 the fiftieth anniversary of Picasso's arrival at the door of the Poterie Madoura, to immerse himself in the study of ceramics (Ramié 1984) and bring Vallauris to widespread modern attention.

On the road signs welcoming the motorist, Vallauris (population 24, 000) proclaims itself an art town, but its public monuments and sculptures are not exceptionally plentiful. With its hundred potters, ceramics are its essence, despite the industry's being again in decline economically. However, the monuments and sculptures are stones which still speak, of particular interest because of the varied tropes of their sites and settings, and the way they can be lived with, in market place, park and street. As Mel Gooding says: 'public art serves many purposes, but none can have more point and dignity than investing a public space with a renewed vitality, extending its availability as a place to be, in which a sense of identity, and of the possibilities of the civil life, are enhanced' (Gooding 1997, 13).

Evaluating the monuments of Vallauris against the question, what constitutes a monument and the space it occupies?, produces diverse and ranging answers. There are monuments which the civic identity of the town has predictably spawned, such as war memorials and an emblematic 'potter', together with a major bronze sculpture gifted by Picasso, which at his insistence was to be exhibited out of doors, for children to play upon. The art world came to Vallauris in Picasso's wake, but his touch on the town, far from being élitist, was frequently democratic: sculpture in the market place and affordable art ceramics for the people, were his legacy. Since Vallauris is a compact community, the visitor can cover the main monument sites comfortably on foot, assisted by generous amounts of pedestrianized space and car parking space. What is striking is, on the one hand, to use Charles Griswold's term, the 'substantive unity' of the Vallauris monuments (1992, 82), linked by civic identity and by human scale, and on the other hand, the protean nature of monumental space as it is experienced in

Vallauris. The four types of monumental space it exemplifies are distinct in themselves, but the spectator experiences a rich sense of the multi-functional in the way they alternate or are combined.

Vallauris is not the size of town to have succumbed to French *statuemania*, (that nineteenth-century proliferation of famous men on plinths, and ample allegorical women). The term monument as used in this paper has a wide definition, and embraces, firstly, solemn, commemorative public monuments such as war memorials, but subsequently some less standard types of monument. In the second place, there are monumental sculptures which the public is invited to enjoy recreationally and with a sense of pride (an emblematic potter; a Picasso bronze); and thirdly, there are buildings or objects which partake of the monumental (from the deconsecrated chapel which Picasso made a temple to peace, to the omnipresent pottery, lent monumentality by the sheer volume and mass of some of its artefacts on display in the streets). [1]

The siting of monuments in Vallauris stays in the memory because of the recurrent patterns of space, the closed and open spaces, the circles and semi-circles, which coalesce and persist as a sequence of shapes in the mind's eye. They can be summed up in four tropes, to which the spectator's response ranges from the closely guided to real independence of view, even appropriation of the monument. First, and indoors, there are wholly bounded (interior) spaces, institutionalized to some degree; second, outdoors, circular, within a park or at a crossroads, marking an enclosed area containing sculptures, but not discouraging access; third, partly open, such as outer courtyards and walls; and fourth, quite open, such as the square where stands Picasso's *The Man with the Sheep*, and the very streets themselves. All the examples can be shown to be site-specific, and they eschew the distancing style of pedestal which could intimidate the viewer.

The behaviour of the visitor viewing monuments in any town may range over, on the one hand, what Gooding describes as museum space which is 'essentially contemplative', 'a place apart, accessible on its own [negotiated but conditional] terms to a public who chooses to go there' (Gooding 1997, 17) to, on the other hand, the public square, which is a much freer arena: 'things are different, however, outside, where new art may be received with incomprehension, indifference or hostility' (ibid).

In Vallauris, behaviour and reactions are also, according to monument and site, now carefully governed, now apparently very free. It will be suggested, however, that the nature of town planning and sense of corporate identity in Vallauris are such as to exert a discreet influence on all sites. The experience begins even before arrival in the town, since the Tourist Office is sensitively attuned to its artistic heritage, and to the wider cultural and religious heritage of the region, and provides appropriately dedicated information. [2] The visitor most naturally gravitates first to the forecourt of the Château-Musée, prominent on maps. Here one finds the National Picasso Museum, where the 1952 *La Guerre* and *La Paix* paintings are housed, and the adjacent Ceramic Museum: these occupy a twelfth-century chapel, built in Romanesque style with thirteenth-century additions and deconsecrated in 1791, and a sixteenth-century chateau respectively.

Category One: Closely Guided

In the chapel, no longer an ecclesiastical building, the visitor finds the first category of monumental space which we examine, wholly bounded space, an interior to which entry is monitored, and with which an artistic pact is made in advance by the visitor, that the viewing of an artefact will take place, with, as Norman would term it, literature available to help interpret it (1997). Picasso wanted to make the building into a temple to peace, and enriched it with symbolic, expository panels: thus it can be considered, for the present purposes, as a stone monument with a painted inside. It fulfils the double function of a monument which calls us to remember, but warns us not to repeat, the Denkmal and Mahnmal connotations of monuments (Carrayou 1996). The *War* and *Peace* paintings occupy not the chancel but what was formerly the small nave, an area into which the visitor, significantly, must step down. The artist sought to make this space as hermetic as possible, for the spectator to feel almost totally surrounded by painting (Forest 1996), with a feeling of there being no exit: the two main paintings, on their panels, meet at the apex of the nave roof and the old approach door was sealed off, and painted over with a third image. The kind of contemplation and indeed reflection required of the visitor is thus very carefully governed, and extraordinarily intense. In terms of art appreciation

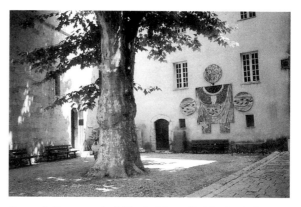

Figure 1 Courtyard of Musée Magnelli, Musée de la Céramique, and Musée National de Picasso, Vallauris. (Helen Beale)

we are still in the realm of what Lawson (1992) calls the individualism of high culture, although the issues raised by Picasso's works affect the collectivity and hence legitimize calling this a public monument.

Leaving the chapel and emerging into the courtyard of the Château-Musée (Fig 1), one is effectively surrounded by apron walls about forty feet (12 metres) high: so the sense of enclosure is still compelling, yet the sky is now above one's head. This natural ante-room (part constructed, part natural growth) serves either to pace re-entry for those emerging into the world outside or indeed to focus attention for those approaching the peace temple and pottery museum. Such transitional space will be discussed further, later on, in category three.

Category Two: Circular Enclosure

Immediately outside the Château-Musée preserve, is the Place de la Libération, 24 août 1944, (formerly Place de la Mairie), the square into which the chapel gave egress until that door was blocked at Picasso's behest (Forest 1996). Surrounded by traffic, cafés and the town library (formerly the town hall) stands the 1914–18 war memorial, within a circular enclosure. This memorial was not, as it might have been, picked from a catalogue but resulted from open competition, the specifications for which itemized the diameter of this space, 20–25 feet, (6–7 metres) and the co-existence of a planting area. This site-specific memorial, by Delfoly of Cannes, was the winning entry from fourteen submissions. It is well preserved, and the surroundings always freshly planted. It constitutes the second trope of

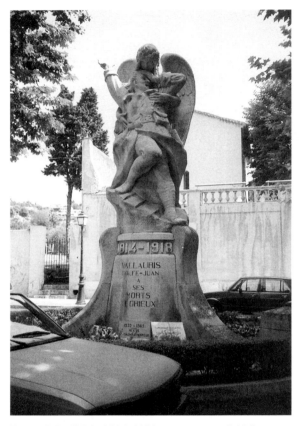

Figure 2 Delfoly's 1914–1918 war memorial, Vallauris. (Helen Beale)

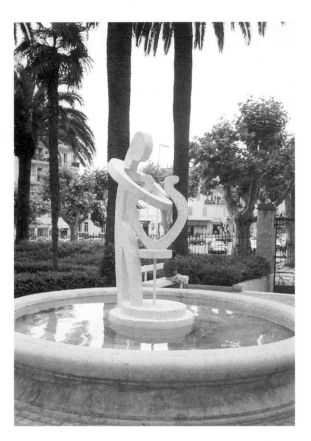

Figure 3 Quéré, *The Potter*, Vallauris. (Helen Beale)

monumental space, the use of a low circular enclosure, no more than a curb, to isolate the space of an exterior monument. The effect of using this category of space is that although the sculptural preserve is marked, in behavioural terms, it is possible to skirt the monument and go on one's way, or, if one chooses to approach, to do so without any sense of obstacle or exclusion, merely of a slight respectful check.

This sculpture in the round (Fig 2) has a number of characteristics which invite contemplation, including the fact that the pedestal is integrated into the all-round design, instead of being distancing and isolating, as is the case on some very frontal memorials. Delfoly has achieved this by continuing the design of the figure group practically on to the flanking arches of the pedestal, uniting the real and the ideal: the heel of the soldier's left foot presses on a realistic depiction of duckboards whereas his

toe touches the venerating iconography of a palm branch, that branch extending down into the pedestal. This feature helps to reactualize the reading of the memorial for the modern viewer, as does the fact that, while Delfoly's design shows a symbolic group of a female allegorical figure sustaining a foot soldier, it is not purely about transcendence, as the winged figure might lead one to suppose. Since the soldier can be discerned struggling to keep a footing on duckboards, while encouraging others onwards, the sculptor has clearly given his work, in part, a documentary quality about trench conditions, which is now intriguing historically. The memorial has also been thrice updated by the addition of plaques, for the Second World War, the Algerian war and the fiftieth Anniversary of the Armistice; the Second World War plaque is also of documentary value in its being unusually explicit about the various fates of the civilian

victims and members of the Resistance during the Occupation.

The other statue in category two, (circular enclosure), stands in front of the new Town Hall, inaugurated 18 January 1989, beside the most modern face of Vallauris in its purpose-built administrative centre. The statue was erected shortly after the inauguration of the building, in 1991–2, and is the creation of a model-maker for ceramics, Martial Quéré, representing *The Potter*. Placed in the centre of a shallow circular pool, among the palm-trees of an ornamental park, Quéré's *Potter,* if not especially remarkable in itself, exemplifies the site-specific monument well integrated into an urban landscaped setting (Fig 3). It is, one must concede, somewhat formulaic, a cypher; it can be floodlit; and it works on the viewer with more of the rapid touch of graphics or advertising than that of sculpture. The vessel being shaped by the potter is depicted in open and minimal form, merely an eponymous V which can be read from a number of angles, though this viewer originally mis-identified the statue as an allegory of music or poetry, Orpheus with a stringed lyre! On closer examination, it can be seen that the allusions are strictly localised, and the statue emblematic of the town: the flexed leg of the figure is turning a small potter's wheel, on which he fashions the pottery vessel.

The low circular enclosure of the pool falls into the same category as the space for Delfoly's sculpture, in that the reserved space for contemplation and symbolism is not too insistent. It could be skirted. Yet it is characteristic of this town that there are seats provided invitingly near the circular pool from which the statue arises, and to which the visitor or spectator may be drawn. Additionally, these seats are beside manicured lawns and foliage: approach roads to Vallauris have the same groomed and managed air. Even though the highly popular boules ground is in the immediate proximity, the park preserves a sheltered and quiet air: there is what Elizabeth Norman, talking of public art in Japan, termed a 'sense of management' of public spaces, which ought to favour the contemplation of public art (Norman unpublished). In Vallauris as a whole, the old order of its late sixteenth-century grid system of streets (Méjean 1975) is not lost since, even with growth and change over the centuries, it remains a coherent yet unregimented town.

Category Three: Partly Open

In category three, 'partly open', we consider perhaps the most ambiguous space, a kind of halfway house of monument space. The first such example is the courtyard of the Château-Musée already briefly evoked. Catering for the transition between a period of intense absorption and the resumption of daily living is an important consideration in the experiencing of monuments, emphasised at the *Memory and Oblivion* congress in Amsterdam (Miller forthcoming), where we were reminded that water, commonly a fountain, often serves in this role, because of its cleansing and purifying associations. The impression given in this forecourt of standing in a well shaft of light can be encountered again in Place Paul Isnard where the Picasso sculpture is sited. An arrangement of wall panels in ceramic, outside the Ceramic Museum entrance, is both decorative and promisingly emblematic of the collection held within, but a more haunting type of exterior panel will be experienced later, on a school wall. As the conclusion to this paper also indicates, additional ceramic works conceived on a monumental scale were placed for public viewing in this courtyard in the summer of 1998. These included works by Roger Capron, the evolution of whose ceramic styles is as self-renewing and resourceful as the history of Vallauris itself.

Also in category three, we cite another war memorial in the form of a memorial plaque affixed to an outer, functional school wall, fronting a main thoroughfare. The reading of such wall plaques can be ambivalent: they have an affiliation, they belong somewhere, but they are at the same time curiously exposed. They have not been put wholly into the public preserve, and it would not be seemly for them to be appropriated freely. Yet they have much less of a formal context than the public statue has and certainly very little of the contextualization of the museum or peace temple. Nowadays a pedestrian crossing leads almost directly to the plaque. It has no contextualization outside itself on the building, but it catches the eye by its very starkness and dignity. It is almost the only monument in the collection described in this paper which cannot be walked around, and is in fact behind railings (those of the school boundary), but it is still in the public domain by virtue of its legibility and its

Figure 4 Memorial plaque, Ecole Alphonse Daudet, Vallauris. (Helen Beale)

Figure 5 Picasso, *The Man with the Sheep*, Place Paul Isnard, Vallauris. (Helen Beale)

physical nearness to passers-by. It is site-specific, to a junior school, the Ecole Alphonse Daudet, because it honours the memory and mourns the sacrifice of former pupils (Fig 4). This is the school which the visitor to Vallauris passes while crossing between the National Picasso Museum and the Town Hall car park. The school's main entrance, round the corner, is animated by energetic youngsters. There seems to be a particularly French reason for the affixing of this ornamental memorial away from the main door, thus averted from the gaze of the youngest children. A familiar trope of sculpted French war memorials is the memorial with two discrete aspects, its more inspirational and heroic aspect facing the local school, for the children to see, and its more grieving and desolate aspect set towards the open street, for the attention of the adults (Giroud et al 1991, 114). The presentation of names, too, is often in France severely egalitarian: here names are in alphabetical order, but some indications of rank are added, not inappropriately because it echoes the intimate pride of a school roll of honour.

Category Four: Quite Open

Category four is 'quite open', free from any kind of museum restraint, and for the public to make free with, yet in the estimation of many, includes the most aesthetically interesting work in Vallauris. In Place Paul Isnard, used on certain days as a market place, stands a bronze cast of Picasso's 1943 sculpture *L'Homme au Mouton, The Man with the Sheep* (Fig 5). Inaugurated here in August 1950, the statue faces the sculpted war memorial, across the interval of a main road. It can be walked right round and touched by the public, since there are neither railings to the sculpture nor any erected perimeter boundary to the square. However, one steps down

into this square, another instance of immersion in monument space, recalling the entry to the temple to peace. Picasso's gift of this cast to the town pre-dates the painting of the chapel and Vallauris's having a proper museum: the authorities wanted to house the sculpture safely in the chancel of the chapel, then being mooted as a civic museum space (the chateau was still inhabited). Picasso exerted his authority to have it set in a public square, initially alarming the councillors by his desire to see the monument, as his biographer records: 'set up outdoors in a square where the children could climb over it and the dogs water it unhindered' (Penrose 1971, 383).

Appropriation of a public monument (albeit less presumptuous than this!), is evidence of the fact that the monument really works in public space, a criterion used importantly in making choices for inclusion in the *Monument et Modernité 1891–1996* exhibition in Paris (Chabert 1996). Picasso's faith in participative art has similarly been vindicated at Vallauris, since the sculpture, while certainly appropriated, by playing children and on market days, has never been damaged. Admittedly, it is a less hermetic or alienating an art object than it could have been, and hence perhaps less susceptible to vandalism. But it is cheering to learn that the blacksmith of the time of the gift hoped that the Picasso statue they were to receive would not be too recognisable (Penrose 1971, 382–3): in Vallauris they do not want the ordinary. It is mounted on a small stone pedestal, echoing the stone retaining wall required at the back of the Isnard square by the sloping fall of the land. As with the Delfoly war memorial, the pedestal is relatively unobtrusive, there because integral to the work; it is very similar to the pedestal shown in Robert Capa's photograph of the original cast in Picasso's atelier in Rue des Grands Augustins (Gilot and Lake 1966, 301). A postcard view of Place Paul Isnard bought in 1992 shows the pedestal to be flush with the height of the trestle tables bearing market wares, which are arranged, without ceremony, right up to the sculpture on all sides. Remarkably, this is not a public monument originally conceived as such, but a sculpture of museum class which has made the transition to public art, from elite to everyday culture, in a site selected by the artist: a site which is normally no quiet haven, with its cafés, markets,

playing children and people on balconies on three sides. Given the successful integration of this sculpture, it was eventually considered by the town authorities that other sculptures might follow suit on public display, but the costs of insurance were found prohibitive and the idea, regretfully, had to be abandoned. Vallauris has a thriving museums support group, with a membership of three hundred in 1998, which would like to see the idea revived.

Finally, also in category four, and in the wake of the market resonance of Picasso's sculpture, the very streets in Vallauris are an art space. This role has been facilitated by the style of town planning. In descending Avenue Georges Clemenceau, the main thoroughfare, from the church of St Anne, with the Delfoly war memorial on one's left right and *The Man with the Sheep* on one's right, the visitor or the inhabitant moves between shops and cafés towards the galleries and studios. One's passage is made more agreeable by traffic-calming measures to make the road one-way and by comfortably wide pavements. The avenue is punctuated by street furniture in the form of monumentally large pots, some planted with greenery, pots so large that they exceed the size of those produced in Vallauris and are made by the Poterie Ravel in Aubagne. Stamped for security reasons with an imprint of the Ravel seal and a Vallauris seal, they affirm the town's identity, and they too are in a sense monuments to its endurance and its character.

That character is best revealed when one follows some of the newer pedestrian ways, (albeit not yet mellowed enough to merge seamlessly into the older town), and penetrates small studios and potteries, each with its own identity. It is common for today's potters, in the workshops of Madoura, Saltalamaccia and Gerbino, as they talk, to affirm continuity over three generations, citing how they are respecting their grandfather's tradition but always evolving. Distinctive to Vallauris is what was described in a recent interview (Establier and Salucki, pers comm) as the artistic equivalent of political co-habitation: artists and artisans respecting each others' work, and even crossing the boundaries. A particular illustration of this is the work of Roger Capron, now aged 70, whose art pottery has been displayed in the Museum for many years, endowing him with cultural gravitas, and yet whose recent witty designer tableware was in the vanguard of the 1998 spring

Figure 6 Galerie Sassi-Milici, Avenue Georges Clemenceau, Vallauris. (Helen Beale)

show downtown, in the Espace Grandjean. This ceramics exhibition was sponsored by the Direction des Affaires Culturelles de Vallauris, indicating local authority support and encouragement. Capron's large ceramic works, mentioned above, were displayed outdoors in Vallauris in summer 1998.

Itineraries suggest themselves easily in Vallauris, by the close proximity of the main monuments to one another, and the orderliness of the place. While retailers in some commercial areas of town might be said to misjudge what constitutes an art space, and the taste of the overspill displays can be dubious and over-commercialized, the real art spaces are in the fastnesses of the potters' and artists' studios, and in the many small but discerning galleries, such as the Galeria Sassi-Milici (Fig 6), whose presentations include the playful, witty style of Capron's recent work. The display material at their doors reflects with more discrimination the quality of the work within.

It might be contended by the reader at this point that Vallauris has no very recent public sculpture in the category of an installation or 'temporary intervention' (Gooding 1997. 17–18), no witty creations with which the public are expected to interact boldly, as Daniel Buren's work at Palais-Royal in 1985–6, Françoise Schein's at the Concorde Métro in 1989–91 or Lawson's work in Givors (Lawson 1992). In general terms, public taste is being educated towards this, and lively commissioning favours it. People want to interact with new monuments, in a hands-on manner, if they want them at all. Evolution and progress happen in waves in Vallauris, however, and the spirit is there for another renewal at the dawn of the Millennium,

redefining monuments once again. For example, Vallauris abhors fixity in commemoration and in art, as witness the real concern in the Madoura Pottery to find appropriate ways of transmitting the memory of Picasso's being there by the evocation of a total presence: showing that he was a creative man with moods, relationships, children; that he had a life and not just an artistic output (Vincent pers comm; Cahiers d'Art 1948). Secondly, just as the town has had to move on when beset by economic problems, since stasis would have meant economic ruin, so it recognises the imperative to change artistically. The Ceramics Biennale has this year (1998) been reconceived and reinvigorated by a change of exhibition concept, said to be needed after thirty years of respecting tradition. Part of the choice of works was in the hands of an invited art critic, and some exhibits moved in October 1998 to Laveno, Italy. The openness of the reinvention of the Biennale bore fruit by the installation of large ceramic works, described as 'monumental' in scale, in the courtyard of the Château-Musée. Such ready externalization of museum objects, such a move towards greater openness of showcasing, is wholly concordant with the range of monument spaces described above.

The advance catalogue notes for this year's Ceramics Bienniale in Vallauris contain a discerning remark about how the potter, by turning the clay, is always close to his centre, in touch with the core of his being (Andréani 1998). Attempts to make the potters form a union, with quality control, have foundered, for they are too individualistic. They work best as a loose affinity of like minds, with their own independence and creativity. The monuments in the town work their influence on an intimate and individual human scale, too. In Vallauris, the spaces for monuments are on a one-to-one scale; neither pedestals or plinths are used to distance or intimidate; perambulation affords easy, gradual immersion. There can be, Naomi Miller reminds us, monuments 'too grand for that moment of quiet contemplation' (Miller forthcoming). Apart from the chapel, the monuments in Vallauris can be seen without straining or craning the neck, without being overwhelmed or daunted by their mass or their design scale. These are monuments which belong where they are, by the constant tailoring of the spaces, letting them evolve in use. Monuments in the widest sense

spread from the civic and cultural centre to the wider and more eclectic periphery of town. New formats of the monumental have been essayed in 1998, in a constant process of protean adaptation which reflects changing public attitudes and, in a close-knit community such as this, reflects and enhances, (as Gooding [1997], quoted above, said it should) the identity of the place.

ENDNOTES

1 Extending the examples from high art to everyday culture, and analysing the interaction between the nature of the townspeople and the public art of their milieu, are considered to be intrinsic parts of the study. This may colour the writing, but a level of immersion in the life of the town, to gauge a sense of place, is seen as a prerequisite to understanding.

2 In order to measure the calibre of response to an enquiry from an intending visitor with informed artistic interests, the initial letter sent by the present author to the Tourist Office avoided being specific about the project in hand. It expressed enthusiasm for sculpture and for Picasso, and indicated broad research interests, but at that stage sought chiefly to evaluate the sensitivity and initiative of the reply. The response was remarkably positive and constructive.

REFERENCES

Andréani C, 1998 Le Geste et la couleur, une poétique céramique, in Forest D, *Biennale de Céramique Contemporaine de Vallauris, 21 juin – 27 septembre 1998*, exhibition notes for press and visitors.

Beal H, 1999 Women and First World War memorials in Arles and la provence mistralienne in *Modern and Contemporary France*, **7** (2), 209–24.

Carrayou S, 1996 Chemin faisant, in *Monument et Modernité à Paris: Art, Espace Public et Enjeux de Mémoire, 1891–1996*, exhibition catalogue, Paris, Electra, 35–49.

Chabert N, 1996 Préface, in *Monument et Modernité à Paris: art, espace public et enjeux de mémoire, 1891–1996*, exhibition catalogue, Paris, Electra, 7–19.

Forest D, 1996 *La Guerre et la Paix*, Paris, Editions de la Reunion des musées nationaux.

Forest D, 1998 *Biennale de céramique contemporaine de Vallauris, 21 juin – 27 septembre 1998*, exhibition notes for press and visitors.

Gilot F and Lake C, 1966 *Life with Picasso*, Harmondsworth, Penguin.

Giroud J, Michel R and Michel M, 1991 *Les Monuments aux morts de la guerre 1914–1918 dans le Vaucluse*, L'Isle sur la Sorgue, Scriba 114.

Gooding M, 1997 Public: Art: Space, *in Public: Art: Space, A Decade of Public Art Commissions Agency, 1987–1997*, London, Merrell Holberton, 13–20 .

Griswold C, 1992 The Vietnam Veterans memorial and the Washington Mall: philosophical thoughts on political iconography, in *Art and the Public Sphere*, (ed) Mitchell W J T, Chicago and London, University of Chicago Press, 79–111.

Lawson T, 1992 Frontières perdues, in *Art et espace publics*, (ed) Charre A, Givors, OMAC – Maison du Rhône, 79–81, 107.

Méjean P, 1975 *Vallauris-Golfe Juan, 3 000 ans d'histoire et de céramiques*, Paris, Editions Foucher.

Miller N forthcoming Building the Unbuildable; the US Holocaust Memorial Museum, in *Memory and Oblivion, XXIXth International Congress of the History of Art*, in Reinink W and Stumpel J (eds), Dordrecht, Kluwer.

Norman E, 1997 *Public Art Practice: two case studies from Tokyo*, The Association of Art Historians Conference, Courtauld Institute, London.

Penrose R 1971 *Picasso, his Life and Work*, Harmondsworth, Penguin Books.

Ramié G, 1984 *Céramique de Picasso*, Paris, Arte, and Vallauris, Adrien Maeght for the Galerie Madoura.

Zervos C (ed), 1948 *Cahiers d'Art*, **23**: 1.

ACKNOWLEDGEMENTS

This paper and related research would not have been possible without the cooperation, interest and enthusiasm of the Mayor and the authorities in Vallauris, and the author is deeply indebted to them, in particular to Madame Michèle Establier, Director of the Tourist Office; Madame Salucki, President of the Friends of the Vallauris Museums; Madame Vincent, Poterie Madoura; and Monsieur Philippe Mottier, Deputy Mayor, for information, guided visits to studios, interviews, and access to documents. She is also grateful to Dr William Kidd and Professor Siân Reynolds of the French Department, University of Stirling. Dr Kidd, creator of the Stirling University French Photographic Archive of French war memorials, 1870–71, 1914–18, and 1939–45, encouraged her work in this field; Professor Reynolds made valuable suggestions on the paper.

AUTHOR

Helen Beale has been a lecturer in French at the University of Stirling since 1968, and has served as a member of its Museum Collections Advisory Committee. Her research interests have moved increasingly from literature to Area Studies, including fine art. Teaching includes art (High Renaissance, modern French), iconography, public sculpture.

6 Heroes and kitsch in post-war monuments

Margaret Garlake

21 Cedars Rd, London SW13 0HP,
England, UK.
Tel.: 020 8876 9366
garlake@talk21.com

Abstract

Since the end of the Second World War a theoretical debate has focused on the role of the monument in modern society, while practitioners and patrons have produced widely divergent forms of monument, agreeing only that the conventional statue of a notable individual is no longer viable. While the ideological content of the conventional monument is widely acknowledged that of alternative forms is sometimes overlooked. The early Welfare State encouraged monuments as celebrations of the ordinary; abstract sculpture was later widely adopted by corporate patrons, while in the 1980s a new type of figurative monument emerged that may be identified as kitsch. However, the continued production of conventional monuments suggests that they are recognised and desired and that the two forms will continue to co-exist since both express deep though conflicting social values.

Key words

Monument, hero, kitsch, sculpture

'The monument', Jochen Gerz has remarked, 'cannot possibly be private property' (Gerz 1997, 77). This self-evident statement serves to emphasise the communal ideological basis of monuments. They emerge from a 'community of interest' (Alloway 1954, 1044) and reveal their sectional allegiances through their forms. The purpose of this paper is briefly to examine the nature and assess the significance of a common social content, in a specific group of recent monuments. Unequivocally figurative, intensively detailed, sometimes with colour, their subjects are usually people engaged in mundane, unremarkable activities. They are sited inconsequentially on streets or in shopping centres, generally without the pedestals or surroundings of the old monument. They emerged in the 1980s and present a counterpoint to the kind of public art often described as abstract sculpture and exemplified by Philip King's *Clarion* in Fulham Broadway, London.

The new monuments fall within a broad category of realism, or hyperreality, in which physical attributes or banal activities are emphasised at the expense of psychological or contextual content. This paradoxically detracts from their life-like or mimetic qualities, as is the case with John Clinch's *The Great Blondinis* (Fig 1) and Stephen Melton's *LIFFE Trader* (Fig 2). Both pieces depend on the viewer's complicity in comic anecdotal content: imminent imbalance and enlarged musculature in the former and intense deference to a cellphone in the latter.

Figure 1 John Clinch, *The Great Blondinis*, aluminium alloy, Brunel Shopping Centre, Swindon 1987. (Margaret Garlake)

Figure 2 Stephen Melton, *LIFFE Trader*, bronze, Walbrook, London 1997. (Margaret Garlake)

Complicity does not, however, acknowledge these people as Us, to be recognised as members of Our immediate community; rather they are rendered Other, set apart by attributes that exoticise and identify specific class and age groups. Though the *LIFFE Trader* would be recognisable as an individual he is dehumanised into a type or class.

The reconceptualisation and physical reformulation of the monument have been the subject of debate since the late 1940s. Today the discussion embraces a thread of millennial consciousness as well as a more rational historical awareness that the monument's role has changed radically during the last fifty years. During this time monuments have been secularized, abstracted, depersonalized and condemned. Their destruction has become a *rite de passage* of national liberation ceremonies, which reasserts the political authority that is attached to them historically. [1] In politically stable societies where memorials to long-dead worthies have little more potency than street furniture, there is a perception today that Heroes on Horses and Men on Pedestals are no longer appropriate to our culture or our public spaces. The alternative, modernist monument, or abstract steel sculpture, while devoid of specific political content, has attracted sustained criticism and is condemned as elitist and exclusive. A widespread distaste for such art is articulated by specialist practitioners and theorists of public art who have established a broad range of models for consultative, democratising practices (Miles 1997, Harding 1997). The gift by the Contemporary Art Society of Henry Moore's *Three Standing Figures* to the London County Council in the summer of 1948 initiated the popular debate on the modern monument in post-war Britain. Moore's sculpture, in which he attempted to establish a contemporary classical form which

Figure 3 Bernard Schottlander, *3b series no. 5*, steel, Milton Keynes 1983. (Margaret Garlake)

combined modernity with an ancient theme, failed to provide a viable model for the new monument because it was both too modern and too backward-looking. It could neither be located historically nor within the contemporaneous culture of 1948.

Much more successful, both visually and intellectually, is a class of post-war monument which is located ideologically within the Welfare State and may be seen as an heroicisation of the ordinary. It is exemplified by Siegfried Charoux's *The Neighbours* in the Quadrant Estate, Highbury, London, and by Betty Rae's *Kore* in old Harlow, Essex. There are many comparable monuments on the early post-war housing estates in London, commissioned or bought by the London County Council, and in the early New Towns. Charoux's group stands within a long lineage of representations of the worker, where realism is an ideological construction rather than a style. Rea's *Kore*, sited off a quiet pedestrian high street, is self-effacing, almost inconsequential. Like Kevin Atherton's better-known *Platform Pieces* in Brixton, it proposes 'a sense of community ownership' (Miles 1997, 145) achieved by mirroring that community to its members, without comment. While such sculptures often adorn or enliven dull and unattractive places their primary role is the more serious one of acknowledging the centrality of the routine and the normative within the social fabric. Functioning within the principles of a democratizing realism and thus against the grain of the conventional historical monument which seeks to celebrate the singular and extraordinary, they nevertheless share with the Man on the Pedestal a quality of *gravitas*.

Figure 4 Wendy Taylor, *Octo*, stainless steel, Milton Keynes 1981. (Margaret Garlake)

In a later New Town, Milton Keynes, the modernist and the revisionist, or populist, monuments are juxtaposed both in space and time. A large number of unequivocally modernist sculptures are situated in the locations of the conventional monuments for which they are substitutes. A brightly coloured abstract steel group by Bernard Schottlander (Fig 3) adorns a public garden while Wendy Taylor's *Octo* (Fig 4) is one of a group of her burnished bronze and steel sculptures that articulate significant commercial or public locations in the town centre. Such works are today considered inappropriate as public art, condemned as an affront to human values and meaningless to the public. Yet, like the architecture which they complement, their technologically immaculate and anonymous forms refer to the economic basis of Milton Keynes in the cultural vacuity of the micro-chip and the service industry. They thus simultaneously reveal an ideology as

Figure 5 Andre Wallace, *The Whisper*, bronze, Milton Keynes 1984. (Margaret Garlake)

Figure 6 John Clinch, *Vox Pop*, bronze, Shopping Building, Milton Keynes, 1988. (Margaret Garlake)

powerful as that signified by Charoux's *Neighbours* and proclaim the death of the monument as a repository of communal social values. A number of representational sculptures sited a few years later than Schottlander's and Taylor's suggest a revision of the concept of the monument in Milton Keynes in the latter part of the 1980s. André Wallace's *The Whisper* (Fig 5) is sited outside the public library. Like Clinch's *Vox Pop* (Fig 6), which stands in a large open courtyard in the main shopping centre, it is predicated on self-recognition and the expectation that receivers will see themselves reflected back in an infinitely familiar image. Both pieces occupy a conceptual space that oscillates between theatricality and banality, in which gesture, stance and expression strain, as on the stage, for effects beyond what is natural. Yet while the generic teenagers involved in *The Whisper* demand and receive a reaction of complicity, an acknowledgment of and participation

in their narrative, a brief examination of *Vox Pop* reveals that its narrative is ruptured, since the relaxed summer atmosphere evoked by a shirtless boy and a man in a vest is confounded by the woman walking her dog in a heavy winter overcoat and boots. Though these figures appear to be strongly individuated, they too are types whose identities are no less generic than that of the whispering teenagers. No personal history may displace their performance of a given role: shoppers for all seasons, they march in a self-replicating circle around the dystopia of the shopping precinct to proclaim its values of conformity in consumption.

Theatricality and parody are central to two recent public works by Alan Sly. *The Window cleaner* (Fig 7) stands outside Capital House, off Edgware Road, not far from *Getting Back on the Right Foot* (Fig 8) at St Mary's Hospital in Paddington. Planning requirements for Capital House stipulated that there should be a sculpture on the site. The artist was asked to design a figurative work that would present no problems of interpretation, that would interact with the dramatic mirror-glass of Capital House and be of a scale that would negotiate between passers-by and the building.[2] Like frozen street theatre, Sly's sculptures, which are sited to be fleetingly observed by a moving viewer, arrest and amuse the casual passer-by who becomes absorbed in the instant of a double-take before the fantasy dissolves.

They depend not on the complicity of self-recognition but on the identification of an Other, rendered through exaggerated facial expressions and gestures as a class-specific but generalised type.

Figure 7 Alan Sly, *The Window cleaner*, bronze, London 1990. (Margaret Garlake)

Figure 8 Alan Sly, *Getting Back on the Right Foot*, bronze, St Mary's Hospital, Paddington 1993. (Margaret Garlake)

The distinction between the recognition of self or Other is less significant in this context than the transformation in all the sculptures discussed here of human figures into parody or caricature and thus false representations of a distant reality. In this respect we may identify all of them as kitsch.

In the large literature on kitsch there is agreement that it represents a 'false aesthetic consciousness'; that it is 'art as recreation and entertainment, easiness of access, quick and predictable effects' which respond to 'the ... public's need to escape from the dullness of quotidian life' (Calinescu 1987, 241). It emerges from and is dependent upon the consumer society within which it satisfies a need for visible signs of upward mobility (Baudrillard 1970, 75). It is also, as MacDonald has emphasised, a medium of social exploitation and control (Calinescu 1987, 238–9) which entertains even while it asserts the rigid class hierarchy that was sustained by the social

policies of the 1980s and early 1990s. If the idealism of the Welfare State is memorialized in its remaining monuments, so is the ideology of the Thatcher years memorialized through kitsch.

The considerable literature on kitsch confirms that it is a complex phenomenon, enmeshed in the social fabric of advanced capitalism. The kitsch work of art is not to be casually dismissed as aesthetically inadequate but, rather, to be acknowledged for its specific origins, to which artists have developed close correlative responses. Harold Rosenberg's assessment of the artist's role in the promotion of kitsch remains apposite insofar as it acknowledges both the economic imperative and the maker's autonomy: 'no question of dishonesty, of "selling-out", but of muscular slackness associated with finding an audience responsive to certain norms' (Rosenberg 1970, 231). Since the collapse of the hierarchical (high/low) classification of art, the term

'kitsch' carries no pejorative connotations. It denotes, rather, simply one more field of critical enquiry within post-modern visual culture.

That kitsch extends beyond the new populist monument is indicated by Lawrence Holofcener's *The Allies* in Bond Street, a portrait group donated, as the dedicatory plaque states, by the Bond Street Association [3] to the City of Westminster 'and the people of London to commemorate fifty years of peace'. High-minded sentiment failed to prevent the reduction of two heroic figures to a pair of under life-size buffoons. In a prime commercial and tourist area, the sculpture's role is to perform as a prop for tourists' photographs of one another as they sit between Winston Churchill and Franklin Delano Roosevelt.

The popularity of *The Allies* alone suggests that the kitsch monument may have a secure future; it is entertaining, intellectually undemanding and ostensibly asserts none of the hierarchical and exclusive values of the condemned conventional monument. National heroes have no place in our fragmented society. However, we continue to commemorate them with affection and dignity for, as Kate Linker wrote when the kitsch monument began to emerge, 'the public want statues; the formula of pedestal + horse + hero + pigeon is deep-seated'. She continued: 'public sculpture, in its communal role, is indisociable from sculpture's traditional definition as an object in space, placed upon a pedestal that removed it from the mundane ground' (Linker 1981). Linker was referring to North America but Ian Walters's memorial to Fenner Brockway, erected by the Greater London Council in 1985, like Philip Jackson's magnificent monument to Raoul Wallenberg (Fig 9), initiated by the Council of Christians and Jews and completed in 1997, indicates that Europeans share the desire for monuments that honour both individuals and fundamental social values.

Ian Walters's monument to Nelson Mandela on London's South Bank and Faith Winter's *Sir Arthur Harris* on the Strand suggest that the monument remains important precisely because of the ideological content which is its unconcealed rationale. The Harris memorial was vandalized soon after it was erected, in protest against the policy of carpet bombing which Harris so enthusiastically promoted during the Second World War. Mandela's monument

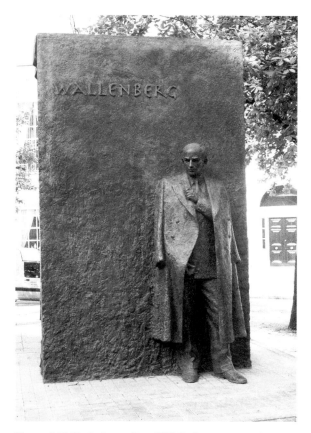

Figure 9 Philip Jackson, *Raoul Wallenberg memorial*, bronze, Great Cumberland Place, London 1997. (Margaret Garlake)

is a running narrative which celebrates his release from Robben Island and his elevation to President of a free South Africa. One day it will presumably become his memorial.

When the conventional monument celebrates public figures it can seldom be separated from a political content which in turn connotes exclusive power denied to the beholder of the monument. It is implicit in the production of the kitsch monument that it will appeal to an indeterminate and disengaged public because it appears to replace ideological content with light, untaxing entertainment. Yet while the kitsch monument evades the heroic it is neither properly local nor domestic [4]; it cannot be incorporated into a notional public ownership because its values are inauthentic and it is intellectually unsustainable. At the same time there is abundant evidence both that the content of

monuments is noted and acted upon and that historical, political and domestic heroes continue to exist in popular perception. The monument, like other aspects of the visual arts, is a complex phenomenon with multiple constituencies. Kitsch and the conventional monument will no doubt continue to co-exist since in their very different ways both express values prominent in contemporary society.

ENDNOTES

1 See also Murphy, this volume.
2 The artist himself proposed the window-cleaner as an appropriate subject. *Getting Back on the Right Foot* is a site-specific adaptation of a work first shown at Chelsea Harbour in 1993. It was donated to the hospital by Henry and Mary Kent.
3 The Fine Art Society expressed heated opposition and refused to join the scheme.
4 See criteria cited by Darke, this volume.

REFERENCES

Alloway L, 1954 The siting of sculpture, in *The Listener*, 17 June 1954, 1044–5.

Baudrillard J, 1990 *Revenge of the Crystal*, London and Concord, MA, Pluto Press with the Power Institute of Fine Arts, University of Sydney, 75.

Calinescu M, 1987 *Five Faces of Modernity*, Durham USA, Duke University Press, 241 & 238–9.

Gerz J, 1997 Invisible monument, in Novakov A (ed), *Veiled Histories: The Body, Place and Public Art*, New York, Critical Press.

Harding D and Büchler P (eds), 1997 *Decadent Public Art: Contentious Term and Contested Practice*, Glasgow, Foulis Press.

Linker K, 1981 Public sculpture: the pursuit of the pleasurable and profitable paradise in *Artforum*, March 1981, 64–73.

MacDonald D, 1964 A theory of mass culture in (ed) Rosenberg B and Manning White D, *Mass Culture*, New York Free Press, quoted in Calinescu M, 1987, 243.

Miles M, 1997 *Art, Space and the City: Public Art and Urban Futures*, London and New York, Routledge.

Rosenberg H, 1970 (1959) *The Tradition of the New*, London, Paladin, 231.

ACKNOWLEDGMENTS

The author is grateful to Alan Sly for information on his work.

AUTHOR

After working as an archaeologist and archaeological conservator in Africa and London, **Margaret Garlake** returned to university to study art history. She was assistant editor of *Art Monthly* in the late 1980s and taught post-war British art at the Courtauld Institute 1989–1999.

7

Destruction or preservation?
The destruction and/or preservation of British imperial monuments in Dublin

Paula Murphy

Department of History of Art,
University College Dublin,
Belfield, Dublin 4, Ireland.
Tel.: 353 1 7067605 Fax. 353 1 7068453
paula.murphy@ucd.ie

Abstract

In the nineteenth century Ireland was ruled from London, and British authority and dominance were reinforced in the public statuary erected in the capital city. Dublin proved the perfect setting for regal equestrian statues and monumental sculptural commemorations of soldier-heroes. However, the nineteenth century saw a dramatic development in the images that peopled public thoroughfares when the monumental statues of British rulers were joined and, effectively, challenged by nationalist heroes.

The statues in their central locations in Dublin wielded a political power that invited opposition. Throughout the nineteenth and into the twentieth centuries attempts to damage and destroy monuments representative of British dominance in Ireland have been numerous. This paper examines the different ways in which a selection of these monuments were targeted and subsequently destroyed or preserved.

Key words

Monument, statue, *Nelson*, *Victoria*, destruction, Dublin, Irish, imperial

Public monuments have traditionally possessed an inherent sense of longevity. Up until the modern period, when such sculptures were erected, they were intended as lasting commemorations, constant and enduring features of the built environment. Therefore the question of how long they should endure in their original location, or perhaps whether they should endure at all, is certainly an issue when considering conservation and preservation aspects of such work. In Ireland we have lost many public monuments mostly for political reasons. Imperial monuments were erected in public locations across the country from the beginning of the eighteenth century into the early twentieth century. In Dublin there were ten such works of particular interest, among which five were destroyed, three were relocated and two are still in place. In this paper four of these works are discussed to illustrate the different approaches that have been taken with controversial public art works in Ireland across time.

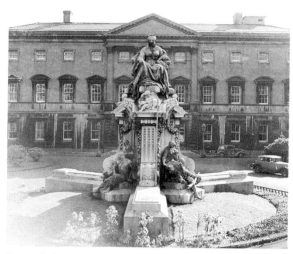

Figure 1 *Queen Victoria*, John Hughes (1908), forecourt of Leinster House, Dublin. (Office of Public Works, Dublin)

Figure 2 Fragments of *Gough* and *Carlisle* in Office of Public Works storage. (Benedict Read)

According to Pliny 'the Greeks were the first who conferred statues as a mark of honour' (Jex-Blake 1968, 23), a status that must inevitably incorporate the possibility of subsequent rejection, given that a figure honoured in one era will often be considered suspect in a later period. And thus it was that Pliny could describe, for example, no less than 360 statues of Demetrios of Phaleron set up in Athens that were 'afterwards broken up' (ibid). The politics of public statuary were particularly evident in Western civilisations in the late 1980s and early 1990s with the collapse of communism. Communist monuments, in their style, scale and position, have considerable propagandist strength and a silent, statuesque likeness of a particular individual enables the continued exertion of power. Russia, in particular, witnessed the tearing down of images of members of the Tsarist regime after the Revolution in 1917, and later saw the removal of statues of communist leaders. In Ireland public statuary has wielded similar power and has witnessed similar opposition. British rule and dominance was projected in the monument type employed, in both form and scale.

When Ireland achieved independence in 1922, Dublin was home to four equestrian monuments, three of which were portraits of British kings, three soldier-hero monuments, commemorating Admiral Nelson, the Duke of Wellington and Viscount Gough, two portrait statues of Lord Lieutenants in Ireland, a colossal monument commemorating Queen Victoria and a lesser one commemorating her husband. While there was considerable opposition to the presence of these public monuments in the city, an official government line indicated that such statues had historic and artistic merit and would not be removed simply because they commemorated a former power in the country.[1] Of particular irony in this context was the fact that the building selected to serve as the seat of the Irish government had the *Victoria* monument located at its entrance front (Fig 1) and the lesser *Prince Albert* statue at its garden front. These objects were no longer monuments in the eyes of many people, but had become monsters, and if the government appeared to have their preservation at heart, there were others who would not countenance their continued presence in the city. As a result several of them were blown up in the course of the twentieth century, specifically between 1928 and 1966 (Fig 2).

There has been no official programme in place for the preservation of public sculpture in Ireland, and when monuments were erected in public spaces they had no accompanying fund for maintenance. Arguments would occasionally ensue as to who had responsibility for individual works. While associations and official bodies have been established over time to address the preservation of tomb monuments and of Celtic antiquities, there is no recognised conservation programme for public statues. Office of Public Works records reveal periods of interest, for example in the 1940s, when the state

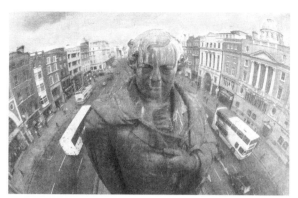

Figure 3 Detail of the *O'Connell* monument. (*The Irish Times*)

of several of the monuments in their care became an issue. [2] At this point various cleaning methods were employed, from washing with soap and water and cleaning down with paraffin to using a dry scrubbing technique. The final treatment in most cases involved coating the statue with linseed oil, a finish not much liked by sculptors because of its uniform and somewhat stultifying result. [3] The condition of the public monuments and their lack of attention has not changed much across time. Over a hundred years ago, in 1888, a city councillor drew attention to the dirty condition of the public statues in Dublin, [4] and following in this tradition, in the mid 1990s a member of the Green Party and local councillor on the 1997 election trail scaled the *O'Connell* monument in the centre of the city to draw attention to air pollution and the damage that it was causing to humans and statues alike. It is also the case that the head of *O'Connell* is covered in bird droppings and, inevitably, the acid must be eroding the bronze (Fig 3).

However, statues in Dublin have been the target of more than bird droppings over the years. The equestrian monument commemorating William III (Fig 4), positioned in the centre of the city in College Green for more than 200 years, was, in its time, treated with various different substances, few, if any of them, purposefully conservationist. This statue, erected in 1701, the work of Grinling Gibbons, was the most public of the monuments in Dublin. It inspired disparate reactions on two occasions annually, serving as a focal point for Orange celebrations in the city and inviting, in response, opposing Nationalist activities (Cosgrave 1913). For celebratory purposes

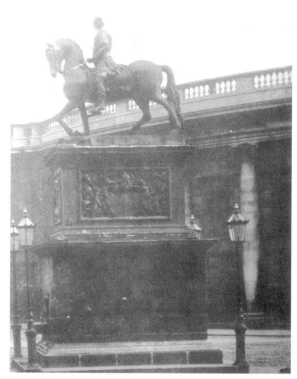

Figure 4 *William III*, Grinling Gibbons (1701), College Green, Dublin.

the statue was regularly painted and bedecked with ribbons and flowers. To what extent the painting of the lead monument was considered a conservation exercise can only be guessed at. Certainly the work was usually carried out under the supervision of a sculptor. However, with equal regularity oppositional forces attacked the statue in a variety of different ways; it was tarred and greased, daubed with paint, covered with mud, bits of it were hacked off, and it was blown up with gelignite on several occasions. It was attacked so often that the monument was considerably weakened. So much so that when it was bombed on Armistice Day in 1928 (Fig 5), although little actual damage was done to the statue on that particular occasion, its instability and the fact that it was considered to have become a physical danger to the public (rather than a mere political one) encouraged the authorities to remove it for detailed inspection, as a result of which it was finally

Figure 5 *William III* after 1928 bomb blast. (*The Irish Times*)

Figure 6 Removal of *Queen Victoria* from Leinster House in 1948. (*The Times*)

decided not to reinstate it. Such was the hatred inspired by this particular monument that it continued to be attacked, even in its discarded and neglected state, in Corporation storage. While the Corporation records reveal almost nothing of what ultimately happened to the statue, and only two fragments from the pedestal are held in the civic collection, it was recorded in 1949 that a request from the City Engineer had been endorsed granting that the mutilated statue be sold as scrap lead to the waterworks department to patch leaks in Dublin's water system during the Second World War.[5] If this was in fact carried out, then rather than being considered worthy of preservation in its own right, the monument came to have no more meaning beyond the functional value of the material out of which it was made.

The destruction of the *William III* statue was followed nearly ten years later in 1937 by a similar bombing incident which blew up the equestrian statue of George II in St Stephen's Green, and in the 1940s the last of the British monarchs was unseated, only on this occasion it was not a terrorist bomb. *Queen Victoria*, the sculptural work of John Hughes, had sat proudly confident in front of Leinster House for 40 years, since her unveiling there in 1908. It was clearly intended that she would reign there for a considerably longer period. This is evidenced by the fact that the lunal stone, selected for the execution of the pedestal, was submitted to the most rigorous examinations in a laboratory in the Royal University of Ireland in 1905 to test its endurance.[6] Immersed in a solution of ammonium compounds for 50 days, it was ultimately deemed in every way suitable for the purpose proposed, a lasting commemorative monument.

However the monument was not to endure in its original location. Leinster House, initially home to

Figure 7 Elevation with numbering of *Queen Victoria*, for dismantling and re-erection, 1948. (National Archives, Dublin)

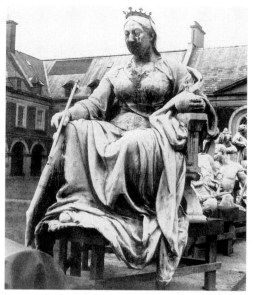

Figure 8 *Queen Victoria* in storage in the courtyard of the Royal Hospital at Kilmainham. (Benedict Read)

the Royal Dublin Society, had, with the gaining of independence, become the seat of the Irish Parliament and while the principle was that such monuments would not be dismantled for political reasons, it was evident that she had to go. The forecourt of the building was redesigned to incorporate car parking for the politicians[7] and in July 1948 *Queen Victoria* was removed from her pedestal (Fig 6) and the monument was dismantled, after the stones were numbered for re-erection. This numbering is visible on the stones, and on a series of outline plans and photographs (Fig 7).[8] The monument, in its fragmented state, was placed in storage in the Royal Hospital at Kilmainham. That this building at the edge of the city was then the Police Headquarters is not insignificant, because the monument even in its dismantled state was still considered to be in need of protection.[9] The statue of the Queen languished in a cart in the courtyard of the Royal Hospital, with the accompanying allegorical groups positioned in a line behind her (Fig 8). The pedestal, perhaps because of its more unwieldy nature, its sense of incompleteness without the bronze sculptures and its less significant and independent status as a support, was taken, in its broken but numbered state, beyond the confines of the building for storage in one of the fields, known as Bully's Acre (Fig 9). The Queen and her attendant figures sat uncomfortably in their new position, a rather sad-looking group displaying their neglect. Their presence was only acknowledged in so far as

Figure 9 Detail of pedestal of *Queen Victoria* in Bully's Acre in the grounds of the Irish Museum of Modern Art (formerly the Royal Hospital at Kilmainham). (Paula Murphy)

Figure 10 Bronze figures from *Queen Victoria* in storage in Daingean, Co. Offaly. (Paula Murphy)

Figure 11 The Dublin *Queen Victoria* in Sydney, Australia. (Paula Murphy)

they were considered to be something of a nuisance, taking up a large amount of space in the courtyard. This became further emphasised as they were subsequently joined there by other Imperial statues blown up in the 1950s. There were many requests, particularly from cities in Canada, to purchase the statue of the Queen, none of which came to fruition.[10] But it is of interest that the Principal Architect of the Office of Public Works, in a report in 1950, indicated that the work should not be displayed in a dismembered state, as the monument was to be read as a complete and considered composition.[11] This position was often repeated officially in the face of subsequent requests to purchase in the ensuing years.

When the Royal Hospital was earmarked for restoration in 1980 the bronze sculptures were removed to more remote and even less satisfactory storage, when they were unceremoniously dumped in a field of tall grass, attached to a museum building

in the Irish midlands (Fig 10). The monument was at this point more effectively fragmented, as the pedestal remained behind in Bully's Acre. It was perhaps, therefore, an opportune moment for the Australians to make their request for the statue, as they were desirous to have the portrait image for Sydney. The Irish Government, finally taking the decision to let her go, granted the request and gave *Victoria* on extended loan to Australia in 1986 (Fig 11).[12] Meanwhile the allegorical figures were further confirmed in their discarded state, remaining in their field until the mid 1990s, when they too found a new location. When Dublin Castle was overhauled and the roof garden was redesigned, it was decided, perhaps not entirely fortuitously, to install the sculptures there (Fig 12), where they are, without doubt, a little out of place, but at least they are once more on public view. It is not without interest that already in the 1950s a number of people in the Dublin art world, not least the Director of the

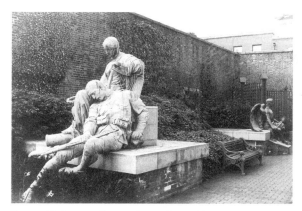

Figure 12 Bronze figures from *Queen Victoria* in the roof garden in Dublin Castle. (Paula Murphy)

National Gallery of Ireland, had indicated that the allegorical groups might well be set up independently in a suitable location.[13]

If the bronze sculptures from the *Queen Victoria* were all once more in public spaces, only the pedestal remained in storage and still in the field to which it had been despatched in 1948. However, in 1997 the sections of the pedestal which incorporated sculptural detailing, putti figures serving as allegories of science, literature and art, were stripped of decades of ivy and installed in the formal garden at the Irish Museum of Modern Art at Kilmainham, formerly the very same Royal Hospital (Fig 13).

An interesting issue arises in relation to the new method of displaying the *Queen Victoria*. Currently all the sculptural elements are publicly exhibited in different locations. It is certainly the case that the monument once dismantled could never have been considered for resiting as a single entity in Dublin. However to what extent can these fragments be considered public art works? Does the artistic presence reside in the monument as a whole or in its individual parts? Is this a monument that might be deemed to be both destroyed and preserved at once? Displayed in fragments the monument is certainly stripped of both its meaning and its context. It is, in effect neutralised.

If *William III* is gone and *Victoria* is neutered, *Prince Albert* continues to hold his own in Dublin. The statue by John Henry Foley is still positioned in the garden of Leinster House (Fig 14), and only a stone's throw from its original location there, where it was erected in 1872. It is not necessarily the case

Figure 13 Putti from the pedestal of *Queen Victoria* in the formal garden at the Irish Museum of Modern Art. (Paula Murphy)

that he is considered a less confrontational figure by Irish nationalists, although certainly his presence might be deemed largely less offensive to those who found these commemorative works generally insulting. It is more the case that he is 'un-getattable'. In the grounds of the garden front of the building, he is protected behind railings and therefore considerably less public than was the *William III* monument. It is also the case that, while *William III* was assigned a watchman (Gilbert 1896, xii), because of the constant fracas in the vicinity of the statue, *Prince Albert* is under constant police protection, positioned as he is in the grounds of the Irish Parliament Building. However, originally placed centrally in the garden, the statue was relocated to the side of the garden in 1948, rendering it less of a focal point and making it ultimately less visible. It is my experience that people are, on the whole, unaware of the presence of this statue in Dublin. In

Figure 14 *Prince Albert*, John Henry Foley (1871), garden of Leinster House, Dublin. (Paula Murphy)

Figure 15 The *Nelson Column*, statue by Thomas Kirk, O'Connell Street, Dublin, 1808.

fact for much of the twentieth century the statue was not only badly weathered, as a result of which it had little presence, it was also surrounded by a fairly high shrubbery. However in recent years the camouflage was cut back and the monument was lightly cleaned.

If *Prince Albert* has sustained the expected longevity of such works, in place now over 100 years, the inception of this statue has some interest in the context of public commemorations, fraught, as it was with indecision with regard to the monument type and to the intended location. While obelisk and column, portrait statue and equestrian monument were all suggested and considered, locations across the city from the less public, St Stephen's Green and Leinster Lawn, to the more public, College Green and Carlisle Bridge (now O'Connell Bridge), were explored as possible sites (*The Dublin Builder* 15 March 1862). In fact for a brief moment in time in 1862 it looked as though Dubliners might be

presented with the unusual visual experience and propagandist statement of having Prince Albert commemorated by a statue in the centre of Carlisle Bridge, the main bridge crossing the river in the centre of Dublin, with Catholic political leader, Daniel O'Connell, confronting him from the edge of the same bridge. The inappropriateness of this was evident and the next of the public sites was selected for serious consideration. This was College Green, where he would have been positioned in the company of *William III*. The Queen was happy, the Corporation was happy, the Committee and the sculptor were all happy and in agreement. However there was some opposition from those who considered the site wholly unsuitable (*The Nation*, 15th April 1865) and the statue was eventually sited, as we have seen, on Leinster Lawn. What is of interest, in the context of the opposition, is that the preservation of the monument and its due respect were at the root of the concerns. The College Green site was deemed to be too small and too noisy. The heavy traffic through that area and constant battles around the *William III* statue were thought to be

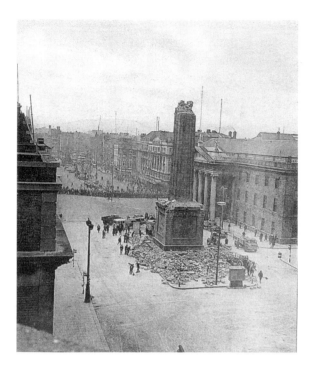

Figure 16 The destruction of the *Nelson Column*, Dublin, 1966. (*The Irish Times*)

Figure 17 Head of Nelson from the *Nelson Column*, Thomas Kirk. (Civic Museum, Dublin)

problematic. And also it was considered that 'its base would serve as a lounging place for cabmen, news vendors and people of that class' (ibid). Not only therefore was the notion of public interraction with monumental statuary an issue in 1865, but also a real exclusivity is evident. While this was intended to be a public commemoration, it would appear it was for a particular, rather than a general public.

The last of the Dublin monuments considered here is that commemorating Admiral Nelson, erected in 1808 (Fig 15), with the statue executed by Cork sculptor Thomas Kirk. While this monument has been destroyed, it lives on in the memory of the people. The *Nelson* statue was yet another public sculptural work targeted from the date of its erection, although more in the form of word than deed. A constant refrain proposed the removal or the relocation of the work (Henchy 1948). However the issue proved more complex, as the monument was not in the possession of either the Dublin Corporation or the Office of Public Works, but was administered by a group of Trustees.[14] And therefore, while the government was still debating what to do

about the statue, in 1966, the year of the fiftieth anniversary of the Easter Rising, the monument was blown up before the celebrations got under way (Fig 16). This statue was a landmark in the city, a meeting place, a focal point, in fact it seemed to mark the very centre of the city. Such was the extent to which it had become a piece of street furniture that it had become familiarly known as 'the pillar'. Few people cared or even considered who was positioned at the top of the column, and, in fact the head, which is now displayed in the Civic Museum in Dublin (Fig 17), reveals such extensive weathering that it clearly can no longer be considered a portrait likeness of Nelson.

Such was the impact of the gap left in O'Connell Street by the absence of the Nelson column that in 1988 a design competition was held inviting ideas for replacing the monument. While this was intended to focus interest on the street in question, the issue of public art and the collaboration between architect

Figure 18 Design for a replacement for the
Nelson Column, 1988. (A & D O'Connor and
Gerda Teljeur)

commemorated on this occasion, but his Dublin monument, and therefore, while figurative elements are clearly signed, the result is an abstract silhouette, a ghost-like presence, a memory of what is not. Like all of the other submissions, this design was never taken beyond the maquette stage, nonetheless the work of this particular team clearly reveals the importance of what has been lost to Dublin.

Dublin was not the only city in Europe where public sculptural work met its end by violent means through this particular period. The truly colossal monument commemmerating Stalin erected in Prague, for example, had a very short public presence as it was blown up in 1962, just seven years after its unveiling. However, of further interest in the context of Central European attitudes to political statuary is the initiative taken in Budapest in 1993 to house such undesirable monuments, all strategically removed from their positions of prominence, in a Statue Park opened at the edge of the city. Some 40 statues can be viewed there and while this might be considered as something of a dumping ground, a form of living death in the context of sculpture, and a pickling of the past, at least the monuments are preserved. If 'a nation's life might be said to be recorded in its public monuments' (*The Irish Builder*, 1st May 1872), that history cannot be obliterated or rewritten by their destruction and therefore the Hungarians appear to have handled the issue in a mature and considered manner. Not so the Irish, but then the destruction and removal of the monuments in Dublin was not so systematic, as the Imperial portraits were targeted over a considerable number of years.

However, as early as 1958 the Director of the National Gallery of Ireland had suggested a similar mode of preservation for these controversial sculptures to the one that was to be employed by the Hungarians 35 years later. In an enlightened letter on the subject of the *Victoria* statue, he promoted the idea of a group display of all the imperial monuments that had been removed from their pedestals by violent or by peaceful means and that were then in storage in Dublin.[15] The location that he proposed was an area known as the Queen's Walk in the gardens of the residence of the President of Ireland in the Phoenix Park. While this would have enabled the preservation of a range of monument types, styles and commemorations that

and sculptor, the end result was to be an exhibition, rather than the realisation of any of the ideas. Almost all of the submissions recognised the need for an emphatic vertical element on the street (O'Toole 1988) and many approached the column replacement in deconstructionist mode, with one of the collaborative submissions representing a monument to absence (Fig 18). Architect brothers Aidan and David O'Connor and Dutch sculptor Gerda Teljeur addressed the void created by the destruction of the *Nelson* column. The significance of this work is in the particular nature of the commemoration. It is not Nelson who is

have now disappeared, leaving public art in Dublin the poorer, it would not have been a public location and would have benefited only a very particular audience of visitors to the Residence. Nor, it appears, would it have been popular with subsequent presidents, because 15 years later, in 1973, the then President Erskine Childers requested statues from storage in the Office of Public Works for the very same location, the Queen's Walk. [16] However he categorically stated in his letter that while he considered outdoor statuary attractive, he did not want statues of oppressors. Perhaps President Childers was of the same opinion as the anonymous author of an Office of Public Works memo written in 1964, who stated in connection with the Victoria statue: 'The best thing for the statue is to let it rest where it is [it was still in the Royal Hospital at that date] until other men and other times have taken our place. Some one then may have the courage, and the way may be open, to have it broken up and to dispose of it as scrap'.[17] Surely it is preferable that these works be preserved in some guise, relocated, fragmented, reinterpreted even, rather than permitting them to be destroyed in the manner suggested?

ENDNOTES

1 Memo from the Taoiseach's Department, March 1938, and reiterated as Resolution no 6 at the Fianna Fáil Ard Fheis, October 1946. S10570, Removal of British Monuments. National Archives, Dublin.
2 Memo on general maintenance of memorials. No 122, P4/47/1, General Maintenance of Memorials: St Stephen's Green, Leinster Lawn, Phoenix Park. Office of Public Works Archives, Dublin.
3 Memo, 20 April 1945, No 68, P4/47/1, General Maintenance of Memorials: St Stephen's Green, Leinster Lawn, Phoenix Park. Office of Public Works Archives, Dublin.
4 City Council Minutes 1888, 180. Dublin Corporation Archive.
5 Report of Town Planning and Streets Committee, 1949, 48. Dublin Corporation Archives.
6 Letter from W E Adeney, Royal University of Ireland, to Secretary of Board of Works, 21 September 1905. OPW 5465/08 Queen Victoria. National Archives, Dublin.
7 Memo for the Taoiseach to reply to a question tabled in Parliament 30 June 1948. Queen Victoria Statue, S6412A. National Archives, Dublin.
8 Numbered drawings in National Archives, Dublin. Numbered photographs in Office of Public Works Archives, Dublin.

9 Letter from T J Morris, Board of Works, to J E Hanna, Department of Finance. A25/16/2/1/, Leinster House Parking Accomodation and Removal of Queen Victoria Statue, Vol. 1. Office of Public Works Archives, Dublin.
10 A25/16/4, Oireachtas: Disposal of Queen Victoria Statue. Office of Public Works Archives, Dublin.
11 Memo from Principal Architect, 10 July 1950. No 58, Oireachtas: Disposal of Queen Victoria Statue. Office of Public Works Archives, Dublin.
12 Memo from Department of the Taoiseach to Department of Finance and Office of Public Works, 11 September 1986. No. 284, Oireachtas: Disposal of Queen Victoria Statue. Office of Public Works Archives, Dublin.
13 Memo from Thomas McGreevy, Director of the National Gallery of Ireland, to Office of Public Works. No. 84, Oireachtas: Disposal of Queen Victoria Statue. Office of Public Works Archives, Dublin.
14 Letter from F C Martin for Trustees of Dublin Corporation, 5 December 1955, Corporation Minutes 1956. Dublin Corporation Archives.
15 Letter from Thomas McGreevy, Director of the National Gallery of Ireland, to Mr. Fagan, Office of Public Works, 2 April 1958. No 93, A25/16/4, Dublin Corporation Archives.
16 Letter from Erskine Childers, President of Ireland, to C Farrell, Chairman, Commissioners of Public Works, July 1973. Office of Public Works Archives, Dublin.
17 Memo, 6 January 1964. No 121, A25/16/4, Office of Public Works Archives, Dublin.

REFERENCES

Cosgrave D, 1913 King William's Statue in College Green, in *The Irish Monthly*, **XLI**, May/June, pp250-6; pp307-13.
Gilbert J, 1896 *Calendar of Ancient Records*, vol VI, Dublin.
Henchy P, 1948 Nelson's Pillar, in *Dublin Historical Record*, **X**:1, pp53-63.
Jex-Blake K (trans), 1968 *The Elder Pliny's Chapters on the History of Art*, Chicago, Argonaut.
O'Toole S, 1988 *Collaboration: The Pillar Project*, Dublin, Gandon Editions.

AUTHOR

Paula Murphy is a lecturer in the History of Art in University College Dublin, where she specialises in the history and theory of sculpture. She has published widely on nineteenth-century Irish sculpture. Dr Murphy served for many years as a Director of the Sculptors' Society of Ireland and is currently a member of the Board of the Irish Museum of Modern Art. She has also served on many public art selection panels in Dublin.

8

Paradoxes of form and function in modern public monuments

Sergiusz Michalski

Technical University of
Braunschweig,
Institut für Kunstgeschichte,
Mühlenpfordtstr. 23,
38106 Braunschweig, Germany,
Tel.: 0531 391 2338,
Fax: 0531 391 8213

Abstract

This paper explores the movement against conventional monuments and statuary, beginning with the modernists of the inter-War years, and goes on to examine the concepts behind the work of Uhlrichs, Gerz and Shalev-Gerz. Installations reflecting perceptions and expectations of the public consciousness are also discussed, as are sculpture and art working with inverse images, mirror images and the absence of image.

Key words

Public monuments, modernism, interaction, memorial, inverse images

TOWARDS INVISIBILITY: A NEW GENRE OF PUBLIC MONUMENTS

The widespread feeling that the status of the political public monument had become meaningless resulted in the mid 1960s in a new art form, the creation of monuments which tried to achieve invisibility as a means of encouraging reflection on the limitations of monumental imagery (Springer 1987–8, Metken 1994). This was to occur within the framework of a comprehensible, and a retraceable, artistic process.

Cultural stereotypes and public instinct had until then considered visibility as an essential prerequisite for public monuments: conceived as they were to rise prominently above ground level, proudly erect (hence also the many phallic associations), sometimes even, like the ubiquitous Statue of Liberty, towering on the horizon. An invisible monument implied the negation of two and a half thousand years of visual

experience. As a result, the introduction of the new category of invisibility seemed to be a prelude to the final abolition of the monument.

In 1916 Guillaume Apollinaire published his autobiographic *Le poète assassiné*. After the public murder of the poet Croniamantal, his adherents discussed the idea of putting up a commemorative statue but then discarded this notion as outmoded. They hit upon the concept of erecting 'une statue profonde en rien' (a profound statue of nothing) as a subterranean structure in the forest of Meudon (where Rodin had his atelier until 1917). The hole in the earth was then sculpted in such a manner as to resemble the outer form of Croniamantal until the hole would be 'replete with his spirit' (Apollinaire 1916 [1977], 300–301).

By this proto-surrealist proposal Apollinaire joined the ranks of the critics of the Parisian 'statuomania', dissociating himself by implication also from Rodin, his former aesthetic idol. Some aspects of this new

idea were taken up a decade later by Picasso when he undertook the task of designing a monument to his deceased friend. Picasso's *Wire construction or monument to Apollinaire* (1928–34) which commemorated Apollinaire publicly, was described by the artist in terms which referred directly to that part of the *Poète* as an 'abstract sculpture which would give form to the void in such a way as to make people think about the existence of it ... I am going to do something that corresponds to the moment described in the *Poète Assassiné* and that means a space with a void' (Lichtenstern 1988, 12).

When faced with the task to erect a First World War memorial in the interior of Berlin's Neue Wache (1930) the architect Heinrich Tessenow contemplated for a while a totally novel solution. One of his friends recorded that he would like to create in the centre of the Neue Wache Memorial an 'abysmal hole, a dark cavern covered only by a grating of bronze cross-beams'. Such a hole would be, in Tessenow's words, 'the only adequate expression for this war and its millions of victims' (de Michelis 1991, 306; Rother 1994, 449–50).

The stark symbolism would confront the viewer with both the carnage and with the still open questions generated by the war. What is more, by virtue of its position underneath the circular opening in the ceiling of the memorial room the hole would become part of an axis linking the symbolic opposites of heaven and hell. In contrast, however, to the discreet symbolism present in Brancusi's famous *Endless Column* in the Tirgu Iu War Memorial (1938) Tessenow did not offer any eschatological dimension at all. In the 1930s it was too early for such a radical solution: Tessenow's simple but brilliant idea was to resurface forty years later, combining the ideas of grave symbolism with that of hollow, undefinable space.

Fifty years after 1916 it was the turn of the leading Pop artist Claes Oldenburg to take up and modify Apollinaire's original idea. Oldenburg's *Proposed Underground Memorial and Tomb for President John Fitzgerald Kennedy* (1965) envisaged a gigantic statue of the murdered President placed in the earth and turned upside down. The statue was to have the same dimensions as the Statue of Liberty (Oldenburg 1969, 146 & 166).

Seen in retrospect Oldenburg's project was not devoid of a certain ambiguity: no doubt he envisaged a memorial approach of some sort, on the other hand he used the project as a preparatory stage for a series of artistic objects whose aim was to abolish the notion of the political public monument as such. As regards the commemmorative framework, Oldenburg referred deftly both to popular iconography and, further on, to the intrinsic meaning of the Statue of Liberty. The events in Dallas were interpreted as topsy-turvying the American dream of liberty and democracy as personified by the New York statue. They constituted, in short, its subterranean negative.

In 1965 Oldenburg was on the verge of elaborating and publicising a series of projects for outscaled trivial everyday objects, blown up to megalithic proportions and inserted as mock-heroic monuments into the urban fabric (Haskell 1971, Rosenthal 1996). He started with an object provocatively designed as a replacement of an existing monument, the 1967 *Proposed Colossal Monument to replace the Washington DC Obelisk - Rotating Scissors.* Later, he projected and realised totally independent objects (*Lipstick, Clothespin*). Whereas the buried and inverted JFK monument did its best to negate the Statue of Liberty through a truly antipodic procedure, the sculptures of the later series loudly proclaimed, the need to establish a new category of public sculpture which would transcend the confines of the political monument.

This latter category interested Oldenburg from then on, but before he turned exclusively to it he tried once more to develop the earth-hole symbolic. In Oldenburg's *Placid Civic Monument* (1967) the ironic strands inherent in the Kennedy project were discarded. On 1st October 1967 a group of municipal grave-diggers employed by Oldenburg dug a grave into the lawn behind the Metropolitan Museum in New York. After documenting the action the hole was filled up once again. Oldenburg expected, erroneously, as we know now, that in due time official triumphalistic war memorials would be erected; with this action he intended to protest against the Vietnam War and its future celebrations. In his view the hole was to serve as a negative of a potential socle. By covering it up he transcended the purely negative form of the Kennedy monument. Joining the structurally-related concepts of a negative form and a grave he proceeded to annihilate them. Oldenburg's compelling logic was to be sorely

absent in the case of the gigantic hole project submitted in 1995 to the Berlin Holocaust competition.

In 1981 it was the turn of the West-German artist Timm Ulrichs, who habitually chose his own person as the subject of his art, to take up the idea of a subterranean monument. He projected a special monument-grave for himself, which he exhibited first in Bergkamen and then, in the late 1980s, in an artistic necropolis near Kassel (Habichthöhe). Ulrichs inserted into the ground a mould of his body's shape with the head down, repeating Oldenburg's Kennedy project, so that the soles of his shoes reached ground level, fixed from below to a thick translucent glass plate. After Ulrichs' death the monument would accommodate his ashes, an idea testifying to a peculiarly Protestant obsession with cremation, and somewhat difficult to imagine in practice. Ulrichs expressly chose the motif of the shoe soles as the main catalyst for inducing in the viewer a kind of philosophical reflection on life in general and that of Ulrichs in particular. No doubt the artist was aiming, without expressly acknowledging it, at the 'imprint' and 'leaving his mark' metaphors. He went on to proclaim that 'having the monument [ie the soles of the shoes] at his feet the beholder will understand that this antipodic empty form relates to the living image like death to life' (*Timm Uhlrichs* 1983, 74). Ulrichs' somewhat pedestrian philosophizing on the strictures and imprints of life shows all the signs of a derivative version of an idea which had once been novel and illuminating.

The key concepts envisaged in these artistic actions were 'invisibility' and 'negative' form, as opposed to the positive. As such they have certain connections with some strands of the philosophico-aesthetic debate on the Holocaust as it developed during the 1970s and 1980s. The catastrophe was increasingly discussed in terms of a 'black hole' or as the very anti-matter of culture and civilization. Figurative visualizing seemed out of the question after 1970. The logic of the debate brought up the idea of circumscribing the empty space in human civilization, a kind of void with abstract bearings. Circumscribing but not depicting the Divine had been a key concept for Byzantine iconophobes. Now it returned as a mode to delimit the empty space left by a whole civilization which had perished in the gas chambers.

In its extreme form this stance appeared during the ill-fated Holocaust memorial competition in Berlin (1994–95). One of the competition entries envisaged a giant hole in the earth, excavated in the very centre of Berlin, measuring 80 x 60 metres wide and long and 50 metres deep (Neue Gesellschaft für Bildende Kunst 1995, 170). The sheer size of the hole and its location would have however transcended any notion of providing a 'negative model', making it instead an exercise in gigantomanic land art. Other realisations and proposals had a more modest character. In the abortive competition for a Jewish memorial on the Börneplatz in Frankfurt (1986) a whole range of proposals expanded on the idea of an empty, semi-ruined or ruined space to be left in a modern city. To counter the false triumphalism of the Buchenwald monument, a separate monument for the Jewish inmates recreated the ground plan of KZ huts by means of an excavation covered with stones (Klaus Schlosser, Tine Steen 1993). Similar plans have been formulated as regards the KZ Ravensbrück.

The most recent artistic developments modify the idea of the black hole. The plan of the famous Basque sculptor Eduardo Chillida to dig a great hole in the holy mountain of Tindaya (Fuerteventura, Canary Islands) in the guise of a 'Monument to Tolerance' (1995; Kügler 1997) is, however, contrary to the opinions of most critics, only partly derived from the current fascination for negative forms. Chillida also sees the black hole as the most adequate symbol of the predicament of modern man, but, in an optimistic development, he plans to dig from the rectangular hole two corridors, one vertical, one horizontal, through the crust of the mountain through which spectators at the bottom would be able to see the light of the sun and moon as universal symbols of hope. Without acknowledging it Chillida aims thus towards a symbolic cosmological effect in the direct tradition of Boullée's interior of the projected Newton cenotaph (1784; Vogt 1969, 46).

As an example the idea of a 'negative-form' monument appeared in the *Aschrott Fountain Monument* in Kassel (Horst Hoheisel, 1988). In happier times (1908), Aschrott, a local Jewish manufacturer, had offered a pyramid fountain to the city of Kassel, intended as a conventional piece of belle époque urban decor without any particular aesthetic or thematic pretensions. In 1939 the local

Figure 1 Sketch of the *Aschrott Fountain Monument,* 1987 (Horst Hoheisel). (Kassel Kulturamt)

Figure 2 The *Aschrott Fountain Monument,* Kassel, 1988 (Horst Hoheisel). (Sergiusz Michalski)

I have designed the new fountain as a mirror image of the old one, sunk beneath the old place in order to rescue the history of this place as a wound and as an open question ... I have rebuilt the fountain sculpture as a hollow concrete form after the old plans and for a week displayed it as a resurrected shape at City Hall Square before sinking it, mirror-like, twelve meters deep into the groundwater. The pyramid will be turned into a funnel into whose darkness waters run down ... there a hole emerges which deep down in the water creates an image reflecting back the entire shape of the fountain. (Young 1993, 45)

A variation of this type appeared in the 1987 sculpture competition in Munster. The German artist Raimund Kummer proposed the 'inversion' of the local First World War Frydag War Memorial, a grating allowing the viewer to look down at the monument protruding earthwards.

Another related, very recent type of monument links the concept of a negative model in a broad sense with a demonstration of, seemingly paradoxical, disfunctionality. With this group we enter the burgeoning artistic area of installations.

In 1995 a monument commemorating the burning of books by Nazi students in Berlin on the 10th May 1933 was inaugurated on the very spot before Berlin University where that event took place. Micha Ullman created a subterranean rectangular room with walls covered by empty shelves. The only viewing access was provided by a small, thick glass panel (Fig 3). When viewed through this rather opaque material the white colour of the shelves and

Nazis in a nonsensical and even by Nazi standards extremist move destroyed the 'Jew's Fountain'; during the war the basin was filled with earth on which flowers were planted. Local inhabitants dubbed it then, not without metaphorical reason, 'Aschrott's grave'. This episode of Nazi terror could hardly stand for Jewish martyrdom, the Nazi having rather harmed Kassel itself, but the paradoxes of this change of form and function have illuminated in a deeper way the consequences of the disappearance of the Jews from German life. In 1988 Horst Hoheisel, a local artist, realized thus a classic 'negative form' monument (Figs 1 and 2).

Figure 3 *The Empty Library* (Micha Ullman), commemmorating the burning of books by Nazi students on May 10th, 1933, Bebelplatz, Berlin (1995). (Sergiusz Michalski)

that of the floor join to suggest the illusion of a less than definable space, though on closer inspection the delimitations of the room are visible. A minuscule bronze tablet inserted into the pavement some distance away provides us, in minimalist fashion, with the name of the artist and the title of the work, but with nothing more.

A symbolism of a similar kind was used by the British artist Rachel Whiteread's 1995 project for a Holocaust memorial in Vienna, the very birthplace of modern anti-Semitism (von Brincken 1996, Santner 1997). The monument shows a concrete cube with books turned with their spines inwards on its outer walls. No functional access of any kind (despite a symbolic door) leads to the interior of the cube, the book collection thus displayed cannot be in reality perused, the interior visited. Despite outward appearances this is then, in relation to potential readers, an empty library, its void echoing the disappearance of the People of the Book. The books of the Jews might have survived but their legitimate owners and readers have not.

Inaccessibility and inversion rites are used to create a negative, in the photographic sense, of the trappings of contemporary civilization.

The Viennese monument is located on Vienna's historic, albeit somewhat cramped, Judenplatz where a synagogue stood until its destruction in a vicious 1421 pogrom and where a statue of the great Lessing (Nathan the Wise) provides, with its historic background of persecution, later illusions of acceptance or assimilation and, ultimately, failed philosemitism, a marked contrast to Whiteread's non-figurative cement cube. The weak side of Whiteread's project is the fact that it apparently grew out of a non Holocaust-related public sculpture in London (*House*, 1993; Lingwood 1997) and that the monument, architectonically speaking, pits itself against its vicinity. Its undisputed semantic advantages do not necessarily translate into aesthetic ones.

Both in the Berlin and the Viennese projects one can discern strong connections with the new genre of installations as practised by Christian Boltanski or Ilja Kabakov. Boltanski's *Missing House* installation (Berlin 1990) also invoked the idea of a negative form: on adjacent fire walls of a former Berlin house (destroyed in 1945) the artist placed signposts listing the names and professions (both Jewish and non-Jewish) of its former inhabitants (Dickel 1992, 42–8; Dickel 1993, 223–40). The gaping hole of the non-existent house, illuminated at night by floodlights, contrasts the texture of memory reduced to mere, written names. With Kabakov these works share the desire to create a small, closed universe, an installation with minuscule visual openings to the outside world, in the sense that these small windows or slits cannot be used for reciprocal visual communication. If a Surrealist parentage or affiliation can be claimed for the Apollinaire-Ulrichs projects, and for Ullman and Whiteread the installation context, then the work of Jochen Gerz seems in some ways to be an extension of the land and concept art of the 1970s.

In the 1970s and 1980s the West German artist Jochen Gerz participated in a series of actions meant to commemorate Germany's unsavoury past. Two of his objects gained international renown: the *Column against Fascism and Racial Hatred*, erected by Gerz and his wife Esther in 1986 in Hamburg-Harburg, and the *2146 Stones Memorial* at Saarbrücken Schloßplatz laid out in 1990–93 by Gerz and a group of young art students.

The difference in Gerz's endeavour lies in a peculiar conception of the artistic metaphor. The linkage with idiomatic rites leads the viewer to re-enact the 'encompassing' metaphor while exploring the artistic structure of the object. In the *Saarbrücken Memorial* Gerz took as his point of departure a documentary initiative concerning former Jewish life in Germany (Bollinger 1992; Stadtverband Saarbrücken 1993; Steinhauser 1993; Reusse 1995, 273–84; Pfütze 1997). With the help of Jewish councils in Germany, he collected the names of all Jewish cemeteries, both existing and destroyed, until he had 2146 topographical references to Jewish necropoli. As a next step Gerz and his aides took out an equal number of cobble stones from the pavement of the Castle forecourt in Saarbrücken, carved on each stone the name of one of the cemeteries, provided it with a date, the day the information was received, and re-inserted them with the inscription facing downward. Thus, a part of the pavement of the Schloßplatz has been reset into a symbolic, yet invisible assemblage of Jewish cemeteries. The visitor to the forecourt may have been forewarned that he is stepping over symbols of destroyed cemeteries. He may experience a certain uneasiness, after all he is trampling on symbols, and may wish to avoid direct physical contact. This is not, however, possible, as some stones have no inscription at all. There is no way to see the difference, no way to avoid physical contact.

Gerz has described invisibility both as an intellectual challenge and as a kind of pragmatic protective measure against eventual neo-fascist defacements. He and his collaborators seem to have been divided as to the necessity of appending explanatory tablets in the vicinity; the artist himself preferring booklets, interviews or other forms of communication. Both the Christian-Democratic opposition in the regional Parliament, and some Jewish groups objected to the memorial because of its paradoxical nature and its unprecedented refusal of visibility. For some Jewish intellectuals the acceptance of this particular form implied compliance in a symbolic effort to 'bury the past' (Bollinger 1995, 97).

The invisible Jewish memorial in Saarbrücken combines a bewildering range of intellectual premises. If one keeps in mind the traditional double meaning of the German word 'Denkmal' ('monument', and 'denk mal', meaning 'think about it' or 'remember', for a good or bad memory), it is certainly one of the most thought-provoking monuments of its kind. We did encounter one of its symbolic premises, earthward inversion, in earlier examples in this paper. Furthermore, invisibility as such might be interpreted as a veiled reference to the Jewish prohibition of images. Though each stone stands for one concrete cemetery, the whole assemblage, might be seen to reflect, on an elementary symbolic level, the Jewish custom of throwing small stones onto the grave. But the cemetery context is from the psychological point of view a very difficult one, we have to march, willy-nilly, on the graveyard symbols. No doubt a kind of catharsis is envisaged as the next step.

A separate element is introduced by the symbolism of the place. The cobblestones constitute a part of the pedestrian thoroughfare leading to the main entrance of the baroque castle. During the Nazi period the building housed the local Gestapo headquarters; in the forecourt thousands of Saarbrücken Jews were assembled to be herded onto the trains going to the extermination camps in the east. That the building is now occupied by the democratic government of the region cannot attenuate the burden of past crimes. Nonetheless Gerz tries to stress the universal message and to disclaim a specifically local memorial context by saying that the primary aim here was to 'adequately express absence'.

Last but not least it seems worth recalling that Gerz and his helpers started inscribing cobblestones on government property in 1990 without any official permission, which, in contemporary Germany, constitutes a transgression of the building code. Though later duly legalized, their actions thus bear the imprint of another artistic phenomenon of the 1960s, namely the happening. Some happening epiphenomena have already appeared in Gerz's 1986 Harburg *Column against Fascism and Racial Hatred*.

In the famous *Documenta 6* at Cassel (1977) Walter de Maria displayed an 'Earth kilometre' as an example of the potential of conceptualized land art. Starting from a small, coin-like brass plug the viewer was invited to imagine a long steel rod which pushed a kilometre into the earth's crust. This idea (presented also on a smaller scale during the Munich Olympics of 1972) may have provided the stimulus

Figure 4 *Column Against Fascism and Racial Hatred*, 1986–93 (Jochen Gerz & Edith Shalev-Gerz). (J P Holden)

Figure 5 The site of the *Column* after its final lowering in 1993, Harburg. (Tomasz Torbus)

for Jochen Gerz's Harburg memorial (Lichtenstein & Wajcman 1994; Gerz & Gerz 1995; Reusse 1995, 266–72). His square column 10 metres high and covered in lead was erected in front of the local city council offices (Fig 4).

For Gerz the lead covering offered the chance to display, by virtue of the material itself, the ambivalent relationship between the German past and the present. Conditioned by weather and the presence, or absence, of sunlight the lead coverings present either a semi-bright metal reflection of present-day society or the dull opacity of lead, the latter referring symbolically to Nazi horrors and oppression. But more important than this is the role of the lead coverings as a reflection of the views of society. The public was expressly invited to state its attitude towards the column by making inscriptions in the lead. The lead coverings were not, however, conceived as tables of pious wishes and decent sentiments. Gerz calculated and accepted as a realistic fact that right-wing or pro-Nazi smears would appear, in fact he even felt from a democratic

viewpoint that they were necessary. Each inscriptional act activated a special, though hardly discernable, sinking mechanism, and so, on the 10th of November 1993, after seven years, the column was completely buried in the ground (Fig 5).

On the place were the pillar once stood is an inscription plate which proclaims: 'Nothing can in the long run replace our own protest against injustice', meaning that monuments espousing a just cause should not give us a convenient pretext for remaining passive and refraining from humanitarian action. In Harburg Gerz demonstrated that the monument as a vehicle of articulating society's set of values might be after all expendable. A small side window offers a side view of the subterranean chamber with the sunken column. The mausoleum effect is aesthetically appealing and in some way continues the string of subterranean monuments analysed above. It is not however very pertinent to the intrinsic message of the monument (see Lovell this volume, Wharton this volume).

Gerz on the whole prefers immaterial messages to material ones. Traditional political monuments, but also the public sculpture of the 1970s and 1980s, failed as far as he was concerned to elicit a larger communal debate. One does not, however, have to possess prophetic faculties to foresee the pitfalls of conceptual art in this particular domain. Even if endowed at the outset with rigorous intellectual premises conceptual art is always in danger of succumbing to democratic conformity and banality.

Gerz's endearing belief in democratic, plebiscitary and participatory elements is influenced by the 'happening' tradition of the 1960s and by Beuys'

post-1980 activities, though his actions do disclaim crass visual effects. They will have to stand the test of time solely on the basis of the pertinence of their mental symbolism.

BLACK FORMS AND THE HOLOCAUST

Sol LeWitt's *Black Form Dedicated to the Missing Jews* is in many ways emblematic for the thinking of the 1980s about the Holocaust. Though not intended at the outset in the classical functionalist sense as a monument its underlying raison d'être is devolved integrally from the public sphere. Designed for a sculptural exhibition in Munster (1987) it was placed in the middle of an elaborate baroque palace courtyard (Bussman & Künig 1987, 173–8). The rectangular black cube was positioned on a place traditionally reserved for equestrian monuments. This place bestowed on the cube the aura, if not function, of a pedestal, and yet with no figure to support it. The cube demonstrated its functional uselessness both through its rectangular form and by its colouring, as a somber parody of a socle it stood in stark contrast to the baroque festivity of the courtyard. The sheer incongruity of the cubic shape with its surroundings invoked the break in civilization caused by Nazi genocide, the black colour being an obvious symbol of mass death, annihilation but also, and this is no doubt the most important, for figurative disappearance into nothingness. Annihilation is thus equated with civilizational disjunction, the cube acquiring the trappings of something like anti-matter. Though hailed as the ultimate conceptualization of the black abyss of the Holocaust, LeWitt's sculpture does not present a novel idea. Tony Smith, one of the pioneers of Minimal Art, had in 1962 already created a black cube and endowed the monolith with the title *Die*. Smith's work was, however, conceived as a sculpture for an interior, an undefined exhibition interior which could not provide the sort of disfunctional friction which appeared, thanks to the baroque environment, in Munster. In both works black is being celebrated not only as the colour of mourning (not all cultures following that particular code) but mainly as an evocation of the non-representational nature of darkness and annihilation. The black pedestal has a stark sacred aura of its own with distant echoes of Kaaba-like structures.

In 1989 LeWitt's cube was reset, in less congenial surroundings, as a monument to the extinguished Jewish community of Hamburg-Altona on the central square of Altona.

MIRROR-LIKE REFLECTIONS

Public monuments are meant to commemorate historical events or historical personalities. As such they form a steadily widening contrast to changing contemporary views and tenets. By becoming themselves a part of history they allow us to measure the distance travelled and to comprehend our personal evolution and the evolution of society. As time goes by the appelative *tua res agitur* ('it is in your interests', Horace *Epistles I*, 18, line 84) espoused by the monument gets weaker and weaker, its reflective function, in the metaphorical and literal sense, amplifies itself.

The mirror is one of the oldest instruments of psychological cognition. Looking into the mirror we attempt to find out something about ourselves. We might also use the mirror, as sometimes actors do, to set ourselves in position before a significant background. When Jacques-Louis David installed a great mirror on the opposite wall of his *The Rape of the Sabines* (1799) he allowed the visitors of his Paris studio to juxtapose or blend their poses with these of his antique heroes. This procedure also served as a source of psychological knowledge or introspection.

In 1979 the East German sculptor Klaus Schwabe proposed a memorial to Ernst Thälmann, the German communist leader murdered in 1944 in Buchenwald by the Nazis, which was conceived as a symbol of the revolutionary struggle as such (Plastik-Kolloquium 1980, Adam 1992). The elongated monument presented its thematic structure in a complex way, expecting the viewer to walk along it on a slightly circuitous path. On the right side of the monument a sculpture showed a group of victims of anti-revolutionary repression. The path followed led then to a group of concave mirrors inserted into the connecting wall. They were to confront the beholder with his own likeness and ask him thus about his role in a society striving for a better future. On the right there followed a figurative allegory of men ascending, no doubt towards a better socialist tomorrow (Fig 6).

Figure 6 Project for the *Ernst Thälmann Monument*, East Berlin, 1979–80 (Klaus Schwabe). (Ulrich Windoffer)

The critiques concentrated from the outset on the fact that Schwabe's Thälmann monument did not include a figure of its nominal hero. After some hesitation Schwabe concurred. He inserted a figure of Thälmann in such a way that the figure would be reflected by the mirrors before the middle part of the monument and thus could be interposed with the reflected image of the viewer. Thus the original idea, though not the simile of an objective historical process, was in a certain way preserved. Schwabe's project was judged in 1980 to be too avant-garde; the Thälmann monument in East Berlin erected in 1983 was a clumsy exercise in traditional pathos. However his idea of reflecting mirrors seems to have born fruit. In the Marx-Engels monument in East Berlin (1986) polished metallic stelae which surround the sculpture at some distance, though displaying small propaganda photos engraved in the metal, permitted also a hazy reflection of the viewer's likeness. This was however a compromise, with no overriding appellative reference.

In exactly the same year (1986) Jochen Gerz referred in his Harburg monument against racial hatred to a mirroring function; sunlight was to produce on the polished lead surfaces a 'reflection of the present state of German society', on sombre days the dull opacity of lead was to evoke memories of Nazi oppression. Since the lead surfaces were to be covered by spontaneous inscriptions of the viewers a peculiar visual overlaying effect of the inscriptions on the reflection was achieved. The column has in the meantime vanished into the ground. In a larger

sense this procedure could pass for an intended simile of its mirror-like transitory nature.

This paper has analysed Micha Ullman's Berlin monument on the Bebelplatz. But the *Library* should also figure prominently as an example of the use of reflection in monuments. During sunny moments the glass plate reflects our own likeness and this reflection superimposes itself on the hazy image of the room below with its empty shelves; these shelves stand, as we know, for a brutally annihilated culture. Ullman has thus chosen a symbolic procedure akin to that of the Harburg monument. When the light is turned on inside the chamber during the night it reveals much more clearly than the hazy-glassy daytime view could do the details of the subterranean chamber. But viewed from a distance amidst the dark place the illuminated plate exudes an eerie disquieting glassy room, in marked semiotic contrast with the rugged pavement and the sombreness of the night.

In a structural sense we can find a similar overlaying and reflecting effect in Maya Ying Lin's famous *Vietnam Veteran's Memorial* (1982, Washington: see Barucki 1987, Ezell 1987, Walsh & Aulich 1989, Griswold 1996). In the 1980s this monument was the subject of heated politico-aesthetic controversies, but this paper concentrates on one aspect. The monument consisted of an identical pair of black granite walls inserted into the lawn of the Washington Mall, meeting at a right angle to point, through an act of intentional topographic symbolism, to the nearby Lincoln Memorial and the Washington Monument. A complete list of America's 58000 Vietnam fallen has been chiseled chronologically onto the wall's marble surfaces, though the word 'Vietnam' itself, in keeping with the minimalist nature of the project, is nowhere to be found.

By walking along the monument we see our likenesses reflected in the intentionally black polished marble with the names of the dead overlaying or superimposing themselves on our faces and bodies. It is a simple but powerful symbol, involving our existence with the open questions about the war in Vietnam and the scandal of another man's death. The height of the black wall rises to correspond with the increasing number of deaths in the late 1960s, and our reflections seem more minuscule by contrast. It drops again to correspond with the last years of the war. This all happens face-

to-face, in direct visual contact with the viewer, and questions our own future. The reflection is distinct but not clear, for, after all, nothing is clear. The monument refuses to give an overt message leaving us with the dead, our doubts and our fears.

In the 1990s mirroring as an artistic device seems to have become itself an artistic convention. Thus in 1995, after protracted political disagreements, a *Deportation Memorial* was instituted in the central square of Berlin's Steglitz district (Joachim von Rosenberg, Wolfgang Göchel: see Seferens 1995). This great Mirror Wall (Fig 7) contains a list of the district's deported or murdered Jews with their Steglitz addresses, some historical photographs and some topographical-historical information about Jewish life in Berlin. The overlaying effect is a very vivid one, the wall mirroring strongly also the surroundings. No doubt the effects are somewhat crass, contrasted with the subdued sombre tone of the other monuments.

On 13th August, 1998 the *Berlin Wall Memorial* (*Gedenkstätte Berliner Mauer*) was inaugurated on the Bernauer Strasse in central Berlin, commemorating the wall that disappeared after 1989 and its almost 200 victims. Only a small part of that infamous structure was preserved (by chance) near the historic Sophienfriedhof, and the architectural firm Kohlhoff & Kohlhoff decided to create a memorial quadrangle by joining two parallel wall segments (the higher 'front' wall and the lower 'rear' wall) with almost twice as high transverse mirroring walls made of polished high-grade steel. Thus the wall fragments and the former 'death sector' ('Todesstreifen') between them could be reflected, although only in good weather, indefinitely. The extant fragments of the wall having been renovated for the occasion the overall impression is that of an obliterating (as regards the traces of history), aseptic cleanliness. This is both in iconographic as in visual categories a somewhat forced, let us say honestly an eerie solution, which produces ghostly effects in a forlorn place.

Whatever their visual merits one trait of the mirroring monuments becomes immediately obvious: they eschew definite answers to the problems facing the beholder. As if contradicting the famous adage of St Paul they do not want to suggest that one day we shall see in a clear mirror, *faciem ad faciem*, the answers to our and modern society's

Figure 7 *Mirror Wall: Deportation Memorial in Berlin Steglitz, partial view*, 1995 (Wolfgang Göchel, Joachim von Rosenberg). (Sergiusz Michalski)

doubts.

ACKNOWLEGEMENTS

This paper is an enlarged version of Chapter VII of *Public Monuments* (Reaktion Books, London, 1998). I am grateful to Michael R Leaman and Reaktion Books for publication permission.

REFERENCES

Adam H, 1992 Erinnerungsrituale - Erinnerungsdiskurse - Erinnerungstabus. Politische Denkmäler der DDR zwischen Verhinderung, Veränderung und Realisierung, in *Kritische Berichte*, **20**: 3, 29.

Apollinaire G, 1916 [1977] *Oeuvres en Prose*, **I**, Paris, Gallimard.

Barucki T, 1987 Ameryka-Ameryka, in *Architektura*, **4**, 27-8.

Bollinger E, 1992 Das Unsichtbare Denkmal, in *Semit*, **III**, 96-98

von Brincken W, 1996 Sturm auf die Bibliothek. Holocaust-Denkmal Entwurf von Rachel Whiteread, in *Kunst-Zeitung*, **2**, 22

Bussmann K & König K (eds), 1987 *Skulptur-Projekte in Münster 1987*, Münster, Westfälisches Landesmuseum.

Dickel H, 1992 Das fehlende Haus. Christian Boltanski in Berlin, in *Ästhetik und Kommunikation*, **78**, 42-8.

Dickel H, 1993 Installationen als ephemere Formen von Kunst, in Diers M (ed), *Mo(nu)mente. Formen und Funktionen ephemerer Denkmäler*, Berlin, 223-40.

Ezell E, 1987 *Reflections on the Wall: The Vietnam Veterans' Memorial*, Harrisburg.

Gerz J & Shalev Gerz E, 1995 *Das Harburger Mahnmal gegen Faschismus. The Harburg Monument against Fascism*, Stuttgart.

Griswold C L, 1996 The Vietnam Veterans Memorial and the Washington Mall: Philosophical Thoughts on Political Iconography, in *Critical Inquiry*, **12**: 4, 688-719.

Haskell B, 1971 *Claes Oldenburg, Object into Monument*, Pasadena, Pasadena Art Museum.

Heinrich C, 1993 Strategie des Erinnerns. Der veränderte Denkmalsbegriff in der Kunst der achtziger Jahre, Munich.

Jenni U, 1993 Alfred Hrdlicka, Mahnmal gegen Krieg und Faschismus, Graz.

Kügler C, 1997 Pharaonisch. Heiliger Berg zu durchbohren: Chillidas Pläne für Fuerteventura, in *Frankfurter Allgemeine Zeitung*, January 4th.

Lichtenstein J & Wajcman G, 1994 'Wir wissen, daß das Verdrängte uns immer verfolgt'. Jochen Gerz im Gespräch, in *Kunstforum*, **128**, 197-99.

Lichtenstern C, 1988 *Pablo Picasso, Denkmal für Apollinaire*, Frankfurt am Mainz, Entwurf zur Humanisierung des Raumes.

Lingwood J, (ed) 1997 *The House*, London. Phaidon.

Metken G, 1994 Die Kunst des Verschwindens: Unsichtbare Denkmäler - ein Situationsbericht, *Merkur*, **48**, 478-490.

de Michelis M, 1991 *Heinrich Tessenow 1876-1950*, Stuttgart, Das architektonische Gesamtwerk.

Neue Gesellschaft für Bildende Kunst, 1995 Denkmal für die ermordeten Juden Europas, Berlin.

Oldenburg C, 1969 *Proposals for Monuments and Buildings 1965-69*, Chicago.

Pfütze H, 1997 Unsichtbar - versenkt - im Traum. Mahnmale und öffentliche Skulpturen von Jochen Gerz, in *Merkur*, **51**, 128-37.

Plastik-Kolloquium, 1980 *Plastik und Raum. Denkmäler und Denkmalsprojekte*, Magdeburg.

Reusse F, 1995 *Das Denkmal an der Grenze seiner Sprachfähigkeit*, Stuttgart, Klett-Cotta.

Rosenthal M, 1996 'Ungezügelte' Monumente oder wie Claes Oldenburg auszog die Welt zu verändern, in Celant G (ed), *Claes Oldenburg. Eine Anthologie*, Bonn, 255-263.

Rother R (ed), 1994 *Die letzten Tage der Menschheit*, Berlin, Deutsches Historisches Museum.

Santner I, 1997 Zählt Beton oder Geschichte? Kontroverse in Wien um Holocaust-Mahnmal und Reste einer alten Synagoge, in *Weltwoche*, February 6th.

Schuller K, 1998 An der Bernauer Straße wacht eine Sphinx mit Pferdefüssen über die Opfer des DDR-Grenzregimes, *Frankfurter Allgemeine Zeitung*, July 6th.

Seferens H, 1995 *Ein deutscher Denkmalsstreit. Die Kontroverse um die Spiegelwand in Berlin-Steglitz*, Berlin.

Springer P, 1987–88 Rhetorik der Standhaftigkeit. Monument und Sockel nach dem Ende des traditionellen Denkmals, in *Wallraf-Richartz Jahrbuch*, **48/49**, 366.

Stadtverband Saarbrücken (ed), 1993 2146 Steine - Mahnmal gegen Rassismus, Stuttgart, Stadtverband.

Steinhauser M, 1993 Erinnerungsarbeit - Zu Jochen Gerz' Mahnmalen. Works of memory - On Jochen Gerz's Memorials, in *Daidalos*, **49**, 104-114

1983 *Timm Ulrichs*, Hanover.

Vogt A-M, 1969 *Boullées Newton Denkmal*, Basel/Stuttgart, Sakralbau und Kugelidee.

Walsh J & Aulich J (eds), 1989 *Vietnam Images: War and Representation*, London.

Young J E, 1993 The Texture of Memory, New Haven & London.

AUTHOR

Dr. Sergiusz Michalski of the Institute of Art History, Technische Universität Braunschweig, is the author of Protestanci a sztuka (1989), The Reformation and the Visual Arts (1993), New Objectivity. Painting, Graphic Art and Photography in Weimar Germany 1919–1933 (1994), Public Monuments. Art in Political Bondage 1870-1997 (1998) and Tableau und Pantomime (in print 2001).

9 Contemporary monuments of the millennial kind

Vivien Lovell

Director, Modus Operandi,
4th Floor, 2-6 Northburgh Street,
London EC1 OAY, UK.
Tel.: 020 7490 0009 Fax: 020 7490 0018

The marks we place on earth tell us who we are. (Highwater 1987)

Abstract

This paper explores some of the concerns underlying the inherent dilemma of the monument at the end of the second millennium, within the context of current issues surrounding 'public art' and 'public space'. Three principal lines of enquiry are illustrated by case studies: the monumental edifice or object-sculpture as monument, artists' responses to existing monuments and, finally, the contemporary memorial as a specific category of monument. An afterword outlines briefly the case study *Gateways for the Millennium* which, from 1992 to the present, has taken the current Millennium date as a conceptual gateway or threshold to inspire (or not) current interdisciplinary initiatives by artists, architects and other creative practitioners.

Key words

Monument, sculpture, public art

The subject of a cartoon series in the *Saturday Independent* newspaper in the mid 1990s, 'Monuments for the Millennium', was both topical and of global significance, understanding the need to take stock and reevaluate the notion of 'monument' and its role at the beginning of the 21st century (Fig 1). But first to definitions. A monument, according to the Oxford English Dictionary, is 'a structure, edifice or erection intended to commemorate a person, action or event', and a millennium (as well as a period of 1000 years) is 'a period of happiness and benign government, or a future age of peace and prosperity'. The fact that the end of the second millennium falls at the end of one of the most violent centuries in history has given cause for reflection on the part of many artists, some of whom are concerned more to mark that overwhelming sense of loss than to create works of celebratory and monumental scale.

The two OED definitions each pose a challenge to contemporary art commissioning practice, which, at its most critically aware, adopts a shy and ironic attitude to the business of monument-making, particularly under the spotlight of pre-millennial

Monuments for the millennium
A series of Public Building Projects to celebrate the year 2000, by John Fardell

31. A realistic human body ride

Figure I 'A realistic human body ride', cartoon in
Monuments for the Millennium, cartoon series by John
Fardell, 1998, *The Independent*. (John Fardell)

tension. This scepticism towards the monument is
unsurprising given the development of Modernism
this century and its pursuit of art for art's sake.
Modernism, after all, according to Sven-Olov
Wallenstein, is 'the epoch, par excellence of the
anti-monument ... contemporary art resists
monumentality and, if it deals with the theme at all,
it is often on an ironic meta-level' (Wallenstein
1997, 105). The inherent dichotomy of
contemporary monuments has been dealt with
tersely by Lewis Mumford, calling it a contradiction
in terms (Mumford 1938).

More recently, 'public art', like 'modern
monument', has been deemed an oxymoron.
Contemporary monument-making of the millennial
kind is inseparable both from the marking of time
and from current theories of public space. 'As
indicated by the expression 'commemorative',
monumentality also implies an essential temporal
function to bring the past into the present, to

condense history and to point to the future as the
promise of a greatness to come. 'In order to theorise
a dissolution of the logic of monumentality, we also
need a theory of public space, which forms the
necessary correlation to all monuments. The
monument seems to be necessarily intertwined
with political space and its vicissitudes, and cannot
survive without its support' (Wallenstein 1997).

Artists, urban theorists and cultural geographers
are acutely aware that no 'public' space is value-
free; virtually all public space is tightly controlled,
monitored, scrutinised, regulated, producing a set of
specific conditioning factors and constraints for the
contemporary public art including the monument.
According to Henri Lefebvre in *The Production of
Space* 'the section of space assigned to the architect
[or, one might add, the artist] perhaps by developers,
perhaps by government agencies – has nothing
innocent about it: it answers to particular tactics and
strategies. It is, quite simply, the space of the
dominant mode of production' (Lefebvre 1974).

The 'dominant mode of production' of visual art
this century has, after all, been shaped by curators,
dealers, critics and collectors, and is contingent
upon the gallery and studio, rather than the civic
plaza, the airport or the hospital waiting room, as
hallowed places for the revelatory encounter with
art. The challenge to artists and commissioners is
how to address the inherent polarities posed by
public art reconciling the function-free and
potentially subversive role for art as pioneered by
Modernism with the perennial demand from 'clients'
or commissioners for a public art that is decorative
or commemorative, emblematic of corporate wealth,
civic values or regenerative policies.

Within this artistic context, the interpretation of
the contemporary monument by today's avant-
garde artist frequently challenges preconceptions
of permanence and prominence. Themes are more
likely to address the exercise of power, the ineffable,
the erosion of borders and territories, the redefinition
of heroism and identity, the sense of loss at the end
of a century fractured by wars.

If a 'permanent' commission is called for, one of
the dilemmas facing the artist is how to provide a
work to sustain a given meaning in a site with many
different publics, and a long-term time frame, or,
alternatively, how to create a work that privileges
the viewer and allows an open-ended and infinite

interpretation. The notion of permanence is itself open to broad interpretation and expectation; monuments may be mobile, whether by accident or design. Equally, they may be ephemeral or temporary, existing for hours, weeks or years; the 'permanent' may be decommissioned, whereas the 'temporary' occasionally remains in perpetuity by popular demand, as with the Eiffel Tower. Physical context and usage may change; what of Britain's Millennium Dome in fifty years' time? At the time of writing, a competition has just been launched for ideas on its future function.

Public art as city emblem parallels the role of architecture as civic monument/cultural icon. The monument signifies the status and aspirations of a city (the *Statue of Liberty* by Bartholdi in New York City, the Guggenheim Museum by Gehry in Bilbao); the artwork or edifice as monument becomes inseparable from the mind's image of that city, mirroring its values, power, politics, patronage and propaganda. An item in the inventory of city assets, a calling card of today's successful city, the monument acts as a major draw for cultural tourism and inward investment. Monumental scale is often a prerequisite of such work, although the media distribution/marketing of the image of a sculpture as small as the mermaid in Copenhagen can override physical monumentality.

But insofar as one takes permanent monuments for granted, does the contemporary monument gradually become 'invisible', and, if so, what strategies are adopted to elude this fate? When explaining the paradoxical invisibility of monuments, Robert Musil wrote 'anything that is imperishable loses its strength of argument, and anything that compartmentalises our life, the scenery of our consciousness as it were, loses its capacity to play a role in that consciousness' (Musil 1957). However, kinetic works by, for example, Calder, Nikki de St Phalle, Tinguely and Oldenburg could possibly be said to side-step this potential 'invisibility'.

Claes Oldenburg's monumental projects are, according to Robert Harbison in *The Built, the Unbuilt and the Unbuildable*, 'useless like all the best monuments … beyond present technical capacity, ruinously expensive, affronts to the dignity and propriety that monuments embody' (Harbison 1991, 58). The Philadelphia *Clothes Pin* continues to exude its off-beat humour in the financial quarter of the city; as does his *Bottle of Notes* in Middlesborough, UK; meaning here is definitely vested in the mind of the beholder. *Clothes Pin*, like the *Statue of Liberty*, is synonymous with the image of the city in which it is located. Similar in scale, *Secret Station* by Eilis O'Connell, sited on a former steel works in Cardiff Bay, acts as a marker for that urban regeneration scheme by embodying old and new technologies, steam and fibre optics respectively, in a contemporary comment on the site's history and current aspirations. *Iron:Man* by Antony Gormley in Birmingham and his subsequent vast-scale *Angel of the North* in Gateshead are each manifestations of the iconic power of the singular sculpture to command public attention and elicit a healthy array of responses. *Iron:Man* in particular appears to embody a capacity for infinite interpretation without loss of confrontational power or popularity; seven years after its inauguration it was voted the most and least favourite sculpture in the city of Birmingham. Like many modern monuments *Iron:Man* eschews the plinth, preferring direct contact with the ground, from which it seems to soar or retreat, embedded in the paving up to its shins. Emblematic of private (Trustee Savings Bank) and public patronage (Arts Council Lottery) respectively, *Iron:Man* and *Angel of the North* each reflect in their scale the level of corporate ambition and funding made available.

Public art monuments as corporate emblems, signifying the level of wealth and taste, the corporate risk-taking, the cutting-edge approach of the broad-shouldered developer, are perfectly represented in *Fulcrum* by Richard Serra at Broadgate in London. Whereas the somewhat restrictive space for this muscular monument was designed for it by the late architect Peter Foggo, the infamous *Tilted Arc* by the same artist for Federal Plaza in Manhattan cut across an existing open public space, intentionally emphasising its lack of social cohesion, but was perceived as a monumental violation of that plaza by its public. Such was the outcry against *Tilted Arc* the piece had to be removed permanently, after a long legal battle fuelled by a hostile press (American Council for the Arts 1987).

As a counterpoint to the real or perceived invasion of space by permanent, free-standing, rarely noticed, but eventually assimilable and invisible monuments, a new strand in public art has gained ground over the

past fifteen years, which seeks to democratise public space by investing civic values and meanings in such locations as underground stations, squares and parks. Francoise Schein's exploration of themes inherent in the Declaration of Human Rights as generic subject matter in Metro stations in Paris, Lisbon and Berlin has inspired a series of works that are at once immense in scale and reference yet human in dimension and universal meaning. Schein's monumental projects address one of the fundamental dilemmas of the modern monument, and that is how to imbue a sense of ownership and shared values in an age of pluralism and multiculturalism. Public space as public monument (Trafalgar Square in London; the Capitol in Rome) is not a new concept but current artistic treatment of it is; democratisation and gendering of a public space forms the subject of current research in the fields of social geography and public art .

Parallel to these sociological investigations, the naming of monuments and public spaces can represent another strand of appropriation and political control as well as a mark of celebration and ownership. Rather than responding to the official practices of public art commissioning, many artists at the end of the twentieth century have become adept at commemorating the uncelebrated, the under-celebrated or the uncelebrateable.

Marking the invisible and the site-specific, Lother Baumgarten charted the winds that criss-cross the harbour area in Barcelona, their names forged in large-scale characters set in the paving. Under the same programme, *Urban Configurations*, Rebecca Horn created a counter-monument comprising a tower of formal elements inspired by the shanty town beach huts swept away by the pre-Olympic civic clean-up. Jaime Plensa's quietly subversive commemoration of a partisan uprising presents a sombre yet surprising series of interventions in the streetscape, a sarcophagus on a public bench, cannon balls encountered here and there.

Artists, intuitively getting under the skin of official monuments, pinpoint contemporary issues and concerns with politics, territories, boundaries, borders, pacifism, dictatorship and propaganda.

Agnes Denes' initiative *Wheatfield: A Confrontation* for Battery Park City, was made in 1982 immediately prior to the creation of Battery Park City, the landfill project on the Lower East Side of Manhattan. Wheatfield effectively disempowered

Figure 2 *Wheatfield: A Confrontation*, by Agnes Denes, New York City, 1982. (Agnes Denes)

the grandeur and setting of the *Statue of Liberty*, rendering it with one stroke a surreal vision in a sea of waving corn – the latter ultimately harvested, ground, sold as flour and baked into bread (Fig 2) . *Liberty* provoked an even more bizarre response by the Catalan artist Antoni Miralda who, as part of his investigation into monuments worldwide, concluded that *Liberty* in New York and *Columbus* in Barcelona were destined for each other's love; they salute towards each other across the ocean and, albeit ill-matched in scale, became the subject of Miralda's trans-cultural match-making event, *The Honeymoon Project*. Engagement and wedding gifts were commissioned by cities internationally: New York City, the dress (Fig 3); Venice, the shoe (in the form of a gondola, floated down the Grand Canal). Birmingham, at the Public Art Commission Agency's initiative (PACA), commissioned the Eternity Ring, working with local people in the city's Jewellery Quarter (Fig 4).

Over recent decades artists have challenged the meaning of existing monuments through juxtaposition, intervention or superimposition. Yves Klein in 1958 became concerned with the idea of lighting the obelisk in the Place de la Concorde with his signature blue – a way of appropriating that Parisian landmark as his own. This was finally realised posthumously in 1983 and again in 1996. Klein's proposal centred on re-presenting the obelisk and its hieroglyphics: 'Les surfaces couvertes de hieroglyphes deviennent une matiere picturale d'une richesse profonde et mysterieuse; inouie et bouleversante. C'est grandiose' ('The surfaces covered with hieroglyphics became a profoundly

Figure 3 *The Honeymoon Project: Wedding Dress for Liberty*, by Antoni Miralda, 1989. (Antoni Miraldi)

Figure 4 *The Eternity Ring for the Marriage of Liberty & Columbus*, Antoni Miralda with Jane Kelly, Hatti Coppard and others, Birmingham 1990. (Antoni Miraldi)

mysterious depiction; overwhelming and extraordinary', from catalogue to the exhibition *Yves Klein at the Georges Pompidou Centre*, Paris, 1983). Such projects evoke the viewer's capacity literally to see the monument in a new light, and achieve their objective through the power of memory as well as through documentation.

An updated version of this sentiment is evident in Jorge Orta's language of signs projected in light, an alphabetical palimpsest inspired by such monuments as Chartres Cathedral and Santa Maria della Salute in Venice. An overlay of projected images may re-empower or disempower monuments; Kristof Wodiczco's projection onto Nelson's Column in Trafalgar Square organized by Art Angel in the mid 1980s, bore the image of a nuclear missile, neatly encapsulated within the monument, at once questioning its validity yet drawing attention to current, more sinister weapons

of war. The more grandiose the monument, the greater its capacity to be undermined.

In 1909 the *Ehrenmal am Mauritztor* in Munster, designed by Bernhard Frydag to commemorate Bismarck's wars against Prussia (the inscription reads 'In Memory of Wars and Victories, and the Re-establishment of the Reich') and popularly known as the Masen temple or Monument of Asses, formed the starting point for Hans Haacke's sculpture *Merry Go Round* in the 1997 Munster Sculpture Project. Haacke's work, the same diameter and height as this nationalist monument and sited in close proximity to it, comprised a cylindrical shack of rough planks, between which could be glimpsed a moving children's carousel, complete with lights and music (Fig 5). Changes in political power shift the meaning of monumental propaganda. The question of what should be done with the toppled statues of Lenin in the Soviet Union was posed in 1992 by Vitaly Komar

Figure 5 *Merry Go Round*, by Hans Haacke, Munster, 1997. (Public Art Commissions Agency)

and Alexander Melamid, who placed an advertisement in Art Forum asking participants to submit ideas on 'how to preserve these monuments for posterity without leaving their former function unproblematized'. An exhibition of 100 ideas followed – the principal strand proving that humour is one of the most effective weapons against such symbols of power. Ideas included a theme park for fallen idols; works to be leased as advertising space; large-scale weather cocks, and supports for children's playground slides. James E Young wrote 'How better to celebrate the fall of authoritarian regimes than by celebrating the fall of their monuments' (extract from the catalogue for the exhibition *Monumental Propaganda*, Uppsala, Konstmuseum, 1997), but Milou Allerholm points out that this signals an almost reverse problem in the west – the lack of visible signs of power (Allerholm 1997). Political and social powers and values invested in architecture present artists with rich source material for counter-monuments; the permission for Christo and Jean Claude's *Wrapping of the Reichstag* in Berlin in 1996 took 25 years from initial concept to realisation during which time the political significance of the building had radically changed. Their earlier wrapping of the Pont Neuf in Paris for two weeks in 1985 obscured and then revealed anew a well-known national monument, which had been briefly yet exquisitely dressed by the Christos in an especially woven fabric dyed 'le couleur des pierres de L'Ile de Paris' according to the press release. For two weeks the Pont Neuf became an even more important and romantic meeting place than was usually the case; a few years later it starred again as a resonant

monument in the expressionist film *Les Amants du Pont Neuf*. A myriad of responses by artists similarly surround the Eiffel Tower as cultural icon, some of which are documented in the catalogue Monument et Modernité, 1891/1996 for the eponymous exhibition, 1996, at the Espace Electra, Paris (Pol Bury, Tania Mourand, Edmund Kuppel).

As a complete counterpoint to the wrapping of exterior architectural forms, Rachel Whiteread's *House* in 1993 took the empty void of an undistinguished terraced dwelling in East London as its starting point. A monument to a private space stripped bare, an exploration of the issues surrounding domesticity and housing, loss and homelessness, privacy and publicness, vulnerability and isolation, belonging and exclusion, *House* aroused a polarity of responses in the brief period of its physical existence on site. Conceived and designed to be temporary, it became a media focus and cause célèbre when Whiteread won the Turner Prize and, simultaneously, the campaign to extend the life of *House* was thwarted by councillors of Bow Neighbourhood committee who voted in favour of its destruction (Lingwood 1995).

Almost a decade earlier, Jean Pierre Raynaud's project for Venissieux near Lyons in 1984–6 had sought to memorialise one among a group of tower blocks scheduled for demolition, by cladding it in the artist's signature white tile, thus creating a permanent monument to a condemned form of public housing. And in 1990, the ordinary domestic dwelling featured as monument in Christian Boltanski's installation *The Missing House*, in which a series of plaques on the walls of houses flanking a gap site, commemorated civilians who died in that Berlin house in the Allied bombings of 1945.

Turning our attention to the challenge of present-day memorials commemorating the individual, artists have notably discarded conventional forms of mimesis, choosing rather to explore a semiotic approach to subject through metaphor. The ready-made object, or metaphorical form emblematic of the person or her/his achievements, often replaces the literal figurative means of representation that reached its zenith as a public art form in the statuary of the nineteenth century. It could be argued that the potency of some Second World War memorials, notably those of Charles Sergeant Jagger, finally mortgaged the subsequent power of the

Figure 6 *The Wattilisque*, monument to James Watt, by Vincent Worapay, Birmingham, 1986–7. (Public Art Commissions Agency)

Figure 7 *Monument to John Baskerville*, by David Patten, Birmingham, 1989–90. (David Patten)

figurative sculpture to evoke pathos and deepest human emotion.

Vincent Woropay in his *Wattilisque* of 1986–7, commemorating James Watt in Birmingham, celebrates the invention of the pantograph in the form of systematically refined granite blocks gradually emulating, and in the top-most element precisely referencing, Chantrey's bust of Watt (Fig 6). Similarly, David Patten's *Monument to John Baskerville*, in Birmingham's Centenary Square, celebrates the letter founder and printer in a sculpture comprising enlarged versions of printing punches each bearing one of the letters of the name Virgil, whose volume of poems was the first book to be printed by Baskerville's press (Fig 7). And Joseph Kosuth's memorial to Champollion in Figeac appropriates the Rosetta Stone, vastly enlarged, as the 'readymade' and significant cipher with which Champollion broke the hieroglyphic code. The

poetry of Wilfred Owen, who died on the battlefields of the Somme in the week before the Armistice of the First World War, is commemorated in Paul de Monchaux's sculpture commissioned by the Wilfred Owen Society in Shrewsbury, in a work 'as moving as it is unsentimental' according to Jonathan Glancey in his review of the piece in *The Independent* (Glancey). This restrained abstract work in granite stands as a metaphor for the pontoon bridge on which Owen died and for the symmetrical structure and imagery of his poem 'Strange Meeting', in which Owen encounters the ghost of a German soldier, who utters the memorable line 'I am the enemy you killed, my friend', is also inscribed on the memorial (Fig 8).

The extrapolation of key issues and themes to inform the artistic concept tangentially and non-literally underlies the success of the modern monument. In an ephemeral memorial created by Richard Wilson and Anne Bean to commemorate

Figure 8 *Memorial to Wilfred Owen*, by Paul de Monchaux, Shrewsbury, 1991–93. (Paul de Monchaux)

the tenth anniversary of the death of their friend Stephen Cripps, a pyrotechnics artist, ice blocks containing significant objects melted over several hours to form a funeral pyre on railway sleepers (Fig 9). All this was within the unlikely yet benign setting of Kensington Gardens in summer 1992. Whereas the intention here was to mark the moment and the artists' response in a work that used ice to evoke the loss of a young life, the challenge to the team of artists commemorating Martin Luther King in San Francisco resulted in a permanent environmental work that demands space and time invested by the viewer in the perception of the piece. Houston Conwill and his collaborators designed a spatial, elemental setting that invites the viewer to participate, but in a non-didactic way, in a series of wall-based texts and images behind a waterscape that creates privacy and enclosure thus encouraging a

Figure 9 *Memorial for Stephen Cripps*, by Anne Bean & Richard Wilson, London, 1992. (Anne Bean & Richard Wilson)

Figure 10: 'Revelations', a memorial to Martin Luther King: by Houston Conwill, Estella Conwill Majozo and Joseph de Paco, San Francisco, 1993. (Houston Conwill)

sense of contemplation (Fig 10). A similar means of engagement is used to chart key events in the extraordinary life of Biddy Mason, 'born a slave,' in the wall-based memorial in Los Angeles, organised by The Power of Place, 1987–89. The evocation of a life through fragmented information, salient quotes, serial texts and images is arguably a more pertinent means than a mimetic sculpture of honouring an individual in an age in which information technology and the media allows virtually limitless access to the human image.

Jan Dibbets, who won the competition to make a new monument to Francois Arago, the nineteenth-century French scientist and politician, also chose a serial rather than a single freestanding solution. In fact the starting points of this commission had been two-fold: the absence of a pre-existing bronze statue of Arago, melted down in the Second World War, and the earmarked site, Le Petit Place de L'Ile de Seine, where the meridian of Paris cuts the Boulevard Arago. In Dibbets' work, the imaginary monument is realised through the installation of 122 medallions bearing the name Arago in the paving along the meridian.

The 1998 proposal for a Princess Diana trail marking the course of her funeral route, also the controversial idea for a new Diana Garden in the grounds of Kensington Palace, concur conceptually with the late twentieth-century move away from the figurative. Perhaps the most elegant proposal to date to mark Diana's death has been that put forward by the designer Gaetano Pesce: an extension above ground of the thirteenth column in the Paris underpass of the fatal accident. The column would

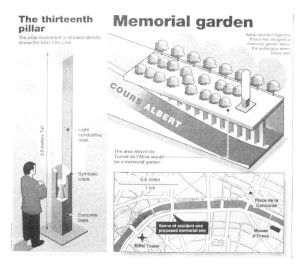

Figure 11 Proposal for the Diana Memorial, Gaetano Pesce, *London Evening Standard*, 12 May 1998. (London Evening Standard)

Figure 12 *Speculative Proposal for the Empty Plinth in Trafalgar Square*, by Jochen Gerz, 1996–98. (Public Art Commissions Agency)

transform from concrete to glass and notate the site, creating a minimalist shrine (Fig 11).

Minimalism and the power to invoke the ineffable through the invisible remain the most potent means of memorialising events of global and political concern. Jochen Gerz and Esther Shalev-Gerz's *Monument against Fascism* in Harburg, a suburb of Hamburg, draws upon public memory and interaction as the means by which the monument was/is appropriated, questioned and ultimately negated. For the Gerzs, the didacticism of traditional monuments is all too closely associated with the characteristics of Fascism: their response to this invitation to produce a commemorative work was to create a counter-monument, one that effectively destroyed itself and moreover implicated the public in the act of its erasure. The forty foot high column clad in lead was gradually lowered into the ground, a few feet every few months, concurrently with an ongoing invitation to the public to inscribe their memories of and responses to the Holocaust into the lead surface. Inscription, sgraffito, signature, graffiti successively overlay one another forming a rich palimpsest of marks prompted by innocence, guilt, memory and loss, interwoven with the sinister occasional sign of neofascism. Now that the work has disappeared, is invisible, its presence and power operates by word of mouth, its existence documented through informative panels installed in the railings

surrounding the area below which the monument is now located (Gerz & Shalev-Gerz 1994, Michalski this volume, Wharton this volume).

Gerz' body of work, from the 1960s to his more recent counter-monuments in Harburg, Saarbrucken and Biron, and including his proposals for Berlin's *Holocaust Memorial* and Coventry's *Public Bench* and *Future Monument*, constitute an important ongoing artistic and philosophical investigation into the meaning and relevance of the contemporary monument. His highly controversial proposal for the empty plinth in Trafalgar Square, commissioned under PACA's programme of Speculative Proposals, stands on the margins of the Royal Society of Arts' official initiative for that space. Elevating the culture of sport to the status of the high arts, Gerz intends to place a section of turf from the home pitch of the winner of the football league (currently at the time of writing Aston Villa) and install it on the plinth (Fig 12). Poking fun at the solemnity of Trafalgar Square, while celebrating the British obsession with football, Gerz's proposal as at late 1999 was neither accepted nor rejected. Mark Wallinger's *Ecce Homo*, the first installation under the official programme, presented us with a figurative regeneration of Christ, blindfolded, standing on the edge of the plinth, at the cusp of the Millennium.

The act of commissioning and creating a memorial is considered by many to be, ironically, tantamount to the process of forgetting: the memorial substitutes for individual and collective memory. Maya Lin's *Memorial to the Vietnam Veterans* in Washington

Figure 13 *Vietnam Veterans Memorial* (detail) by Maya Lin, Washington DC, 1981. (Public Art Commissions Agency)

DC should not, according to Jochen Gerz, have been commissioned at all, insofar as any memorial effective as an instrument in the cathartic process of national mourning, would ultimately be equally effective in the process of national forgetting, thereby letting the US Government off the hook of its responsibility and guilt. Praised widely as a minimalist stroke of genius (admittedly strongly influenced formally by the work and teaching of Richard Serra), Maya Lin's Vietnam memorial has also attracted criticism from a minority sector who believed that American heroism was insufficiently addressed (Fig 13). A conventional bronze three-figure work by Frederick Hart, positioned uncomfortably close to the Maya Lin, was the outcome. In fact the *Vietnam Veterans Memorial* also employs strategies of the traditional monument to achieve its effect (resilient materials, text) combined with a strictly minimalist form that maximises site, time, sense of engagement, and the power of physical and cerebral reflection.

Three major strands emerge at the end of the twentieth century as powerful means of commemorating persecution, war, loss of multiple lives. The first is the evocation of absence through monument-as-site, implicating the viewer necessarily in a time-based experience (*Vietnam Memorial* by Maya Lin, the Jewish Museum and its permanent exterior installation by Daniel Liebeskind in Berlin, also his landscape design for the site of the concentration camp at Sachsenhausen); the second strand mirrors

absence/loss through a literal or metaphorical absence on the part of the artwork (the Gerz's *Monument against Fascism* in Harburg, and Jochen Gerz's *Monument against Racism* in Saarbrucken). Rachel Whiteread's Jewish Library memorial in Vienna, inaugurated in 1999, invokes a sense of loss by casting in positive the conceptual interior space of the library. The third strand emerges as a process-based approach to the conception, creation and meaning of memorials, by engaging the public in individual and group responses which effectively complete the work. Gerz's memorial in Biron employs this tactic, the final work comprising a series of plaques on a minimal obelisk, each bearing an individual answer to the same (secret) question posed by the artist to each villager: what would be, in their eyes, an event or cause of sufficient import to risk their life.

Commemorating the more recent loss of thousands of civilian lives, the NAMES Project *AIDS Memorial Quilt* was created in the US as a composite work of art/craft and stands as a public testimony to the suffering and death of 10,688 HIV-positive patients in the late 80s, and as a protest against the inadequate action of the political and medical authorities to the dilemma. Of monumental scale and significance, the *AIDS Memorial Quilt* bears the hand and skills of numerous individuals and community groups, a giant exemplar within the longstanding folk art tradition and history of the American quilt (Fig 14).

Figure 14 Names Project *AIDS Memorial Quilt*, Washington DC, 1989. (Richard Strauss)

There are no conclusions to this paper: the monument and its counterpart, whether permanent or temporary, critical or celebratory, will continue to evolve and transmute, always reflecting if not deflecting the circumstances under which it was created.

AFTERWORD: RECENT MILLENNIAL PROJECTS IN THE UNITED KINGDOM

Gateways for the Millennium was the ironic title of an international collaborative workshop which took place at the Royal Institute of British Architects (RIBA) in 1994, following an initiative in 1992 by Public Art Commissions Agency for Public Art Forum. More than one hundred architects, artists, landscape architects and representatives from other creative disciplines, from philosophy to choreography, spent a weekend working in teams on real or notional projects which addressed the given theme. The purpose was to provide a stimulus for new collaborative practice, reflecting the essence of its organising body, the Alliance for Art, Architecture and Design.

The Alliance, which still exists informally as a network, encourages and promotes collaboration between artists, architects, craftspeople and other creative professionals, for a lasting effect on the planning and design of public spaces. The International Collaborative Workshop produced in

1994 some extraordinary proposals: video monuments of two thousand one-second contributions to an electronic store of information; a 'mass global phone party' hosted by the telecommunication companies; rethinking the East Thames Corridor Strategy to incorporate millennial beacons; the Millennium Exchange, an opportunity to swap significant objects from life with fellow citizens; the building of 1:1 scale sections of a larger Millennium project; a glass bridge across the Thames from Waterloo to Downing Street.

A range of approaches was in evidence at the Alliance. Some of the groups simply accepted the chaos of the whole affair, throwing their imaginative energy into entertaining presentations. Some spent the time in quiet consideration of the meaning of what they were doing. Still others got down to serious urban development and planning for the future. Some groups allowed for a more sardonic, less idealistic account of human nature and offered wry comment on the eagerness to celebrate the Millennium in the first place. 'Whose Millennium?' they asked.

Groups looked at how the Millennium might be used to focus on issues of civil rights, racism, homelessness and equality of dignity and opportunity for all, and how to keep these in the public eye. There was also preoccupation with what was being lost and acknowledging the appalling events of our century, recognising that 'the future is a condition of the present' (Carey 1994).

One of the groups voiced a sense of unease with the idea of the monument as such, and proposed a celebration of the Millennium as an opportunity to start a healing

process in western industrial society, which was described as being 'on a countdown'. The group suggested choosing a simple concept for a world net of 'special places' which would represent a complete contrast with normal life, and proliferate throughout the whole of the next century as the legacy of the Millennium. A similar idea was put forward by another architecturally minded group, which interpreted the idea of a 'gateway' as an opening into a new state of mind, located in, again, a series of special places throughout the country, providing rest and 'solace away from visual promiscuity' (Paul Williams, presentation at the Alliance Workshop, June 1994).

Humorous, philosophical, sober, cynical, abstract, prosaic, the workshop uncovered a wide range of attitudes to the Millennium and how it should be marked, which was productive less in terms of coming up with a viable strategy for action than in opening up some sort of discussion as to the real significance of the event to us all at the end of the twentieth century' (Melhuish 1994)

Allerholm M, 1997 Monumental propaganda, in *Index*, **3–4.97**, 105 & 116–7.

American Council for the Arts, 1987 *Public Art, Public Controversy: Tilted Arc on Trial*, New York, American Council for the Arts.

Carey F, 1994 Gateways to the millennium: A national alliance for art, architecture and design events, in *Art and Architecture*, Autumn, 3.

Gerz J and Shalev-Gerz E, 1995 *The Harburg Monument Against Fascism*, Ostfildern, Verlag Gerd Hatje.

Harbison R, 1991 *The Built, the Unbuilt and the Unbuildable*, London, Thames & Hudson.

Highwater J, 1987 paper given at *Public Art in America* conference, Philadelphia, PA.

Lefebvre H, 1974 *The Production of Space* D Nicholson-Smith (trans), Oxford, Blackwell.

Lingwood J (ed), 1997 *House*, London, Phaidon.

Melhuish C, 1994 When tomorrow comes, in *Building Design*, 8 July, 11.

Mumford L, 1938 *The Culture of Cities*, New York, Harcourt, Brace.

Musil R, 1957 *Prosa, Dramen, Spate Briefe*, A Frisk (ed), Hamburg.

Wallenstein S, 1997 Notes on the logic of monumentality, in *Index*, **3–4**, 62–107.

AUTHOR

Vivien Lovell was the Founder/Director of the Public Art Commissions Agency and is now Director of Modus Operandi. After taking degrees in History of Art and arts administration she worked as an arts officer and gallery director for a number of local authorities and agencies. She has led a large number of public art and curatorial projects, and has been a member of many committees. She was elected Chair of the Public Art Forum 1991–93 and initiated, with the Royal Institute of British Architects, the National Alliance for Art, Architecture and Design. She is a Fellow of the Royal Society of Arts, and an Honarary Fellow of the Royal Institute of British Architects.

Part 3

Technical Approaches

10 Modern conservation of outdoor bronze sculpture

Andrew Naylor

Janet Naylor – Andrew Naylor,
Sculpture and Conservation Consultancy,
33 Westerkirk Drive, Madeley,
Telford, Shropshire TF7 5RJ, UK.
01952 581448 / 07775 597459, fax: 01952 585581
j-and-a-naylor@mac-I.net

Abstract

An overview of the historical background to the conservation of bronze sculpture, an assessment of the position of bronze sculpture conservation now and some thoughts on possible future developments.

Key words

Conservation, bronze, public sculpture, patination, standards, accreditation, status.

INTRODUCTION

This paper is about bronze sculpture, rather than any of the other materials commonly or occasionally associated with outdoor sculpture. Because it is a material the author has specialized in over a long period, the general topics raised are in some respects relevant to other specialist fields.

Many societies have made sculpture as a statement of confidence in their ideology and power, with the implicit intention that it should always look good and last forever, that being the timescale envisioned for their predominance. With this belief came the need to care for the sculptures and here also are the roots of conservation. On the demise of those civilisations sculpture was lost, damaged or decayed, to be rediscovered, collected and venerated by later societies, resulting in the need to clean, repair and care for them. From the late Middle Ages Europeans have been avid collectors of ancient sculpture and, in more recent times, ruthless consumers of art from societies that recognised the ephemeral nature of the materials they used, but ensured continuity by simply replacing what became decayed, worn out and at the end of its functional life. In the affluent West, progressively more cleaning, repairing and caring was required. From the very beginning, the repair of sculpture was assigned to those who came from the same technical background as the original makers; carvers for wood and stone, modellers and foundry workers for bronze, modellers and potters for ceramics. Although from a different time and culture, their role was to 'restore' the object to suit the values and preconceptions of their own time.

'Conservation' is a modern concept, developed mainly since the middle of the nineteenth century. It is a rejection of the potential for falsification associated with restoration and is linked to the philosophy of the Arts and Crafts Movement. It is a relatively small step from the idea of 'truth to materials' to 'truth to the object'. Simply defined, 'restoration' is a conscious effort to return an historic object to a notional appearance at a given point in

time; as such, by accident or intent, it may or may not be an accurate interpretation. 'Conservation' is a much more cautious approach, an exercise in halting or at least minimizing the rate of decay and accepting that everything that has happened to the object is a valid part of its history (although some of those things may be contributing to continued decay or obliterating the visual reading of the object and may need to be altered). Conservation of outdoor public sculpture is an even more recent phenomenon. Some towns and cities in the UK had a maintenance programme for outdoor sculpture, bronzes in particular (Liverpool until the 1960s and London until the 1970s), but in the main, for most of the twentieth century, neglect has been the norm.

Figure 1 Bronze statue of *William Gray*, by William Day Keyworth, Hartlepool, showing the disfiguring pale green, dark green and black of corrosion and sulphation. (Janet Naylor)

BRONZE

Bronze is a copper-based alloy, usually with tin and a little lead added; it is the traditional metal for sculpture and is very familiar to the conservator. It is vulnerable to atmospheric pollution which, in combination with acidic rainwater, etches away the sculptor's intended finish and into the surface. A combination of grime, corrosion and erosion produces the typical pale green streaks and dense dark green to black surface which camouflages the form (Fig 1). The way in which outdoor bronzes corrode and the rate of deterioration can vary significantly depending on the aggressiveness of the environment and the positioning of the sculpture in a particular site. The sculpture's orientation to the prevailing wind and rain conditions and to local pollution sources can result in different types of surface corrosion from one side of a sculpture to another. In urban areas especially, bronze is subject not only to pollutants that are damaging in terms of their chemical properties and corrosiveness, but also to wind-borne particles which in effect continuously sandblast the surfaces of the metal. Reactions can occur between different components of airborne pollution which accelerate the corrosion process. In addition temperature gradients may effect the rate of corrosion. Generally, the higher the temperature and humidity, the more rapid the corrosion rates. Corrosion affects the surface visually, because it causes physical erosion which leads to loss of detail and surface texture (which alters the way in which the surface reflects light) and because it changes the patina, the original surface finish.

PATINA

At the mention of the word 'patina' in the company of a mixed group of sculptors and conservators, hackles will begin to rise, positions will be taken, confusion and misunderstanding will reign. Initially a patina is applied to the surface of a bronze at the foundry or in the sculptor's studio. An extensive range of colours can be created and there are literally thousands of recipes involving different combinations of (mostly hazardous) chemicals (see Hughes & Rowe 1982 [1991]). The surface of the metal is converted into variously coloured compounds as it comes into contact with the chemical mixture.

To the sculptor the term 'patina' is the original finish applied to a new bronze sculpture. This patina is not merely a coloured finish to a sculpture, it is an integral part of the sculpture, it affects and enhances the form and the surface texture. When the sculptor is making the sculpture in clay, plaster, wax, etc, for translation into bronze, he or she must take into account the changes and subtleties that can be wrought by reworking the waxes or fettling the cast bronze, and in turn, what effect that will have on the applied patina. For example, a patinating compound will have a different effect on a polished surface to its effect on a rough, textured surface. When the surface is prepared to receive the patina it is not then merely a matter of applying the chemical solution and waiting for it to turn brown or whatever colour, the skilled patinator may choose to dramatize the form by visually deepening hollows with a cold, dark dense colour and raise peaks with a light, warm one. The variables are practically infinite; different patinating solutions can be applied over ground colours; the patina can be selectively cut back to reveal the glow of the underlying bronze. There is no single way of arriving at that final original patina.

Conservators, on the other hand, also use the term patina to describe a 'changed surface' of an object, in this case to describe the layer of oxides and corrosion products remaining after the original patina has undergone considerable change (including total loss), that can be stabilized and will enhance the visual reading of the sculpture. Some of those working in the field believe that, despite many decades of bombardment by a chemically aggressive cocktail of atmospheric pollutants, the Holy Grail of the original patina may still exist under the overlying layer of corrosion. Contractors working on bronze conservation projects, many of their clients and the specification writers frequently make the misguided assumption that bronze should be basically brown. This is the reason that many public bronze sculptures are turned into a dead, bland, more or less even brown after conservation by contractors. A sad example is C Sergeant Jagger's recently restored *Artillery Memorial* at Hyde Park Corner, London. The bronze figures, dark and grimy though they were, had a compelling, dramatic, emotional presence imbuing power to the sense of waste, destruction and death that Jagger had experienced first-hand. The pale, even brown produced by the contractors

has taken away that drama. Further, they match unusually closely the colour of the bronze (treated at the same time) of the adjacent *Wellington Memorial* by Joseph Boehm and the *Machine Gun Corps Memorial* by F Derwent Wood. This is a phenomenon difficult to explain when the sculptures were made at different times by different individuals, unless they were repatinated extensively at the time they were restored.

Artificial patinas are never completely stable; they tend to change and develop new mineral forms with time, corresponding to the acidity of local rain, the amount of abrasion from wind-blown particulates, and other accumulated detritus on the surface and the amount of water that rests or condenses on the surface over a long period of time. Corrosion on outdoor bronzes becomes most noticeably apparent as the copper content converts to a bright-green sulphate. That sulphate is soluble; it does not form a coherent film and, thus, streaking and run-offs develop. In crevices where water does not wash the surface, the particulate matter accumulates and thickens to form black scabs which contain copper, sulphur and oxygen as well as other, mostly carbon- and iron-containing, materials. In areas of green and black streaks it is usual to find deeper etching underneath the pale green streaks, which provides a convenient route for rainwater to run down, thereby exacerbating the problem. In addition the leaching out of copper results in a slightly different composition to the underlying metal which stimulates an electrolytic reaction, accelerating the problem.

As the black scab formations increase, pitting of the metal surface frequently develops beneath them. The pits usually continue to grow underneath what may appear to be a fairly stable crust. If chlorides are present the pits may continue to develop underneath the corrosion crust or previously applied protective coatings, eating deeper into the metal; eventually the salts produced erupt through the crust or coating. Ultimately, corrosion reaches a cyclic stage where the rain-washed surface converts continuously to a bright blue-green loosely adhering sulphate which then washes off.

Bronze patches applied by the foundry to repair casting defects will, because their crystalline structure has been changed by reworking, react differently in the corrosion process. In addition, other materials

may be present such as solder, lead or plastic filler repairs and corroding iron core supports left from the casting process, which may burst the casting as the rust increases in volume.

TREATMENTS

Because of differing philosophical attitudes, and levels of technical understanding, there is a wide range of treatments applied to outdoor bronzes, some of them potentially destructive. A little over a decade ago, at the time of two definitive international conferences on the treatment of outdoor metal sculpture,[1] the predominant issues of interest and conflict centred on the use of glass bead as opposed to nut shell as shot-blast mediums for surface cleaning. Since then 'conservation' philosophy, emanating primarily from institutional conservators and endorsed by a handful of private sector conservators, has moved on and now calls for more cautious procedures, with the emphasis on maintenance and monitoring, advocating as little intervention to the object as possible. Although mechanical cleaning methods utilizing industrial equipment are no longer considered suitable by conservators, they are still favoured by contractors dealing with large public or outdoor sculptures.

Industrial air-driven shot-blast equipment is cumbersome and crude and can be very destructive. The protective clothing worn by the operator is clumsy and vision is severely limited by the heavy helmet, ricochet damage to the visor and dust, water or slurry. The machines are designed to be used at high pressures, but can be adapted to work at lower pressures, although at pressures less than about 40 psi (2.8 bar or 0.28 MPa), shot-flow may become uneven. In humid conditions, the shot absorbs moisture and the problem increases. There are associated problems concerning dry storage, containment, removal and disposal of contaminated dust, slurry and water (but it is not uncommon to see health and environmental regulations ignored), as well as noise pollution caused by the compressor. Types of abrasive material vary enormously, as do their characteristics, some being more aggressive than others. Blast cleaning with abrasive shot can also be carried out using water instead of air as the driving medium. Another variation is water alone at tremendously high pressures, such that the velocity of the water droplets on impact with the surface has a similar effect to that of solid shot blast material. They all to a greater or lesser degree result in over-cleaning and the subsequent need for repatination. By and large, although contractors will claim to be operating at low pressures, in practise they tend to use higher pressures at every opportunity in order to save time.

Smaller, more precise shot-blasting equipment is available and does operate at very low pressures, but it still does not overcome the problem of over-cleaning of raised detail or around stubborn accretions, under-cleaning in recesses and the obscuring effect the mixture of water and blast medium has over the surface being treated.

Shot blasting and repatination of bronze sculpture destroys any remaining evidence of early finishes and causes unacceptable levels of metal loss (comparable to a considerable period of total neglect), thus negating the justification for treatment. Similarly, it has been found that bronze is more tolerant of some corrosion products than was suspected, that these are not necessarily aesthetically distracting and are in fact reasonably stable given simple, low-cost maintenance. It is less damaging to the object if only dirt and loose or aggressive corrosion products are removed and repatination is kept to an absolute minimum (preferably none at all), and that cosmetic recolouring is achieved by paint or tinted wax.

Simple hand-cleaning processes are more effective and controllable, though not completely, because areas physically difficult to treat by hand are usually the areas most adversely affected by corrosion and pollutants. Some conservation contractors include flame cleaning in their repertoire of hand-cleaning techniques. Flame cleaning is a method of removing heavy sulphation in areas often difficult to reach. The deposit is rapidly heated using an oxy-acetylene welding torch to shatter the deposit, but the method is only partially effective and the operator's vision is reduced by the necessary protective goggles. The more careful and skilled the hand cleaning, the higher labour costs become, but this can be offset by less need for re-patinating, reduced environmental problems and lower equipment and material costs.

CHANGING STANDARDS

Some years ago, Jackie Heuman, sculpture conservator at the Tate Gallery, London, published a paper describing her discovery of the remnants of tinted lacquers on a nineteenth-century bronze (Heuman 1992). On reading the account, Janet Naylor immediately examined an eighteenth-century bronze that was in her workshop at the time, the equestrian *George I* by Jan Van Nost Junior, and discovered traces of paint. As a result it has become our practice to examine all bronzes very closely and adapt our treatments to increase the chance of finding these often obscure traces of surface finishes. Recently, working for supportive custodians we have been able to use, slow, painstaking cleaning methods on two statues and discovered traces of undocumented gilding on both. These discoveries beg the question; how much evidence has been removed since the time of Jackie Heuman's publication by the crude methods still used by conservation contractors with their limited concerns? From an art historical perspective, which is an element of the professional conservator's concern, the validity of the more considered approach is demonstrated.

Within the conservation community dealing with outdoor sculpture, there is deep concern over inconsistent, but generally low standards of treatment. Raising standards is a very difficult matter when there is no official body with the authority to impose higher standards.

The Public Monuments and Sculpture Association (PMSA) is an awareness-raising, promotional organisation for the entire field of public monuments and sculpture, not only conservation. It is, in effect, an amenity body comparable to the Victorian Society, the Garden History Society and a whole host of others. As such the results of its enterprise, most notably the National Recording Project, but also guidelines for conservation, saving sculpture at risk, the Advisory Panel and so on, are available to all. That it is as effective as it has proven to be since its inception in 1991 is due to the sheer dedication and enthusiasm of its members.

English Heritage is an arm of government charged with the responsibility for looking after public sculpture and monuments; as such it can steer, guide or advise, but has limited ability to intervene in the choice of conservation contractor.

The stated principal activity of United Kingdom Institute for Conservation (UKIC) is, to quote from page one of the 1998 annual report, '[to carry] on the activities of a professional body for conservators concerned with the advancement of education in and the promotion for the benefit of the public of the highest standards in conservation of items and collections of items of cultural, aesthetic, historic and or scientific value ... and the development of standards and guidelines in ethical, contractual and other areas relating to conservation'. UKIC is the only organisation that has the potential to regulate the conservation of public sculpture by the accreditation of its members. At the time of writing it is poised to introduce accreditation, but the accreditation debate has dragged on for at least twenty years and the opportunity for truly effective accreditation may have been missed. Currently, membership of UKIC is no guide whatsoever to quality of service offered; it indicates only that the member has paid a subscription to UKIC.

While the debate rumbled on and conservators were not able to claim an organised professional status, the responsibility for the conservation of public sculpture and monuments has slipped into the remit of the architect. Initially, some architects were unfamiliar with sculptural materials and techniques, untutored in the subtleties of the history and development of sculpture, and unclear regarding the distinction between restoration and conservation. The idea that bronze public sculpture was and always should be brown held sway in many situations. Shot blasting and re-patinating is quicker than conservation, requires little skill, no knowledge of the subject matter and is therefore quick, cheap and to the contractor, profitable. However, as more architects have gained increased understanding of the proper care of outdoor sculpture and the damage caused by inadequate conservation, the groundswell of opinion is changing. Experienced conservators of long-standing and proven ability are often now called upon to act in a supporting role to the architect. Yet, generally, due to the absence of recognised professional status, the sculpture conservator has been replaced by a specialist contractor within the construction industry, ie an

artisan with practical craft skills but lacking a depth of academic understanding.

Accreditation of conservators is an essential, welcome though overdue first step along the road to the professionalization of the conservation of public monuments and sculpture. In the short term, for accreditation to be even partially effective, applications from 'fast track' candidates need to be scrutinized with rigour. In the longer term (but this should be much less than the twenty years it has taken to reach this point), it is important that there are established resources to provide high quality education for technicians, and specialist contractors, to enable them to progress to higher levels and for already experienced conservators to broaden their expertise to maximize their contribution and to provide the next generation of professionals who will have technical expertise backed up by scholarship.

CONCLUSION

The introduction of competitive tendering into the conservation of public sculpture and a lack of cohesion and initiative on the part of conservators has led to the conservation of outdoor bronzes and other metals associated with outdoor monuments and sculpture being carried out by contractors who do not have a comprehensive understanding of the material or object. To counter the situation and enhance the status of conservators, UKIC must take decisive action to ensure that accreditation is effective. There is also a need for a training resource to provide the next generation of professionals.

ENDNOTE

1 *Sculptural Monuments in an Outdoor Environment*, Pennsylvania Academy of Fine Arts, Philadelphia, November 1983, and *Conservation of Metal Statuary and Architectural decoration in Open-Air Exposure*, Paris, October 1986.

REFERENCES

Heuman J, 1992 Removing corrosion on a painted outdoor bronze sculpture with mild chelating agents, in *The Conservator*, **16**, 12–16.

Hughes R and Rowe M, 1982 (1991) *The Colouring, Bronzing and Patination of Metals*, London, Thames & Hudson.

AUTHOR

Andrew Naylor studied sculpture at Leeds College of Art and went on to work in the engineering industry to learn techniques relative to sculpture. He spent four years on the shop floor as a welder/fabricator before taking up a lectureship in metal sculpture at Bradford College of Art. At the same time he set up in partnership with Janet Naylor to carry out freelance work connected with sculpture; original sculpture for exhibitions, TV props and conservation. The two partners rapidly gained a reputation for high quality work in conservation and this became the core business of the practice, Naylor Conservation, which expanded to become a leader in the private sector. In 1993 Andrew and Janet Naylor resigned and together formed a new practice called Janet Naylor – Andrew Naylor, Sculpture and Conservation Conservancy, specializing in consultancy and research covering a broad spectrum of conservation and sculpture related issues.

11 The conservation of public sculpture in Aberdeen

Jennifer Melville

Aberdeen Art Gallery
Schoolhill, Aberdeen AB10 1FQ, UK
01224 523702

Abstract

In autumn 1997 a programme of cleaning and conservation of ten of Aberdeen's public monuments was carried out. The ten statues ranged in age from a very early figure in lead, known locally as *The Mannie*, which from 1708 had adorned the city's main public well, to the most recent, *Sea Fantasy* by T B Huxley-Jones. Also included in the programme were statues of *George, 5th Duke of Gordon*, and *Lord Byron*. The soldier *General Gordon* was cleaned as was a figure of *Hygeia*, symbol of health, which graces a nineteenth-century park. National heroes *William Wallace* and *Robert Burns* were included, as were royal sitters *Prince Albert* and *Edward VII*. The different materials and ages of the statues each presented different challenges for the conservators and this paper describes these problems and addresses the public's reception of the cleaning and conservation programme.

Key words

Aberdeen, sculpture, conservation, granite, Burns, Wallace, Byron

INTRODUCTION

Public monuments and sculpture have an identity and character of their own. They can come to typify a city, standing as beacons to its history and cultural and historical identity. Nowhere is this more true than in Aberdeen where the grey granite city centre is punctuated by sculpture, spanning four centuries and cataloguing that period of the city's life. The public are very aware of the city monuments, particularly their state of repair or disrepair, and they follow developments carefully, writing to the local paper or to the staff of the Council when the state of the monuments is of

concern. The programme of cleaning and conservation began officially when John Larson, Head of Sculpture Conservation at the National Museums & Galleries on Merseyside, was invited to visit the city in order to carry out a preliminary survey of the monuments and sculpture and to make recommendations on their care. His initial report was submitted in August 1992.

Larson's visit was pre-empted, not by staff of the Arts Department realising that a need existed for such a report, but by an article in the local paper in January of that year, in which the President of The Robert Burns Club was pictured in front of the city's statue of the national bard. A further close-up of the

head of *Burns* revealed the poor condition of the figure, principally as a result of bird droppings having amassed on his head. The newspaper article went on to point out how, on the 100th anniversary of the unveiling of the statue (which we were reminded 7000 citizens had witnessed) the statue was now in such a sorry state that Burns would no doubt be turning in his grave if he could but see its present condition. Three days after the article appeared another photograph of the statue was featured, this time showing a council worker giving the statue a quick wash and brush up, using a broom and a bucket of water, in time for the Burns' Night celebrations which were to take place that evening. Appropriately a poem appeared below the photograph:

Haud still Robbie, I'll wash yer face
Aiberdeen birds dinna ken their place
It really is a disgrace
A man like you should bow your head
To feathered nuisance.

For your birthday you'll again shine bright,
Like your words a shining light
Your voice will ever take its place
Among Aul' Scotia's brave.

So dinna worry, we'll nae forget ye
Every year we came tae dicht ye
Contract Services, Council or the Region
Nae doo' will ever bury you – in Grampian!

It was at this point that staff of the Arts Department, who were responsible for such monuments, decided to take action and explore better methods of caring for such public sculpture.

Larson's report had assessed the condition of 14 sculptures in the city and of these ten were identified as needing treatment. Aberdeen District Council allocated around £150,000 for the programme, money being allocated from the City Improvement Fund. The local paper *The Evening Express* followed events, running a headline 'Outrage at £150, 000 Bill To Clean Statues'. In the article a pensioners' action group was quoted as saying that the cash should be spent on people services, not 'lumps of stone' (*Evening Express* 1997). The scheme was particularly controversial because the current council

cuts were so stringent, with residential homes and nurseries under a very real threat of closure. Within Arts and Recreation, the library purchasing budget was to be cut completely and three libraries threatened with closure. Interestingly the paper made great play of the fact that the conservation was to be carried out by an English firm. Some doubts were assuaged, however, by the fact that the survey would also look at the physical state of the monuments and whether or not they were safe. In complete contrast, the Council publication, *Bon Accord*, reported the story, as one might expect, from a completely positive angle, emphasising the worth of the statues, the skill of the conservators and the care and deliberation which the staff had taken in selecting the appropriate firm for the work and the most suitable sculptures for attention. It also pointed out that the previous year the Council had spent £27, 000 repairing council houses which had been in a dangerous condition.

Officials from the Council's Architects Division had carried out general cleaning over the years (with brooms and buckets of water), but this was to be the first time that the monuments had been looked at by conservation specialists. The survey was undertaken by Naylor Conservation, Shropshire, one of three firms recommended by Larson. Like Larson the company found that Aberdeen's collection of municipal sculpture was generally in good condition, with little evidence of widespread structural damage, but that a programme of cleaning and conservation should be carried out in order to preserve the statues. As things turned out the programme identified further problems which might not have been discovered otherwise.

GRANITE: GEORGE, 5TH DUKE OF GORDON

Damage to Aberdeen's sculpture echoes the kind of damage found in other cities throughout the world, with vandalism at the top of the list in terms of causes of damage. This is exacerbated by car and industrial pollution, though in Aberdeen with its stiff easterly breezes that is never too much of a problem but cold, salty air and the ravages of seagull droppings are: the seagulls vying with the pigeons to take the best spot on the various bronze heads dotted around the city, the larger and fiercer seagulls usually winning.

Of all the sculptures the easiest to deal with by far were those made of granite. Since granite is a hard stone it is not one which sculptors would necessarily select and for that reason not the most obvious of choices. In Aberdeen it is perhaps the most common stone used, because Aberdeen's wealth throughout the nineteenth century was sustained by the granite industry, its wealthiest citizens were granite merchants and as good businessmen and creative Victorians they were determined to utilise granite to its fullest potential, for buildings but also for decorative features, such as columns, for gravestones and also for sculpture. With the advent of steam-powered machinery, the Aberdonians captured the market in decorative granite; granite polished to look like marble was 'reinvented' (this technique having been lost, apparently, since the Ancient Egyptians). Such sculpture has a hard, linear character but it has too a monumentality which can give a figure a sense of power, if carved large enough. It is also extremely durable.

This proved to be the case with a statue of George, 5th and last Duke of Gordon, which was designed by Thomas Campbell (1790–1858), who had found fame when commissioned by the Duke of Devonshire to execute a statue in marble of the sister of Napoleon, Princess Pauline Borghese. The Gordon statue (Fig 1) was carved in granite from the Dancing Cairn quarry, a particularly bright and clear light grey granite and stands upon a plinth of red granite from Stirlinghill Quarry near Peterhead. It was unveiled in 1842, thus making it the first large public statue in the city. The local academic Professor Traill published a pamphlet in 1844 *On the Introduction into Scotland of Granite for Ornamental Purposes*, a work which was inspired by the erection of this monument. It was important for the Aberdeen granite merchants to display their technical abilities with this hard stone, and in reports on these statues it is referred to constantly.

This statue was also the earliest example of a sculptor's work being reproduced in granite, for carving with such stone requires specialised tools and expertise. While such a method was disapproved of by some sculptors, as becomes clear when examining the history of some other monuments in the city, carving in granite creates an immensely hard and solid structure and in the case of this statue there was no need to do more than remove biological

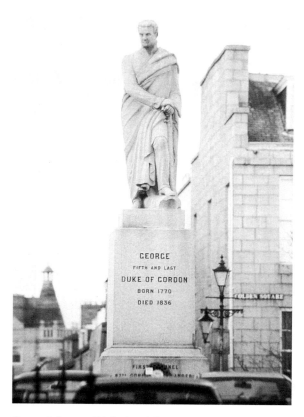

Figure 1 *George, 5th Duke of Gordon* 1842, by Thomas Campbell (1790–1858). (Aberdeen City Council)

growth and general soiling by water washing, using bristle brushes and a small quantity of non-ionic detergent, followed by low-pressure water washing. It was decided to use this soft, low-pressure washing technique since a more stringent method might well make water penetration into the stone go deeper, thus allowing a greater bed for algae growth than existed already. The pointing was repaired, with the most appropriate mortar selected and biocide was applied. Some graffiti remained faint but still visible, but the physical appearance of the piece was nevertheless greatly improved.

GRANITE: HYGEIA

In 1883 Duthie Park, which was funded by the shipping family Duthie, was opened to the public. Blue Ribbon temperance meetings were held and a procession by tradespeople emphasised the proposed function of the park, to bring health and

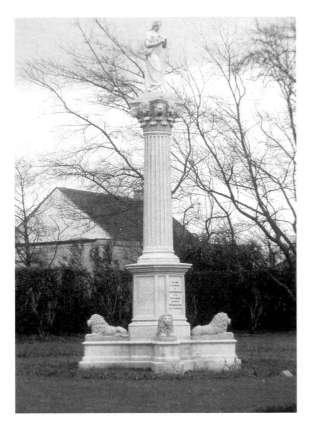

Figure 2 *Hygeia*, by James Pittendrigh Macgillivray (1856–1938). (Aberdeen City Council)

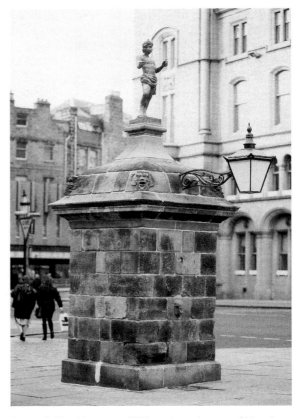

Figure 3 *The Mannie*, c 1708, artist unknown. (Aberdeen City Council)

well-being to the working classes of the city. A figure of *Hygeia*, symbol of health, it was suggested, should surmount a memorial to Elizabeth Crombie Duthie, whose idea the park was. The sculptural scheme was suggested by Scotland's best-known sculptor, James Pittendrigh Macgillivray (1856–1938) in 1896, who suggested not only the figure, but also its positioning in an amphitheatre of foliage. A female figure Hygeia holds a cup from which a snake, the traditional symbol of health, drinks (Fig 2). The statue was designed by the Manchester sculptor Cassidy and his Belgian assistant Schots, and was carved in Aberdeen by a local granite carver who worked from a life-size plaster maquette of the statue, reproducing it in granite and using pneumatic hammers for the first time for this sort of project. The result is far more delicate and detailed than the earlier statue of *George 5th Duke of Gordon*, but could never have the delicacy of a bronze. As with *George 5th Duke of Gordon*, being a granite

sculpture, this statue required little more than soft cleaning which was straightforward and uneventful.

LEAD: THE MANNIE

Another, much earlier piece, however, caused much greater concern. It is a strange figure known simply as *The Mannie* (Fig 3). In 1706 the first piped water supply was brought to the city from a spring in Carden's Haugh to the public well. The entire building and statue had been set up in 1708 by William Lindsay, goldsmith and water overseer and from that year on *The Mannie* had adorned the public well in the main square of Aberdeen. The well was enclosed by a square well-house with a stone roof. The figure above, which has classical overtones, is nude except for a loincloth. He stands in an active position with his arms held forward, and old photographs reveal that he was once holding a bow and quiver, so he may possibly have been an

Eros. These old photographs were not of a sufficiently good quality to allow an accurate recasting, so it was decided to leave the figure unarmed. Once the entire structure had been scaffolded and sheeted the figure was found to be of solid casting. It appears that it was made by repeated pouring of small quantities of lead, giving a layered appearance.

The figure was removed to Naylor Conservation's workshop and a bronze rod, which was sleeved in a copper tube, was removed from inside the figure and replaced with one of stainless steel. A fracture in shin and ankle was welded up. The iron armature in the other leg was then exposed, but was found to be in good condition and resealed. Five other areas of surface damage were lead-welded and dressed off to match the original. Laminations in the lead base were also welded. The figure was refixed using stainless steel studs and nuts, and capped with leaded steel domes. The door and frame were treated *in situ*. They were shot blasted, using a copper oxide blast medium, and pits in the surface were treated with Jenolite (a proprietary rust treatment). The ironwork was given a three-coat paint system, finishing in matt black. The lock was cleaned and lubricated.

The structure had been moved several times, most recently in 1972 when traffic congestion resulted in the well being moved back to near its original position in the Castlegate. Presumably it was at this point that the electrics to the lamp had been refitted, but were now entirely unsatisfactory. The lamp consists of an iron bracket and copper lamp. The iron bracket was given the same treatment as the door. The lamp was stripped down, the perspex glazing discarded and the paint removed with Nitromors[1]. The lamp was reshaped, re-wired back to the fuse box with PVC-coated mineral insulated cable and re-glazed using vandal-proof Lexan[2]. The spotlight fitting (which was a comparatively recent addition) was removed (because it directed water into the electrics and was very weak) and replaced with a new, purpose-made fitting in copper. A new access window was designed to be waterproof and fabricated from soldered sheet copper. This was glazed with glass because Lexan is not heat-resistant.

The copper work was given a three-coat system, ending in matt black. Biological growth and general soiling was removed by applying biocide followed by light mist spraying with continual agitation of the surface with bristle brushes. Areas of pollution accretion were removed using a micro-abrasive with aluminium oxide at 50–80 psi (3.4–5.5 bar or 0.34–0.55MPa). Hard cement pointing was removed with chisels and a hand-held diamond cutter. Edges of joints were masked with tape to avoid smearing and staining. Tests of different sand, hydrated lime and white cement mortar mixes were carried out to determine the most appropriate match. Joints were re-pointed with the best matching mortar. The masking was removed from the bronze. The scaffold was struck and the site cleared of spent materials.

BRONZE: LORD BYRON

Lord Byron had spent part of his youth in Aberdeen where, before the death of his cousin in 1794, he had lived in relative obscurity with his mother. At the beginning of this century, James Pittendrigh Macgillivray had been approached by former pupils of the Aberdeen Grammar School to design a statue of Byron to be positioned in the grounds of the school, which Byron attended. It was hoped that the statue would be ready for the Jubilee Celebrations of the Grammer School in 1913 but delays resulted over wrangles between the artist, who wanted the statue to be of bronze, and the Committee, many of whom were involved in Aberdeen's thriving granite industry and who wanted the statue to be carved in granite, copied from an original in the same way that *George 5th Duke of Gordon* and *Hygeia* had been executed. Macgillivray (whose nick-name was Macdevilry) in spite of having approved, indeed suggested, such a course of action for *Hygeia*, was outraged at this proposal. He was not impressed by the supposed poverty of the former pupils of this illustrious school, who were paying for the statue, writing 'there is plenty of money in the pockets of the Aberdeen men to prevent them stooping to rob an artist for the decoration of their town'.[3]

Macgillivray prevented the statue from being carved in granite, but the casting of a full-size statue, using his maquette as a model, was carried out without his permission (Fig 4). A model of it was made by an Alec Leslie and cast by a Mr Parlant. Macgillivray's opinion of the finished monument was scathing: 'the big work in Aberdeen is not my personal handiwork', he wrote 'and falls considerably short of what it might have been from my hand'.[4]

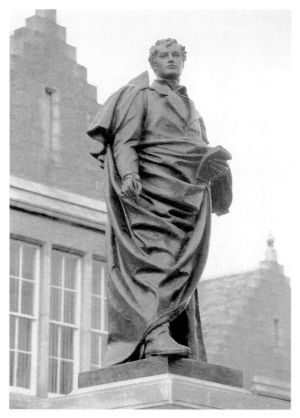

Figure 4 *Lord Byron*, c 1913 after an original by James Pittendrigh Macgillivray (1856–1938). (Aberdeen City Council)

Figure 5 *General Gordon*, c 1883 by Thomas Stuart Burnett (1853–88). (Aberdeen City Council)

In terms of treatment the statue proved to be far less controversial than in former times. Macgillivray's insistence, however, that bronze would be longer-lasting than granite proved not to be the case and this statue suffered from the ravages of the elements over the years. It had an overall green appearance and was streaked and stained by corroding metal.

The bronze and granite were tested to determine the most appropriate cleaning methods. The stone was masked off. The wax was removed from the bronze with Nitromors and a hot pressure washer. Products of corrosion were removed using a combination of hot pressure washing (approximately 80 degrees C° & 1000 psi [69 bar or 6.9MPa]) JOS cleaning[5], flame cleaning and finally the application of fine bronze brushes completed the cleaning procedure. The pencil held by Byron in his right hand, which had been snapped off by vandals, was brazed back in place. Casting flaws were filled with bronze-bearing polyester resin filler. The bronze was chemically re-patinated and coated with benzotriazole dissolved in methylated spirits. The bronze was given a hot application of micro-crystalline wax. The masking was removed from the stone and applied to the bronze. In the case of the granite plinth biological growth and general soiling was removed by water washing using bristle brushes and a small quantity of non-ionic detergent, followed by low-pressure water washing. Areas of pollution soiling were removed using air-abrasive aluminium powder at 80–100 psi (5.5–6.9 bar or 0.55–0.69MPa). Pointing was removed with chisels and hacksaw blades. Edges of joints were masked with tape to avoid smearing and staining. Tests of different sand, hydrated lime and white cement mortar mixes were carried out to determine the most appropriate match. Joints were re-pointed with the best matching mortar. Biocide was applied.

The masking was removed from the bronze. The scaffold was struck and the site cleared of spent materials.

BRONZE: GENERAL GORDON

A statue of *General Gordon* c1883 by Thomas Stuart Burnett celebrates the life of General Gordon who was killed at Khartoum in 1885. This statue was unveiled in 1888 (Fig 5). John Larsen had noted in 1992 that the bronze statue and its plinth were generally in good condition but that the figure would benefit from a light cleaning and protection with a wax and acrylic coating. The monument was appropriately scaffolded and sheeted, and the bronze and granite were tested to determine the most appropriate cleaning methods. The stone was masked off. The resident wax was removed from the bronze with Nitromors and a hot pressure washer. Products of corrosion were removed using a combination of hot pressure washing (approx. 80 degrees C & 1000 psi [69 bar or 6.9MPa]) JOS cleaning, flame cleaning and fine bronze brushes. Casting flaws were filled with bronze-bearing polyester resin filler. The bronze was chemically re-patinated and coated with benzotriazole dissolved in methylated spirits. As with all the sculpture a brown patination was chosen as being that most likely to have been used when the sculptures were first cast. Although this seemed strange when one was so used to seeing them all being various shades of green, after a few months the brown colour seemed fitting. The bronze was given a hot application of micro-crystalline wax.

BRONZE: THE WALLACE

The idea for a statue of William Wallace for Aberdeen had been that of an Edinburgh man, Mr John Steill, who left three thousand pounds for the erection of a statue to Wallace which, he instructed, should 'take the form of a colossal statue in bronze'. Twenty-four sculptors competed to win the competition, which was judged by the artist Sir Joseph Noel Paton (1821–1901). He selected the design of William Grant Stevenson (1849–1919), the finished statue being unveiled in 1888 (Fig 6). The choice made the Scottish artist Sir George Reid despair: 'the pedestal of the Wallace statue is simply

Figure 6 *William Wallace*, 1888, William Grant Stevenson (1849–1919). (Aberdeen City Council)

atrocious', he wrote 'speaking about barbarianism in the XIXth century this is about the best example of it I have seen for many a day'. [6]

Examination of the sculpture revealed that barbarism has also been committed in this century on the work and the results of this ill-advised treatment have left this the most badly damaged and vulnerable of all the statues in Aberdeen. The plinth of the statue was badly stained by rust, which seemed to be running from the feet of the figure. The cause of the severe rusting and staining of the plinth could not be established from exterior examination but by looking inside the statue it became clear that the bronze statue had been fixed to the granite base with iron armatures secured inside the legs which had at some point been filled up to the shins with concrete. The armatures had rusted severely, causing expansion and cracking

Figure 7 *Robert Burns*, 1892, by Henry Bain Smith (1857–1893). (Aberdeen City Council)

around the ankles of the figure and this raised concerns about the long-term structural stability of the monument.

The only clear solution was to remove the rusting iron supports and to replace them with steel ones, but this would require the removal of the figure from the granite base and its subsequent transportation in special cradles, to a workshop where the existing iron could be carefully broken out, the cracks in the bronze repaired and the new supports inserted before re-erection. A report went to the relevant Council Committee on 28 April 1998. In the interim as much work as could be done on the statue while *in situ* was carried out; the monument was appropriately scaffolded and sheeted. The bronze and granite were tested to determine the most appropriate cleaning methods. The stone was masked off. Any remaining wax was removed from the bronze with Nitromors and a hot pressure washer.

Products of corrosion were removed using a combination of hot pressure washing (approx. 80 degrees C & 1000 psi [69 bar or 6.9MPa]) JOS cleaning, flame cleaning and fine bronze brushes. The head of the figure was removed to allow examination of the interior. This was then replaced. Casting flaws were filled with bronze-bearing polyester resin filler. The bronze was chemically re-patinated and coated with benzotriazole dissolved in methylated spirits. The bronze was given a hot application of micro-crystalline wax. The masking was removed from the stone and applied to the bronze. Biological growth and general soiling was removed by water washing using bristle brushes and a small quantity of non-ionic detergent, followed by low-pressure water washing. Tests were carried on the rust staining. Mora poultices[7] proved to be the most successful and were, therefore, applied.

The *William Wallace* statue was the focus for celebrations on the anniversary of his death on 23rd August 1998. The pedestal is inscribed with the speech which Wallace gave at his trial and is an emotionally charged focus of nationalistic pride. The film *Braveheart* had quite recently highlighted Wallace's life and had enforced his image as the guardian of Scotland. The announcement that Scotland would have its own parliament also fell within the period of conservation and was another occasion when the Wallace statue was a focal point for photo calls. With Wallace now an instantly recognisable hero the statue had become in a short period of time particularly sensitive, so that when it was covered with scaffolding for months, longer than any of the other statues, as further problems were identified the complaints began to come in. In the case of this monument there was no alternative but to improve its appearance as much as possible and to work on attending to its structural state by recommending further expenditure and in the meantime pacifying a vocal public by explaining the conservation problems as clearly as possible. Nevertheless, the prospect of *Wallace* going south of the border attracted national media coverage. (Since writing this paper the conservation work on *Wallace* was completed.)

BRONZE: ROBERT BURNS

In the case of the city's other focal point of nationalistic pride, the *Burns* statue, a much less problematic

case greeted us. This statue, which had been unveiled in 1892, is situated opposite Aberdeen's grandest hotel and is on perhaps its prettiest city centre street, Union Terrace. Burns is in eighteenth-century costume. In his left hand he holds a daisy and in his right a bonnet. A plaid hangs from his shoulders (Fig 7). Henry Bain Smith (1857–1893), who designed this monument, had served an apprenticeship in a granite yard in Aberdeen but had gone on to become a talented sculptor, naturally preferring bronze to granite. Cast on 8th July 1892 the statue was unveiled on 16 September of the same year but since that date had had only a cursory cleaning as described already.

The monument was appropriately scaffolded and sheeted. The bronze and granite were tested to determine the most appropriate cleaning methods. The stone was masked off. The wax was removed from the bronze with Nitromors and a hot pressure washer. Products of corrosion were removed using a combination of hot pressure washing (approx. 80 degrees C & 1000 psi [69 bar or 6.9MPa]) JOS cleaning, flame cleaning and fine bronze brushes. Casting flaws were filled with bronze-bearing polyester resin filler. A new mountain daisy was modelled and cast in bronze. This was fixed into a re-tapped hole and secured with a lock nut. Two spare daisies were cast. The remains of a general gilding scheme were discovered over all parts of the statue but, for reasons of cost rather than aesthetics, it was decided not to re-gild the statue so the bronze was chemically re-patinated and coated with benzotriazole dissolved in methylated spirits. The bronze was given a hot application of micro-crystalline wax. The masking was removed from the stone and applied to the bronze. Biological growth and general soiling were removed by applying biocide, followed by light mist spraying with continual agitation of the surface with bristle brushes. Areas of pollution accretion, graffiti and 'banding' (from previous cleaning and graffiti removal) were removed using a micro-abrasive with aluminium oxide at 80–100 psi [5.5–6.9 bar or 0.55–0.69MPa]. Hard cement pointing was removed with chisels and a hacksaw blade. Edges of joints were masked with tape to avoid smearing and staining. Tests of different sand, hydrated lime and white cement mortar mixes were carried out to determine the most appropriate match. Joints were re-pointed

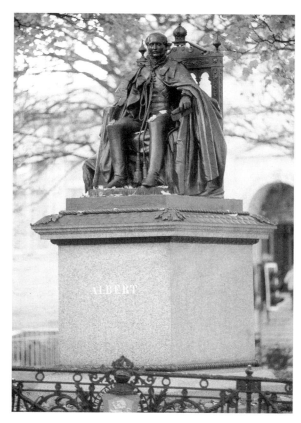

Figure 8 *Prince Albert*, 1863, by Baron Marochetti (1805–1867). (Aberdeen City Council)

with the best matching mortar. Some areas of the gilt inscription were touched up. Biocide was applied. The masking was removed from the bronze. The scaffold was struck and the site cleared of spent materials.

BRONZE: PRINCE ALBERT

The statue of *Prince Albert* by Baron Marochetti (1805–1867) was erected two years after the Prince Consort's death in 1861 and was unveiled in 1863 by Queen Victoria and other members of the Royal Family (Fig 8). It had originally stood at the junction of Union Street and Union Terrace but after the erection of Drury's monument to Albert's son, Edward VII, in 1910 on that site, *Prince Albert* was moved to the other end of Union Terrace, to the leafy area in front of the central Library. The figure is seated in a gothic chair and is 6ft 6in (2.1m) high. A very ornate

Figure 9 *Edward VII*, 1914, Alfred Drury (1857–1944). (Aberdeen City Council)

sculpture, the Prince Consort wears the uniform of a Field Marshall and the robe of the insignia of the Order of the Thistle. A cockaded hat is held in his right hand, his head is bare, and he wears large jackboots. Because the figure is situated on a fenced-off grassy area, he has not been subject to the same vandalism as many of the other statues, though pollution and biological growth had affected this piece in the same way as the others.

The monument was appropriately scaffolded and sheeted. The bronze and granite were tested to determine the most appropriate cleaning methods. The stone was masked off. The wax was removed from the bronze with Nitromors and a hot pressure washer. Products of corrosion were removed using a combination of hot pressure washing (approx. 80 degrees C & 1000 psi [69 bar or 6.9MPa]) JOS cleaning, flame cleaning and fine bronze brushes. The tassels behind the chair were re-fixed with new bronze studs. The brackets fixing *Albert* to his chair

were re-fixed using stainless-steel studding and nuts.

Casting flaws were filled with bronze-bearing polyester resin filler. The bronze was chemically re-patinated and coated with benzotriazole dissolved in methylated spirits. The bronze was given a hot application of micro-crystalline wax. The masking was removed from the stone and applied to the bronze. Biological growth and general soiling was removed by water washing, using bristle brushes and a small quantity of non-ionic detergent, followed by low-pressure water washing. The inscription was re-gilded. Biocide was applied. The masking was removed from the bronze. The scaffold was struck and the site cleared of spent materials.

BRONZE: EDWARD VII

The statue of *Edward VII*, by Alfred Drury (1857–1944), which had replaced that of Albert on Union Street is the most prominently placed, elaborate and the finest of all Aberdeen's statues. It had also been the most vandalised and considerable work was required to restore it to its former state.

The monument comprises a full-length figure of Edward VII in robes of the Garter, holding the sceptre with the cross and holding the sovereign's orb (Fig 9). A plinth of red polished Peterhead granite has an entablature frieze of bronze ornament, the centre of which is a St Andrew's shield with the figure of the saint upon it. The plinth is flanked by two figure groups. *Peace*, to the left, is a seated female figure of Britannia breaking a sword. Originally, she was seen being crowned with a laurel wreath by a girl representing *Gratitude*. This wreath had been stolen in about 1937. On the right is a group of three figures, representing *Imperial Unity*. The seated figure is Britannia, whose left arm encircles a figure emblematic of the Indian and African peoples. A third figure, representing Canada and Australia, extends a hand of friendship to be kissed by The Mother of Nations.

Some missing pieces of bronze would have to be recast and replaced as part of the work scheduled for the statue. John Larson had pointed out that the seating area below the statue encouraged its vandalism. It is a rare sheltered sunny spot in Aberdeen, affording the lounger an extensive view of the main street and is therefore very popular.

Late-night revellers had vandalised the sculpture, removing not only the wreath but also part of the chain and sceptre of Edward VII, actions which hopefully will be less likely to recur due to the installation of closed circuit television cameras. Nevertheless, in the meantime the various losses to the sculpture had to be attended to.

The monument was appropriately scaffolded and sheeted. The bronze and granite were tested to determine the most appropriate cleaning methods. The stone was masked off. The right hand group was lifted back into its correct position and fixed in place with purpose-made bronze brackets. This was fixed to the bronze with bronze studding and to the granite with stainless-steel studding. The wax was removed from the bronze with Nitromors and a hot pressure washer. Products of corrosion were removed using a combination of hot pressure washing (approx. 80 degrees C & 1000 psi) JOS cleaning, flame cleaning and fine bronze brushes. Casting flaws were filled with bronze-bearing polyester resin filler. The bronze was chemically re-patinated and coated with benzotriazole dissolved in methylated spirits. The bronze was given a hot application of micro-crystalline wax. The bronze plaques, shield and decorative band were hand-cleaned with bronze brushes, re-patinated and waxed. The bronze parts of the orb & sceptre and the remains of the Order of the Garter chain were removed and cleaned. The remains of gilding were discovered on all these elements. All were re-gilded. Missing elements from the chain were cast using the existing elements as patterns. These were gilded. The chain was re-fixed with Hilti HIT C50 resin. The fixing on the cross was adjusted so that it could be re-fixed securely, and in the correct orientation. A replacement part for the lower part of the sceptre was modelled up, cast in bronze and gilded. This was fitted with stainless-steel studding into the granite. The granite was reinforced with a stainless steel sleeve. This sleeve, together with the granite, was gilded. The masking was removed from the stone and applied to the bronze. Biological growth and general soiling were removed by applying biocide followed by light mist spraying with continual agitation of the surface with bristle brushes. Areas of pollution soiling were removed using a micro-abrasive with aluminium oxide at 80–100 psi. Areas of graffiti were removed or reduced by air abrasion and solvents. Isolated

Figure 10 *Sea Fantasy* by Thomas Baylis Huxley-Jones (1908–69). (Aberdeen City Council)

thick pollution accretions were removed by up to three applications of a Mora poultice. Pointing was removed with chisels and hacksaw blades. Edges of joints were masked with tape to avoid smearing and staining. Tests of different sand, hydrated lime and white cement mortar mixes were carried out to determine the most appropriate match. Joints were re-pointed with the best matching mortar. The masking was removed from the bronze. The scaffold was struck and the site cleared of spent materials.

BRONZE: SEA FANTASY

The newest sculpture to be attended to in this programme was *Sea Fantasy* by Thomas Baylis Huxley-Jones (Fig 10). The bronze was hot pressure washed, coated with benzotriazole dissolved in methylated spirits and given a hot application of micro-crystalline wax. One week later the piece was vandalised by having paint thrown over it. Trials showed that a combination of heat and solvents with cotton cloths and soft bronze brushes was the best method of removing the paint, so this was done by the same team who had worked on the sculpture initially. Damaged areas were re-patinated and hot waxed.

CONCLUSION

Conservators and curators will continue to disagree on recommended methods of cleaning and their collective decisions will be further affected by the views of the public and whoever is approving funding for the conservation, in our case the Councillors of the City. John Larson's report pointed

out that, in spite of such treatment, the sculptures were in fact in a reasonably good state of repair. He stated that the most pressing need was to institute a regular programme of maintenance for the sculpture; his suggestion was that the sculptures should be checked and treated on an annual basis. He also recommended that a photographic archive should be set up so that the changing condition of monuments could be assessed. There is clearly a need for a scheduled programme of maintenance but this may be the most difficult thing to achieve for, while there is often money made available for a high-profile new project, to find money to maintain an existing project can be far more difficult, if not impossible.

In the case of bronze statuary the recommended maintenance programme (van Zeist & Lachevre 1983), in terms of staffing, is simply not feasible. In an ideal world we should be topping up the wax coating perhaps twice a year and checking to ensure that the works have not been vandalised or the coating broken in any way. In reality this will not be possible. Ultimately the answer may be to move towards sponsorship, such as the Adopt a Monument Scheme which now exists in New York. There is no doubt that Aberdeen's citizens feel tremendous pride in their monuments, but when it is a question of choosing between funding social services and conserving monuments, the monuments will lose every time. People quite naturally complain when they look bad but object to programmes which are costly and disfigure the environment, even for a short time. The principal task for the curator is keeping the momentum up, and also ensuring that the powers that be do not consider that to be an end to the programme. The programme of care must continue and allow the monuments which have been conserved, and many others which do not carry their kudos, to maintain their present condition and to continue to grace and enhance a very beautiful city.

ENDNOTES

1 Dimethylene chloride paint remover.
2 Methylmethacrylate sheet.

3 Letter to Harry Townend 23 August 1923. Macgillivray Papers, National Library of Scotland, Edinburgh
4 Ibid.
5 JOS wet abrasive vortex cleaning system supplied by Stonehealth Ltd. 73 London Road, Malborough, Wiltshire, SN8 2AN. Tel.: 01672 511515, Fax: 01672 513446.
6 Letter from George Reid to J Irvine Smith, 16 August 1888, Aberdeen Art Gallery Archives.
7 'Mora' Poultice devised by the late Paulo Mora and Laura Mora of Rome, consisting principally of a chelating agent, ethylene diamine - tetra - acetic acid (EDTA) and additives.

REFERENCES

Evening Express, Saturday 15th March 1997.
van Zeist L and Lachevre J-L, 1983 Outdoor bronze sculpture – problems and procedures of protective treatment, in *Technology and Conservation,* Spring, 18–24.

ACKNOWLEDGEMENTS

The author would like to thank Jim Forbes and Norman Adams for assistance with the illustrations, Robert Taylor for allowing her to refer to his technical data, and her former colleagues Celia O'Malley and Rachel Hewison, who painstakingly researched and catalogued the monuments and public sculpture of Aberdeen.

AUTHOR

Jennifer Melville received her degree in the History of Art from the University of Aberdeen and carried out further study at Manchester University. She has been Keeper of Fine Art at Aberdeen Art Gallery since 1995, and is studying for a PhD at the University of Edinburgh. Her research interests are mainly in the area of the late nineteenth-century art. She has curated exhibitions on the sculptor James Pittendrigh Macgillivray and, more recently, on the artist Robert Brough.

Plate 1 Memorial window from St Michael and All Angels' Church, Bugbrooke, Northamptonshire. (Tony Haylock/NIWM) See also Figure 11, p 17.

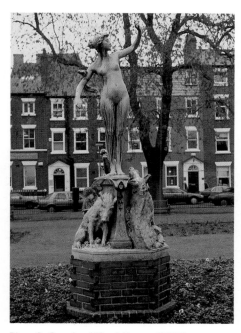

Plate 2 *Circe* by Alfred Drury (1894) current location in Park Square, Leeds. (Leeds City Council). See also Figure 4, p 29.

Plate 3 Evidence of serious corrosion on statue of *John Harrison* by Charles Henry Fehr (1903). (Sculpture Conservation Centre, Liverpool). See also Figure 6, p 30.

Plate 4 Decorative plaque suffering from serious bronze corrosion which is causing structural damage and straining. (Sculpture Conservation Centre, Liverpool). See also Figure 9, p 31.

Plate 5 *Lion fighting a snake* (anon June 1883) vandalised with paint. (Sculpture Conservation Centre, Liverpool). See also Figure 10, p 31.

Plate 7 *Monument to John Baskerville*, by David Patten, Birmingham, 1989–90. (David Patten). See also Figure 7, p 83.

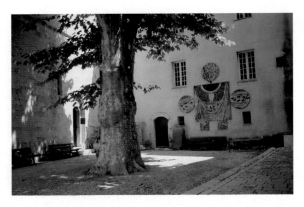

Plate 6 Courtyard of Musée Magnelli, Musée de la Céramique, and Musée National de Picasso, Vallauris. (Helen Beale). See also Figure 1, p 41.

Plate 8 *Memorial for Stephen Cripps*, by Anne Bean & Richard Wilson, London, 1992. (Anne Bean & Richard Wilson). See also Figure 9, p 84.

Plate 9. Names Project *AIDS Memorial Quilt*, Washington DC, 1989. (Richard Strauss). See also Figure 14, p 87.

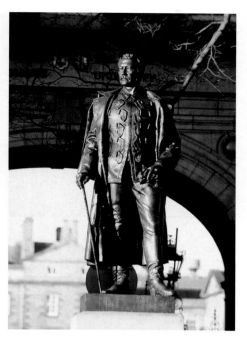

Plate 11 *General Gordon, c* 1883 by Thomas Stuart Burnett (1853–88). (Aberdeen City Council). See also Figure 5, p 102.

Plate 10 Bronze statue of *William Gray*, by William Day Keyworth, Hartlepool, showing the disfiguring pale green, dark green and black of corrosion and sulphation. (Janet Naylor). See also Figure 1, p 92.

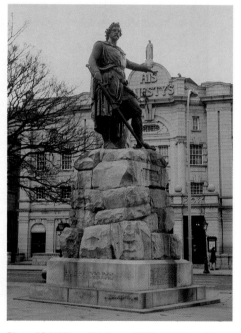

Plate 12 *William Wallace*, 1888, William Grant Stevenson (1849–1919). (Aberdeen City Council). See also Figure 6, p 103.

Plate 13 An area of epoxy paint (4.5 × 3 mm) on corroded copper which has been exposed to ten pulses at 532 nm, 3.2 J/cm². Paint has been removed from almost all of the irradiated region and corrosion from the central region. See also Figure 5, p 112.

Plate 14 Test cleaning on corroded copper roofing. Alkyd paint has been removed (1.06 μ, 0.6 J/cm²) from an area approximately 10 × 10 mm, leaving a dark green surface. The surface of the cleaned area has been carefully scraped away in the upper right corner to reveal the light blue corrosion beneath. See also Figure 11, p 114.

Plate 15 An area of copper roofing (11 × 7 mm) partially cleaned at 266 nm, 1 J/cm². In some areas removal of the epoxy paint has been accompanied by removal of the corrosion layer, although overcleaning is not as extensive as at 1.06 μ and 532 nm. See also Figure 17, p 117.

Plate 16 Laser and micro-airabrasive cleaning tests (area 18 × 12 mm). Alkyd paint was removed from the upper half using micro-airabrasive cleaning (ground almond shell, 24-60 mesh, 2-3 bar) and from the lower half using laser radiation (1.06 μ, 0.6 J/cm²). Scratches are still clearly visible in the laser-cleaned area. See also Figure 18, p 117.

Plate 17 Initial laser cleaning test on the back of the *Dancing Nymph* statue. A wavelength of 1.06 μ was used. See also Figure 21, p 118.

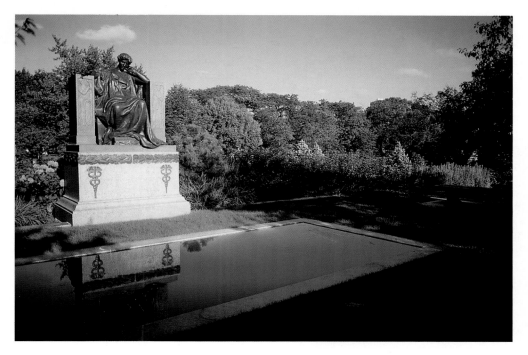

Plate 18 French and Bacon, *Marshall Field Monument*, c 1910, Graceland Cemetery, Chicago. View of the monument after conservation, 1997. (Dennis Montagna). See also Figure 9, p 132.

Plate 19 John J Boyle, *42nd New York Infantry Monument*, Gettysburg National Military Park, Pennsylvania, 1891. Detail of the monument's bronze group after glass bead peen cleaning and lacquer coating, 1980. (GNMP Archives). See also Figure 13, p 134.

Plate 20 John J Boyle, *42nd New York Infantry Monument*, Gettysburg National Military Park, Pennsylvania, 1891. Detail of the monument's bronze group after eighteen years exposure and no maintenance of the initial treatment, 1998. (Dennis Montagna). See also Figure 14, p 135.

Plate 21 Robert I Aitken, *Samuel Gompers Memorial*, 1933, bronze, Massachusetts Avenue at 10th Street, NW, Washington, DC. Detail of damage to surface caused by abrasive cleaning, 1987. (Dennis Montagna). See also Figure 17, p 136.

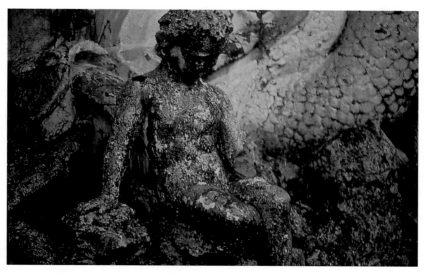

Plate 22 Detail of a figure from the *Hochgurtel Fountain* before restoration. (Melbourne City Council). See also Figure 2, p 140.

Plate 23 View of the lower portion of the New York obelisk, north side. (George Wheeler, MMA). See also Figure 5, p 162.

Plate 24 Soiling to the front and rear sides of granite flake being removed from north side of the New York obelisk. (George Wheeler, MMA). See also Figure 6, p 162.

Plate 25 Detail of surface of the London obelisk showing soiled granite on an area from which a loosely adherent flake was removed for analysis, 1996 (Nicola Ashurst). See also Figure 10, p 167.

Plate 1 x40PPL

Plate 3 x200PPL

Plate 2 x200PPL

Plate 4 x200 XPPL

Plate 26 Thin-section photograph of flakes removed from the London obelisk. 'The outer edge of the flake seemed to carry a layer of soiling which is somewhat similar to that previously reported. However, it is unlikely that such a remnant as the surface shown would not have survived the reported cleaning procedures. It is considered to represent current soiling related to the dark areas. The fractures extending across the section should be noted, together with those extending inwards from the outer surface to the left of centre.' (Lithan Ltd, 1996). See also Figure 11, p 167

Plate 27. Thin-section photograph of flakes removed from the London obelisk. 'The plate shows firstly a crush zone in which a feldspar grain has been disrupted *in situ* and, secondly, that the constituents of the soiling to the surface can be at least partially attributed to the inherent mineralogy. While this damage is most likely of comparatively recent origin, it is similar to that which would be expected from the original working methods used to dress the surface. The debris appears to be fixed in place by the amorphous brown matrix which may be a previous treatment. The nature of the fractures should be noted.' (Lithan Ltd, 1996). See also Figure 12, p 168.

Plate 28 Erosion: below the second stage platform both ashlar and moulded work is slightly eroded due to penetrating rainwater through the structure (Ingval Maxwell). See also Figure 5, p 178.

Plate 29 Close observation of resoiling patterns on previously-cleaned buildings constructed of Binny reveal similar profiles to those that exist on uncleaned stone. (Ingval Maxwell). See also Figure 17, p 186.

Plate 30. The *Albert Memorial*, during repair, June 1998: detail of the head of *Architecture* mosaic. (English Heritage Photo Library). See also Figure 3, p 199.

Plate 31 The *Albert Memorial*, during repair, May 1998: the cross after restoration. (English Heritage Photo Library). See also Figure 5, p 200.

Plate 32 The *Albert Memorial*, during repair, June 1998: the restored statue of *Medicine*, in the *Greater Sciences*. (English Heritage Photo Library). See also Figure 7, p 201.

Plate 33 *Wellington*, Woodhouse Moor, Leeds (1854, Baron Marochetti). (Benedict Read). See also Figure 2, p 209.

Plate 34 Rome, Atrium of the Capitoline Museum. The Atrium was conserved in 1990–93 with an intervention planned with a long-term maintenance programme. The programme is still continuing, demonstrating how efficient constant maintenance is in terms of damage prevention and costs. See also Figure 2, p 216.

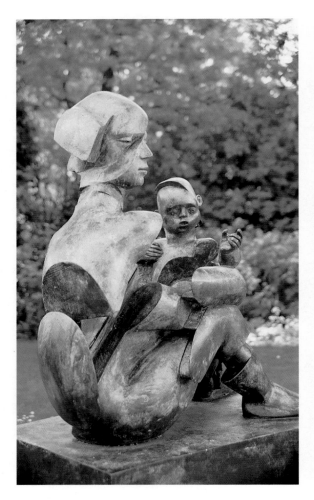

Plate 35 Glyn Williams' *Mother and Child*, acquired 1995, has been placed in the grounds of Dr. Charlesworth's former mental institution. Williams requested that his work be placed not before the large formal building, but in the shadow of a tree on the fringe where it works so much better. (DMU). See also Figure 4, p 222.

Plate 36 *The Jazz Player* by Richard Thornton. Installed recently and much enjoyed by passing pedestrians. (DMU). See also Figure 7, p 225.

12 Laser removal of paint layers from corroded copper

Possible applications to bronze sculpture cleaning

Martin Cooper

Laser Technology,
Conservation Centre, National
Museums & Galleries on
Merseyside, Whitechapel,
Liverpool L1 6HZ, UK.
Tel.: 0151 478 4904
Fax: 0151 478 4990
sculpture@nmgmccl.demon.co.uk

Abstract

Initial tests have been carried out using the fundamental (1.06 μ), frequency doubled (532 nm) and frequency quadrupled (266 nm) outputs from a Q-switched Nd:YAG laser to remove two different paint layers (alkyd and epoxy-based) from a sheet of corroded copper roofing. The aim of the tests was to optimize the laser parameters (wavelength, fluence) so that removal of the paint layer was carried out with minimum removal of material from the underlying corrosion layer (in this case, brochantite). The interaction of laser radiation with copper and cuprite surfaces has also been studied. Although corroded copper roofing is very different from bronze sculpture, these tests provide information about the interaction of laser radiation with paint layers and common corrosion layers which will prove valuable in assessing the suitability of the technique for bronze sculpture. Possible applications to the removal of black epoxy-based paint layers from bronze civic sculpture in Liverpool and disfiguring corrosion products from a late nineteenth-century, life-sized bronze sculpture by Onslow Ford are briefly discussed.

Key words

Laser, cleaning, corrosion, copper, paint, bronze, sculpture

INTRODUCTION

The past ten years have seen the development and introduction of laser cleaning systems for conservation (Cooper 1998). A number of systems, based on the Q-switched Nd:YAG laser which emits extremely short (typically 10^{-8}s) pulses of near infrared laser radiation, are now commercially available and are being used by conservators in a number of countries across Europe. Lasers deliver a pure form of energy in a highly controllable manner. This has enabled the conservator to clean certain types of surface with a level of control not previously attainable using more conventional methods of cleaning (Fig 1).

At present laser cleaning is most commonly applied to the cleaning of stone sculpture: marble, limestone and sandstone, but as the technique becomes more

Figure 1 A seventeenth-century over-life-sized terracotta statue of *Neptune*, attributed to Puget. The right side has been laser-cleaned. Dirt layers have been removed in such a controlled manner that areas of original terracotta wash have been preserved.

widespread applications are becoming more diverse. The Nd:YAG laser has now been used successfully to clean terracotta, aluminium, plaster and ivory sculpture and at a recent international conference, *Lasers in the Conservation of Artworks* (LACONA II), research was presented in which a number of different laser types were used to clean a wide range of materials including paintings, stained glass and parchment.

The cleaning of metal sculpture by laser (Larson 1995, Cottam & Emmony 1997) has not received the same level of attention as the cleaning of other materials. Most applications of laser cleaning involve the removal of some form of 'dirt' layer (including thick pollution encrustations, thin soiling, dust, paint and adhesive from past treatments and biological materials) from a relatively simple substrate. It is often possible for the conservator to optimize the laser parameters so that the laser beam can discriminate between the dirt and substrate. In this case the cleaning process becomes self-limiting, ie removal of surface material stops as soon as the dirt has been removed, and overcleaning is avoided. The removal of paint from a metal surface by laser is a similarly relatively simple task and lasers are now used on an industrial scale to strip paint from aircraft (Schweizer 1995). The cleaning of a corroded bronze sculpture, however, is a far more complex process. The original surface has long since disappeared and the surface often consists of several distinct corrosion layers, the relative extent of which vary across the sculpture. The aim of the conservator

is often to return the surface to a state which is stable and as close as possible to the original surface, in terms of surface relief and texture. This often requires, in addition to removal of the 'dirt' layer, removal of a range of corrosion products to varying degrees across the surface. Due to the complexity of the surface it is unlikely that the cleaning process will be self-limiting. Current laser cleaning systems will require a certain degree of refinement to optimize the control with which cleaning is carried out, so that the conservator can decide exactly what to remove and what to leave on the surface.

The work described in this paper was carried out to provide information about the interaction of laser radiation with paint layers and common corrosion products which, it is hoped, will prove valuable in assessing the suitability of the technique in the conservation of bronze sculpture.

Figure 2 The *Phoenix* laser cleaning system developed for conservation by The National Museums and Galleries on Merseyside (NMGM) and Lynton Lasers Ltd. The system employs a Q-switched Nd:YAG laser to provide laser radiation in the near infrared part of the spectrum in pulses of about 10 ns, which is typical of laser systems being used in conservation. Beam delivery is via an articulated arm.

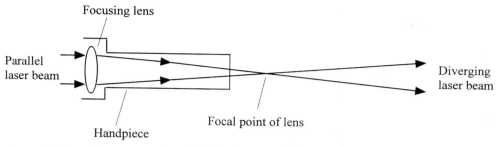

Figure 3 Schematic representation of the handpiece used during cleaning. A lens within the handpiece produces a diverging beam. This means that the cleaning effect becomes softer as the distance from the object increases.

METHOD

A Lynton Lasers *Phoenix 2 (+)* laser cleaning system was used to provide laser radiation at wavelengths of 1.06 μ (near infrared), 532 nm (green) and 266 nm (ultraviolet), in pulses of approximately 10 ns duration. The system provides a maximum pulse energy of 500 mJ and a maximum repetition rate of 20 Hz. With this system laser radiation is delivered to the artwork via an articulated arm (similar to that shown in Figure 2). The beam emerges through a pen-like handpiece, within which a lens is used to produce a diverging beam (Fig 3). An important parameter in laser cleaning is the 'energy density' or 'fluence' of the laser beam on the surface being cleaned. It is a measure of the concentration of energy in the beam on the surface. Close to the focal point of the lens the energy is concentrated in a very small area and the beam becomes very intense. As the distance from the handpiece is increased the energy is spread over a larger area and the beam becomes weaker. The cleaning effect is therefore determined by the distance between the handpiece and the object (assuming the pulse energy is constant). Selection of pulse energy, repetition rate and fluence allows the conservator to control beam size, rate of cleaning and level of cleaning.

Cleaning tests were carried out on a sheet of corroded copper roofing, approximately thirty years old. The copper was covered by a relatively smooth, even, light blue corrosion layer between 15 μ and 40μ thick. X-ray diffraction (XRD) revealed the layer to be composed mainly of brochantite $(Cu_4[OH]_6SO_4)$ with small amounts of cuprite (Cu_2O). These are typical bronze corrosion products. Although copper roofing is different from bronze

sculpture in terms of chemical composition and structure (wrought as opposed to cast, see Lins 1983), it was felt that a better understanding of the interaction between the laser beam and corrosion layer would be obtained by working on a flat surface which could be sampled and characterized at regular intervals. Two types of paint were used for the tests: (i) a black alkyd paint and (ii) a black epoxy paint, chosen since they are suitable for outdoor use. The paint layers were brushed onto the corroded copper and allowed to harden before testing.

Initial tests were carried out, with the sample mounted on a translation stage and the articulated arm of the laser system clamped in position, to establish the optimum laser parameters (wavelength and fluence) for removal of the paint layers with minimum removal of material from the underlying corrosion layer. The interaction of laser radiation with brochantite, cuprite and copper was then studied using optical microscopy, scanning electron microscopy (SEM) with X-ray analysis (EDS), X-ray diffraction (XRD) and infrared spectroscopy (FTIR). Cleaning tests were then carried out at the optimum fluence and wavelength, using the hand-held delivery arm.

RESULTS

Initial tests

Optimum parameters for removal of the alkyd paint were found to be a wavelength of 1.06 μ and a fluence of approximately 0.6 J/cm² (fluence values quoted are mean values [±25%] and have been calculated by dividing the pulse energy by the beam size as measured with burn paper). Figure 4 shows an area of the painted surface exposed to

Figure 4 An area of alkyd paint (4.5 × 3 mm) on corroded copper which has been exposed to twenty pulses at 1.06 μ, 0.6 J/cm² (beam diameter 3 mm). The paint has been removed from approximately half of the irradiated area.

twenty pulses with a beam diameter of 3 mm. Paint has been removed completely from approximately half of the irradiated area, exposing the corrosion. At lower fluence the paint was not removed and at higher fluence both the paint and corrosion were removed more efficiently, ie in fewer pulses. Removal of paint at 532 and 266 nm was not as selective as at 1.06μ and resulted in greater corrosion removal.

The epoxy paint proved to be more difficult to remove. A low fluence irradiation at 1.06μ and 532 nm discoloured, rather than removed, the paint turning it a light brown colour. Removal of the paint

Figure 5 An area of epoxy paint (4.5 × 3 mm) on corroded copper which has been exposed to ten pulses at 532 nm, 3.2 J/cm². Paint has been removed from almost all of the irradiated region and corrosion from the central region.

Figure 6 An electron micrograph (EM) showing an area of surface of the brochantite corrosion layer.

required a higher fluence, in excess of 1 J/cm² and was accompanied by removal of the underlying corrosion and damage to the metal. Figure 5 shows an area of the surface exposed to ten pulses at 532 nm (3.2 J/cm², beam diameter 2 mm). Paint has been removed from almost all of the irradiated region and the corrosion has been removed completely from the central area. The lighter ring surrounding the corrosion is paint which has been discoloured by the less intense outer part of the laser beam. No discolouration of the paint layer was observed at low fluence for 266 nm radiation, but a fluence of 1 J/cm² was required to compensate for the relatively small amount of paint removed per pulse at low fluence. The optimum wavelength, in terms of paint removal and preservation of the corrosion layer, was not clear from these initial tests.

The interaction of laser radiation with copper corrosion layers

The interaction of laser radiation with brochantite, cuprite and copper has been studied at 1.06μ, 532 and 266 nm. Surfaces were irradiated at 0.6 and 1 J/cm² (the fluence levels were chosen on the basis of results from the initial tests) and the results examined by optical microscopy and SEM. At all wavelengths

Figure 7 Electron Micrograph showing an area of brochantite exposed to laser radiation at 1.06 μ, 1 J/cm².

Figure 8 Electron Micrograph showing an area of copper exposed to 100 pulses at 1.06 μ, 0.6 J/cm². Slight melting within the surface imperfection.

tested, irradiation of the brochantite layer led to discolouration: light blue to dark green. It was possible to carefully scrape away the surface of the corrosion using a fine scalpel to reveal the original colour beneath, suggesting that the discolouration was restricted to the upper 5 μ of the layer. Chemical analysis, including EDS, XRD and FTIR, did not reveal any chemical differences between the original corrosion and discoloured areas. A possible explanation for this is that the discolouration is caused by a particle-size effect rather than a chemical effect: the irradiated surface (Fig 7) has a much rougher surface than the original brochantite (Fig 6) when viewed at high magnification. In addition to discolouration of the surface layer, there was also some loss of material: the amount of brochantite removed per pulse was dependent on the fluence and wavelength used. At 0.6 J/cm² the ablation rate (depth removed per pulse) was found to be a minimum at 1.06 μ (0.1 μ/pulse) and a maximum at 532 nm (0.7 μ/pulse). At 1 J/cm² the ablation rate was a maximum at 1.06 μ (5 μ/pulse) and a minimum at 266 nm (0.6 μ/pulse). Ablation rates were estimated from cross-sections of samples of corroded roofing irradiated by a known number of pulses. Considering a wavelength of 1.06 μ, each pulse incident on brochantite at 1 J/cm² (minimum fluence required for epoxy paint removal) removes

a depth of approximately 5 μ. At the 0.6 J/cm² fluence required for removal of alkyd paint this figure is only 0.1 μ/pulse. This suggests that removal of the alkyd paint could be achieved with very little loss of corrosion, provided it is carried out at a wavelength of 1.06 μ and a fluence of 0.6 J/cm².

Figure 9 Electron Micrograph showing an area of copper exposed to 100 pulses at 266 nm, 0.6 J/cm². Melting across the irradiated region.

Figure 10 Electron Micrograph showing the effect of 100 pulses at 1.06 μ, 0.6 J/cm² on cuprite. Melting is stronger than on a copper surface.

Table 1 Parameters for cleaning of copper roofing

	wavelength	fluence
Removal of alkyd paint	1.06μ	0.6 J/cm²
Removal of epoxy paint	1.06μ, 532 nm, 266 nm	1.0 J/cm²

Figure 11 Test cleaning on corroded copper roofing. Alkyd paint has been removed (1.06 μ, 0.6 J/cm²) from an area approximately 10 × 10 mm, leaving a dark green surface. The surface of the cleaned area has been carefully scraped away in the upper right corner to reveal the light blue corrosion beneath.

Figure 12 Electron Micrograph showing the boundary between cleaned (left side, 1.06 μ, 0.6 J/cm²) and uncleaned (right side, alkyd paint) parts of the copper roofing.

Figure 8 shows an area of a copper surface irradiated by 100 pulses at 0.6 J/cm² (1.06 μ). Most of the surface has not been affected but there is very slight localized melting within some of the surface imperfections. At 266 nm the effect of 100 pulses is much more extensive (Fig 9): there is melting across the whole of the irradiated area and also slight discolouration (appearance of a slight purplish tinge). This is possibly a consequence of the increase in absorption of energy at the shorter wavelength (Kearns et al 1997). As fluence is increased damage becomes more extensive for each wavelength.

Interaction with a cuprite surface was stronger than with a copper surface (Fig 10) at each wavelength. The surface discoloured, turning from a reddish-brown to a purplish-brown colour, and melting was evident across the irradiated area. There was also partial removal of the oxide layer. Again, the damage was most extensive at 266 nm.

These results have confirmed that there is no 'self-limiting' effect at the fluence levels necessary for removal of either of the paints (at any of the wavelengths tested), ie once the paint has been removed, subsequent pulses will lead to some modification of the corrosion layer. At 0.6 J/cm² modification to brochantite is restricted to removal

Figure 13 Electron Micrograph showing a cross-section through a cleaned area of copper roofing. The alkyd paint has been removed (1.06 μ, 0.6 J/cm²) and the corrosion layer (dark) is still intact. The underlying copper (light) has not been exposed to the laser beam.

Figure 14 Electron Micrograph showing a cross-section through a cleaned area of copper roofing. The alkyd paint has been removed at 532 nm, 0.6 J/cm². In some areas corrosion has been removed to such an extent that the copper has been uncovered and exposed to the laser beam.

of a relatively small amount of corrosion (approximately 0.1μ/pulse) and slight discolouration of a thin layer at the surface. At 1.0 J/cm² more corrosion is removed. In order to establish how much corrosion is lost in the course of removing the paint layers, cleaning tests were carried out holding the delivery arm rather than with it clamped in position.

Cleaning tests

Areas of the copper roofing were cleaned using the parameters in Table 1. Figure 11 shows a small area from which the alkyd paint was removed. Almost all the paint was removed leaving a relatively smooth, discoloured surface. The discoloured corrosion was carefully scraped away (using a fine scalpel) from a small area in the upper right hand corner, to reveal the unaffected light blue corrosion beneath. Figure 12 shows an electron micrograph of the boundary between the cleaned and non-cleaned areas. Figure 13 shows an electron micrograph of a cross-section through a cleaned area of the corroded copper. The paint layer has been removed completely from this

area, leaving a brochantite layer of between 7 and 29 μ in thickness. This would suggest that, during the course of the cleaning, a depth of approximately 5 μ of corrosion has been removed (the thickness of the paint layer varied between 5 and 30 μ). The corrosion layer remains intact after cleaning. In contrast, Figure 14 shows a cross-section through an area cleaned at 532 nm, 0.6 J/cm²; a greater depth of corrosion has been removed which in a few places has led to exposure of the underlying copper. Results from the earlier tests suggest that partial melting of the surface will occur once the brochantite layer has been removed.

Figure 15 shows an electron micrograph of the epoxy paint-coated surface, exposed to 1.06μ laser radiation at 1 J/cm². Although the paint layer was removed from this part of the surface, the formation of small globules on the surface indicates that the brochantite layer has also been removed and the underlying surface partially melted. A cross-section through a cleaned area (Fig 16) confirms removal of the brochantite layer. Similar results were obtained at 532 nm. Figure 17 shows an area partially cleaned at 266 nm (1 J/cm²). More corrosion was preserved

Figure 15 Electron Micrograph showing an area of copper roofing from which epoxy paint has been removed at 1.06 μ, 1 J/cm². The formation of small globules on the surface indicates that the brochantite layer has also been removed and the underlying surface partially melted.

Figure 16 Electron Micrograph showing removal of the epoxy paint layer has been accompanied by removal of most of the brochantite layer.

than at 532 nm and 1.06 μ and the overcleaned areas were not as widespread. However, such areas could still be detected by the naked eye. There is no discolouration of the paint remnants owing to the different mechanism operating in the ultraviolet (Srinivasan & Braren 1989): irradiation of the epoxy at 1 J/cm² leads to direct breaking of the chemical bonds, ie with very little heating effect. The heating effect is much stronger at 532 nm and 1.06μ which leads to discolouration of those areas of epoxy paint receiving a fluence below that necessary for removal.

Removal of the epoxy paint was much less controllable than the alkyd paint as a result of the increased fluence required to effect paint removal. This shows that the success with which fresh paint can be removed from corroded copper is heavily dependent on the type of paint. It is important to note that fresh paint is likely to behave differently from paint which was applied twenty years ago to a monument and since then exposed to weather and pollution. These tests have demonstrated that, in some cases, careful optimization of wavelength and fluence can make possible removal of

unwanted paint layers with very little loss of the underlying corrosion.

Comparison with micro air-abrasive cleaning

Some preliminary tests were carried out to compare the removal of alkyd paint from corroded copper roofing by laser (1.06 μ, 0.6 J/cm²) and by micro-airabrasive cleaning. The abrasive cleaning tests were conducted using ground almond shell (24-60 mesh) at a relatively low pressure of 2-3 bar (29–43.5 psi or 0.2–0.3 MPa). The nozzle diameter was 1 mm. The cleaning rates of the two methods were comparable. Figure 18 shows the boundary between the two areas. The upper area was abrasive-cleaned. Most of the paint has been removed although small remnants can be seen across the surface. In some areas paint removal has been accompanied by corrosion removal and the underlying copper has been exposed. The lower part of Figure 18 was laser-cleaned. Again, almost all of the paint has been removed. The surface of the corrosion was discoloured during cleaning and now has a dark green appearance. Cleaning has been very even and scratches in the surface are still clearly visible (these appear to have been destroyed during abrasive cleaning). Also, the copper has not been exposed.

Figure 17 An area of copper roofing (11 × 7 mm) partially cleaned at 266 nm, 1 J/cm². In some areas removal of the epoxy paint has been accompanied by removal of the corrosion layer, although overcleaning is not as extensive as at 1.06 μ and 532 nm.

In both tests it was possible to remove the remnants of paint with acetone and cotton wool.

Neither technique was able to completely remove the paint layer without some overcleaning. Using a laser, the paint was removed in a much more uniform manner and any features in the surface were cleaned and preserved much more effectively. This suggests that preservation of tool markings in a sculpture's surface is much more likely if a laser (with parameters optimized) is used to remove the majority of paint.

Figure 18 Laser and micro-airabrasive cleaning tests (area 18 × 12 mm). Alkyd paint was removed from the upper half using micro-airabrasive cleaning (ground almond shell, 24-60 mesh, 2-3 bar) and from the lower half using laser radiation (1.06 μ, 0.6 J/cm²). Scratches are still clearly visible in the laser-cleaned area.

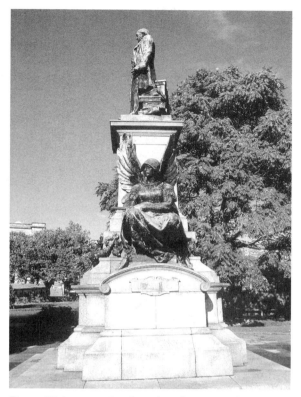

Figure 19 An example of outdoor bronze sculpture in Liverpool.

POSSIBLE APPLICATIONS TO BRONZE CIVIC SCULPTURE

Liverpool has a wealth of outdoor bronze sculpture (Fig 19). Between twenty and thirty years ago much of this sculpture was painted with what is believed to be a black epoxy paint in an attempt to reduce the amount of maintenance work. Unfortunately, during the course of time the paint layer has failed in places and moisture has been able to penetrate through to the metal. Corrosion has therefore continued beneath the 'protective' layer. The paint layer also has the effect of obscuring much of the surface detail. Conservation treatment, the first stage of which would be careful removal of the paint layer, is needed to both stabilize the sculpture and improve its aesthetic qualities. Unfortunately the epoxy paint is extremely difficult to remove in a controlled manner using conventional methods. It is hoped that, although the paint is epoxy-based, twenty years exposure to the Liverpool atmosphere

Figure 20 Corroded surface of the *Dancing Nymph* statue. The surface has a very uneven texture and the corrosion is extremely active.

Figure 21 Initial laser cleaning test on the back of the *Dancing Nymph* statue. A wavelength of 1.06 μ was used.

will have altered its properties sufficiently to allow selective removal using a Q-switched Nd:YAG laser operating at 1.06 μ.

REMOVAL OF UNWANTED CORROSION PRODUCTS FROM A NINETEENTH-CENTURY BRONZE STATUE

A late nineteenth-century life-sized bronze sculpture of a dancing nymph by Onslow Ford, originally on display inside the Lady Lever Art Gallery, Wirral (Merseyside), was later moved outdoors. Since then the original smooth surface has been replaced by an extremely dark, uneven surface which detracts hugely from the visual appeal of the statue (Fig 20). Corrosion was extremely active and treatment was therefore urgently needed. Across much of the surface there were three distinct layers: uppermost, a very dark greenish black layer, believed to be a mix of corrosion (mainly the mineral antlerite, $Cu_3[SO_4][OH]_4$), dirt and wax; a light bluish/green layer (containing active chloride corrosion) and a reddish/brown cuprite layer next to the metal surface. It is important to note that in some places the positions of cuprite and chloride were reversed, ie the powdery chloride existed beneath the cuprite. The aim of the conservation work was to remove all of the active corrosion and leave a smoother, more even surface (closer to the texture of the original bronze) while preserving as much of the surface detail as possible.

Initial tests were carried out on the back of the statue (Fig 21) at 1.06 μ. The dark surface layers were removed revealing slightly lighter green corrosion beneath. A small patch on the right side of the test area was taken a stage further by increasing the fluence slightly. The green corrosion was removed and the cuprite layer exposed. This work is ongoing but the results to date appear promising; the high level of control achieved using the laser was not possible using solvents, poultices or mechanical cleaning with a scalpel. More detailed tests are now required to establish the most suitable means of removing the remnants of unwanted corrosion products without overcleaning the surrounding material. The most effective solution will probably combine several techniques. This work has shown that, owing to the sensitivity of many corrosion layers to laser radiation, laser cleaning of bronze sculpture is highly unlikely to be a self-limiting process. To minimise overcleaning it is necessary, therefore, to optimize the beam quality so that the cleaning effect is as even as possible across the beam. Work is currently being carried out to refine laser cleaning systems for bronze sculpture.

CONCLUSIONS

The work carried out has shown that there are likely to be specific problems in the conservation of bronze sculpture, such as the removal of disfiguring paint layers or corrosion products, where the laser will prove to be a valuable tool. Although the fluence required to remove the unwanted layers here was in excess of that required to produce slight modification of the underlying surface, the control

with which this was achieved was such that scratches in the surface of the uppermost corrosion layer were preserved. The optimum wavelength for such work is likely to be 1.06 μ provided as low a fluence as possible is used (to minimize the loss of material from the surface beneath). If a relatively high fluence (>1 J/cm^2) is required to remove the unwanted layer, then a different wavelength may produce better results. Since the cleaning process is not self-limiting, excellent beam quality is needed. Optimum cleaning in the two sculptural case studies presented here will almost certainly be achieved, not by using a single magical technique, but by using a combination of techniques, of which the laser is just one. This work has shown that the success of cleaning depends to a large extent on the nature of the material being removed and the nature of the surface beneath. Most importantly, however, it depends on the skill and judgement of the conservator carrying out the work.

REFERENCES

Cooper M I, 1998 *Laser Cleaning in Conservation: an Introduction*, Oxford, Butterworth-Heinemann.

Cottam C A and Emmony D C, 1997 Laser cleaning of metals at infra-red wavelengths, in *Restauratorenblatter, Proceedings of LACONA I*, Vienna, Verlag Mayer, 95-8.

Kearns A, Fischer C, Watkins K G, Glasmacher M, Steen W M, Kheyrandish H and Brown A, 1997 Removal of copper oxide from copper surfaces using Q-switched Nd:YAG radiation at 1064 nm, 532 nm and 266 nm, in *EurOpto97*, Munich, June.

Larson J, 1995 Eros: the laser cleaning of an aluminium sculpture, in Heuman J (ed), *From Marble to Chocolate: the Conservation of Modern Sculpture*, London, Archetype, 53-8.

Lins A, 1983 Outdoor bronzes: some basic metallurgical considerations, in Naude N (ed), *Sculptural Monuments in an Outdoor Environment, Philadelphia, November 2, 1983*, 8-20.

Schweizer G, 1995 CO_2 lasers reduce waste from aircraft paint removal, in *Opto and Laser Europe*, **18**, 42-3.

Srinivasan R and Braren B, 1989 Ultraviolet laser ablation of organic polymers, in *Chemical Reviews*, **89**, 1303-16.

EQUIPMENT

Laser used: *Phoenix 2(+)* Q-switched Nd:YAG with second and fourth harmonic generation.

Supplier: Lynton Lasers Ltd, Lindow House, Beech Lane, Wilmslow, Cheshire SK9 5ER, UK; tel. 01625 536 646

ACKNOWLEDGEMENTS

The author is extremely grateful for financial assistance from the Headley and Monument Trusts.

AUTHOR

Martin Cooper graduated in Physics from Loughborough University, where he also completed a PhD, *Laser Cleaning of Stone Sculpture*, in 1994. He has since been working at the National Museums and Galleries on Merseyside, continuing research and development into the use of lasers for cleaning artworks. The author is part of the Laser Technology section, based in the Conservation Centre, which works closely with conservators to develop laser-based systems for cleaning, scanning and non-contact replication of artworks.

13 Protective coatings for outdoor bronze sculptures
Available materials and new developments

Hannelore Römich and Monika Pilz

Fraunhofer-Institut für Silicatforschung (ISC)
Würzburg, Bronnbach Branch, Bronnbach 28,
D-97877 Wertheim-Bronnbach, Germany.
Tel.: +49 (0)931 4100 703
Fax: +49 (0)931 4100 799
roemich@isc.fhg.de

Abstract

The impact of the environment on works of art causes their continuous deterioration. Bronze objects in particular, placed outdoors and thus unsheltered against weathering and the effect of pollutants, can be badly affected by corrosion after only a few years.

Effective conservation treatments are requested by conservators, curators and owners of objects in order to lower the costs of maintenance and to prevent further deterioration of metal sculptures. This paper gives an overview of the possibilities and limitations of the application of coatings to protect outdoor sculptures and it presents new developments in the field. General testing procedures for the evaluation of conservation materials in the laboratory are described by using treatments based on ORMOCERs (Trademark of the Fraunhofer-Gesellschaft zur Förderung der angewandten Forschung, Munich, Germany) as an example. Special compositions of these inorganic-organic hybrid polymers were specifically developed for bronze conservation within the scope of an international and interdisciplinary project funded by the *European Commission DGXII Environment* programme.

Key words

Bronze sculptures, corrosion protection, coatings, conservation, material development

CORROSION OF OUTDOOR BRONZE SCULPTURES

Different stages of bronze corrosion can be observed by following the changes in colour, the chemical composition and the structural character of the patina. The original appearance of an outdoor bronze object, with polished surface or artificial patina, changes within a decade to black or green, according to the local environmental conditions. Depending on the surface orientation and its exposure to rain, condensation and drainage, green stripes and black spots may occur on the metal object which change the original artistic

intention and aesthetic expression (Fig 1) (Baer 1988, Riederer 1993).

A large number of studies have been made on the understanding of bronze corrosion and the deterioration mechanism of different alloys (Mattsson & Holm 1982, Letardi *et al* 1997). The structure and chemical composition of the patina developed on bronzes which were exposed to various climatic conditions were of special interest. Patina samples from bronze sculptures in Germany (Mach & Snethlage 1989, Riederer 1993, Assfalg & Mach 1996), Austria (Pichler forthcoming), Italy (Marabelli 1987, Alluno-Rosetti & Marabelli 1976), Sweden (Strandberg *et al* 1996), Portugal (Pichler & Vendl 1996) and the USA (Livingston 1991) were analysed, mainly by X-ray powder diffraction. A number of studies for which the above mentioned references can give only examples, was linked within a EUREKA project (EUROCARE COPAL EU 316, Mach 1998).

The formation of corrosion products such as brochantite, antlerite, chalcantite and paratacamite, observed on outdoor sculptures, was simulated in the laboratory. The influence of SO_2, O_3, NO_2 and NaCl on the corrosion of bronze and patina was studied in climate chambers, also by combining these pollutants (Strandberg 1997). Special emphasis was made to reproduce 'natural green' patina, consisting mainly of brochantite, since it is assumed that this type of patina provides a protective effect for bronze substrates (Pichler Vendl forthcoming).

Recently, an extensive exposure programme was evaluated, summarizing information on the corrosion progress of copper and bronze samples after one, two, four or eight years of natural weathering. Corrosion data from 39 sites in 14 countries were correlated with the local environmental conditions (Stöckle & Krätschmer 1998; other references to be published in the Proceedings to the *UN ECE-Workshop on the Quantification of Effects of Air Pollutants on Materials*, Berlin, 25th – 27th May 1998, organised by the Umweltbundesamt, 14191 Berlin, Germany).

CONSERVATION PROBLEMS AND TREATMENTS

Guides to the maintenance of outdoor bronze sculptures (eg Naudé & Wharton 1993) have been issued but still there is no general agreement between

Figure 1 Detail of an unprotected bronze surface exposed to an urban environment. (Hannelore Röemich)

experts in different countries concerning cleaning or pre-treatment techniques as well as preservation methods. The aesthetic goals for maintenance and the expected final appearance of the treated sculpture depend on the intention of the artist and are the responsibility of the owner or curator.

Regular cleaning procedures are recommended for the maintenance of outdoor bronze sculptures. However, it may be desirable to avoid periodical cleaning in some cases or it may be financially inevitable to prolong maintenance cycles in other cases. For this purpose protective treatments have to be promoted, respecting the natural ageing process of the sculpture but retarding any further degradation process (Baer 1988).

The aesthetic demands on the surface finishing to be preserved differ considerably, raising questions whether the natural patina, although damaged and disfigured by pollution, should remain or rather be cleaned off to regain the original metal surface of the bronze. Artificial patination would be a third possibility. As there is no general agreement among experts on this item, it would be ideal to propose a conservation treatment, flexible in use and adaptable to the specific requirements set up for the object of interest. General requirements for coating materials include the effective protection from further corrosion of the substrate, achieved by good adhesion of the polymer on the surface and by good penetration of the pores of cast metal or even more of the patina. Effective coatings have good barrier properties against water vapour and air pollutants. Good ageing properties of the coating material are

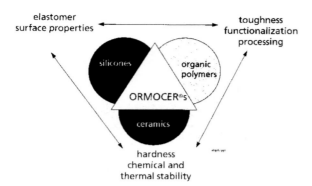

Figure 2 Relationship of ORMOCERs to other classes of materials and possible combinations of properties.

necessary for a satisfactory weathering resistance. Especially important from the conservator's viewpoint is the reversibility of the treatment: coating layers on thinly patinated or bare metal sculptures should be removable using chemical treatments with organic solvents, while coatings on sculptures with thicker layers of patina will imply the risk of removing patina when removing the coating, preferably by mechanical methods. Equally important for the treatment of large metal sculptures is the curing of the polymer at ambient temperatures, also considering the application of the coating on site (Pilz & Römich 1997).

At present the conservator can choose between different organic lacquers, waxes and natural resins (Baer 1988, Riederer 1993).

A number of studies have been carried out to evaluate and improve the protective properties, ageing characteristics and aesthetic qualities of different coating materials, especially of waxes and

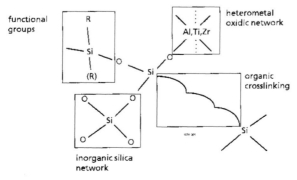

Figure 3 Structural units of ORMOCERs.

polyacrylates (Smith & Beale 1987, Brostoff & de la Rie 1997). The effectiveness of coatings was compared by investigating the SO_2 deposition and weight gain of samples (Strandberg 1997). X-ray diffraction (XRD), scanning electron microscopy (SEM), Fourier transform infrared spectroscopy (FT-IR) and electro-chemical impedance spectroscopy (EIS) were employed to characterize coatings (Mouray 1997, Price et al 1997, Letardi et al 1998, Sembrat 1998). Besides, efforts were made to develop a new non-destructive method on the basis of photoacoustic and photothermal deflection spectroscopies to control patina layers and/or protective coatings (Klewe-Nebenius 1998). Another approach concentrated on radioactive tracing methods to analyse the barrier properties of coatings (Balek et al 1997).

Besides these laboratory experiments the performance of coatings has been studied in a number of case studies (Brendel 1998, Marabelli et al 1998).

The experiences of different conservators with the same type of material may differ considerably. In general, wax treatments are reported to provide protection up to two years, whereas pure organic polymer coatings may last about five to ten years. This is not ideal from a conservation point of view and does not conform with what may be expected from state-of-the-art coating technologies.

NEW DEVELOPMENTS

When it was found that the application of organic polymer coatings in the field of bronze conservation had its limitations, the need to develop new materials became apparent.

The base material proposed for the new conservation treatment is a heteropolysiloxane, a so-called ORMOCER. These inorganic-organic hybrid materials combine properties of organic and inorganic polymers by connecting structural units on a molecular scale (Fig 2). The synthesis is based on the sol-gel process, using organically functionalized silicium-alkoxides as starting compounds. In a first step the inorganic network is formed by hydrolysis and polycondensation reactions of the reactive precursors. In a second step the organic network is build up by organic crosslinking reactions (Fig 3).

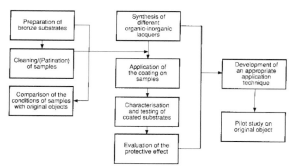

Figure 4 Strategy for the development of new coatings based on ORMOCERs.

ORMOCERs have been developed for various fields of application, eg as materials for microelectronics, bulk materials for biomedical application, as functionalized fibres or as coatings for polymers, ceramics and metals (Schottner *et al* 1994). The potential of ORMOCERs as conservation materials was investigated for stained glass windows (Römich & Fuchs 1992), ceramics (Pilz & McCarthy 1995), enamels (Pilz & Troll 1998), and iron (Pilz *et al* 1998).

Due to their chemical structure ORMOCERs are expected to provide good adhesion qualities to metal surfaces as well as to corrosion products – even under humid conditions. A research project was launched to develop ORMOCERs for bronze conservation. The necessary compromise between long-term stability and reversibility of the lacquer was a particular challenge in this field of chemistry (Pilz & Römich 1997, Römich & Pilz 1998). A systematic work programme was set up for the development phase (Fig 4; Pilz 1995).

First of all, it was important to select a variety of test samples, representing different corroded bronze surfaces. Flat-rolled and cast samples were more appropriate for testing, whereas in the last phase of material development shaped cast specimens were included. Since samples with natural patina on bronzes were not available, copper roof samples with green and black patina were treated instead.

As the nature and amount of the various structural units determine the properties of the ORMOCER, a variety of precursors and reaction conditions was considered. Starting from 13 ORMOCER lacquers a total number of 300 coatings were prepared by modifying additives, hardeners, solvents as well as multilayer systems (eg base coat with good adhesion properties, top coat with barrier

Figure 5 German bronze bust, coated with ORMOCER by Naylor Conservation in 1995. (Hannelore Roemich)

properties). After a screening on rolled bronze sheets 16 variations of ORMOCER-coatings were selected for extensive laboratory testing. The stability of the coating materials was evaluated after accelerated weathering, including exposure to temperature and humidity cycles at elevated pollution levels, UV-radiation and salt spray test.

Besides the visual inspection, the corrosion progress of samples was analysed by light microscopy, X-ray microanalysis and infrared spectroscopy. Special attention was given to the adhesion qualities of the coatings, tested on uncorroded rolled bronze sheets by using the crosscut test (DIN 53131).

After two years of material development and laboratory testing in climate chambers, an outdoor exposure programme was started at the end of the project. A variety of bronze samples coated with six different ORMOCER systems as well as reference

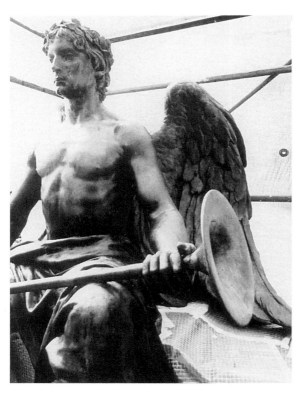

Figure 6 *Angel with trumpet*, treated with ORMOCER in 1995 by Naylor Conservation (by kind permission of the Office of Public Works, Dublin, Eire). (Hannelore Roemich)

Figure 7 Bust of *Bugenhagen*, wax treatment of the bust in 1997 (Conrad 1997).

samples (untreated, coated with wax or acrylic lacquers) were exposed at selected sites in Germany, Denmark, Romania and Great Britain.

Several pilot applications on original statues were carried out to observe coatings under natural conditions. On the German bronze bust (Fig 5) different cleaning techniques were employed to study the influence of the pretreatment on the performance of the coating. For the statue in Ireland (Fig 6) the owners decided to preserve the natural patina. Here it was of special interest to observe the coating qualities on porous patina. On the bust of *Bugenhagen* (Fig 7) an optimized ORMOCER-coating was applied on a test area to compare its effectiveness with that of wax (Conrad 1998). The conservator in charge pointed out that the visual appearance of the area coated with ORMOCER was more similar to matt wax treatments than to glossy organic polymer coatings.

All samples and objects treated since 1995 will be evaluated after a few years of weathering on site.

Figure 8 Bust of *Bugenhagen*, ORMOCER treatment of the pedestal in 1997 (Conrad 1997).

The most outstanding advantage of ORMOCERs is their variability. Conservation treatments will always represent a compromise in many respects: ORMOCERs provide a selection of coatings, featuring

qualities like weathering resistance, reversibility or change in appearance. The kind of surface (with or without patina), the degree of cleaning and the age of the sculpture, for example, will direct the choice of any coating system.

CONCLUSIONS

Protective coatings – pros and cons

Unprotected bronze surfaces in the outdoor environment will always corrode with time, leading to a change in surface appearance. The development of green 'patina' might be desirable from an aesthetic point of view, but in most cases black corrosion products will also build up, causing disfiguring patterns on the object. If a statue is not protected against corrosion regular maintenance procedures are necessary, which is considered by most experts as the 'softest' preservation concept. However, it might be desirable or inevitable to prolong maintenance cycles, if objects are not easily accessible.

Wax coatings, the most commonly used conservation treatments at present, have the advantage of being reversible, but at the same time they require re-treatment within some years. Wax-treated bronze surfaces turn matt and natural green patina gets darker, which is an acceptable effect for most curators and conservators.

The advantage of organic lacquers is that they provide a better protection, which prolongs the maintenance cycles for a few years. Their disadvantage is connected mainly with the ageing properties of organic polymers, which may become visible by yellowing or loss of adhesion or may even cause problems when the lacquer has to be removed. Their visual impact can be partly reduced if an additional wax coating is applied.

Special heteropolysiloxones or ORMOCERs being developed for their application in bronze conservation are a promising new attempt in this field. However, an adequate compromise had to be found with regard to stability and meeting the conservator's requirements of reversibility, protective effect and aesthetic qualities.

As preventive conservation methods are not practicable for outdoor bronze sculptures, effective coatings are the only long-term treatments to provide protection against corrosion. Nevertheless, all coating applications represent a compromise, taking into account the needs of the object and the possibilities and limitations of the applied material.

ACKNOWLEDGEMENT

The development of ORMOCERs for bronze conservation was accomplished within a research project funded by the European Commission (reference number EV5V-CT92-0107).

REFERENCES

Alunno-Rosetti V and Marabelli M 1976 Analyses of the patinas of a gilded horse of St. Mark's basilica in Venice: corrosion mechanisms and conservation problems, in *Studies in Conservation* **21**, 161–170.

Assfalg E and Mach M, 1996 COPAL-Denkmäler: Patina-Untersuchungen mittels Ionenchromatographie, in *EUROCARE-COPAL EU 316, Proceedings of the workshops in Prague (1995) and Vienna (1996)*, Vienna, Institut für Silikatchemie und Archäometrie, 7pp.

Baer N, 1988 Conservation notes: maintenance of outdoor bronze sculpture, in *The International Journal of Museum Management and Curatorship* **7**, 71–75.

Balek V, Málek Z, Cásenský B, Nižňanský D, Šubrt J, Večerniková E, Römich, H and Pilz, M, 1997 A new approach to characterization of barrier properties of ORMOCERs protective coatings, in *Journal of Sol-Gel-Science and Technology* **8**, 591–594.

Brendel K, 1998 Bronzen im Freien – Oberfläche und Restaurierungstechnik, *Zeitschrift für Kunsttechnologie und Konservierung*, Jg. 12, **1**, 108–117.

Brostoff L B and de la Rie E R, 1997 Research into protective coating systems for outdoor bronze sculpture and ornamentation, in MacLeod I D, Pennec S L, Robbiola L (eds), *Metal 95, Proceedings of the International Conference on Metals Conservation*, Semur en Auxois, France, London, James & James, 242–244.

Conrad W, 1998 Von Luther bis Lenin – zu einigen freibewitterten Bronzestatuen und anderen Metallplastiken in Sachsen-Anhalt vor und nach den Restaurierungen in den Jahren 1991–1997, in *Metallrestaurierung*/Metal Restoration, Arbeitsheft 94, Bayerisches Landesamt für Denkmalpflege, München, (ed M Petzet), 156–62.

EN ISO 2409: Gitterschnittprüfung von Anstrichen und ähnlichen Beschichtungen, *Deutsche Industrienorm (German Industrial Guideline)*, May 1981.

Klewe-Nebenius H and Faubel W, 1998 Zerstörungsfreie Oberflächenprüfung an atmosphärisch korrodierten Kupfer- und Bronzeobjekten, in *Metallrestaurierung /* Metal Restoration, Arbeitsheft 94, Bayerisches Landesamt für Denkmalpflege, München, (ed M Petzet), 90–4.

Letardi P, Bazzuro B, Ventuo G and Beccaria A, 1997 The high altar of St Siro by P Puget: A study of alloy and patina

components, in MacLeod I D, Pennec S L, Robbiola L (eds), *Metal 95, Proceedings of the International Conference on Metals Conservation*, Semur en Auxois, France, London, James & James, 76–80

Letardi P, Becaria A and Marabelli M, 1998 Application of electrochemical impedance measurements as a tool for the characterisation of conservation and protection state of bronze works of art, in *Metal 98, Proceedings of the International Conference on Metals Conservation, Draguignan– Figanieres, France, 27–29 May 1998,* (ed Mouray W, Robbiola L), James & James, London, 303–8.

Livingston R A, 1991 Influence of the environment on the patina of the Statue of Liberty, in *Environ. Sci. Technol.* **25**, 1400–1407.

Mach M and Snethlage R, 1989 Die Analyse der Patina von Bronzen im Freien, *Zeitschrift für Kunsttechnologie und Konservierung* **3/1989**, 231–235.

Mach M, 1998 Coordination of COPAL-Activities, Contact address: Bayerisches Landesamt für Denkmalpflege, P O BOX 10 02 03, D-80076 München, Germany.

Marabelli M, 1987 Characterisation and conservation of metallic monuments, in *Conservation of metal statuary and architectural decoration in open-air exposure*, ICCROM Symposium, Paris, 209–234.

Marabelli M, Bartuli C and Colombo B, 1998. New studies for the conservation of the Marcus Aurelius monuments, in *Metallrestaurierung/*Metal Restoration, Arbeitsheft 94, Bayerisches Landesamt für Denkmalpflege, München, (ed M Petzet), 134–8.

Mattsson E and Holm R, 1982 Atmospheric corrosion of copper and its alloys, in *Atmospheric Corrosion,* 365–381.

Mouray W, 1997 Synthèse des essais sur les revêtements de protection des métaux (1986–1995), in MacLeod I D, Pennec S L, Robbiola L (eds), *Metal 95, Proceedings of the International Conference on Metals Conservation,* Semur en Auxois, France, London, James & James, 225–227.

Naudé V N and Wharton G, 1993 *Guide to the Maintenance of Outdoor Sculpture*, Washington DC, American Institute for Conservation of Historic and Artistic Works.

Pichler B and Vendl A, 1996 Untersuchungen an Metall- und Patinaproben des Bronzemonuments Marques de Pombal in Lissabon, Portugal, in *EUROCARE-COPAL EU 316, Proceedings of the workshops in Prague (1995) and Vienna (1996)*, Vienna, Institut für Silikatchemie und Archäometrie, 77pp.

Pilcher B, 1998 Analytical investigations of outdoor bronze monuments, EUREKA Project EU 316 EUROCARE-COPAL in *Metallrestaurierung/*Metal Restoration, Arbeitsheft 94, Bayerisches Landesamt für Denkmalpflege, München, (ed M Petzet), 63–9.

Pichler B and Vendl A forthcoming Contribution from ISCA, in *Development of a new non-destructive method for analysis of the atmospheric corrosion and corrosion protection of copper and copper alloys*, Conclusion report for project ENV4-CT95-0098.

Pilz M and McCarthy B, 1995 A comparative study of ORMOCERS and Paraloid B72 for conservation of outdoor glazed ceramics, in *The Cultural Heritage*, IV European Ceramic Society Conference, Riccione, Italy, 2–6 October

1995, **14**, 29–39.

Pilz M, 1995 Contribution of the ISC, in Römich H (ed), *New Conservation Materials for Outdoor Bronze Sculptures*, Research Report 3, Final Report to EC Environment Project EV5V-CT92-0107, 25–74.

Pilz M and Römich H, 1997 Sol-gel derived coatings for outdoor bronze conservation, in *Journal of Sol-Gel-Science and Technology*, **8**, 1071–1075.

Pilz M and Römich H, 1997 A new conservation treatment for outdoor bronze sculptures based on ORMOCER, in MacLeod I D, Pennec S L, Robbiola L (eds), *Metal 95, Proceedings of the International Conference on Metals Conservation,* Semur en Auxois, France, London, James & James, 245–250

Pilz M, Seipelt B and Kiesenberg J, 1998 Transparent coatings – suitable corrosion protection for industrial heritage made of iron? *Metal 98, Proceedings of the International Conference on Metals Conservation, Draguignan– Figanieres, France, 27–29 May 1998,* (ed Mouray W, Robbiola L), James & James, London, 291–6.

Pilz M and Troll C, 1998 Conservation and preservation concept for endangered historic enamels, *Proceedings of the 18th International Congress on Glass,* San Francisco, 5 – 10 July 1998, 8pp (available only on CD-Rom).

Price C, Hallam D, Ashton J, Heath G and Creagh D, 1997 An electrochemical study of waxes for bronze sculpture, in MacLeod I D, Pennec S L, Robbiola L (eds), *Metal 95, Proceedings of the International Conference on Metals Conservation,* Semur en Auxois, France, London, James & James, 233–241.

Riederer J, 1993 Erhaltung von Metallskulpturen im Freien, *Restauro,* **3**, 176–181.

Römich H and Fuchs D R, 1992 A new comprehensive concept for the conservation of stained glass windows, *Bol. Soc. Esp. Ceram.* **31-C**, 137–141.

Römich H and Pilz M, 1998 Materialentwicklung für die Bronzekonservierung. *Metallrestaurierung/*Metal Restoration, Arbeitsheft 94, Bayerisches Landesamt für Denkmalpflege, München, (ed M Petzet), 85–9.

Römich H (ed), 1995 *New Conservation Methods for Outdoor Bronze Sculptures.* Research Report 3. Final Report to EC Environment Project EV5V-CT92-0107, 1993 – 1995.

Schottner G, Rose K and Schubert U, 1994 Concepts for the design of intelligent organic-inorganic hybrid polymers, in *Advances in Science and technology: Intelligent Materials and System* **10**, 251–262.

Sembrat J, 1998 Reliable methods for the measurement and monitoring of protective barrier coatings for outdoor monuments, in *Metal 98, Proceedings of the International Conference on Metals Conservation, Draguignan – Figanieres, France, 27–29 May 1998,* (ed Mouray W, Robbiola L), James & James, London, 286–90.

Smith R and Beale A, 1987 An evaluation of the effectiveness of various plastic and wax coatings in protecting outdoor sculpture exposed to acid deposition – a progress report, in *Conservation of metal statuary and architectural decoration in open-air exposure,* ICCROM Symposium, Paris, 100–104.

Stöckle B and Krätschmer A, 1998 Korrosion von Kupfer

und Bronze im Rahmen des UN/ECE-Bewitterungsprogramms, *27. Jahrestagung der Gesellschaft für Umweltsimulation e.V.*, Pfinztal, Karlsruhe (Germany), 11/1 –11/15.

Strandberg H, Johansson G and Rosvall J, 1996 Outdoor bronze sculptures – a conservation view on the examination of the state of preservation, *ICOM Committee for Conservation Triennial Meeting, Edinburgh Proceedings,* **2,** 894–900.

Strandberg H, 1997 *Perspectives on bronze sculpture conservation – modelling copper and bronze corrosion,* unpublished PhD thesis, Göteborg University.

AUTHOR

Dr. Hannlore Römich was trained as a chemist. She has been working at the Fraunhofer-Institute für Silicatforschung in Würzburg, Germany, since 1988 and since 1994 is the head of the working group 'Research for Conservation' – now located in the monastery of Bronnbach. Dr. Römich is particularly interested in the conservation of stained glass and metal and is involved in projects concerned with the development of new protective coatings. Over the last three years she has been running a newly-established training course in Germany entitled 'Scientific aspects in stained glass conservation'. Her latest research topic is concerned with laser cleaning of stained glass. The results presented in her paper were achieved within the framework of a project funded by the European Commission, which was co-ordinated by Dr. Römich.

Dr. Monika Pilz, chemist, has considerable experience in conducting the development and testing of new ORMOCERs (inorganic-organic hybrid polymers) for various fields of application. She has been responsible for the material development in the EC-project 'New Conservation Methods for Outdoor Bronze Sculptures' (1993–1995) and has carried out various ORMOCER pilot applications on selected bronze monuments in collaboration with restorers and conservators. Since last year Dr. Pilz is working for an industrial company.

14 Bronze conservation in the United States at the dawn of the new century

Dennis R Montagna

National Park Service, Philadelphia Support Office,
200 Chestnut Street, 3rd Floor, Philadelphia,
Pennsylvania 19106 USA,
Tel. +001 215-597-5824 Fax:215-597-0932
dennis_montagna@nps.gov

Abstract

A study of the history of outdoor bronze conservation in the US suggests that our stewardship has improved, marked by the use of gentler cleaning methods and guided by conservation theory that values preservation over restoration. In addition, a few steward groups have established maintenance programmes to care for their conserved works. Tough challenges still remain. Maintenance programmes, crucial for long-term preservation, seldom follow initial treatments. Consequently, while planning maintenance programmes we should be implementing treatments that will fail gracefully if they are not maintained. Finally, many monument stewards turn to eager but unqualified sources for treatment, a decision often resulting in greater harm than that rendered by neglect.

Key words

Bronze, conservation, maintenance, statues, United States

Anniversaries are useful things. They encourage us to remember the past and to take stock of where we have been. By implication, they also invite us to consider the future that lies ahead. A few years ago, the fiftieth anniversary of the end of the Second World War commanded global attention and invited us to reflect upon warfare raging in our own time. In the United States during 1997 we celebrated another fiftieth anniversary, marking the racial integration of major league baseball when Jackie Robinson took the field in 1947 as the new second baseman of the Brooklyn Dodgers. In so doing we also considered the gains made in racial integration in our society in the intervening years and the challenges that still remain.

In 1998, the United States marked the centennial of the Spanish-American War, an event that Americans remember as their first major assertion of national will on the world scene, and the beginning of what we in the US have modestly come to call The American Century. Perhaps this is why we, as a nation, are having some difficulty fully embracing the new century lurking on the horizon. Having fared very well during the twentieth century, we may now be realizing the difficulty in going for two in a row.

Setting aside our trepidation about the new century, this is a good time to take stock of how we are caring for the monuments that we have built to mark the people and events that are important to us. In the United States, most bronze and stone monuments were created in remembrance of the Civil War that had torn the nation apart from 1861 to 1865. Consequently, the lion's share of our

Figure 1 Daniel Chester French and Edward Clark Potter, *General Ulysses S. Grant Monument*, 1897, bronze and granite, Kelly and Fountain Green Drives, Fairmount Park, Philadelphia, Pennsylvania. Photograph of dedication ceremonies, 1899. (Anonymous)

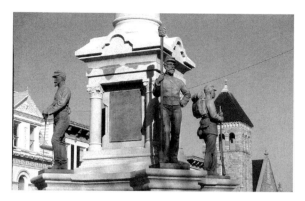

Figure 2 August Zeller, *Schuylkill County Soldiers' and Sailors' Monument,* 1891, bronze and granite, Garfield Square, Pottsville, Pennsylvania. Detail of sandblasted bronze and granite surfaces, 1988. (Dennis Montagna)

bronze monuments was created roughly between 1875 and 1925, so we are presently marking the centennial of the high-water mark of that phenomenon. In 1897 the *Ulysses S. Grant Monument* was built in Philadelphia to memorialise the commanding general who had been the victor when the bloodshed stopped (Fig 1). Today, the monument is subject to an ongoing maintenance programme which began with its conservation in 1983, leading us to consider another anniversary of sorts. We are also marking the twenty-fifth anniversary of the first real efforts by conservators in the US to address the need to care for what is now a vast collection of outdoor bronze sculpture. How are we doing as stewards of this class of cultural patrimony? At the risk of damning by faint praise, I'd say that we are doing better than we were a few years ago, but setbacks sometimes equal the gains we have made. While many bronzes have been conserved during the past quarter century, relatively few receive the subsequent maintenance that they require. In addition, while many stewards of public sculpture turn to experienced conservators for the help they need, many others subject the bronzes in their care to damaging treatments carried out by contractors whose expertise, shall we say, lies elsewhere. Such are the bronze conservation challenges that lie before us as we greet the new century and the new millennium.

Let us begin with some conservation history. Concerted efforts to clean outdoor bronze sculpture appear to have been relatively rare in the United States before the early 1970s (Weil 1987). The bronze cleaning that did occur generally used readily available commercial and industrial cleaning methods. Sandblasting and acid cleanings were the most widespread of these methods and usually had a devastating effect on bronze sculpture. Hard, jagged sand particles coupled with the relatively high pressure levels used by sandblasters, or the combination of acid cleaners and scouring, removed virtually all corrosion products, and they did it quickly. The sandblasting that damaged the bronze and polished granite components of the Pottsville Soldiers and Sailors Monument in Pottsville, Pennsylvania was completed in the space of a morning (Fig 2). Typically, these cleanings were carried out not by trained conservators, but by general contractors, by cleaning companies, or by misguided volunteers. These cleanings either left the bare bronze surface to weather once again, or were followed by application of a clear lacquer coating or paint. Seldom was the coating properly formulated or adequately applied and maintained. The *Hamilton White Monument* in Syracuse, New York was sandblasted and coated with a clear lacquer in the early 1970s (Fig 3). Remnants of the unmaintained coating are visible only in sheltered areas visible on the right side of the photograph, and the rest of the bare metal surface is corroding anew.

By the 1970s, American art conservators, trained in the care of museum objects, had become increasingly interested in the conservation of outdoor

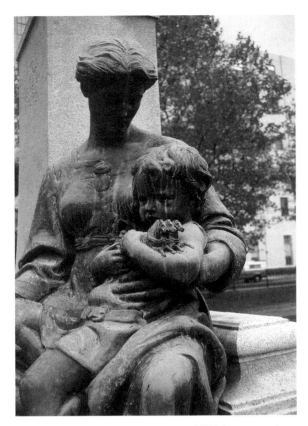

Figure 3 *Hamilton White Monument*, 1905, bronze and granite, Syracuse, New York, 1987. (Dennis Montagna)

Figure 4 Henry L. Ellicott, *First Pennsylvania Cavalry Monument*, 1890, bronze and granite, Hancock Avenue, Gettysburg National Military Park, Gettysburg, Pennsylvania. Glass bead peening of the monument's bronze figure, 1979. (GNMP Archives)

works of art. Working in conjunction with the scientific community, conservators began to examine more closely the phenomena of bronze corrosion and to develop conservation treatments that included a range of mechanical and chemical cleaning methods. The chemical cleaning methods usually consisted of acidic or alkaline strippers that were both labour-intensive and often difficult to control. Some of the mechanical techniques employed abrasive pads and dental tools, while others centred on the use of various abrasive media fed into a controlled air flow.

Best-known of the air abrasive methods, glass bead peening was developed at this time and quickly became the leading bronze cleaning system by the mid-1970s (Fig 4). While many viewed peening as a gentler alternative to sandblasting, it too was designed to remove all corrosion products from the bronze surface. The system's spherical glass particles, delivered at 60–80 psi, were thought

to leavethe bronze substrate intact, unlike sandblasting in which a jagged-shaped media, delivered with typically higher blasting pressures, would tear into softer bronze surfaces. Following cleaning, a new chemical patina and a protective lacquer coating were usually applied (Weil 1980).

Glass bead peening gained in popularity during the mid 1970s due, in part, to its use as the method for cleaning prominent monuments in New York City's Central Park, Saint Louis, Missouri, and Richmond, Virginia (Fig 5). Within a few years many conservators began to question the concepts behind glass bead peening: that the presence of any

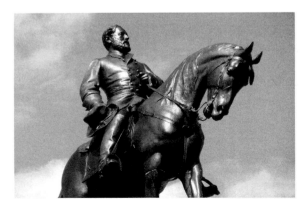

Figure 5 Jean Antonin Mercié, *Robert E. Lee Monument*, 1890, bronze and granite, Monument Avenue, Richmond, Virginia. Detail of the bronze equestrian group after glass bead peening and repatination in 1982, 1983. (Dennis Montagna)

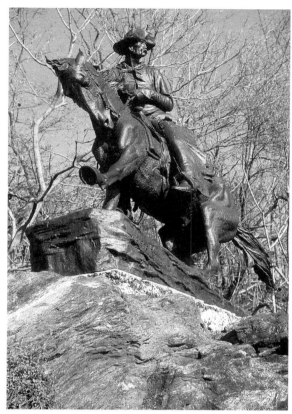

Figure 7 Antoni Popiel, *Brigadier General Thaddeus Kosciuszko Monument*, 1910, bronze and granite. Lafayette Park, Washington, DC. Detail of walnut shell blasting of a corroded bronze surface. The lighter-toned area has been cleaned of dirt and friable corrosion products in preparation for an application of a protective coating, 1987. (Dennis Montagna)

Figure 6 Frederic Remington, *Cowboy*, 1908, bronze, Kelly Drive, Fairmount Park, Philadelphia, Pennsylvania. View of the sculpture after eight years of annual maintenance of the wax coating, 1990. (Dennis Montagna)

corrosion products were inherently harmful and must be removed to effectively preserve bronze statuary, and that the cleaning process itself did not further compromise the bronze surface.

Laboratory analyses conducted by Smithsonian Institution conservators and the National Bureau of Standards, coupled with the field experience of practising conservators, indicated that such aggressive treatments were really not needed to ensure the long-term preservation of bronze sculpture. More importantly, glass bead peening was shown to remove metal from bronze substrates (Veloz & Chase 1989). Consequently, the bronze conservation field made a concerted shift toward the use of less invasive cleaning methods. In essence, this shift is based on a conservation theory that favours preservation and stabilization of the bronze surface over attempts to restore them to an original

colouration by replacing the corrosion products, sometimes called 'the patina of time', with an entirely new chemical patina.

Throughout the 1980s, glass bead peening was supplanted by gentler cleaning methods. The least invasive of these involved a simple soap and water washing followed by an application of microcrystalline waxes, usually to a heated bronze surface. This became the method of choice for the Baltimore Bronze Project, a conservation programme begun in 1981 (The Baltimore Bronze Project 1989). During the programme's five-year duration, conservators treated 45 bronzes. Two years later, in 1983, the same method was used to clean and coat 25 bronze monuments in Philadelphia (Fig 6) (Bach 1985, Tatti 1985). These cleaning projects depended heavily on adherence to a coating maintenance regimen. Philadelphia's bronzes have been inspected and maintained each spring for the past 15 years.

As the bronze cleaning programmes were getting underway in Philadelphia and Baltimore, other conservators were developing air-abrasive cleaning procedures that sought a more thorough, yet gentle, removal of grime and superficial corrosion products. Low-pressure blast cleaning with soft agricultural media strives to leave intact the denser, more firmly-adhered corrosion products and the metal substrate beneath them. Pulverized walnut shells have become the most widely used of the agricultural media (Fig 7) (Montagna 1989, Veloz & Chase

Figure 8 Daniel Chester French and Henry Bacon, *Marshall Field Monument, c* 1910, bronze and granite, Graceland Cemetery, Chicago, Illinois. View of the monument before conservation, 1996. (Andrzej Dajnowski)

Figure 9 French and Bacon, *Marshall Field Monument, c* 1910, Graceland Cemetery, Chicago. View of the monument after conservation, 1997. (Dennis Montagna)

1989). Embodied in this gentler cleaning method is an intent to leave behind a surface able to receive a renewable protective coating, usually a wax or a lacquer. These less invasive cleaning methods often obviate the need to carry out the extensive surface repatination required by methods that stripped bronzes to bare metal. Typically, when hot wax coatings are applied to walnut shell blast-cleaned surfaces, they saturate and darken them, often approximating the appearance of a repatinated surface.

Conservation treatments often include manipulation of the appearance of corroded bronze surfaces through repatination. Lacquer coating systems are usually selected to protect repatinated surfaces, in part because they do not saturate and darken the surface, as do heat-applied waxes. The *Marshall Field Monument* in Chicago's Graceland Cemetery was cleaned using walnut shell blasting

(Figs 8 and 9). After cleaning, the surface was repatinated with potassium permanganate and ferric nitrate in water to achieve a reddish brown colouration, similar to that which archival research indicated the bronze had possessed historically. The surface was then coated with lacquer. (Treatment of the monument was designed and carried out by conservator Andrzej Dajnowski; see also Weil 1985.)

Alternative cleaning systems are being explored through research and field work. Chief among them is a water blasting procedure, used at various pressures to effect a range of surface cleaning treatments. At pressures of 1500–2000 psi, the system can produce cleaning results that resemble those achieved with walnut shell blasting (Lins 1982), but, used at higher pressures, it cleans much more aggressively. Although water blasting pressures in the 7000 psi range can strip the surface to a degree beyond the comfort level of many of us, methods that remove much, if not all, of a bronze's corrosion products can be particularly desirable when extensive repatination, or a patina of a lighter tone is desired.

Thus far we have mostly considered the development of methods used to carry out initial cleanings of outdoor bronze statues. Indeed, the field of conservation has focused much attention upon this primary phase of monument care. But what happens next? All the cleaning treatments we have discussed presuppose adherence to a regimen of periodic inspection and coating maintenance if the benefits of an initial conservation treatment are to be retained. The wax and lacquer coating systems

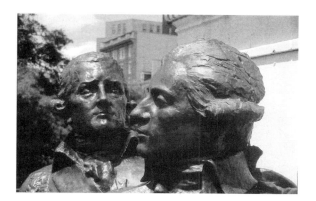

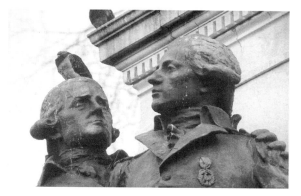

Figure 10 Jean Alexandre Joseph Falguière and Jean Antonin Mercié, *Major General Marquis Gilbert de Lafayette Monument*, 1891, bronze and marble, Lafayette Park, Washington, DC. Detail of proper right figure group after conservation, 1988. (Dennis Montagna)

Figure 11 Jean Alexandre Joseph Falguière and Jean Antonin Mercié, *Major General Marquis Gilbert de Lafayette Monument*, 1891, Lafayette Park, Washington, DC. Detail of conserved proper right figure group three years after treatment, 1991. (Dennis Montagna)

most frequently used for maintaining outdoor sculpture in the United States have inherent maintenance requirements. Microcrystalline waxes, usually applied to a heated bronze surface, perform best when inspected and renewed at intervals of one to three years. Lacquer coatings should be repaired when scratched or abraded. Moreover, manufacturers typically advise that these coatings be completely removed and reapplied at five-year intervals. Coating tests have suggested that cold waxes applied to lacquer coatings and maintained frequently can extend the life of the lacquer. But some conservators complain that waxes used in this way hinder the repair of damaged lacquer coatings.

We possess sufficient understanding of how to maintain the coatings we are applying, but does this maintenance take place? With the exception of Philadelphia's annual maintenance programme and a few others, not many conserved outdoor bronzes receive the maintenance they need to keep their coatings, and by extension the initial conservation treatment, viable. One conservator colleague told me that of the dozens of outdoor bronzes he has treated since beginning his practice in 1991, only two have received their planned maintenance. Monuments cared for by the U.S. National Park Service have often not fared much better. A monument to General Lafayette sits directly across the street from the White House. It received a walnut shell blast cleaning and a wax coating that

provided protection for the bronze and returned to the work a semblance of the lively reflective surface that it once possessed (Fig 10). But the coating did not receive a timely inspection, washing and re-waxing, and after three years' exposure in a fairly harsh environment, it is blanched, dulled and in need of care (Fig 11).

The key challenge we face, and it may be an insurmountable one, is the implementation of long-term maintenance. Most conserved historic monuments are never maintained and the ones that do receive maintenance enjoy a treatment or two, but seldom does a maintenance programme survive the management regime that initiates it. Making a dramatic difference in the appearance of a disfigured bronze through a conservation treatment is both exciting and photogenic. Maintaining that conserved appearance is not. Bronze maintenance is the conservation equivalent of keeping the floors swept, and is the activity most likely to get lost in management's inevitable press to develop new ideas and initiatives. For these reasons, it is difficult to fund maintenance without listing it as a separate item in a government's budget. In addition, because donors who fund conservation projects often thrive on the visual impact that their contribution can make, maintenance has little cachet for them and may seem rather ephemeral. When it is performed well and in a timely manner, maintenance produces no dramatic changes that can be unveiled by politicians or captured on video for the evening

Figure 12 John J Boyle, *42ⁿᵈ New York Infantry Monument*, 1891, bronze and granite, Hancock Avenue, Gettysburg National Military Park, Pennsylvania. View of the monument before glass bead peen cleaning, c 1980. (GNMP Archives)

Figure 13 John J Boyle, *42ⁿᵈ New York Infantry Monument*, Gettysburg National Military Park, Pennsylvania, 1891. Detail of the monument's bronze group after glass bead peen cleaning and lacquer coating, 1980. (GNMP Archives)

news. Some managers of monument collections have begun to address these problems with a measure of success, in some cases by establishing legally binding fiduciary obligations to care for monuments in the public realm. In other cases, fund-raising for bronze conservation includes not only the cost of the initial treatment, but also money used to establish an income-producing maintenance endowment to ensure that funds for ongoing care will be there when they are needed.

Another approach to ensuring that coatings are maintained centres on improving their quality, longevity and maintainability. There are reasons to be both optimistic and pessimistic about this. Improvements in wax application procedures are providing hope that we can extend the life of these relatively short-lived but readily maintainable

coatings. One conservator has begun using a direct-feed airless spray system to apply second coats of wax to bronzes that have received a heat-applied first coat. Several monuments conserved under the stewardship of the City of Philadelphia's Art Commission, not among those cleaned in the early 1980s, have received this type of wax application and after nearly three years in an aggressive urban environment seem to be faring quite well.

Another less optimistic but more pragmatic approach may be called for as well. As we continue to plan for maintenance when we treat outdoor bronzes, perhaps we should assume that maintenance is not likely to occur. With this in mind, we might opt not to carry out a treatment in some cases. When we do choose to treat, maybe we should design treatments that will be able to fail gracefully.

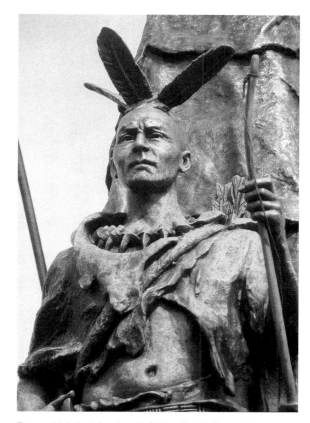

Figure 14 John J Boyle, *42nd New York Infantry Monument*, Gettysburg National Military Park, Pennsylvania, 1891. Detail of the monument's bronze group after eighteen years exposure and no maintenance of the initial treatment, 1998. (Dennis Montagna)

Figure 15 Henry Kirke Bush-Brown, *Major-General John Sedgwick Monument*, 1913, bronze and granite, South Sedgwick Avenue, Gettysburg National Military Park, Pennsylvania. Detailed view of the detergent and water cleaning of the bronze surface, 1981. (GNMP Archives)

Gettysburg National Military Park commissioned a host of glass bead peening and surface lacquering treatments around 1980. The *Tammany Indian of the 42nd New York Infantry* was cleaned at that time, depicted here just before and just after treatment (Figs 12 and 13). Those treatments have never been maintained and, after twenty years, exhibit an advanced state of failure (Fig 14). At this point, they stand in dire need of not merely maintenance, but of extensive conservation. Even with removal of the remnants of the lacquer coating, the visual pulling together of relatively bright surfaces to the more corroded ones on more skyward-facing surfaces will require considerable time, skill, and expense. By comparison, other treatments carried out at Gettysburg during the same period were much less invasive. The simple washing and waxing method

used in Baltimore and Philadelphia was employed to conserve all of the park's equestrian portraits in 1981 (Fig 15). A photograph of the *General Meade Monument*, taken in 1996, shows that these coatings went unmaintained as well, and that the wax coating had completely weathered away from the bronze's most exposed surfaces. At that time, the Park Service's Philadelphia Support Office conducted a training course for new monument maintenance staff to establish an ongoing monument maintenance programme at the park. We selected the *Meade Monument* as one of our training pieces and used walnut shell blasting to remove remnants of the residual wax coating before applying a new wax coating (Fig 16). Because this monument had not received the invasive cleaning that others at the park had, we were able to bring it back to a maintainable state by using a fairly simple cleaning and coating system.

In addition to ensuring that periodic maintenance follows a conservation treatment, the other challenge before us concerns the role and availability of conservation professionals able to carry out treatments. How can we ensure that appropriate treatment decisions are made and that trained and experienced minds and hands perform treatments? During the past decade, through the national Save Outdoor Sculpture! project and other initiatives, we in America have witnessed a heightened public awareness of the need to care for the outdoor bronzes that many had heretofore thought would

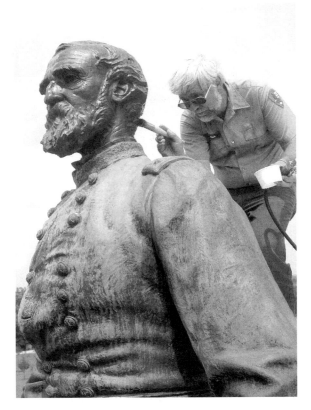

Figure 16 Henry Kirke Bush-Brown, *Major-General George G Meade Monument*, 1896, bronze and granite, East of Hancock Avenue, Gettysburg National Military Park, Pennsylvania. Detailed view of the waxed bronze surface after fifteen years exposure and no maintenance of the initial treatment, during application of an initial wax coat, following walnut shell blast cleaning of the bronze surface, 1996. (Dennis Montagna)

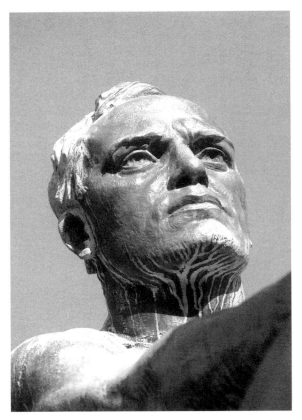

Figure 17 Robert I Aitken, *Samuel Gompers Memorial*, 1933, bronze, Massachusetts Avenue at 10th Street, NW, Washington, DC. Detail of damage to surface caused by abrasive cleaning, 1987. (Dennis Montagna)

take care of themselves. This awareness has resulted in well-conceived monument care programmes, but it has also had a downside. A public emboldened by a mission to take action and make a difference might not always take wise action, and the difference they make might not be for the better. The bronze *Mountaineer Monument* that sits on West Virginia's state capitol grounds in Charleston provides a good example. It was sandblast cleaned by a construction company that responded to a Request for Proposals sent not to conservators, but to the general building trades and to commercial cleaning companies. After its sandblasting, the bronze received a heavy coating of lacquer that has formed drips in some areas and in others entrapped sand particles against the heavily

abraded bronze surface, creating a memorial of sorts to an unfortunate treatment choice.

Another wrong turn was taken by the American Federation of Labor, when they asked the foundry who had cast their monument to Labour leader Samuel Gompers in the mid-1930s to clean it for them in the late 1980s. Their cleaning method of choice utilised power-driven wire wheels with which they began to refinish the surface, much as one would clean and chase a newly-cast bronze (Fig 17). Despite the fact that this treatment was halted before it proceeded very far, and a somewhat less invasive cleaning method instituted, the new dark brown patina that the foundrymen introduced bears little resemblance to the greener patina that the bronze probably carried when it was new.

In both cases, prospective clients of conservation services looked to other trades that made sense to

them, in one case to a company that maintains buildings and in the other, to one that makes bronze sculpture. Obviously, we should enhance our efforts to guide owners of outdoor bronzes in need of conservation toward the professionals who possess the training and skills to design and carry out appropriate treatments. But beyond this, we should work to increase the number of conservators capable of dealing with the challenges of treating works that do not reside in climate-controlled settings, instead suffering the hardships inherent in a life spent outdoors. Arguably, treatments that will be successful in such an environment must focus at least as much upon the need for long-term maintenance as they do upon initial treatments. This is not only a matter of practicality, but one of professional ethics as well.

Only the removal of bronzes from the outdoor environments for which they were created to the protection afforded by a museum setting can guarantee their future well-being. This is seldom a feasible or an appropriate course of action. These usually commemorative works were designed to be exhibited outdoors and, with few exceptions, they will remain there. Ultimately, it is up to us as stewards of our monument collections to take decisions wisely, to work with trained conservators to plan appropriate courses of action and to use gentle cleaning methods coupled with a commitment to an ongoing maintenance program. We should also advocate treatments that will leave the work no worse off than when we found it, if the treatment is not maintained. These approaches seem to offer the best hope for preserving the irreplaceable body of monumental sculpture that has been entrusted to us by the people of the last millennium.

REFERENCES

Bach P B, 1985 Choreography and caution: The organization of a conservation program, in Naude V N (ed), *Sculptural Monuments in an Outdoor Environment*, Philadelphia, Pennsylvania Academy of the Fine Arts, 51–57.

The Baltimore Bronze Project: A Summary, Baltimore, Commission For Historical and Architectural Preservation, 1989.

Weil P D, 1980 The conservation of outdoor bronze sculpture: A review of modern theory and practice, *AIC Preprints*, 129–140.

Weil P D, 1985 Patina: Historical perspective on artistic intent and subsequent effects of time, nature and man, in Naude V N (ed), *Sculptural Monuments in an Outdoor Environment*, Philadelphia, Pennsylvania Academy of the Fine Arts, 21–27.

Weil P D, 1987 Conservation of metal statuary and architectural decoration in open-air exposure: An overview of current status with suggestions regarding needs and future direction, in *Proceedings of the Symposium, Conservation of Metal Statuary and Architectural Decoration in Open-Air Exposure, Paris, 6–8 October, 1986*, Rome, ICCROM.

Lins A, 1992 The cleaning of weathered bronze monuments: A review and comparison of current corrosion removal techniques, in Drayman-Weisser T (ed), *Dialogue 89: The Conservation of Bronze Sculpture in the Outdoor Environment: A Dialogue Among Conservators, Curators, Environmental Scientists and Corrosion Engineers*, Houston, National Association of Corrosion Engineers, 209–230.

Montagna D, 1989 *Conserving Outdoor Bronze Sculpture: The Thaddeus Kosciuszko Monument, Washington, DC*, Washington, DC, National Park Service.

Tatti S A, 1985 Bronze conservation: Fairmount Park, 1983, in Naude V N (ed), *Sculptural Monuments in an Outdoor Environment*, Philadelphia, Pennsylvania Academy of the Fine Arts, 58–66.

Veloz N F and Chase W T, 1989 Air abrasive cleaning of statuary and other structures: A century of technical examination of blasting procedures, *Technology and Conservation Magazine*, **10** (1),18–28.

AUTHOR

Dennis Montagna directs the U.S. National Park Service's Monument Research & Preservation Program, based at the Park Service's Philadelphia Support Office. The programme provides comprehensive assistance in the interpretation and care of public sculpture, commemorative monuments, and historic cemeteries. He holds a PhD in Art History from the University of Delaware (1987), and participated in the 1989 ICCROM Architectural Conservation Course in Rome, Italy.

15

Melbourne's monuments
Conservation issues and approaches

Robyn Riddett

Allom Lovell & Associates Pty Ltd,
Conservation Architects, 35 Little Bourke Street,
Melbourne, Victoria 3000, Australia,
Tel. +61 3 9662 3344, Fax +61 3 9662 1037,
allomlovell@tpgi.com.au

Abstract

In recent years most of Australia's capital city and municipal councils have established regular conservation and maintenance regimes for their often previously neglected, but expanding, collections of historic and new outdoor sculpture. Cemeteries, which also contain important public historical monuments, lag behind. The philosophical approach and industry standard followed is the Australia ICOMOS *Charter for the Conservation of Places of Cultural Significance* (The Burra Charter) which has been used in relation to buildings for twenty years and is now increasingly being used for cultural landscapes and, more recently, for monuments.

To 'polish or not to polish' monuments is a vexed question and the debate remains unresolved, at least in regard to appearance and patina. While the Burra Charter requires that 'a respect for the existing fabric ... should involve the least possible physical intervention', sometimes extensive intervention and reconstruction is required to save monuments. The restoration of the *Exhibition (Hochgurtel) Fountain* and the *River God* both needed considerable replacement of fabric.

Melbourne's monuments have an unfortunate tendency to be relocated away from their original locations and, while in some instances this has compromised their significance, in others it has ensured their survival. The *Burke and Wills* monument has been moved three times around the streets of Melbourne; the last occasion saw it completely reconstructed and restored.

The *Westgarth Fountain*, sculpted in Aberdeen, Scotland, is of immense aesthetic interest in its depictions of the kangaroos and emu heads functioning as water spouts. It was pulled out of a creek before being restored and bought back by its original owners. Reinstallation on its original location however was impossible but it still retains its original link with the Royal Exhibition Building.

A somewhat novel way of conserving monuments has been instigated by the National Trust. Ghoulish tales of ghosts in cemeteries under a full moon always excite the imagination and the idea of moonlit tours instantly appealed to the popular mind. While the Trust could not rustle up the ghosts, the public came in droves and all the tours were booked out, each series having raised about A$4,000 (£1,520) towards the restoration of historic monuments.

Key words

Melbourne, fountains, headstones, statues, sculptures, conservation

SOS & SMOCM

Public monuments are not what they used to be. In Australia in recent years most of the capital city and larger municipal councils have established regular conservation and maintenance regimes for their often previously neglected but expanding collection of historic and new outdoor sculptures. Cemeteries, which also contain important public historical monuments, lag behind. Spurred on by the American Save Outdoor Sculpture! programme (SOS!), the AICCM (Australian Institute for the Conservation of Cultural Materials) established a special interest group SMOCM (Sculpture, Monuments and Outdoor Cultural Material) in 1990. While it has since languished, at least in Melbourne, it was one of the catalysts which led to active conservation programmes.

The City of Melbourne has been very successful in commissioning and maintaining public monuments of which it has approximately 100 in its care. By budgeting a percentage of all capital works funds to monuments, it established a perpetual fund with the flexibility to determine where the funds are spent. The Emerging Sculptures Trust offers tax deductibility to organisations who wish to commission and fund works. In partnership, the council identifies key sites and implements a strategic programme of commissioning and conservation. The conservation programme covers emergency, remedial and regular cleaning works and annually contracts out to specialists. Meanwhile the parks and gardens staff are trained to keep an eye out for damage.

THE PHILOSOPHICAL APPROACH

For the last twenty years the Australia ICOMOS *Charter for the Conservation of Places of Cultural Significance* (The Burra Charter) has been used in relation to buildings. Increasingly it is used for cultural landscapes and more recently for monuments. Conservation plans, mandatory for historic buildings, are now also frequently prepared for monuments to gain a clear understanding of their aesthetic, historic, scientific and social significance and to formulate a conservation policy and implementation strategy to guide the works.

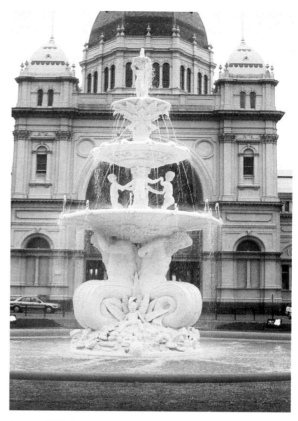

Figure 1 The restored *Hochgurtel Fountain* at the south entrance to Melbourne's Royal Exhibition Building. (Robyn Riddett)

PHYSICAL INTERVENTION ON SIGNIFICANT FABRIC

To 'polish or not to polish' is still a vexed question and the debate remains unresolved, at least in regard to appearance and patina. While the Burra Charter requires that 'a respect for the existing fabric ... should involve the least possible physical intervention ... [and] should not distort the evidence provided by the fabric'.. (Article 3), sometimes extensive intervention and reconstruction is required to save monuments. Is the patina of age a necessary part of a historic bronze's appearance? Does its retention or removal have a significant long-term effect on the fabric? Should the streaks be cleaned while retaining a general green hue? And what about the artist's intent and the original spectator's view?.

Figure 2 Detail of a figure from the *Hochgurtel Fountain* before restoration. (Melbourne City Council)

Would we view Donatello's *David* or Ghiberti's doors any differently if or when they were tinged with green? In Australia, at least, the green is being removed, monuments are being cleaned and waxed and returned to something of their original appearance. Where conservation is concerned, less is more and intervention on significant fabric is kept to a minimum and is reversible.

To conserve monuments, particularly water-driven ones, and to comply with public safety, considerable intervention and replacement of elements is often the only way to ensure their survival and is not necessarily contrary to the Burra Charter.

The restoration of the *Exhibition (Hochgurtel) Fountain* (Fig 1) and the *River God* both involved considerable replacement of fabric. Before conservation, the *Hochgurtel Fountain*, constructed in 1880 in association with the Royal Exhibition Building now being considered for World Heritage nomination, had suffered from inappropriate repairs, the hydraulic system had failed and many of the details were either buried under applied coatings or missing altogether (Fig 2). No photographs existed to guide reconstruction but by using remaining evidence which gave clues to style and form, together with evidence from nature, many of the platypuses and goannas were reconstructed with a high degree of accuracy and great care was taken as to their actual placement. All of the spigots were carefully angled before casting to ensure that they were set at the correct angle. Moulds were taken of the figures and new ones cast where the originals were beyond repair. Much of the reinforcing material and hydraulic system were necessarily replaced.

The *River God*, by notable Victorian sculptor

Figure 3 The monument to Burke and Wills. (Melbourne City Council)

Charles Summers, was the first sculpture in the Fitzroy Gardens. Dating from 1862, it took advantage of Melbourne's first reticulated[1] water supply from Yan Yean Reservoir. A century later the statue was removed to the council depot where it dejectedly remained until its resurrection in 1996. By then its original location was no longer viable, so a new site which had many of the attributes of the original was chosen. Illustrations of the original guided the construction of the rocky site, pool and force of the water, which still comes from Yan Yean and which had long ceased to even dribble. A significant part of its restoration was the painstaking application of a very fine 3mm unpainted surface finish to represent the eroded outer layers of the figure.

MOVING MONUMENTS

Melbourne's monuments have had an unfortunate tendency to wander away from their original locations. While in some instances this has compromised their

significance, in others it has ensured their survival.

The monument to *Burke and Wills*, legends in themselves, has also assumed a similar status (Fig 3). Sponsored by the Royal Society in 1860, Robert Burke (1820–61) and William Wills (1834–61) set out to cross the continent from south to north and thus explore the hitherto unknown hinterland. Having reached the Gulf of Carpentaria on the outward journey, they began the return only to die of starvation in the desert. Five years later a bronze and granite monument was erected on the hill in the middle of the intersection of Russell and Collins Street, a key intersection and view in Melbourne's most prestigious street. In 1886 construction of the cable tram route along Collins Street caused them to be moved to Spring Street, and so began the first stage of what was to become Burke and Wills' next epic journey, around the streets of Melbourne, one step ahead of public transport.

The construction of Parliament Station approximately 100 years later necessitated relocation to their penultimate resting place, the then new and since defunct, city square where they were installed over the flowing stream of a municipal fountain. With the demise of the square they were relocated further south and are now located on the corner of the intersection of Collins and Swanston Street, one block away from where they started out and on the same tram line that caused their relocation in the first place. Now they sit in the street more like a piece of sculpture than a monument (Fig 4). While the monument still retains its historic and aesthetic significance, its formal relationship with its original setting, which has considerably changed since 1865, has been lost. Over the years the figures had become separated from their plinth and the bas-relief panels removed. The moulds for the castings were on the verge of being thrown out and in many ways this last move has been their salvation. All the parts of the monument have undergone extensive conservation and they are now back.

A similarly colourful tale surrounds the *Westgarth Fountain* (Fig 5) According to its modest inscription, William Westgarth, pioneer and Old Colonist, presented it as a gift to the citizens of Victoria, with the inscription: 'To Victoria from one of her earliest colonists in pleasant remembrance 1840–88'.

Sculpted from granite in Aberdeen, Scotland, it is of immense aesthetic interest in its willowy and unnatural depictions of the kangaroos and lively

Figure 4 *Burke and Wills* sit like a sculpture in the street at the intersection of Collins and Swanston Street, Melbourne. (Melbourne City Council)

emu heads functioning as water spouts. The emus were sculpted from models cast in the London zoo. The fountain was originally located outside the Nicholson Street entrance to the Royal Exhibition Building where the dispensation of reportedly iced water on a hot summer days was no doubt appreciated by visitors and dogs alike.

Some time in the past the Exhibition Trustees sold the monument to a local Italian firm of monumental masons. When they vacated their yard, the base, along with other rubble, was bulldozed into the Merri Creek where it lay for many years before being rediscovered. About 60% was salvaged. Unwilling to return the top, the monumental masons were instead given the base to restore and when complete, sold it back to the Trustees for $100, 000 (£38,022), reaping a handsome profit in the process. What really mattered was that the fountain was recovered and Westgarth's tribute remained on public view.

Reinstallation in its original location had since become impossible because of the movement of trucks required to service the exhibitions, so a location about 50 metres further east from the building and closer to Nicholson Street was selected. While something of its original purpose has been lost in its new setting, it is now more visible and it still retains its link with the Exhibition Building and its own intrinsic aesthetic and historic significance.

Suffering to a greater degree as a result of relocation is the horse trough erected in 1926 by the Purple Cross Service in memory of the Australian light horses used at the Front in the First World War. Only one horse survived the war. The inscription reads:

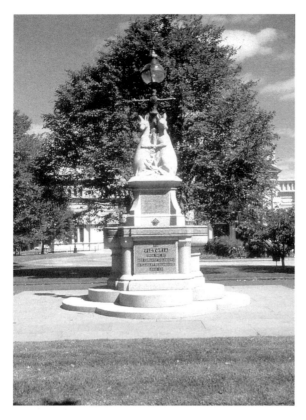

Figure 5 The *Westgarth Fountain*, Melbourne, bedecked with kangaroos and emus. (Robyn Riddett)

He gains no crosses as a soldier may,
no medals for the many risks he runs,
he only, in his puzzled, patient way,
sticks to his guns.

Originally designed for a curved site in St Kilda Road, its form is now irrelevant to its present location near the Shrine of Remembrance, where it now sits like a lost soul in a memorial sculpture park.

The latest in the saga of Melbourne's moving monuments, located next to the horse trough, are the copies of the statues at Hyde Park Corner, London. Originally purchased by the Felton Bequest for the State Library and Art Gallery, they were sited in the forecourt along with sculptures of *Joan of Arc*, *St George* and *Sir Redmond Barry* for over forty years. As a result of intense lobbying by the Returned Servicemen's League, and taking advantage of a recent forecourt upgrade, they have been consigned to the Shrine of Remembrance and erected back-to-

back, out of context, with no appropriate setting taking account of their scale and perspective, thus losing their monumentality. The significance of their original purpose, both as art works for the Gallery and as memorials, has also been considerably compromised.

One other major relocation is worthy of comment. As a result of an outbreak of typhoid aboard the *Manlius* which arrived in Hobson's Bay in 1842, a large number of bodies were interred in a burial ground at Gellibrand's Point. Gradually the railways encroached and the burial ground became neglected. In 1899 the bodies and all surviving headstones in reasonable condition were exhumed and reinterred in the new Williamstown Cemetery about a kilometre away. Assuming that there were about 32 bodies as indicated by the headstones, and allowing for another 18 as indicated by graves, the authorities were somewhat startled when eventually 920 bodies were removed and reinterred in a vault made from concrete and old railway sleepers, surrounded by a low fence made from ornamental cast-iron posts and galvanised steel gas pipes set on a basalt plinth (Fig 6). Some of the more decayed stones were laid directly into concrete. Today they are significant historic documents not only recording the typhoid outbreak but also giving testimony to the maritime history of the area, the perils of the sea and convicts. Of particular interest are two imported stones, one from Wales and another from Bishop's Stortford, Hertfordshire, England.

More enlightened than many cemetery trusts, the Williamstown Cemetery Trust instigated the conservation of these significant monuments, which are probably the oldest in Melbourne and which can rightfully be considered as public history documents. The stones are sedimentary and igneous, originating from various parts of Australia, New Zealand and Britain. The proposed conservation action is to first gently clean and undertake localised consolidation of friable surface material with an ethyl-silicate-based consolidant. They will then be removed from their existing concrete bedding before further cleaning and consolidation. The other option of total immersion consolidation was considered, but rejected on the grounds that the risk of fracture due to salt crystallisation was too great. The proposed spray application will achieve sufficient localised penetration to hold friable surface material which would otherwise be lost.

Following treatment, the headstones will be set on a slightly raking stainless steel frame, which will enable rainwater run-off and all will be relocated in their existing position. It was considered that the amount of pinning with adhesive repair required to erect them upright might cause disintegration and, besides, the existing arrangement has, over time, taken on a degree of significance in its own right.

CEMETERIES: CONSERVATION AND RAISING FUNDS

Most cemetery trusts are less enlightened than the one at Williamstown, which is of concern, since they are guardians of significant historical monuments which are arguably now part of the public record.

Under the Cemeteries Act in Victoria, only the owners of the right of burial are allowed to restore or maintain a monument in a cemetery. Cemetery trusts can only remove monuments which are a public danger and, to make matters worse, a fee of some A$200 (£76) has to be paid to the trust before any work can be carried out. In addition the budgets of the cemetery trusts are ridiculously low and the average person does not know where to go to get expert advice. Nothing could be a greater disincentive to conservation and the National Trust (Victoria) has continued lobbying to have funding increased.

Victim to this appalling situation is the memorial erected over the grave of Governor Hotham in 1858, one of the most important public monuments in Australia. Over 15 metres high, it dominated a section of the Melbourne General Cemetery, which is a veritable Who's Who of historical figures. Suffering the usual problems of metal corrosion in the reinforcing rods, and after some concern about its alleged dangerous state, the Cemetery Trust, in its wisdom, spent A$30,000 pulling it down instead of trying to raise around A$200,000 (£76,000) to keep it up. It is now in storage and its reinstatement is not in sight.

A somewhat more novel way of conserving monuments has been instigated by the National Trust (Victoria). S T Gill was a notable artist whose sketches of life in early Melbourne and on the gold fields have won him an immortal place in Australian history. After a disappointing response to a public appeal where only A$200 (£76) was raised for the restoration of Gill's headstone, the Trust hit upon a

Figure 6 Graves in the Williamstown Cemetery which are now important principally as public history documents. (Robyn Riddett)

more dramatic and infinitely more lucrative approach. Ghoulish tales of ghosts in cemeteries under a full moon always excite the imagination and the idea of moonlit tours instantly appealed to the popular mind. While the Trust could not rustle up the ghosts, the public came in droves and all the tours were booked out, each series having raised about A$4,000 (£1,520).

To a considerable degree these grave monuments have now moved into the public domain as historic testament and hopefully they will continue to receive much needed public support.

From its very beginning the *Springthorpe Memorial*, in the Boroondara Cemetery, Kew, Melbourne, was a popular tourist attraction (Fig 7). Constructed between 1899 and 1907, from marble and local Harcourt granite, by Dr Springthorpe, it was a memorial to Annie, 'a pattern daughter, perfect mother and ideal wife'. Costing about £10,000 it was designed along the lines of a Greek Revival temple by notable Melbourne architect Harold Desbrowe Annear. Bertram Mackennal carved the statues, Sir John Longstaff designed the bronze python rain water heads and Alfred August Fisher the stained glass while Professor Tucker advised on the inscriptions, all from romantic poets.[2] Integral to its setting is the surrounding garden but the reflective pool and rose garden have disappeared. Nevertheless, of all Melbourne's funerary monuments, the *Springthorpe Memorial* is the most famous and attracts the most attention. Today cemetery tours and sculpture walks are organised to raise funds for conservation.

Figure 7 The *Springthorpe Memorial*, Boroondara Cemetery, Kew, Victoria, a work of sepulchral genius. (Robyn Riddett)

THE NIGHTMARES OF THE FUTURE

At the start of a new Millennium, will the many new works being commissioned by councils and corporations become the conservation nightmares of the future? Will new or experimental materials last? Will the sculptures be seen as decoration and whimsy by future generations or will they become significant monuments in significant settings? Perhaps they will be the dogs which come back to bite us (Fig. 8) We shall have to see.

Figure 8 Larry La Trobe, by Pamela Irving (1992) adds a touch of whimsy to Melbourne's main pedestrian thoroughfare (Swanston Walk). (Robyn Riddett)

ENDNOTES

1 Reticulation: a term used chiefly in Australia and New Zealand for a network of pipes used in irrigation and water supply.
2 Sir John Longstaff (1861–1941), studied at the National Gallery of Victoria Art School and later in Paris where he became an acquaintance of Toulouse-Lautrec. He painted in the style of the French salons and of the Royal Academy where he exhibited. He is represented in Australia's major galleries and was notable as a painter of official portraits. Edgar Bertram MacKennal (1863–1931) studied at the National Gallery of Victoria Art School and at the Royal Academy, London. He worked in Rome and Paris where he met Rodin. He is represented in the Tate Gallery, London. He worked as head designer at Coalport Potteries, Shropshire, until returning to Melbourne to undertake the sculpture on the façade of Parliament House, Melbourne. He is noted for many other sculptural commissions. Harold Desbrowe Annear (1865–1933) was a notable Melbourne architect, art patron and collector. He designed interesting and modern houses for many prominent Melbourne citizens, particularly artists and those in art circles. Alfred Auguste

Fisher (?–1916) was born in Warwickshire but settled in Sydney and then Melbourne as a stained glass craftsman. Examples of his work are in other states in Australia, as well as New Zealand, South Africa and China. Thomas George Tucker (1859–1946) became the founding professor of Classics and English at Auckland University College in 1883. In 1885 he was appointed professor of classical philology at the University of Melbourne.

REFERENCES

Australia ICOMOS Inc, 1994 *The Illustrated Burra Charter*. Sydney, Australia ICOMOS.
Costa G, 1997 Spooky steps into Melbourne's past, in *The Age*, 15th April.
Green R, 1996 Victoria's Watering Places, in *Historic Environment*, **12**:2, 31–36.
Kerr J S, 1996 *The Conservation Plan: A Guide to the Preparation of Conservation Plans for Places of European Cultural Significance*, 4th edn, Sydney, National Trust.

Parsons B, 1998 Grave concern for crumbling past, in *The Age*, 16th March.

Sagazio C (ed), 1992 *Cemeteries: Our Heritage*, Melbourne, National Trust of Australia (Victoria).

Sagazio C, 1997 Grave concerns, in *Trust News*, December, 21.

Young D, Dickens J and Young L 1995 *Sydney Open Museum: a Conservation Management Plan for the Sydney City Council*, Campbell, ACT.

ACKNOWLEDGMENTS

The author would like to thank the following people for their generosity in supplying information for this paper: Jennifer Dickens, Heritage Victoria; Linton Lethlean, former Director of the Exhibition Trustees; Peter Lovell, Director, Allom Lovell & Associates Pty Ltd; Donna Midwinter, SMOCM; Helen Millicer, formerly City of Melbourne; Andrew Patience, Reuben Studios; Shane Power, Melbourne City Council; Dr Celestina Sagazio, National Trust of Australia (Victoria).

AUTHOR

Robyn Riddett is an associate director of Allom Lovell & Associates Pty Ltd, Conservation Architects, Melbourne and is an architectural historian and interior designer. She is also a past President of Australia ICOMOS, and has been a long-standing councillor of the National Trust of Australia (Victoria). She has extensively researched and undertaken work in relation to many of Melbourne's major restoration projects including many of Melbourne's historic buildings. Some of the projects with which she has been associated include the Princess Theatre, the Royal Exhibition Building, the ANZ Gothic Bank and the Regent Theatre.

Part 4

Case Studies

16 The role of conservation in the design of conceptual monuments

Glenn Wharton

549 Hot Springs Road,
Santa Barbara, CA 93108 USA,
Tel.: 805 565 3639 Fax: 805-565-3649,
gewharton@aol.com

Abstract

This chapter reviews issues of longevity and the role of conservation in the design of contemporary monuments. Many conceptually-based monuments are not intended for material longevity. Conservators and others involved in the design process are challenged to reassess their notions of permanence in order to extend the meaningful life of these new monuments. If the essence of the monument is conceptual rather than material, then it is the concept that must be preserved. The materials themselves may be expendable or replaceable.

Key words

Conservation, monuments, public art, longevity, ephemeral, contemporary art, conceptual monuments, conceptual art

INTRODUCTION

Monuments shape our understanding of the past. They capture a moment in time, they memorialize a place, they glorify an individual. Considerable discussion has taken place in recent years concerning the power of monuments to reduce complex events into symbols that guide our perception of the past.[1] Some critics argue that traditional monuments and figurative sculptures present us with fixed images that prevent us from developing our own narratives of history. They perpetuate a particular view of the past without allowing us to interpret or contest their meaning.

Some contemporary artists have responded to this discussion by inventing new forms of monuments. These works are frequently interactive, including the viewers as participants and engaging them in the memorial process. Some are designed to increase public awareness of environmental issues or to evoke social change. Central to this rethinking of monument design are issues of time, permanence and change. The process of material deterioration or disappearance is often key to the meaning of these new monuments.

To resolve questions of material durability and selection during the design of contemporary monuments, the people involved must share a common understanding of the monument's physical life expectancy. The anticipated life of a monument will influence the choice of materials and the level of future maintenance required. If a monument is expected to last for less than five years, the artist is free to use experimental and ephemeral materials.

Figure 1. Original maquette for installation at the Tsing Hwa University School of Engineering by Margaret Shiu Tan, Taiwan. Currently in construction phase. Materials of original design: rubber balls, ink, plastic tubing, air compressor. (Margaret Shiu Tan)

Rapid deterioration may be accepted and very little maintenance will be required of the artwork's owner. For a monument with a desired lifespan of five to twenty years, a fair amount of planning and attention to material selection is required, yet some non-permanent materials such as plastics and electronics may be employed. If a monument is expected to last 'forever', or more than twenty years, a rigorous standard of review must be applied. The proposed materials, connecting and anchoring mechanisms, site preparation and budgeting for maintenance must be carefully reviewed, and funds must be allocated for future conservation measures.

Conservators and other technical experts are often included in the design process to help ensure the material longevity of monuments. Knowledgeable in techniques of fabrication and mechanisms of deterioration, they understand how materials age in a public environment and what kinds of abuses they suffer. Conservators are equipped to advise on the selection of materials, the fabrication methods, the preparation of documentation archives and the development of guidelines for future strategies of care.

New forms of monuments challenge conservators' usual efforts to strive for longevity. To be an effective member of the design team, the conservator must employ the fundamental principals of conservation in new ways to honour the artist's objectives. The following examples of six recent projects explore how artists, conservators, and others with technical expertise have worked together from this perspective.

CONSERVING THE CONCEPT

If the artist is primarily concerned with communicating a concept, then it is the concept that must endure. In her design of an installation for the entrance lobby to the Tsing Hwa University School of Engineering in Taiwan, artist Margaret Shiu Tan is attempting to link a concept to the progress of students through the educational programme.[2] The original project consisted of racquetballs that would be blown around in clear plastic tubing throughout the lobby, driven by large air compressors (Fig 1). Each student beginning a course of study at the School of Engineering would write his or her name on a ball that would be tossed into the system. The ball would continuously bounce around through the plastic tubes until the student graduated, when he or she would receive the ball as a personal memento.

Tan initially performed her own research to locate balls that would bounce for four years and ink that would adhere to rubber while enduring constant abrasion. She spoke with technical advisors in the plastics and air-conditioning industries. She consulted with a conservator, architects and engineers from the university. This process of investigation and collaboration led to a fundamental change in the design of her project. Instead of plastic tubes, the balls will now be carried through the lobby on conveyor belts.

In addition to advising on the selection of materials, conservators can help document the artist's concerns and objectives. Conservators are well equipped to assist in creating a documentation archive that contains a carefully phrased statement of the artist's intentions, as well as drawings and photographs to inform maintenance decisions in the future. In conserving material culture of the past, conservators routinely face difficult questions about stabilizing, reintegrating and replacing aged materials. To find answers they perform research or interview artists about the original material construction and the criteria for how the work should age.

In the instance of Margaret Tan's project, the artist was able to distill her intent down to its most

minimal concept of linking the processing of balls to the matriculation of students. She was able to retain this concept even as her technical advisors suggested fundamental changes in her original design. The specific materials and mechanism of her initial design were less important than her central idea.

Unlike the materials that make up traditional monuments, the materials of Tan's project will be replaced in the near future. In fact, the balls will be routinely replaced as students graduate, fulfilling part of the design concept. The longevity of her project will not depend on the preservation of the original materials. It will depend largely on the successful marketing of the concept and the appreciation of the students, faculty, and staff who will pass by it on a daily basis. The more people appreciate and enjoy the installation, the more attention it will be given and the more likely it will be cared for in the future.

MONUMENTS THAT RECEDE INTO THEIR ENVIRONMENTS

Artists frequently work in a team with architects, landscape architects and others in the design of contemporary monuments. The model of *seamless* or *integral* collaboration is often employed in projects that incorporate artistic inspiration and thoughtful landscaping into large, complex building projects. If successful, the work of the artist cannot be distinguished from that of others on the design team.

The art of Helen Mayer Harrison and Newton Harrison typifies this genre of design. Their work is a sophisticated form of public art in which they frequently combine technical expertise with community participation in a process of evaluating previous land use, damage to ecosystems and public memory of place. Their work often disappears into its natural and urban surroundings, offering a subtle and poetic comment on the nature of place. Although their projects are frequently inspired by environmental politics, they are not dogmatic. As Newton Harrison describes their approach, 'We're not propagandists, we're storytellers' (Rodriguez 1997, 23). The questions they raise in their design, community involvement and implementation are often playful and indirect.

California Wash: A Memorial (Fig 2) is a monument to the vanishing ecology of a river wash

Figure 2. *California Wash: A Memorial,* by Helen Mayer Harrison and Newton Harrison, Santa Monica, CA, USA. 1996. Collection: City of Santa Monica. Materials: rolled and welded steel painted with aliphatic acrylic polyurethane topcoat, stainless steel, concrete, bronze, granite, crushed glass, rocks, fibre-optic lighting, fluorescent lighting, native plantings, sand, water. (Bill Short)

as it enters the Pacific Ocean. The Harrisons were challenged by the Santa Monica Arts Commission and local business owners to redesign an ugly, foul-smelling storm drain that channels run-off water from the Hollywood hills through the urban environment to the Santa Monica Bay (Rodriguez 1997).

During their research, the Harrisons learned that the site of the storm drain was once a river wash, which is a specific ecosystem that contains stones, soil, and plants that were carried down from the mountains to the sea. The vegetation of a wash is an intricate mix of species native to the marine environment and those that survived the voyage down the river.

Through collaboration with architects, landscape architects, engineers, a concrete contractor, a

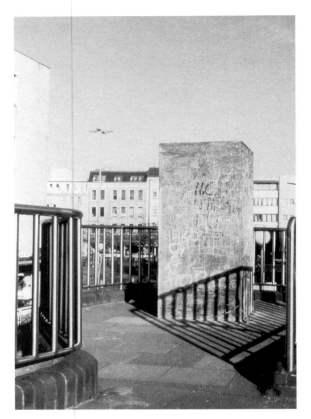

Figure 3. *Monument Against Fascism,* by Jochen Gerz and Esther Shalev. Harburg (near Hamburg), Germany. 1986–93. Materials: lead sheet over central core. (James M Clark)

sculpture fabricator, city traffic planners, horticulturists and an art historian, the design of *California Wash: A Memorial* evolved into a elaborate set of elements that play on the theme of the vanishing river wash and its modern urban environment. Cast bronze fauna are embedded into concrete. Rock and stone expanses suggest geological striations as well as an urban grid. Undulations in a steel fence mimic the waves of the adjacent ocean. Through this complex presentation, the viewer is coaxed into pondering notions of permanence and change in nature, as well as the practical demands of the modern urban environment.

In a monument where the work of the artists is indistinguishable from that of their collaborators and even from the natural context, it is critical to document which aspects of the memorial must be preserved in the future and honoured as a work of art. The durable materials used in this monument are combined with naturally occurring plants and the constantly shifting materials of the environment. In the future, some of these materials will gradually change, some will need replacement and some will need maintenance.

The care of this monument will require an understanding of the artists' intent and tolerance for change. What plant species are acceptable, especially if the original selection does not survive the coastal marine environment? How concerned are the artists with the specific colour and gloss of the paint used to finish the steel fence?

These questions are particularly critical in light of recent legislation regarding artists' moral rights. The International Berne Convention in 1989, the Visual Artists Rights Act passed by the US Congress in 1990 and other national and local laws protect artists' works from mutilation or distortion that would harm the artistic integrity or the artists' reputations (Esworthy 1997). These rights include protection against negligence or inappropriate maintenance procedures by the owner.

The best way for conservators and others to ensure appropriate maintenance is to develop strategies accepted by the artist during the design phase. With complex integral design installations such as *California Wash: A Memorial*, it is important to specify the manner and degree to which each aspect of the project must be maintained. The paint applied to the steel fence, for instance, must be periodically replaced. With proprietary materials such as paint, it is important to specify the material and aesthetic criteria of the artist without insisting on brand names that may not be available in the future.

MONUMENTS THAT DISAPPEAR

During the 1980s Jochen Gerz and Esther Shalev, Sol Le Witt, Hans Haake, Ulrich Rückriem and others designed monuments that used their lack of permanence, or their disappearance, to 'alleviate the burden of the past without re-mythologizing it' (Causey 1998, 218). Their work primarily focused on the memory of fascism and the atrocities of the Second World War in Germany. The work of these artists has been called *counter-monuments,* or *anti-monuments.* As described by art historian Andrew Causey, the 'counter-monument is in the public

domain and may invite public participation, but resists monumentality because it does not put itself outside time' (1998, 221). The focus of these monuments is often their own removal, disappearance or absence, rather than their physical presence.

In their *Monument Against Fascism* (Fig 3, and see Lovell this volume and Michalski this volume), Jochen Gerz and Esther Shalev constructed a column covered with lead sheet, one metre square and twelve metres high. A nearby panel solicited the public to inscribe their names in the lead. The column was gradually lowered into the ground and buried over a seven-year period, in reference to the invisible histories of those who suffered during fascism.

The goals of this monument were to invite public participation, stir public memory, and cause the viewer to reflect on the disappearance of the victims of fascism. The physical disappearance of *Monument Against Fascism* is central to its meaning. Although it is now underground, it will be conserved in the memory of those who experienced it and made inscriptions in the lead sheeting. Its significance will be extended through continued public discussion of its meaning. Like other temporary monuments, its material preservation will be through archival housing of photographs, drawings and other forms of documentation.

In the case of *Monument Against Fascism,* as with other monuments that disappear or deteriorate, the selection of durable materials was less important than the selection of the right materials to achieve the artists' purpose. The use of lead sheet allowed viewers to inscribe their comments on the surface of the monument. It also offered the colour, texture and associations desired by the artists. Given the criteria of a seven-year life expectancy above ground, lead sheet was sufficiently durable.

PROCESS OVER PRODUCT

Untitled (Questions) by Barbara Kruger (Fig 4) was a temporary mural installation on an exterior wall of the Museum of Contemporary Art in Los Angeles. It was commissioned to follow a show organized by the Museum titled *Forest of Signs* that exhibited artists who employ language and signage in their iconography. The mural was originally designed with the words of the American Pledge of Allegiance

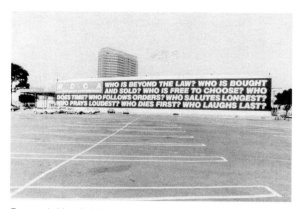

Figure 4. *Untitled (Questions),* by Barbara Kruger, Museum of Contemporary Art, Los Angeles, CA, USA. 1989–1990. Materials: commercial sign paint on exterior wall of industrial building. (Art on File)

written on the stripes of the flag. It was intended to mock Americans who overuse the flag and the Pledge of Allegiance as a symbol of American loyalty.

The artist and the museum were caught off-guard when Japanese-American residents of nearby Little Tokyo angrily condemned the proposed design. The artist quickly discovered that local residents held strong memories of the mural's intended installation place: it had been the site from which Japanese Americans were deported to internment camps following the bombing of Pearl Harbour in 1942. Residents were enraged that such a powerful symbol as an American flag would be erected in the very place that their rights as citizens had been so grossly denied (Doss 1995).

Adapting to this new-found aspect of her project, Kruger engaged the community in redesigning the piece. As she explained, 'My whole artistic life has been a series of negotiations to try to be effective. To be effective you need a reality test. The process is most important. It's a real social relationship, bringing different histories together and challenging stereotypes' (Doss 1995, 240). In the end, all parties settled on replacing the Pledge of Allegiance with a series of questions challenging American democracy: *Who is beyond the law? Who is bought and sold? Who is free to choose? Who does time? Who follows orders? Who salutes longest? Who prays loudest? Who dies first? Who laughs last?*

Like *Monument Against Fascism*, this work was temporary by design. It was commissioned by the Museum to display for two years. By focusing her

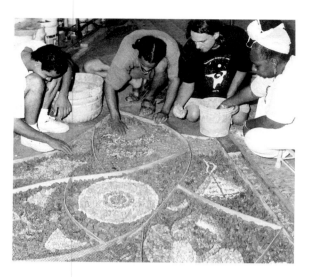

Figure 5. Artist Rafala Green working with neighbourhood youth to prepare mosaic tesserae. Phillips Neighborhood Gateway Project. St. Paul, MN, USA. 1993–1998. Materials: stone, glass, reinforced concrete, steel, string, landscaping. (Petronella J Ytsma)

attention and considerable time on the process of community interaction, the artist altered the point of her work from the product to the design process itself. Not only was the Japanese-American community engaged in the discussion and forced to remember a painful period of history, but the process also engendered considerable public debate in the local media. Many residents in Los Angeles had forgotten the historical significance of the mural's location. Some were completely unaware of this dark chapter of internment in recent American history.

To understand this work in the context of longevity, we must accept that the process of community involvement and mobilization of the Japanese-American community in Los Angeles became the artist's primary objective. Through the media, she communicated to a wider audience and rekindled the memory of a painful and embarrassing period.

The success of *Untitled (Questions)* must be measured by the stated objectives of the artist. Careful articulation of these objectives during the design process, even as they change, will help conservators and other collaborators assess the relevance of material choices in fabrication. In this instance, the mural was intended to last for two years. During the design process, the focus of attention shifted from the original form to community

involvement and media attention. This change in the artist's intent is understandable given the public interest in the originally proposed design. Other collaborators in the design process must follow the artist's direction as it evolves toward its final incarnation.

LONGEVITY AND COMMUNITY ACTIVISM

Many contemporary artists are concerned with promoting social change through their work. In what has recently been called *new genre public art*, community activism and social intervention is the motivating force behind the design of these projects (Lacy 1995). In her recent book on public art and cultural democracy, Erika Doss describes public art as having 'the unique potential to encourage the public to realize their voice – their power – in the public sphere. And public artists are equally empowered to invent that sphere as a place where ideas about cultural democracy can be debated and refreshed, tested and tried anew' (1995, 249). Instead of creating bronze heroes of military and political victors, these artists are glorifying ordinary individuals and leaders of previously disenfranchised social groups. They are designing new forms of monuments to previously unrecognized heroes (Capasso 1996).

In 1992, artist Rafala Green was awarded a commission to create a public arts plaza in a park in Minneapolis (Fig 5). Her commission followed a ten-year battle to tear down a liquor store at the site (Sohn 1996). The liquor store had become a locus for drug-dealing and violence. Residents of the neighbourhood organized a successful effort to demolish the store and annex the land beneath it to an adjacent park. Neighbourhood activists decided to create a work of art in place of the store, intended as a monument to what the neighbourhood could become rather than a monument to its history. The Phillips Neighbourhood Gateway Project grew out of this dream, in cooperation with other neighbourhood groups and the Minneapolis Arts Commission.

During the past five years, Green has brought in twenty-one artists and technicians to train children in techniques of cutting, polishing and setting mosaic and terrazzo stones.[3] She works with community volunteers to organize and implement each phase

of the project. The formal elements of the artwork include a macramé-covered archway entrance to the park, four mosaic-tiled benches and five mosaic pathways. The design motifs for the benches and pathways grew out of ideas articulated by youth participating in the project. There is a Female bench, a Male bench, a Children's bench and a Dream Bench. The mosaic pathways contain signs and symbols significant to the five cultural groups that reside in the neighborhood.

The intent of the artist clearly extends beyond the creation of a functional work of art for people to enjoy. Equally important to her is working with residents of the neighbourhood to replace its violent past with a sense of pride and community spirit. Her method is to incorporate the community into the artistic process. In all, over 1,500 people have worked on the project during the past five years.

In anticipation of future maintenance and protection from vandalism, the artist trained a neighbourhood group of 'guerilla gardeners' to cut and reset replacement stones, remove weeds and regularly sweep the pathways and benches. The guerilla gardeners have already repaired some vandalism on the benches.

By using a vast number of volunteers, including neighbourhood children, Green and her technical advisors may sacrifice the highest levels of craftsmanship, but the process has helped the people in the neighborhood develop a strong sense of pride and ownership of the project. If we can consider the transfer of pride to young people as the essence of this work of art, then it is a resounding success. The longevity of the project may be measured in part by the physical durability of the mosaics and terrazzo flooring, but the impact on the lives of the children and community must be factored into the final assessment.

PERMANENCE OF PLACE

Monuments are often designed specifically for their sites. They interpret the history of the place or they comment on its natural ecology. The meaning is inextricable from the physical context. For these monuments, preservation *in situ* is essential. Laws protect site-specific monuments and works of art (Esworthy 1997), yet many 'sophisticated' commissioning agencies require artists to waive

Figure 6. *Host Analog,* by Buster Simpson, Oregon Convention Center, Portland, OR, USA. 1993. Collection: Metro Regional Government, Portland, OR. Materials: Douglas Fir trunk; seedlings of cedar, fir, and hemlock; stainless-steel irrigation and misting system. (Peggy Kendellen)

these rights in their contracts. Inevitably, situations arise in which building owners or local governments wish to redevelop the land under these artworks, and all parties return to the language used in the original contract.

Host Analog (Fig 6) offers an interesting example of a site-specific project. It was created by Buster Simpson in 1993 as a monument against habitat destruction (Oakes 1995). The monument is composed of an old-growth Douglas fir trunk that had fallen in the 1950s. The trunk was cut into eight segments, then installed under a misting irrigation system to simulate the moist environment of the Pacific Northwest forest in the United States. Simpson scattered seeds and seedlings of cedar, fir, and hemlock, which have slowly germinated and established a network of saplings and root systems over the host log. As the seedlings grow and take hold, the underlying log will gradually rot away.

The artist stated that 'the success of this piece is dependent on its continuance. Future developments need to accommodate themselves to the *Host Analog,* just as the regenerated forest landscape has accommodated itself atop the host log. It requires the patience of a thousand years' (Oakes 1995, 120).

The City of Portland did not wait for a thousand years. Seven years after installation, momentum is gathering to construct a new addition to the Convention Center that would encroach on the site of *Host Analog*. In commissioning this work of art,

did the City of Portland sell its rights to develop this urban space for a thousand years? Does any artist have the right to lay claim to a space for a thousand years?

Ultimately these issues, like those of many other site-specific projects in recent decades, may be settled through a public process of discussion, or perhaps in the courts. Thoughtful consideration of the artist's intent and the needs of the owners during the design process in light of artists' moral rights legislation will guide future conservators and administrators in their decisions. Fortunately for *Host Analog*, the architect for the new extension of the Convention Center is sensitive to the desire of the artist and is currently striving for a design that will avoid the removal of the monument.[4]

CONCLUSION

Artists are taking divergent paths in the design of contemporary monuments. In traditional monument design, the goal of the artist is to memorialize an individual, a place, or a moment in time through the use of durable materials and symbols that will last in perpetuity. The goal of many contemporary artists is to engage the viewer in the actual process of memorializing, often deliberately sacrificing the use of stable materials and universal symbols.

Conservators are at times requested by public agencies and other commissioning bodies to assist in the design process. Their expertise in material stabilization and repair can help in the selection of appropriate materials, fabrication technologies and future strategies of care.

To successfully collaborate in the design process, it is critical for conservators and others to understand the essential goal of the artist and the anticipated life expectancy of the monument. The artist's primary intent and the expected life of the monument must drive the design process. If the artist is interested in creating public awareness, instilling community pride or stimulating social change, then these processes should take precedence over the final selection of durable materials and other criteria normally used when designing traditional monuments. The enduring impact of the process may take priority over the material longevity of the product.

Conservators must re-examine their fundamental notions of permanence when collaborating in the design of a monument that will not physically endure. Yet, if employed in an appropriate manner, the established concepts of conservation will make an important contribution to the design process. Conservators' knowledge will help focus the process on problems that may occur in the future. Their experience will assist in the development of a documentation archive that will help art historians, public art managers and conservators create appropriate strategies to increase the longevity of the monument, however its longevity is defined.

ENDNOTES

1　Good sources for discussion of the meaning of contemporary monuments may be found in *Public Art Review* **7**(2), 1996, and **8**(1), 1996.
2　Information on this work of art was obtained from personal communications with the artist.
3　Most of the information on this work of art was obtained from personal communications with the artist.
4　Personal communication with Peggy Kendellen, Portland Regional Arts & Culture Council.

REFERENCES

Capasso N, 1996 That was then: Boston-area memorials, in *Public Art Review*, **7**(2), 20–21, 41.

Causey A, 1998 *Public Spaces In Sculpture Since 1945*, London, Oxford University Press.

Doss E, 1995 *Spirit Poles and Flying Pigs*, Washington, DC, Smithsonian Institution Press.

Esworthy C, 1997 *From Monty Python to Leona Helmsley: A Guide to the Visual Artists Rights Act.* Washington, DC, National Endowment for the Arts Office of General Counsel.

Lacy S (ed), 1995 *Mapping the Terrain: New Genre Public Art*, Seattle, Bay Press.

Oakes B, 1995 *Sculpting With The Environment,* New York, Van Nostrand Reinhold.

Rodriguez A, 1996 On the beach: An ambitious coastal art project in Santa Monica recreates a lost California landscape, in *Landscape Architecture* **12**, 20–23.

Sohn B, 1996 *The Phillips Neighborhood Gateway* (project brochure), Minneapolis, Minneapolis Arts Commission.

FURTHER READING

Becker H S, 1984 *Art Worlds*, Berkeley, University of California Press.

Clark J M, 1996 Jochen Gerz: The cultural perspective, in *Public Art Review* **7**(2), 18–19.

Clark, J M, 1996 Creating intersections of meaning, in *Public Art Review*, **8**(1), 10–13.

Cruikshank J L and Korza P, 1988 *Going Public: A Field Guide to Developments in Art in Public Places*, Amherst,

Arts Extension Service Division of Continuing Education, University of Massachusetts.

Finkelpearl T, 1996 The anti-monumental work of Maya Lin, in *Public Art Review* **8**(1), 5–10.

Kandel S, 1996, May 3 Good environment: 'California Wash: A Memorial', *Los Angeles Times*.

Karasov D, 1996 Is placemaking an art?, in *Public Art Review* **8**(1), 24–5.

Lacy S, 1996 Love, memory, cancer: A few stories, in *Public Art Review* **7**(2), 5–13.

Woodbridge S B, 1996 'Veiled Histories' Conference, in *Public Art Review* **8**(1), 26–8.

ACKNOWLEDGMENTS

The author would like to thank the Samuel H Kress Foundation for providing him with a publication fellowship through the Foundation for the American Institute for Conservation. This paper is a distillation of ideas that are being developed for a forthcoming book.

Particular thanks are offered to Virginia N Naudé and Molly Lambert for their critical review of this manuscript. The author is also greatly indebted to the following friends, colleagues and artists for their help in refining his notions of longevity in contemporary art and monuments: Howard Becker, Erika Doss, Greg Esser, Gail Goldman, Barbara Goldstein, Rafala Green, John Griswold, Mickey Gustin, Maria Louisa de Herrera, Jackie Heuman, Janet Hughes, Peggy Kendellen, Debra Lehane, Rosa Lowinger, Cathy McNamera, Donna Midwinter, Susan Nichols, ShirleyPurcilly, Vivian Donnell Rodriguez, Robert Schultz, George Segal, Michael Several, Margaret Shiu Tan, Julie Silliman and Donna Williams.

Special thanks are reserved for Harvey Molotch who provided a sociological perspective on issues of longevity in art and life. Finally, the author would like to thank Stan Kerr, who provided a secret place to read and write.

AUTHOR

Glenn Wharton is a sculpture and archaeological conservator in private practice, based in Santa Barbara, California. He serves as Conservation Director for the Japanese Institute of Anatolian Archaeology. Through his interest in the conservation and maintenance of outdoor sculpture and historic sites, he works with artists and art agencies as a consultant on public art projects. He is co-author of *Guide to the Maintenance of Outdoor Sculpture*, and he is currently working on a book that will explore issues of longevity and conservation in the design of public art.

17

Cleopatra's needles: London and New York

Their histories, conditions and futures

Nicola Ashurst

Adriel Consultancy,
22 Hockley, Nottingham,
NG1 1FP, UK.
Tel.: 0115 941 9777
Fax: 0115 941 8700

Abstract

Since the relocation of this pair of granite obelisks in Central Park, New York, and on the Thames Embankment, London, the blame for their current condition has frequently been levelled at their new environments. Articles and letters in the press have also regularly reported the loss of large amounts of granite surface and hieroglyphic detail. This chapter puts the current condition of the obelisks in the context of their 3,500-year histories. It summarizes the various assessments and treatments that have been undertaken in their respective new homelands and, in relation to the London obelisk, describes the investigations by which London's Cleopatra's Needle is being kept under observation.

While the decay of significant pieces of stone, such as these obelisks, is always of concern, the rate at which this is occurring is far more gradual than many would fear. As always with any stone decay, the weather plays a significant role, but with the obelisks, many of the defects which weather is exacerbating were initiated in the obelisks' stonework long before their journeys to London and New York.

Key words

Obelisk, Cleopatra's Needle, London, New York, granite, stone, conservation

INTRODUCTION

Cleopatra's Needles in London and New York belong to a family of 55 known Egyptian obelisks which were relocated throughout the world in the nineteenth century. The London and New York Cleopatra's Needles are considered to be magnificent examples of ancient culture. The London obelisk is situated on the Victoria Embankment, Westminster, between Hungerford Bridge and Waterloo Bridge and between Charing Cross and Temple Underground stations. The New York obelisk is situated in Central Park, adjacent to the Metropolitan Museum of Art.

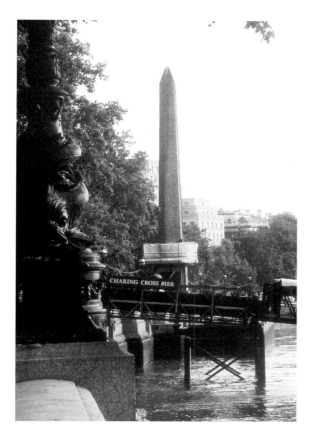

Figure 1 The London obelisk on the north bank of the River Thames, central London. (Nicola Ashurst)

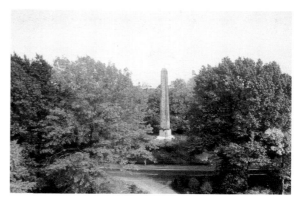

Figure 2 The New York obelisk in its Central Park location. (George Wheeler, Metropolitan Museum of Art)

Both obelisks are were first erected at An (Heliopolis) in about 1500 BC and are therefore approximately 3,750 years old (Figs 1 and 2).

The London obelisk was presented to the British people in 1819 and, after a lapse of about half of a century, reached London on January 20th 1878. It was placed in the care of the Metropolitan Board of Works by the Monuments (Metropolis) Act of 1878. Responsibility for its care passed to the London County Council in 1889 and to the Greater London Council under the London Government Act of 1963. Since then it was looked after by London County Council and is now under the care of Westminster City Council.

Common to their histories, since taking up residence in London and New York, have been periodic letters and articles of alarm in the press attributing blame for their condition to their current environments. A recent outburst of this phenomenon

in London was an article in *The Times* entitled 'Time to Save Cleopatra's Needle from London?'

Work begins this week on assessing structural and pollution damage to Cleopatra's Needle as fears grow that one of London's best known, but perhaps least appreciated, landmarks is in jeopardy. Pressure is growing for it to be moved from its exposed position by the Thames, alongside the busy and fume-choked Embankment, to a place of safety, such as the British Museum. Over the weekend, engineers from Westminster City Council delicately scraped samples from the 3,500-year old obelisk, which was once rose red but is now a grubby grey. After analysis of the granite chippings, a decision will be made on cleaning the monument. Sandblasters or high-pressure hoses would cause more damage, further eroding the inscriptions which celebrate the victories of Pharaoh Tuthmosis III. Conservationists will rely instead on sponges and buckets of hot soapy water. (Frost 1996)

This article set the scene for the most recent investigation of London's Cleopatra's Needle. In keeping with many such articles written since 1878, much of this one is misleading.

Historical records and associated authoritative evaluations of condition can be located for both the obelisks. An understanding of factors in their Egyptian histories shows how significant these have been as contributors to their current conditions. Information since their arrivals in London and New York can be added to the equation to convince that neither

Figure 3 The New York obelisk on point of leaving Alexandria for its journey in the hold of the transportation ship The *Dessoug*. (Metropolitan Museum of Art)

obelisk is in imminent danger of major deterioration. Key documents substantiating this assertion are listed in the references below.

ORIGINS AND EGYPTIAN HISTORY

Beginnings at the Temple of An (Heliopolis)

The London obelisk is approximately 20.88 metres (68 foot 5½ inches) high, weighing in excess of 168.7 tonnes (186 tons). It is about 3,570 years old, and passed the first 3½ millennia of its history in Egypt. Only the most recent 120 years have been spent in London.

Both the London and New York obelisks were hewn as monoliths from the granite quarries of Syene in the Aswan district of Upper Egypt. They were first installed flanking the entrance of the Temple of the Sun in An (or Heliopolis, about six miles north east of Cairo) by Pharaoh Thothmeses some time after 1570 BC. Their hieroglyphics were carved over a period of time, heavily promoting the personal virtues of the pharaohs to whom they refer. The obelisks remained in place in relatively moderate weathering conditions for approximately 1,000 years.

In 525 BC, when Egypt was subjugated by the Persians, the obelisks were vandalized. They were damaged by fire, possibly redressed and overthrown.

> Using thermoluminescence, the same procedure used to date ancient pottery, [the Objects Conservation Department of the Metropolitan Museum] found that the stone had in fact been in a fire at exactly the time of Cambyses, when the Persians pillaged and burned ancient Heliopolis. Because the obelisk had been toppled first, part of it had been protected from the flames by the sand of the desert. The south and west faces were badly damaged, however, and are unreadable in places. Most of the loss of stone over the centuries was from this exposed area.
>
> In addition, the toppled obelisk remained on its side, partially buried at Heliopolis for about 500 years until the Romans raised it in Alexandria. During this time it experienced Egypt's seasonal flooding and was further damaged by the action of salt crystallisation. The salt damage made the stone more susceptible to the effects of freeze-thaw cycles when it arrived here [in New York] in 1880 and went unprotected for almost five years. (D'Alton 1993, 70)

1900 years in Alexandria

In 12 or 22 BC, the obelisks enjoyed a rebirth of official regard as symbols of power of the state. They were exhumed by the Romans and transported to the harbour of Alexandria. They were erected on the sea shore and spent the next 1,900 years there.

In the years 1301 and 1303, at least two severe earthquakes shook Alexandria, levelling much of the city. The London obelisk was toppled and became completely buried, while the New York obelisk remained standing for the next six centuries (Julien 1893a). These additional six centuries of burial would have given more protection to the surface of the London obelisk granite than the New

York obelisk received in the open air. In 1801-2, the London obelisk was exhumed and examined.

The journeys from Alexandria

In 1878, the London obelisk was placed inside a cylindrical steel caisson. When the caisson was damaged by rocks at the waterfront, the granite was submerged in sea water for several days. It then began its journey, being towed back to London (Fig 3).

In 1879, the New York obelisk was encased in a wooden box and after ten days immersion in the sea was transported in the hold of a ship to New York (Fig 4). Both obelisks were submerged in the sea for a number of days. As these were one-off dunkings, a limited amount of salt could have entered and remained in the granite pores. This would not have had the cumulative effect of, for example, a repeated wet/dry cycle and the associated increasing amounts of deposited salt that damages stone. The limited amount of salt deposited in the obelisk by the dunkings would not have been responsible for any subsequent decay of the stone.

Since their relocations, the New York and London obelisks have been closely studied and their surfaces observed at regular intervals. The detailed records taken of the New York obelisk during the 1880s provide an invaluable database and reference point for further assessments of the obelisk's conditions. They include detailed photographs of each side. The London investigations were not recorded in as much detail and were less graphic, leaving us to rely more on current evaluations to establish conditions and rates of deterioration.

THE OBELISK IN NEW YORK

In February 1883, geologist Persifor Frazer examined chips of the granite of the New York obelisk and declared:

> The first thing that strikes one is the freshness and soundness of the rock. No 'maladie du granite' is observable, and this fact will answer the first and natural question as to why this rock was so much preferred by the Egyptians for monumental purposes. (Frazer 1883)

Figure 4 The London obelisk following its journey from Alexandria, in the process of re-erection on the north bank of the Thames. (Illustrated London News, September 21st, 1878, 53)

However, within a couple of years, small pieces of granite began to be found lying around the base and during the next year, 1884, fragments, sometimes of considerable size, began to fall. Four years and eight months after the New York obelisk's re-erection, it was treated with melted paraffin applied to an artificially warmed surface. Prior to this application, however, approximately 780 pounds of loose stone fragments were removed from the surface of the obelisk (Julien 1893b) (Fig 5). The historic records show 'that the new, rapid and extensive decay that became evident during the first few years of the obelisk's residence in Central Park occurred essentially entirely on the faces that had shown a prior history of decay before coming to New York' (Lewin et al 1983, 19).

In 1886 a report on *The Disintegration of the Egyptian Obelisk in the Central Park, New York*, was read to the American Society of Civil Engineers by Thomas Egleston.

> It was supposed when the Obelisk was brought here that it was in a perfect condition, and that it

Figure 5 View of the lower portion of the New York obelisk, north side. (George Wheeler, MMA)

Figure 6 Soiling to the front and rear sides of granite flake being removed from north side of the New York obelisk. (George Wheeler, MMA)

had not suffered at all by its exposure to the climate of Egypt for 3,500 years. A careful examination of the Obelisk itself, however, showed that this was not the case, but that disintegration has been going on for a very long time in the interior of the stone, which has only become apparent within a few months, owing to the fact that, until its erection in the Central Park, there were no causes which tended to attract attention to the weakness of the stone'. (Egleston 1996)

In 1889, a committee of eminent local scientists, engineers and Egyptologists examined the obelisk on behalf of the Commissioners of Public Parks and reported that there was no increased tendency for crumbling and that the general surface appeared sound and fresh, with no signs of recent disintegration. After the descaling and waterproofing treatments of 1884, this is not entirely surprising. Localized reapplication of the paraffin was, however, undertaken as a result of that inspection. (ibid)

In 1983, the Objects Conservation Department of the Metropolitan Museum of Art, New York, conducted a survey of the obelisk and subjected a few sample pieces to various tests to assess the true condition of the stone (Fig 6).

They determined that the obelisk is quiescent now, no longer in active decay. Contrary to periodic reports in local newspapers, the surface has not been much harmed by the polluted atmosphere of the city, beyond being further darkened by carbon deposits and slightly roughened. Most of the apparent damage took place a long time ago in ancient Egypt, and it was this damage that continued to be played out when the stone first arrived in New York. (D'Alton 1993, 66) (Fig 7)

In the conclusion to their report, the Museum's scientists write, 'The Obelisk is now stable, and its substance is one of the most durable of stones. It needs only the normal, routine maintenance care that such a tough, noble, irreplaceable example of an ancient culture merits. Any improvements to the stone, such as restoring it to it pinkish color, would require further study. Until such time, the safest treatment is no treatment at all.' (op cit, 70)

THE LONDON OBELISK

The following summary record of assessments and treatments to the London obelisk has been extracted from the definitive article by S G Burgess (Deputy

Chief Chemist of London County Council) and R J Schaffer, DSIR (Building Research Station, Garston, Herts) published in 1952, and from records of cleaning and consolidation treatment undertaken since 1949, provided by select papers from the files of London County Council and the London Division of English Heritage.

1878-79

The London obelisk was erected in September 1878 and application of a waterproofing compound commenced within a year. Scientists who examined the obelisk in July 1879 (Sir J W Bazalgette, Chief Engineer to the Metropolitan Board of Works) found that exfoliation of the stone was taking place and scales of some thickness could be detached, especially near the base, which would correspond to the fire-damaged portion of the shaft. They considered the damage to be due to the physical action of water and subsequent frost and recommended that a preservative solution, Browning's Colourless Preservative, prepared by the Indestructible Paint Company, should be applied. A solution reported to have consisted of Dammar resin[1] and wax in petroleum spirit was applied in several coats, starting with a very weak solution.

The stone was cleaned. There is no record of the nature of the soiling and how this was removed, nor whether any fragments of stone became detached.

1890

The obelisk was inspected by John Dixon CE who had been responsible for its transportation to London. He reported that he failed to detect any sign of decay. Interestingly, this information was reported by the Indestructible Paint Company, who had applied the Brownings Colourless Preservative solution in May 1879.

> After making a careful personal examination of the monument, my critical eye fails to detect upon its surface a sign of any decay whatever. Were there such, there could be no doubt there would be grains of the stone lying on the altar steps, and top of the pedestal. I climbed up and could not see one sign of any decay. I also could see glittering points on the surface of the solution

Figure 7 Portion of the south side of the New York obelisk showing the transition of surface conditions. (George Wheeler, MMA)

supplied to me by the skilled chemists of the British Museum, at the suggestion of my old friends Sir Richard Owen and Dr Birch, and of which two coats or washes were given with the greatest care. (Dixon 1890)

1894-5

In 1894, W J Dibdin and A R Binney (Chief Chemist and Chief Engineer to the London County Council) examined the stone of the obelisk to a height of 3.0 to 4.6 metres (10 to 15 feet) on the north east side and 9.1 metres (30 feet) on the north-west side. The predominance of decay was noted at the bottom of the obelisk (fire-damaged zone). The north-west face was found to be in a much worse condition than the north-east (probably the face that was exposed during the benign neglect period). Its surface was

covered with minute fissures and particles of granite could be easily separated. Pieces that could be separated from the north-west side were larger and apparently more decayed than those on the north-east, being weathered on both the outer and inner surfaces. A slight appearance of vegetable growth was also noted. The conclusion was that the monument should be re-treated. This work was carried out in 1895.

1910

In 1910, W E Riley and Dr F Clowes (Architect and Chief Chemist to the London County Council) inspected the obelisk. They found that fragments could be removed with the fingernail and that the posterior surfaces of these were soiled, confirming that water and soiling had been able to penetrate the fissures. They thought that the physical action of moisture and frost was the main weathering agent and that this was of a comparatively serious nature. However, one of the officers had also undertaken the examination in 1894 and was of the opinion that the condition in 1910 was similar to that observed on the previous occasion. Their inspection led to another recommendation that the stone should be cleaned and the preservative treatment renewed at intervals of no more than five years.

1911

In 1911, the stone was cleaned. There is no record as to how this was done. It was then treated with an ointment composed of solid paraffin or ceresin, partly dissolved in a suitable vehicle which was allowed to evaporate and then the surface warmed.

1917

In September 1917, the obelisk narrowly escaped destruction in an enemy air raid when a bomb exploded nearby on the Embankment pavement. A hail of shrapnel splinters pockmarked the pedestal and one of the bronze sphinxes but did not touch the obelisk. Several sections of bronze clasps were dislodged and the fixing clasps to at least one of these was broken.

In September 1969, the Historic Buildings Board of the Greater London Council discussed damage to the monument during the two world wars. Most of the damage had occurred during the First World War. As damage did not affect the obelisk, but only its nineteenth-century setting and did not add to maintenance, plus the fact that the war scars in themselves were felt to have historic interest, the Council resolved that war damage to Cleopatra's Needle, Victoria Embankment, be not repaired (Greater London Council 1969).

1932

The obelisk was washed down with pressure water from a fire appliance of the London Fire Brigade. Scaffolding was not erected and no report on the condition of the stone was made. No re-application of surface treatment was made.

1948-9

A preliminary inspection from temporary scaffolding led to the decision by London County Council that the stone of the London obelisk should be cleaned and treated with a preservative. Inspection from a full scaffold revealed the stone to be covered for the most part with a hard, black deposit which obscured much of the surface and which subsequently proved difficult to remove (Burgess & Schaffer 1952, 1027).

The pattern of soiling was similar to that recorded in 1894. Examination of the granite at higher levels revealed practically no sign of flaking, the amount present being quite small in relation to the total area. The tendency to flaking was most noticeable on the north-west and north-east faces where, under the dirt, some wax preservative was found as scales firmly attached to the stone.

> Before the work was undertaken enquiries were made through the UK Scientific Mission in Washington about the condition of the corresponding obelisk ... and about the treatments that had been applied to it. (ibid)

It is possible that the soiling of 1949 represented deposits on the granite since its re-erection in 1878.

The deposits were found to be very hard and quite insoluble in water. Lissapol N detergent (ethylene oxide condensate) was used in a 1%

solution of water with associated energetic scrubbing with bristle brushes to clean the less soiled parts of the south-east and south-west faces, but made practically no impression on other areas, even when wire brushes were used. (The wire brushing was found to have no effect on the granite, except to remove already loosened flakes.)

After experimentation, the remaining deposits were removed with a mixture consisting of nine volumes of carbon tetrachloride with one volume of benzene, emulsified with a 1% solution of Lissapol detergent.

On completion of cleaning, the surfaces were treated with a low melting-point paraffin wax 49°C (120°F) in a 10% solution of white spirit. Two applications were made and, after allowing the solvent to evaporate, the surface was gently heated with a blow lamp to melt the wax into the fissures. 'Regrettably, however, the stone subsequently darkened in colour and soon lost its freshly-cleaned appearance' (op cit, 1028).

1952

At the time of the 1948–9 cleaning and surface treatment, Burgess and Schaffer undertook analytical work on loose flakes collected from the obelisk in an attempt to determine the nature of the black surface deposit and to find an explanation of how it may have been formed and why it was so hard and intractable. They did not feel that their observations led to any firm conclusion, but they are recorded in their article of 1952 as matter of record. The key findings were that in thin section, under microscope, soiling was found to have an average thickness of about 5mm, being deeper within depressions in the stone surface. It was opaque and showed no sign of structure or of crystalline inclusions. Besides forming a superficial film, the opaque soiling was found to fill some, but not all, of the other fissures in the rock. It was deduced that those which had not filled with the black material were of comparatively recent origin. The film was felt to consist essentially of carbonaceous matter bound with mineral matter containing silicon and iron as the main elements. It was felt that the accumulation at the time could represent the whole period since the obelisk was erected in London in 1878 or at least a period of thirty-eight years.

1954

The inspection of 21st January 1954 noted that the granite had resoiled but that the hieroglyphics were still discernible. The surface of the wax applied after the cleaning did not appear to have been penetrated.

1966

In 1966, the obelisk was abrasively cleaned by Szerelmey Ltd. Copper slag abrasive 36–60 sieve was used at 'low' pressure. No surface treatment was applied.

1979

The next and most recent cleaning was in 1979 using the detergent 'Cleansolve' as supplied and applied by Antique Bronze Ltd. Analysis of the detergent at that time showed that it had a negligible sulphate determination. A 0.2% solution in tap water had a pH of 8.2 (Varley 1978). The selection of the detergent was made following in situ trials of it and a proprietary cleaning material based on hydrofluoric acid.

At present, no written record has been found of any inspection of the granite surfaces made at the time of the 1979 cleaning.

Post-1979

Regular inspections of the lower parts of the obelisk were made between 1979–86 by officers of the Greater London Council (GLC), but a thorough inspection of the whole of the obelisk has not been made since 1979 (Fig 8).

MOST RECENT STUDIES OF THE LONDON OBELISK

In 1992, the Department of Property Services of Westminster City Council, current caretakers of the London obelisk, sought the advice of Sinclair Johnston Consulting Engineers regarding the structural stability of the London obelisk and the advisability of its cleaning. Soiling deposited on the surface since the most recent clean of 1979 had begun to create a visually significant streaky weathering pattern, giving it an appearance, to some, of neglect. The technical

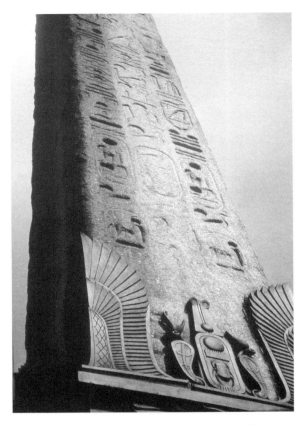

Figure 8 View of the lower portion of the London obelisk, west side. (Nicola Ashurst)

conservation practice Adriel Consultancy, which specializes in the cleaning and surface repair of historic masonry surfaces, working in collaboration with Sinclair Johnston, prepared a series of reports (Ashurst 1992, 1996, 1997a and 1997b).

One of the recommendations of the first report (Ashurst 1992) was that due to the complex history of physical and chemical intervention that the London obelisk had experienced as a result of cleaning and surface treatments, the high historical value of its surfaces and the effect of London's weathering environment, a detailed understanding of the surfaces and their current modes of deterioration was essential. To contribute to this, a programme of laboratory analysis was recommended. In preparation for this, in May 1992, an inspection from a mobile platform provided an overview of the condition of the three of the sides accessible from the road. Conditions observed at high level and low level were the same as has been

Figure 9 Details of surface and hieroglyph conditions within the middle zone of the London obelisk (Nicola Ashurst)

described in the literature so far.

The analytical work and associated investigations were undertaken in October 1996. Definitive analytical data would have required the comparison of exterior weathered surfaces with the interior of a core extracted from a discreet location on the obelisk. The analytical work nevertheless commenced by analysis of detached flakes. Adriel Consultancy worked with Lithan Ltd of Belfast[2], a specialist geological advisory service with experience in important dual aspects of the analysis of stones, particularly granite, and the interpretation of results into meaningful conservation and repair programmes. Inspection of the surfaces, the taking of samples and the design of the analysis programme was undertaken jointly by the two practices. Samples of loose flakes were taken from the four sides of the obelisk from within the lowest 2.1 metres (seven feet), generally within the confines of the bronze clasps. They were all therefore within the fire-affected zone (Fig 9).

FINDINGS OF ON-SITE AND ANALYTICAL WORKS

Surface inspections

Greater differences in surface conditions appeared to have been produced by the natural grain of the granite than the orientation of each of the faces. Conditions within washed and unwashed areas on each face were found to be similar. The obelisk surfaces were not friable, but spalling and scaling associated with surface fracturing, which was mainly parallel to the surface of the stone, was found to be taking place. Scaling losses were not evenly distributed on each face and orientation

Figure 10 Detail of surface of the London obelisk showing soiled granite on an area from which a loosely adherent flake was removed for analysis, 1996 (Nicola Ashurst)

Plate 1 x40PPL

Plate 2 x200PPL

Figure 11: Thin-section photograph of flakes removed from the London obelisk. 'The outer edge of the flake seemed to carry a layer of soiling which is somewhat similar to that previously reported. However, it is unlikely that such a remnant as the surface shown would not have survived the reported cleaning procedures. It is considered to represent current soiling related to the dark areas. The fractures extending across the section should be noted, together with those extending inwards from the outer surface to the left of centre.' (Lithan Ltd, 1996)

did not play a significant part in the observable level of loss. On all surfaces, soiling accumulation and algal growth could be seen beneath removed flakes (Fig 10). It could also be seen that fractures existed between the various constituents of the granite and within the feldspar constituent pieces.

Cleaning of the obelisk would only remove surface soiling. This would alter the appearance of the obelisk, revealing more of the natural pink colour of the granite, an exercise principally of visual improvement, rather than improvement in the condition of the granite. More frequent washing than a one-off cleaning programme would be necessary to remove loosely adherent soiling particulates which might deposit behind developing flakes within the surface. To materially contribute towards the stone's well-being this would need to be done annually and in each instance would need to be a carefully executed operation, probably requiring full scaffolding.

Key findings of the analysis (Kelly 1996)

From the chemical analysis:

- The presence of soluble salts was confirmed with the most likely candidate being gypsum. The total amounts of salts were considered small, although even in the quantities present, they would be having a small damaging effect. Other decay mechanisms were considered to be of greater significance.
- Sulphur (S) and iron (Fe) were found to have been depleted from the outer surface of the

granite, either due to weathering or previous cleaning. This is a new finding to previous literature on the London obelisk.

From the mineralogical analysis (the examination of thin sections): (Figs 11 & 12)

- Micro-fracturing was found to have affected all the components of the granite, particularly the feldspars. The system of fractures running parallel to the stone surface had affected granite in a

Plate 3 x200PPL

Plate 4 x200 XPPL

Figure 12 Thin-section photograph of flakes removed from the London obelisk. 'The plate shows firstly a crush zone in which a feldspar grain has been disrupted *in situ* and, secondly, that the constituents of the soiling to the surface can be at least partially attributed to the inherent mineralogy. While this damage is most likely of comparatively recent origin, it is similar to that which would be expected from the original working methods used to dress the surface. The debris appears to be fixed in place by the amorphous brown matrix which may be a previous treatment. The nature of the fractures should be noted.' (Lithan Ltd, 1996)

manner which over-rode the differentiating properties of its constituents. Within the feldspars, two further fracturing systems were found, one perpendicular to its outer surface and one relating to its natural cleavage. These fracture systems were found in all samples from all faces. They are the major determinant in the granite's current and future condition.

- Soiling was observed within all the fractures, the soiling comprising external particulates and/or products of breakdown from within the stone.
- The detailed constituents of the granite were identified. These included calcite which weathering forces could affect by dissolving or converting into soluble salts such as gypsum.
- Alteration products within some of the feldspars were found to be undergoing selective depletion by chemical solution.

From scanning electron microscopy (SEM):

- Detailed investigation of the soiling independent of the stone was undertaken. Soiling samples from beneath the flakes and on the outer surface of the obelisk were found to have similar constituents. Part of the soiling could be attributed to the mineralogy of the granite. In at least one sample, the soiling within a fracture was believed to be affixed by remains of a previous wax-based coating.

Analysis by infra-red spectroscopy (IRS):

- Small amounts of materials found are most likely paraffin waxes from previous treatments, although there are such small amounts present that they are not likely to affect the condition of the granite.

Strategic conclusions following analysis

THE MAIN MODE OF DETERIORATION

The effect of moisture and frost on the fracturing systems, rather than pollutants and inherent soluble salts, is the prime source of deterioration.

All orientations of the obelisk were found to be experiencing loss of surface flakes in a manner indicative of contour scaling. This mode of deterioration was primarily independent of the constituents of the granite.

The systems of fracturing to the granite surface are expected to open and close as the result of surface heating and selective water uptake. Debris within fractures will enhance this by having a wedging effect. The depth of this system of fracturing and fracture systems running at angles to the stone surface is not known and will not be determined unless cores are taken and analysed. Environmental

data for the site shows that the action of freeze-thaw should be expected to be a significant decay factor.

The fractures will therefore continue to be affected by moisture/frost and temperature in their current environment. This is the particular mode of deterioration of this piece of external stonework.

ANALYSIS INFORMATION FOR THE PROPOSED SURFACE CLEANING PROGRAMME

The analytical work confirmed that cleaning of the surface granite would only remove the light level of soiling adherent to the surfaces, but would not deal with any soiling within fractures or behind partly detached flakes.

The analysis confirmed the advisability of testing a range of detergents during the trial cleaning programme with the possible extension of materials to include white spirit and a biocide to kill algae growths.

It was also advised that all cleaning procedures would need to be adopted very gently, controlling and minimizing the amount of water used and avoiding water freezing.

SURFACE STABILIZATION

Surface treatment: Materials applied to stabilize the granite surfaces were deemed unlikely to be effective due to the surface fracturing systems. These materials should certainly not be applied unless all the necessary investigations are undertaken. Essential to this would be the taking of cores as comparison between weathered and unweathered zones.

Reattaching flakes: The possibility of reattaching loose flakes by injection of free-flowing adhesive to their rear would require removal or reduction of soiling from the rear and injection into a dry void. The practicalities of achieving successful removal and readhesion would need to be tested on a flake by flake basis using the skills of a stone conservator. The overall success of such an operation could not be predicted and could only be determined on observation of completed work.

Recording and monitoring the obelisk surfaces

Because of the existing fracture systems, it was acknowledged that the surface of the granite

would continue to lose flakes, unless moisture and/or frost and soiling could be prevented from entering its surface.

While the analytical work has contributed to the establishment of a deeper understanding of the stone and its condition, it is unable to provide advice as to the condition of the obelisk when it was installed, at what rate breakdown took place subsequent to that and at what speed it will continue to operate.

For these reasons, it is important for a detailed record of the granite surface conditions to be prepared to record current surface conditions and provide a basis for monitoring and detailed comparison in the future. Thus the rate at which the monument is deteriorating may be determined.

It has been recommended that the surface monitoring be undertaken using stereo-photography. When viewed in three dimensions, these photographs enable small surface variations to be detected. Stereo photographs can either be compared at a future date to the real stones or to subsequent photographs. Because of the nature of losses being experienced by the obelisk, this method should prove very useful in the recording and monitoring of its surface.

A proposal has been developed for stereo-photography monitoring at three scales:

- All surfaces of all faces would be first photographed at very large scale, the whole of each side being captured in one or two photographs. These would serve as an overall record of the surfaces and their hieroglyphs, as well as providing a locational base for smaller-scale photographs.
- Surfaces would then be recorded at an intermediate scale of approximately three to five photographs per side (top, middle and bottom).
- The third level of recording would involve stereo-photography of a select number of areas approximately four foot square. These would be at a range of heights on each face and record conditions of sound, intermediate and more heavily degraded granite. They would be selected to be within the top sound zone, the fire-affected bottom zone and the zones affected by partial submersion during the phase of benign neglect.

During the next cleaning operation the scaffolding would also enable the British Museum to record the hieroglyphs on a 1:1 scale.

Further analysis of the granite

While analysis of surface flakes has provided a good amount of very important and useful information, there is still inadequate understanding of the granite in its unweathered form and the depth of surface which has been affected by the fracture systems already described. The option of taking a core of granite from a discreet location behind the bronze clasps will be pursued. (Some of the clasps need to be removed to enable clearing out, inspection and resecuring.)

The bronze elements

Generally, the surfaces of the bronze leaf elements were considered to be sound. The level of corrosion in a few localized areas of coating breakdown is superficial at this stage, as is the corrosion/alteration caused by bird droppings. Of greater concern is the displacement of the bronze sections. The clasp of at least one of these is broken and the unit sits unattached.

Removal of the existing wax and its replacement is also recommended. This would be in keeping with the maintenance procedures undertaken on the sphinxes and the many other bronze sculptures in Central London.

PROCEDURES AND RESULTS OF ON-SITE CLEANING TRIALS

On-site cleaning trials were undertaken in June, 1998. The works were overseen by the author and were executed by Stonewest Ltd.[3] The trial cleaning areas were located on the north-west elevation of the obelisk to areas confined by the bronze leafage.

A series of conservation-grade detergents were assessed in the knowledge that they would achieve a safe method of cleaning, possibly without 100% removal of soiling.

The materials trialled were (as described on product data sheets):

- Cleansolve Solution 207 - 'a fatty acid salt of substituted cyclic alcohol (potassium methyl cyclohexyl oleate)',

- Synperonic N - 'an aqueous solution of a condensate of nonylphenol with ethylene oxide',
- Vulpex liquid soap - 'a fatty acid salt of substituted cyclic alcohol (potassium methyl cyclohexyl oleate)'.

The soaps were effectively diluted in water. Due to the success of the results, it did not seem necessary to use white spirit which would have provided additional operational difficulties.

The cleaning materials were applied and the granite surfaces agitated with soft, compact, crinkle-wire phosphor bronze brushes. While extreme caution was exercised at all times during the works, it proved difficult, even with forceful scrubbing, to detach any flakes of granite. Surface rinsing with low-pressure water further confirmed the tenacity of the granite surfaces.

A good level of cleaning was achieved by all the cleaning agents. The on-site trial works also revealed that the surfaces of the bronze were generally in very good condition and that removal of the existing wax prior to rewaxing would be readily achievable using hot water under low pressure (Fig 13).

CONCLUSIONS AND FUTURE OF THE LONDON OBELISK

The deterioration that the London obelisk is now experiencing is not new, not to this decade and not even to the last 120 years in the London environment. The rate of loss to surfaces is very small since the obelisk's arrival from Alexandria.

The obelisk is made of a high-quality granite. London's pollutants are not the major source of decay, but, rather are secondary to moisture and frost. However, it must be remembered that the obelisk's surfaces are riddled with microfracturing systems which freeze-thaw weathering cycles are able to exploit.

Any losses to the obelisk surface are always of concern. The fact that it is an irreplaceable example of an ancient culture means that detailed recording and ongoing monitoring of its surfaces from the large scale to the small scale are important. Not only will this recording provide an important, detailed record of the obelisk's surfaces, it will enable quantification of any further losses. The small-scale defects within the obelisk's surface mean that while major losses are not being experienced, there is

nevertheless a responsibility to routinely inspect the granite surfaces and a commitment to review small-scale developments within its surface conditions.

ENDNOTES

1. Dammar resin obtained from Dipterocarpaceae (genur Shorea or Hopea) trees growing in Malaysia and Indonesia and used as high quality clear varnish.
2. Lithan Ltd. 39 Newton Park, Belfast, BT8 4LL. Tel.: 01232 701479.
3. Stonewest Ltd., Lamberts Place, St. James Road, Croydon, CR9 2HX. Tel.: 020 8684 6646

REFERENCES

Ashurst N, 1992 *Cleopatra's Needle, London - Initial Assessment of Cleaning and Surface Repair Requirements,* research report for Department of Property Services, Westminster City Council.

Ashurst N, 1996 *Cleopatra's Needle, London - Findings of the Analysis Programme and the Associated Investigations,* research report for Department of Property Services, Westminster City Council.

Ashurst N, 1997a *Cleopatra's Needle, The Embankment, London - Specialist Technical Stonework Report No.3 - Results of the On-site Cleaning Trials,* research report for Department of Property Services, Westminster City Council.

Ashurst N, 1997b *Cleopatra's Needle, Specification for the Cleaning of the Granite to the Shaft, Bases and Paving and Repointing of the Bases,* research report for Department of Property Services, Westminster City Council.

Burgess S G AND Schaffer R J, 1952 Cleopatra's Needle, in *Chemistry and Industry,* 1026-1029.

Coe J A, Sherwood S I, Messerich J A, Pillmore C L, Andersen A and Mossotti V G, 1992 Measuring stone decay with close-range photogrammetry, in *Proceedings of the 7th International Congress on Deterioration and Conservation of Stone,* **2**, 917-926.

D'Alton M, 1993 *The New York Obelisk or How Cleopatra's Needle Came to New York and What Happened When It Got Here,* The Metropolitan Museum of Art, New York.

Dixon J, 1890 letter, in *The Times,* May 28th 1890.

Egleston T, 1886 The disintegration of the Egyptian obelisk in the Central Park, New York, in *Transactions of the American Society of Civil Engineers,* **XV**, 319.

Frazer P, 1883 Cleopatra's Needle: Mineralogical and chemical examination of the rock of the Obelisk, in *Transactions of the American Institute of Mining Engineers,* **XI**, 353-79.

Frost B, 1996 , Time to Save Cleopatra's Needle from London?, in *The Times,* Monday September 2 1996, 6.

Greater London Council, 1969 Minutes of the Historic Buildings Board, September 1969, file ref. GLX/DG.PT1/H/2/29 CA to COL.

Johnston S, 1992 *Report on the Condition of Cleopatra's Needle*

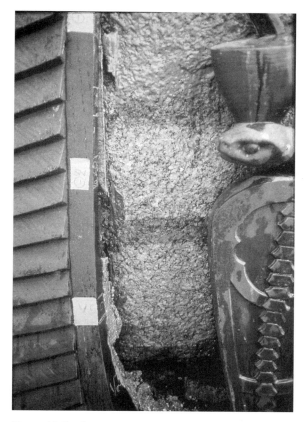

Figure 13 Final appearance of cleaned surfaces achieved during the 1997 on-site cleaning trials utilising dilute conservator detergents only with associated brushing with fine, crinkle-wired phosphor bronze brushes and low pressure water rinsing. (Nicola Ashurst)

(with Adriel Consultancy), internal report, Department of Property Services, Westminster City Council.

Julien A A, 1893a A study of the New York Obelisk as a decayed boulder, in *Annals N.Y. Academy of Science,* **VIII**, 93-166.

Julien A A, 1893b The misfortunes of an obelisk, in *Bulletin of the American Geographical Society,* March 1893, 66-137.

Kelly J, 1996 *Cleopatra's Needle London, Condition: Analysis: Recommendations.* research report by Lithan Ltd.

Lewin S Z, Wheeler G E and Charola A E, 1983 *Stone Conservation and Cleopatra's Needle: A Case History and an Object Lesson,* Department of Objects Conservation, Metropolitan Museum of Art, New York.

Varley P, 1978 internal memorandum to Nigel Bridger (for Scientific Advisor), Greater London Council, Inner London Education Authority, 14 May 1978

Weiss N R, 1995 Chemical treatments for masonry: an American history, in *APT Bulletin,* **XXV1** (4), 9-16.

ACKNOWLEDGEMENTS

The author would like to acknowledge the assistance of the following people in the preparation of this paper: Dr George Wheeler, Research Chemist, Metropolitan Museum of Art, New York; Mike Stock, Senior Architect, London Division, English Heritage; Sinclair Johnston, Principal, Sinclair Johnston Consulting Engineers, London; the Department of Property Services, Westminster City Council, for permission to use parts of reports prepared for them; and Norman Weiss.

Author

Nicola Ashurst trained as an architect in Australia, completing postgraduate conservation degrees there and at ICCROM in Rome. Her working career has included six years with the Technical Advisory Service of English Heritage. Since that time she has operated Adriel Consultancy, a specialist practice providing professional technical input into the cleaning and surface repair of external stone and other traditional masonry materials.

18

The Scott Monument, East Princes Street Gardens, Edinburgh
The cleaning debate

Ingval Maxwell

Historic Scotland
Longmore House
Salisbury Place
Edinburgh EH9 1SH, UK
Tel.: 0131 668 8619
Fax: 0131 668 8620
ingval.maxwell@scotland.gov.uk

Abstract

In 1992 a Public Local Inquiry was held in Edinburgh to determine if listed building consent should be granted to clean the stone of the *Scott Monument*, situated in the city's East Princes Street Gardens. Following 23 days of hearings, submitted evidence and cross-examination, the determining issue was identified as being whether or not the potential benefits of cleaning would outweigh any risk of harm to the monument. After careful consideration of the evidence presented at the inquiry, and of the Reporter's findings, the Secretary of State for Scotland concluded in March 1994 that listed building consent to stone-clean the monument be refused.

This paper explores the physical evidence of surface soiling and weather erosion on the monument, how this was assessed and presented to the Inquiry.

THE *MONUMENT*

Following the death of Sir Walter Scott in 1826 an intense period of national mourning culminated in the completion of a monument to him in 1844. The consequence of a competition, it was designed by George Meikle Kemp, a carpenter by trade and, reputedly, a self-taught architect. Rising as a great steeple to over 61m (200 ft) in height it was modelled on Gothic architectural details, found at Melrose Abbey in the Scottish Borders, and on the continent.

A Category A listed building, it is described in the Secretary of State's *List of Buildings of Architectural or Historic Interest* as:

Scott Monument, East Princes Street Gardens,

Princes Street, Edinburgh. G M Kemp 1840–44. Statue of Sir Walter Scott, Sir John Steele, marble 1846. Gothic, Melrose detail, 200' 6'' tiered spire with flying buttresses. Statuary added to complete original scheme 1874, 1876, 1882.

Its square plan form extends in diminishing steps over five stages, the lowest of which is surmounted by distinctive diagonal buttresses. Constructed on the site of an earlier stone quarry, its foundations extend some 16m (53 ft) below the level of Princes Street (Fig 1).

Kemp, who had submitted the design under the pseudonym John Morvo, the medieval master mason of Melrose Abbey, did not live to see the monument completed, as he died in a drowning accident in the Union Canal in 1844.

Figure 1 The *Scott Monument*, Edinburgh, situated on the open south side of Princes Street, it is a prominent feature in the Edinburgh skyline. (Ingval Maxwell)

BINNY SANDSTONE

The *Monument* was specified to be constructed of Binny sandstone from West Lothian. This stone was transported for most of its journey to Edinburgh along the canal in which Kemp died. The stone, well-known for its natural waterproofing qualities, was quarried from between the shale oil beds that were ultimately to spawn the district's flourishing paraffin oil industry in the later half of the nineteenth century.

Three quarry outlets (in 1858) supplied Binny Stone from around the village of Uphall (NT 057730). Coming from the Lower Carboniferous geological period in the upper oil-shale group, the stone emerged with a fine-grained pale-yellowish/brown hue.

In hardness Binny stone has a Schmidt hammer rebound number of 30, a mass density of 2160 kg/m^3 and a porosity of approximately 16%. Its earliest referenced use is in 1794, and it ceased to be worked about 1899. It was latterly used only for monumental purposes.

LISTED BUILDING CONSENT

Where listed buildings, or buildings in a conservation area, are concerned, Scotland differs from the rest of the United Kingdom. In acknowledging that physical changes in stone can occur as a result of the techniques used, stone cleaning has been deemed to be an 'alteration' since 1992. This definition has required that all proposals to clean listed buildings

require listed building consent or, in the case of unlisted buildings within a conservation area, planning permission. Such an approach had been determined necessary to ensure that appropriate damage limitation decisions were made as part of the project consideration.

In consequence of official deliberations following the application by the owners for listed building consent to repair and to clean the *Monument*, consent to repair was given but consent to clean was refused. This decision was appealed and, as a result, a Public Local Inquiry into whether or not the *Monument* should be cleaned was arranged.

SOILING

Since its construction, the five-stage *Monument* had soiled in a variable manner through a complicated process of interactions between the qualities of the original Binny stone, its siting, orientation and exposure, micro-climatic effects and architectural detailing. It had not weathered uniformly and, in some areas, soiling had progressed into erosion cycles.

In considering whether or not to clean, the complexities involved were, perhaps, the most intricate and difficult that have ever been encountered. The uniqueness of the design, the quality of finish, and high artistic content of the sculptural detail and subject matter, dictated that no risks should be taken. While inevitable natural forces were at work, it was considered inappropriate that these inherent difficulties should be compounded by the application of techniques which could physically, chemically or aesthetically subject the structure, and its detail, to other unnecessary dangers that could exacerbate the rate of natural decay.

Background photographic evidence

Although it is impossible to date precisely early photographs of the *Monument*, it is possible to put them into a chronological sequence by taking account of the development of surrounding growth, the addition of statuary to the canopied niches and the emergence of more recent buildings captured in the background. As a result of reading such sequences it is possible to determine the fact that visual tonal changes of the surface, in the broadest sense,

occurred progressively. Through the careful identification of individual stone blocks, it is feasible to plot their increasing visual density on the black and white photographs. While care had to be exercised during such interpretation, it was generally noted that the more exposed projecting carved details, such as crockets, finials, parapet copes tracery and corbel work, tended to darken down progressively faster than plain-faced ashlar. The systematic emergence and placing of new sculpture on the structure was also readily seen by the pristine lighter tones of the new stone, evident even in shadow-covered areas. These pieces eventually toned down with exposed weathering, and this visual change was noted when comparing a sequence of similar-viewpoint photographic editions.

Fifth stage

Given the extremes of exposure to which it is subjected the uppermost fifth stage is less uniform in its soiled appearance than it ought to be. While the apex, and all upper crocketed arrises of the eight-facet spire are uniformly dense in appearance, the plain-face facets display a surprising amount of raw stone. In part this is due to surface erosion but, more significantly, it is also due to recent surface re-tooling.

The same is true of the Cap-House, below the upper canopied niche levels, where five-tooth chisel work had been taken over the otherwise polished faces, thereby driving the surface back into raw, unweathered material. Abrasive carborundum-block rubbing techniques have also been used on the surface in the vicinity of beds and other details. Both actions have combined to produce visually lighter surface patches.

Finials, canopies and statuary are uniformly soiled, although two, relatively clean, replacement finials (c 1970 and of different stone) have been set into the surrounding parapet on the west face. Parapet copes are uniformly soiled, while pierced quatrefoil panels are less densely coloured as they display some signs of surface erosion.

An analysis of the outer soiled layer revealed that it was between 20 and 100 microns in thickness. With few exceptions this factor was found to be the situation over the entire monument.

Figures 2 (Top) and 3 (Bottom) Soiling: characteristically all upward-facing surfaces (Fig 2) and high surface area to volume features, such as finials, crockets and weather shedding faces (Fig 3), soil to a uniformly dense tone. (Ingval Maxwell)

Fourth stage

Of all the levels, the penultimate fourth stage displays the most uniform pattern of soiling with projecting sculpture, finials, expressed pilasters, hood mouldings and carved detail emerging uniformly dense in tone. Viewed from the fifth stage above, virtually all direct water-collecting upper surfaces are uniformly dark in tonal unity (Figs 2 and 3). The vertical surfaces are generally in a sound condition, although some localized weather erosion exists in the vicinity of joints and beds, around the arrises of some moulded work and in the vicinity of more sheltered drying out zones, such as under overhangs, projecting corbels and moulded work. Micro-climatic soiling variants are evident on bottle mouldings and on associated cavettos. Here, the surface tonal density can vary over a considerable range on the same stone. Associated contoured soiling of a segmental profile is evident around openings, and on wind divide arrises.

Localized erosion is evident where drying out airflow movements are high, and some associated surface breakdown is evident in the vicinity of a few masonry beds. Here, deterioration had progressed a distance of 6 to 8mm (¼–³⁄₈ ins) into the stone, occasionally penetrating up to 15mm (⁵⁄₈ ins) or more. Otherwise, arrises and sculptured detail remain sharp, and stones were found to be in a good, sound, original polished condition.

Third stage

Stage three differs from stage four in that there is less uniformity in soiling on the plain-face ashlar work than at the higher level. However, exposed features, finials, string-courses, hood mouldings, expressed wall shafts, tracery and weathering set-offs are uniformly and densely soiled. Here a consistent factor is the greater surface area of individual stones and features exposed to the elements (and therefore water intake), than plain-faced work. On all rectangular corner buttresses, wind-divide arris-soiling is evident. Characteristically, this is expressed on individual stones as a local segmental, or triangulated, profile extending onto the various faces in a pattern which relates to the alignment of mortar bedding. Triangular and parallel profile soiling also extends around vertical joints in plain-face work, and a

variety of tonal ranges are evident on individual ashlar blocks. Fresh-coloured stones exist in the sheltered recesses, behind the pointed lancet arches that carry the fourth stage parapet and platform deck. Significantly, the weather-susceptible projecting archwork, crockets, capitals and cusps have taken up uniformly deep soiling patterns, similar to that of the underlying interlaced tracery work. Here, air movement can consistently deposit high levels of moisture on the greater water-holding surfaces of these individually moulded areas. Vertical patterns of leeward- and windward-related soiling are also evident on the wall shaft bottle and cavetto details of the central lancets, and these consistently run in parallel with the architectural design features, crossing over many individual stones in the process (Fig 4).

A 'rising damp' type of erosion pattern exists on the lower half of the pierced balustrading at the third (and fourth) stages. Some associated surface decay is also evident on the corbelled course immediately below the decking.

Plain ashlar, associated wall shafts and moulded work display variable degrees of soiling over a wide tonal range, emphasising the range of surface variations associated with individual stone blocks. In some circumstances, concentrated pockets of ferrous staining breaking through to the outer surface are also revealed. Additional consistent and regular patterns of light soiling are evident in the vicinity, and alignment, of many joints and beds on the plain-face buttress returns.

In general, arrises remain sharp, and the original surface polish is evident on much of the masonry at this stage. However, some variable degrees of decay and erosion have worked through the outer soiled surface to reveal a mineral-rich underlayer in sheltered drying-out zones. Particularly noted in the cavetto, adjacent to the lower terminating capitals of the interlaced tracery, these variable profiles can be related to the diversity in micro-climatic air movement, direction and orientation.

In-depth contour staining has created a soiled profile, some 30–44mm (1¼–1¾ ins) deep, which picks up the curved architectural profiles on the corner buttresses set-offs. Variable degrees of surface erosion are evident in the adjacent curved niches, and associated run-off zones.

Second stage

As a direct result of the greater degree of free-standing exposure to the atmosphere and all-over weathering, the entire corner pinnacle assemblies, flying buttresses and terminating finials are more uniformly and densely soiled than the integrated plain-faced work. A few lighter coloured blocks where the underlying core material is exposed reveals that localized surface erosion has taken place. Consistently, contour scaling is evident on the flying buttress, lower-half, upper-face weathering. Here, and on a few broken crockets, the processes of dark tone resoiling is evident on exposed core material. Algal colonization occurred on the south-west pinnacle east face, indicating that biological growth could become readily established, given the correct conditions.

Sculpture is uniformly and densely soiled, although a less soiled piece is evident on the north-west face of the north-west pinnacle, indicating the use of a stone other than Binny.

Wind-divide segmental-soiling exists on virtually all arrises, and wind-blown surface staining run-off patterns extended over a variety of stones, irrespective of bed alignment and detail.

Soiling patterns, picking up the underlying stratigraphy of individual ashlar blocks, can be seen where dark-toned vertical, horizontal and inclined banding emulates underlying natural geological beds of variable mineralogy.

Second stage platform deck

Of all the soiling and weathering zones on the *Monument*, the two-metre strip extending below the decking on the corner buttress projections consistently displays the greatest degree of surface erosion and breakdown. Directly attributed to water penetration through the platform, surface breakdown is evident to a variety of degrees in the fifteen ashlar courses between the deck and the capitals of the underlying pointed arch rings. Here, stones in the continuous corbel course, plain-face ashlar and integrated blind arcading, have lost much of their original surface, exposing an iron-rich orange/brown coloured underzone to the elements (Figs 5 and 6).

Nearby sculpture, canopied niches and more exposed outer masonry, including project gargoyles

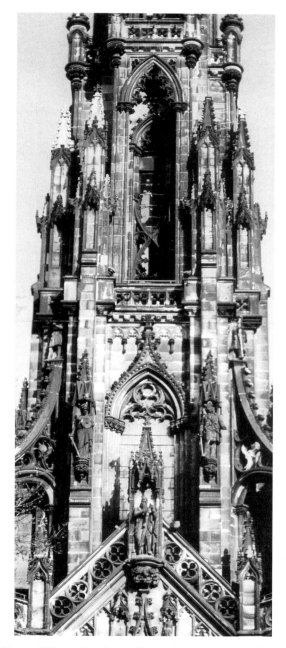

Figure 4 Vertical surface soiling is by no means uniform. On the plain ashlar faces of the third and fourth stages some blocks have hardly soiled at all. Others are partially soiled with a clear sub-division evident on the stone, while protected recessed planes generally are only lightly soiled. Variable microclimatic soiling effects are also evident on wind-divide arrises and in the cavettos of the complex architectural pilaster shafts. (Ingval Maxwell)

Figures 5 (top) and 6 (right) Erosion: below the second stage platform both ashlar and moulded work is slightly eroded due to penetrating rainwater through the structure (Fig 5). While not creating any constructional distress, the loss of moulded work has occasioned an aesthetic lacuna (Fig 6). A 'rising damp' erosion profile is also evident on the pierced parapet work above the platform. (Ingval Maxwell)

and set-offs, on the other hand, have retained the overall dark soiling without surface loss. Interface soiling run-off patterns are evident where the masonry tails of this work integrates with the more persistently saturated plain ashlar structure.

Variable degrees of erosion are evident in the disrupted surfaces and associated contours relate, through orientation and exposure, to areas where drying-out air movement across the surface is liable to be high.

A 'rising damp' erosion pattern is evident on the quatrefoil and blind-face parapet panels, where under-drip erosion is also evident below the surmounting cope. Densely soiled masonry retains its original arris and polish while adjacent eroded stone (even on the same block) loses much of the surface detail. More exposed sculpture, crockets, finials and canopies are generally darkly and uniformly soiled, although air-movement soiling profiles are evident in the form of contours. These follow the profile of curved bottle work on the segmental arch rings.

Variable degrees of soiling density are evident on individual stone blocks, where the naturally inherent geological stratification is also apparent in banded tones. On the eroded facework variable hues of rust-brown coloured contouring is evident on a number of blocks, and a small degree of surface efflorescence, on the first three courses underlying the platform deck on the east elevation, can also be observed.

Algal surface growth is evident on the uppermost parapet cope, and gargoyle, at the extreme south-east corner.

Some contour scaling is apparent on the surface breakdown erosion zone, where adjacent remnants of the original polished surface still remain. These scales are peeling away from the underlying block in profiled contours some 2–3mm ($^1/_{12}$–$^1/_8$ins) thick. Although visually disruptive they are of no structural concern.

A similar situation to that identified on the third stage exists in the parapet gable profiles over the central principal arched openings. Here, carved detail, sculpture and pilaster work, free-standing from the *Monument*'s integrated main build, are uniformly soiled black. Plain-face work, set as infill to blind arcading and under corbel and cope projections, is less heavily soiled. Generally, arrises are sharp and true, sculptured detail relatively intact and much of the original polished surface remains. As elsewhere, some deep tonal variation exists in the soiling where this is associated with localized surface water run-off at the extremities of architectural detailing, and at planes of interpenetration.

Some opening up of the natural beds has occurred on parts of individual stone blocks where surface erosion has also removed strips of the uniform dense soiling. These cut across the original tonal variations.

Figure 7 Soiling: the cluster columns and buttress work supporting the second stage platform display a complex series of wind-divide and micro-climatic originated soiling. This relates to air movement and rainwater wetting profiles and extends over the architectural details on common vertical alignments, irrespective of the underlying course work or geology. Some additional geological variations on individual blocks are also evident. (Ingval Maxwell)

First stage

Extending up from the lower platform, the four central complex clustered columns display a wide variety of soiling tones and densities. This directly relates to orientation, exposure and prevailing air movement directions. Over the height of the columns visually evident vertical contours delineate junctions between principal and secondary wetting and drying zones. The integrated cross-section geometry of wind-divide arrises, cylindrical drums and projecting bottle nibs contributes to the multiplicity of these patterns, which extend uniformly over the column height independently of natural bedding patterns (Fig 7).

Figures 8 (left) and 9 (top) Soiling: localised variation in soiling is evident in the vicinity of architectural profiles and inclined weathering slopes. Dense profiles can be found on the return face of stones that reflect the architectural moulded detail of the weathering face (Fig 8). Consistently, inclined slope soiling extends some 25–40mm onto the face, and can cross over individual blocks in alignment (Fig 9). Associated bands of slightly eroded facework can often be found in parallel alignment. (Ingval Maxwell)

Additional micro-climatic effects are also evident in the top two courses below the projecting capitals. Here segmental profiles reveal variations in air movement that relate to projecting and run-off surfaces. Predominantly horizontal surface variations in soiling tone also reflect the underlying stratigraphy and mineralogical variations that exist in individual stone blocks. Further soiling complexities are evident in horizontal and vertical bandings associated with joints and beds, and localized concentrated surface water run-offs produce mineralogical soiling in the vicinity of capitals and set-offs on the underlying ashlar. Associated localized patches of erosion are evident, although original arrises and moulded detail have stayed sharp and polished surfaces remain true.

First stage platform

Localized erosion, in the form of contour scaling, is evident on the horizontal ogee course that acts as the platform's perimeter cope. Related to the high degree of surface water run-off, significant resoiling has taken place where the original surface has been lost. This has occurred to such a degree that the tone and density now virtually repeats that of the original adjacent soiled colour on the same stone.

Following the vertical rise and horizontal tread alignment of the access steps a rising damp erosion contour exists above a profile that retains the original polished surface. This is evident on the terminating corner buttress plinths. Above this, in the wetting and drying zone, the band of surface erosion penetrates the stone to a depth of 3–6mm ($1/8$–$1/4$ ins).

Variants in the mineralogical make-up of individual blocks are evident in the form of brown rust contour staining and stratigraphic banding relating to the natural bed alignments of the stone.

Micro-climatic effects in the form of concentrated run-offs are evident below the ogee cope on the south-west buttress plinth, west face, and south-east plinth, south face, where segmental soiling and erosion profiles exist on the uppermost plain face ashlar. Rising damp mineralogical profiles are also evident on the reprise of the vertical plain-face ashlar that terminates the inward stepping weathering at the buttress base (Figs 8 and 9).

Close examination of the polished ashlar reveals an inherent mottled surface soiling effect. This relates to the natural bed alignment and a variety of exposure circumstances.

Arrises and polishwork remain remarkably intact and true to the original finish throughout the platform.

On the central monolithic block that supports the *Sir Walter Scott* statue by Steele, deep tone wind-divide arris segmental-staining on the north and south faces contrasts sharply with the otherwise light degree of soiling that exists on the two other faces. This also contrasts with the high level of overall soiling that exists on the east and west faces. Wetting and drying erosion breakdown is also more evident on the north and south faces, suggesting a complexity of microclimatic effects at work in this the most sheltered spot of the entire *Monument*. In reality, air movement through and between the surrounding cluster columns and buttresses is very high indeed.

BINNY STONE: VISUAL ASSESSMENT

Where surface decay and erosion have taken place this allows an insight into the soiled patterns of Binny Stone. As a result, a number of consistent zones become visually evident in the outer 25mm (1 ins) of the stone in cross-section. Bearing in mind the stone's 16% porosity factor, and the negative weathering effect of the monument's design, the stonework can be, and has been, subjected to high levels of rainwater saturation.

Where the original exposed polished faces remain, a variety of tonal effects are evident although, in the main, surface soiling tends towards a very dark brown/blue/black hue. The extreme dense tone can be directly related to a pattern where the monument's architectural or sculptured elements of a high surface area to volume ratio are subjected to high degrees of surface water saturation, absorption and retention. While tonal differences in this primary zone can be considerable, even on the same block, variations also exist from block to block. This is dependent upon the degree of overall protection afforded from the elements by other parts of the monument's design and the inherent composition of the stone.

Underlying the outer soiled zone is a visually obvious secondary thin white layer zone, comprising a thickness no more than a few grains in total. In some locations this thin section has been made more obvious where a gentle localized abrasive stripping and tooling has occurred on the surface of individual stones.

Underlying this zone, a dark brown third zone extends in profile depth to some 10mm ($3/8$ ins) or so in from the outer finished surface. This zone reveals a rich rust-brown colour that matches that exposed where surface erosion has taken place beyond 2–3mm ($1/12$–$1/8$ ins) in depth. The extremities of its overall thickness also closely match the depths at which the 2mm- and 10mm ($1/12$–$3/8$ins)-thick contour scale separation occurs.

Underlying this complex zoning is the fourth zone. This most closely matches the original quarry colour of the stone. Predominantly buff-coloured in nature, close examination reveals an even distribution of dark brown particles in an otherwise lightly-toned matrix. A lesser distribution of highly reflective particles is also evident. Sand grain sizes are, on

Figure 10 Thin section: Binny Stone. Microscopic examination of thin sections reveal that the actual surface soiling layer is extremely shallow, extending from between 10–100 microns in thickness (at maximum, the equivalent of half a grain of sand in dimension). In-depth soiling can also be observed in the pore structure of the stone. (Historic Scotland)

average, some 200 microns in diameter, and under microscopic examination the open-pore structure becomes visually evident (Fig 10).

RESOILING OF DAMAGED STONE

Where, over the years, the *Monument* has been accidentally damaged, an opportunity has been afforded to study how quickly significant surface colour changes can take place on freshly exposed Binny stone.

For example, as a result of scaffold pole damage on the edge of one of the west elevation first stage platform access steps, a fresh sliver of stone was broken off from an upper arris. Viewed shortly after the accident occurred, the four zones of in-depth colour variations were clearly visible in the freshly broken stone. Viewed some eighteen months later, the light fourth tone, original 'quarry' colour, had lost most of its contrast and had become more uniformly tinged with a dark brown hue to produce a more uniformly darker tone on the broken face than originally observed. The spalled piece has since been indent repaired.

An earlier fractured fragment which had been broken off the top west corner of the surrounding ogee lintel over the ground level main entrance door revealed no obvious original on the remaining face, zone four quarry colour on the remaining face.

Only zones one, two and three (surface soiling, light outer staining and in-depth brown discolouration) were evident. Comparison with the even earlier fractured top east corner of the same lintel (the same stone) revealed that surface resoiling had taken place to a degree that was not dissimilar to the zone one soiling on the original adjacent undamaged polished external face. Elsewhere, other previously physically damaged areas reveal that the zone four in-depth profile is also much less evident. Frequently the broken faces were found to have resoiling that matched the outer zone one soiling on original surfaces (Figs 11 and 12).

From these wide-ranging situations it can be determined that in-depth discolouration and rapid resoiling of broken surfaces is a consistent feature of how fresh Binny stone performs when directly exposed to the elements. This factor alone has a significant and direct bearing on the likely performance of the inner stonework should it be re-exposed to the elements by cleaning.

Detailed further close examination of a number of retrieved broken sculptured fragments revealed that these pieces featured a uniform in-depth brown tone. In cross-section this matched that noted in zone three of the fractured plinth step, but with no zone four colour evident. All the features (crockets, finial and sculptured pieces) had a common denominator in their original attachment to the *Monument*. Here, due to their exposure and high surface area to volume ratio, all the carved surfaces would have allowed an increased and easy passage of moisture into the stone's core, subjecting it to frequent total saturation. Unlike the plinth steps, through which moisture would mainly transmit on the vertical and horizontal planes (to produce parallel in-depth staining contours to these faces) such openly exposed and frequently saturated stone produces through-and-through in-depth staining and discolouration.

Elsewhere, a visual correlation could also be drawn between stone which had a greater extent of surface area exposed to the elements (and therefore degrees of saturation) and the extent of in-depth colour changes that had taken place. This correlation extended to the internal zone three soiling where the greatest degree of saturation consistently resulted in significant in-depth mineralogical colour change.

When linked to the relatively thin outer soiled

Figures 11 (left) and 12 (right) Resoiling: exposed wounded stone surfaces, caused either by accidental breakage (Fig 11) or contour scaling (Fig 12), frequently show resoiling characteristics where the intensity of the resoiling is often as great as that on the adjacent undamaged original tooled and polished surface. (Ingval Maxwell)

zone (100 microns) and the variation in the surface distribution patterns of mineralogical redeposition, and considered against the interface between wetting and drying zones, the variable soiled appearance which inevitably results can be pre-determined by careful observation of the uncleaned surface. In other words, with the outer densely soiled layer being no more than half a grain of sand in thickness it is possible to read through the film to see the underlying structure of stone without having to remove the soiled zone. This analysis could also reveal the likely subsurface effects that would

Figures 13 (left) and 14 (right) Comparison of pre- and post-cleaned stone surfaces. From cleaning tests carried out on the *Monument* (Fig 13) it was possible to extrapolate likely localised visual effects on individual stones. Here, following removal of the surface layer, the underlying variegated soiling profiles of the stone's underlying geology remains evident. The inherent effect of the geological bedding structure is also evident on uncleaned stone (Fig 14) clearly indicating that soiling is more than just an applied atmospheric phenomenon. (Ingval Maxwell)

Figures 15 (top) and 16 (right) Resoiling: the monolithic base block upon which the Scott statue sits (Fig 15), and the exposed Binny stonework of the nearby National Gallery of Scotland (Fig 16), display significant resoiling characteristics some 25 years after they were initially cleaned. Close examination confirms a co-relation of heavily resoiled surfaces and the micro-climatic effects of enhanced wetting and drying. (Ingval Maxwell)

manifest following cleaning (Figs 13 and 14).

In addition to noting the extent of resoiling of exposed stone resulting from contour scaling, close examination of previously damaged surfaces on the sculpture and ashlar blockwork reveal similar patterns. Where this had occurred, it had done so to a degree which completely matched the original outer zone one soiling density on the adjacent undamaged surface. Further support for this resoiling profile was evident where vandals had scratched the stone through the darkly soiled zone one (and two) to reveal the rich brown zone three, of lighter hue,

beneath. In comparing earlier incidents of vandalism of a similar nature (on the same fifth stage piece of sculpture), the freshness of the underlying zone three brown colour was found to be lost as resoiling 'healed over' the scratched open 'wound', toning it back to a near match of the outer zone one hue.

Furthermore, assessment of other accidentally damaged areas throughout the *Monument* revealed that freshly broken surfaces soon matured to a deeply soiled tone, not dissimilar to the untouched original zone one tone on undamaged adjacent surfaces of the same stone.

Where previous masonry repairs, using fresh stone, other than Binny, had been carried out in the 1970s, it is evident that the original raw surface of that material also toned down and matured as an inherently natural soiling process took place. This was particularly obvious on the first stage north-east corner where there are indented ashlar faces, and at the fifth stage west face, where finials had been replaced. In both situations dark outer surface soiling was well advanced. Being a different stone to Binny, a direct comparison of the in-depth zones was not possible. However, it was possible to suggest that, had Binny been used, the maturing and soiling process of the outer surface would achieve a match in hue to existing soiling in a relatively short space of time.

COMPARATIVE ANALYSIS OF ARCHITECTURAL DETAILING AND SOILING

In its simplistic form, the *Scott Monument* is constructed as a series of pyramidal shapes within an overall pyramidal form, with no effective mechanism to collect and control the discharge of accumulated rainwater. It weathers in a 'negative' fashion, each successive layer taking and accommodating the surface water run-off and loading from the layer above. The variable degrees of in-depth soiling makes it clear that a variety of mineralogical changes have taken place within the porous stone structure and these visually affect the outer surface appearance. High concentrations of surface water inevitably correlate with in-depth deep-tone surface soiling and this, proportionally, predominates on the perceived visual build when viewed from a distance. Comparison with other Binny structures confirm that surface saturation from rainfall and in-depth saturation (from, for example, faulty gutters) produces similar surface soiling and in-depth staining of types readily found on the *Monument*.

There are three buildings nearby in Edinburgh, constructed of Binny, which provide useful material for a comparative analysis with the *Scott Monument* in a pre- and post-cleaning condition. The Tolbooth Church, Castlehill (1839–44), New College and Assembly Hall (1845–50) and The National Gallery (1854) offer appropriate information. Not too distant, many buildings in Rutland Square (1830 onwards) are also constructed of Binny. Many of the properties in Rutland Square have been cleaned with devastatingly different visual effects and consequences.

At close quarters, it is almost impossible to distinguish between the natural soiling patterns of the uncleaned *Scott Monument* and that of the Tolbooth Church. This is the result of the same pyramidal form and exposed detailing being used in the design and construction, particularly of the spire. On the main body of the church, free-standing finials, parapets, tracery, hood mouldings and set-offs provide identical soiling patterns from which parallels can be directly drawn. Similarly, New College and the Assembly Hall have finials, dormers, buttresses, hood mouldings and weathering string-courses which also provide direct comparative dates. On both sites soiling variations on plain-face ashlar confirm that considerable diversification also exists on individual stone blocks. Furthermore, microclimatic effects on wind-divide arrises, sheltered overhangs and high exposure facets ensure parallel degrees of negative weathering in a similar manner to that noted on the *Monument*.

Of these three sites, only the National Gallery has been cleaned. Undertaken during the mid 1960s, resoiling has now taken place in some areas to such an extent that it is difficult now to distinguish these from the adjacent uncleaned masonry of the Assembly Halls (and from the resoiled cleaned statue base-block of the *Scott Monument* itself) (Figs 15 and 16). Most notably, high exposure and high surface area to volume features such as masonry parapets, upper level eaves courses, free-standing columns, wind-divide arrises and base courses have resoiled to a significant degree after only some 25 years. Consistently, all these features constructed from a stone with 16% porosity obtain high degrees of direct rainwater saturation (Figs 17 and 18).

From this additional factor it is not unreasonable to project the view that a rapid resoiling of cleaned Binny stone on the *Scott Monument* would occur.

OTHER RISKS ASSOCIATED WITH CLEANING BINNY STONE

In Rutland Square, the visual effects of a variety of stone-cleaning methods can be observed on the surface of the Binny stone buildings. Initially, in the 1970s, two buildings were cleaned using an approved

Figures 17 (top) and 18 (right) Comparison of pre- and post-cleaned soiling on columns. Close observation of resoiling patterns on previously-cleaned buildings constructed of Binny (Fig 17) reveal similar profiles to those that exist on uncleaned stone (Fig 18). From such information a likely visual appearance of post-cleaning resoiling of the *Monument* can be extrapolated. Here, the wind-divide micro-climatic vertical profile on columns can be assessed. (Ingval Maxwell)

process of mechanical abrasion and disc cleaning. This resulted in the two outer zones of in-depth soiling being physically removed from the stone, to expose an overall rich rusty brown (zone three) finish as a result. This finish contrasts markedly with the deep soiled (zone one) surface of adjacent uncleaned building and relates directly to colours evident on eroded surfaces where the dark brown

(zone three) profile has become exposed through localized natural deterioration and decay.

Changing to chemical cleaning process in the mid 1970s, the 'approved' use of hydrofluoric acid was subsequently encouraged. Here, the overall finish is a general opening-up of the original polished surface of the stone to reveal geological stratification, with removal of the outer (zone one) soiling to create a

Figures 19 (top) and 20 (right) Comparison of pre- and post-cleaning soiling related to architectural detailing. Visual correlations can be made which link the visual effects on individual moulded stones on the *Monument* (Fig 19) and similarly profiled but larger scaled building facades, in this case the National Library of Scotland, George IV Bridge, Edinburgh (Fig 20). A clear visual link is established between in-depth geological soiling on the cleaned sample where arrises, profiles and bedding planes (both geological and constructional) have an effect on the surface appearance. Extrapolation can therefore give a good indication of likely visual post-cleaning effects that reflect pre-cleaning features. (Ingval Maxwell)

wide variety of unnatural surface colours. These appear to bear no visual relationship to any of the 'natural' in-depth soiling zones of Binny or, for that matter, its original 'quarry' colour.

The use of different applications are evident on individual properties, where various treatments extend across the facades to end at legally defined building lines. These inevitably ignore the construction details. Here, it is possible to observe significant colour variations on either side of the same stones that cross that legal line.

Figures 21 (top) and 22 (right) Induced decay consequences of cleaning. Having been 'signed off' as being in a sound and stable state some 25–30 years ago many cleaned sandstone buildings are now displaying the effects of enhanced levels of surface decay and erosion. As cleaning was often only carried out on the principal facade, it is possible to effect a direct comparison of the physical state of the cleaned and uncleaned faces of the same stones as they 'turned the corner' of the building. Preliminary investigations are revealing that the cleaned faces have often eroded at a rate of between six and ten times that of the uncleaned parts. This effect is leading to an increased level of masonry indent repairs being required, such as here in the pre- (Fig 21) and post- (Fig 22) repair works situation in George Square, Edinburgh. (Ingval Maxwell)

In addition, a variety of alien tones emerge within individual stones, some of which have been bleached beyond the recognisable. Associated areas of buildings that have been subjected to levels of high saturation and water retention due to poor maintenance emerge darker in tone than the adjacent plain-face build. Inherent mineralogical layers in individual stones which cross the legal boundary between properties similarly emerge darker in tone after cleaning.

The resulting effects on exposed water retention parapets, string-courses, sills and colour contouring within individual blocks, all forewarn as to the likely

visual effects of a 'cleaned' *Scott Monument* should any chemical processes be employed in a cleaning regime.

SUMMARY

As a result of the variety of site trials undertaken to date, it is possible to extrapolate the likely visual outcome of cleaning if these results are assessed against the *Monument*'s complex soiling patterns and inherent effects of erosion (Figs 19 & 20).

The stone's underlying mineralogical changes, which remain following removal of the surface soiling, have many strong parallels with the way in which uncleaned sandstone buildings weather and change in surface appearance. Although much is related to wind-divide arrises and in-depth saturation effects on leeward and windward faces, the porosity of the stone and its ability to take up water to effect internal mineralogical changes is also of critical importance. Of greater concern is the emerging evidence that stone cleaning can induce enhanced rates of decay in some sandstones (Figs 21 and 22).

With Binny, vertical face run-offs create mineralogical profiles in the vicinity of the adjacent wetting/drying zones (to either side of the concentrated run). Where a general series of minute run-off rivulets occur, post-cleaned buildings frequently display these in a more obvious fashion, and surface disruption may also take place.

As a result, many post-cleaned buildings display ingrained mineralogical contours that reflect the external pre-cleaning soiling profiles. The same is true of the 'rising damp' contours which extends upwards from water retention surfaces in the region of some 50mm (2 ins) above the primary surface that takes in the water.

True rising damp, resulting from direct ground contact, and vertical penetrating damp, from features such as scarcements and ledges, leave a deep soiling profile evident on post-cleaned surfaces. Inclined 'rising damp' profiles, which soil across a variety of stone courses in the uncleaned situation, can also re-emerge as a darker mineralogical profile post-cleaning. This is of particular concern where run-off is concentrated onto an adjacent surface from a weathering slope. These circumstances are expressed in Binny as a tone darker than the adjacent plain-face surface.

Figure 23 The variations of sandstone. The structure of sandstone and the complex nature of its soiling are generally not well understood. As a result its cleaning is frequently argued as being necessary for its 'maintenance' when, in reality, the soiling effects are doing the building no harm by being left untouched in place. Through not understanding the inherent in-depth nature of associated geologically triggered surface colour changes, the removal of a mineral-rich surface often exposes a mineral-depleted interior, hence the increased post-cleaning erosion rates. (Ingval Maxwell)

Microclimatic effects will inevitably continue to work on structures following cleaning. The evidence of how these react with the structure's pre-cleaned geometry is the precursor for understanding the resoiling profiles post-cleaning. The more exposed the structure to rain-bearing winds, the more acute the original and post-cleaning soiling will be. All wind-divide arrises, water-holding horizontal ledges, scarcements and bases resoil at a faster rate than vertical ashlar. A close examination of the uncleaned structure will reveal where this microclimatic influence will occur in future.

The variable mineral content within the natural composition and bedding of the stone will, post-cleaning, also result in different degrees of resoiling. To an extent this is dependent upon the amount of inherent minerals still capable of being put into solution as part of the normal wetting and drying cycles that could be transported to the outer surface for redeposition. Given the high iron content of Binny (and the underlying richness of this in the weathered zone three layer) the mobilization of ferrous particles to the surface is liable to increase should the outer zones of the stone be opened up as a result of cleaning processes. Inevitably, enhanced surface 'rusting' and colour depth changes would result from the increased degree of water penetration that would occur should the outer face be removed (Fig 23).

Comparison with other cleaned buildings illustrates that this process can also lead to rapid colonization by surface algal growth. This can quickly negate the initial effects of cleaning and current evidence of algae having established itself on the uncleaned *Monument* indicates this effect was a distinct post-cleaning possibility.

Overall, the combination and inter-reaction of one architectural element with the other complicates the process and leads to considerable and variable degrees of soiling and weathering. It is inevitable therefore that the complex 'negative' weather effects, which combine in the design and make-up of the *Scott Monument*, will lead to a complex rapid resoiling pattern over a relatively short space of time if cleaning is proceeded with. This will vary in time due to exposure, detail and inherent mineralogical content of the stone. It will occur unevenly and result in an unsatisfactory visual effect that, at the same time, increases the risk of surface erosion and decay. As such, it was argued inadvisable to proceed and clean the structure and this view was upheld in the Inquiry Reporter's findings.

POSTCRIPT

In July 1998 the *Scott Monument* was undergoing a grant-aided 65-week programme of repair works. The approved scheme comprised masonry indent repairs, including recarving and refixing missing ornament, taking down and reconstructing loose elements, repointing, re-aligning services where possible, installing bird deterrent measures and painting associated joinery.

To ensure a high degree of sympathetic and relevant masonry repairs, a detailed site investigation and analysis was carried out to identify an appropriate source of replacement stones for the indent pieces. As a result, approval was obtained for the reopening of one of the original Binny quarries to supply sufficient matching material. This appropriate and applaudable action will ensure that the replacement stones will perform, weather and soil exactly like the original.

REFERENCES

Ashurst N, 1994 *Cleaning Historic Buildings*, 2 vols, London, Donhead.

Andrew C, Young M and Tong K, 1994 *Stone-cleaning: A Guide for Practitioners*, Edinburgh, Historic Scotland .

Gifford J, McWilliam C and Walker D, 1984 *The Buildings of Scotland: Edinburgh*, London, Penguin.

Historic Scotland, 1997a *Stone-cleaning Granite Buildings*, Technical Advice Note 9, Edinburgh, Historic Scotland.

Historic Scotland, 1997b *Biological Growths on Sandstone Buildings. Control and Treatment*, Technical Advice Note 10, Edinburgh, Historic Scotland

McKean C, 1992 *Edinburgh: An Illustrated Architectural Guide*, Edinburgh, Royal Institute of Architects in Scotland.

McMillan A A (ed), 1987 *Building Stones of Edinburgh*, Edinburgh, Edinburgh Geological Society.

Masonry Conservation Research Group, 1992 *Stone-cleaning in Scotland*, 5 vols, Edinburgh, Historic Scotland.

Masonry Conservation Research Group, 1995a *Research Commission Investigation: Cleaning of Granite Buildings. Report and Literature Review*, Edinburgh, Historic Scotland.

Masonry Conservation Research Group, 1995b *Research Commission Investigating Biological Growths, Biocide*

Treatment, Soiling and Decay of Sandstone Buildings and Monuments in Scotland. Report and Literature Review, Edinburgh, Historic Scotland.

Webster R G M (ed), 1992 *Stone-cleaning and the Nature, Soiling and Decay Mechanisms of Stone, Proceedings of the International Conference*, Edinburgh 14–16 April 1992.

AUTHOR

Ingval Maxwell joined Historic Scotland's predecessor, the Ministry of Public Buildings and Works as an architect in 1969. He was appointed Director of Technical Conservation, Research and Education Division in Historic Scotland in 1993 where he initiated various research projects, addressing topics such as the cleaning of sandstone and granite buildings; fire loss of the built heritage; and the sourcing and use of traditional building materials – all of which are published. Mr Maxwell is an active member of a number of UK conservation bodies including the Royal Incorporation of Architects in Scotland's Conservation and Professional Accreditation Committees; the Royal Institution of Chartered Surveyors' Professional Accreditation Panel; the International Council on Monuments and Sites (ICOMOS) UK Executive Committee; The Conference on Training in Architectural Conservation (COTAC) and the Register of Architects Accredited in Building Conservation. He is currently the external examiner for Bournemouth University's Architectural Materials Course and has been involved in the Council of Europe's Panel of Experts work. He also serves on the European Commission's 'COST Action C5' programme concerned with 'Urban Heritage & Building Maintenance'

19

The application of cathodic protection to historic masonry structures

A case study

Bill Martin

Building Conservation and
Research Team, English Heritage
23 Savile Row,
London W1X 1AB, UK
Tel.: 020 7973 3000
Fax: 020 7973 3001
bill.martin@english-heritage.org.uk

Abstract

In 1995 the Architectural Metals Conservation Studio of English Heritage installed an impressed current cathodic protection system on the corroding metal fixings embedded within the masonry structure of the Inigo Jones Gateway which stands in the grounds of Chiswick House, an English Heritage property in London. The result of significant research and development, the project represents the first application of such a system to a composite masonry structure in the United Kingdom and suggests potential for further development in the field of the conservation of public monuments.

THE INIGO JONES GATEWAY PROJECT

The application of impressed current cathodic protection (ICCP) to passivate the corroding ferrous cramps and dowels embedded within the masonry of the Inigo Jones Gateway[1] at Chiswick House in

Figure 1 The completed project with ICCP installed in the Inigo Jones Gateway. (English Heritage Photo Library)

London (Fig 1) represents the first occasion in the United Kingdom that electrochemical rehabilitation techniques have been used in preference to more traditional replacement techniques for the treatment of an historically important composite masonry structure. The decision to use this technique resulted from a careful risk analysis of treatment options where the assessment was informed by detailed knowledge and experience in the fields of stone and metal conservation, combined with an awareness of the potential for technology transfer from more mainstream construction and material repair methodologies.

This project may be seen as providing a useful example for any future interventions of an associated nature, in two ways. Firstly, in that the system employed (ICCP) has great potential, with further development, for the non-destructive treatment of a range of metal corrosion problems. Secondly, that a multidisciplinary approach to such problems may provide a far more flexible means of risk analysis than the rather more usual route of commissioning

a series of reports from specialist contractors who will tend to concentrate, quite naturally, on their own specialism. The multidisciplinary approach will depend upon the coordination of the assessment by a suitably qualified and experienced project leader for its success.

The Inigo Jones Gateway project was challenging in several ways. The structure, Bath stone with later flanking walls in brick, had been the subject of a number of repair interventions in the past. None of these had successfully addressed the main causes of deterioration but rather had, as is so often the case, treated the apparent symptoms. This had resulted in a large percentage of the Bath stone surface being obscured with a range of unsuitable mortar repairs, many of which were considerably harder and less permeable than the underlying stone. Not only did the application of these mortars, combined in some instances with what appeared to be a water repellant, probably provide a greater risk of physical deterioration to the underlying and surrounding stonework by virtue of their unsuitable physical characteristics, but they also prevented an acceptable visual assessment of the condition of the stonework surfaces of the structure .

When a survey of the structure was commissioned by English Heritage in 1990 it was found that not only was the surface of the stonework deteriorating but a number of the embedded ferrous fixings were corroding sufficiently to crack and dislodge masonry elements, threatening the structural integrity of the gateway (Fig 2). Indeed, an element of the upper pediment of the gateway collapsed shortly after the survey was completed. The specialist survey outlined a method of intervention which would address the perceived problems but which included, as an important element, the dismantling of at least part of the Gateway to allow the removal and replacement of those embedded ferrous fixings that could be seen to be causing present and potential physical disruption to the structure with resulting damage to the historic stonework. The Building Conservation and Research Team (BCRT) of English Heritage were asked by the project architect to comment upon this set of outline recommendations.

The Team's assessment was that, in general terms, it agreed with the survey's findings on the levels of deterioration, the probable causes and their remedial treatment. However, it was felt that two

Figure 2 Ferrous corrosion within the stone of the Gateway. (English Heritage Photo Library)

factors required greater emphasis. The pediment had originally been covered in lead sheeting: this had, at some time, been stolen by vandals and was replaced with a fibreglass covering. Unfortunately this had also been stolen and the upper surfaces of the pediment had been exposed to the elements for several seasons, thereby ensuring a far greater infiltration of liquid moisture into the upper levels of the structure than would otherwise have been the case. It was noted that the main incidence of visible disruption due to cramp expansion was in this upper area. Also, without sufficient visual access to the stone surfaces beneath the mortar repairs it was impossible to assess the likely risk in terms of physical damage to the stonework as a result of dismantling the structure.

The analysis of the risks involved with any remedial intervention would centre around these two points. As any conservator experienced in the treatment of stone or similar porous materials would be aware, the assessment of current condition provides targets for intervention but the prevailing environment, its possible modification and the requirements for the removal of harmful or destructive elements provide the framework for the rationale of that intervention. Just as in the case of sculptural detail, for example, the assessment of how far to go in terms of intervention will depend not only on the definition of its current condition but also in the ways that the factors affecting that condition may be beneficially or otherwise altered (Fig 3).

It has become accepted practice in the case of sculptures that are affected by rusting ferrous cramps,

Figure 3 An example of a complex environment for an already decayed stucco architectural sculpture, the Charioteer from the Ickworth Frieze. (Bill Martin)

either placed there as part of the original construction or to integrate reconstructions at a later date, that fixings that may cause staining and physical damage are removed by careful dismantling and replaced by alternative fixings with a similar application but produced in materials, for example austenitic stainless steels, that do not carry the risk of rusting if exposed to moisture. Such a dismantling process will usually be part of a wider programme of conservation including cleaning, repair and perhaps consolidation. However, even with an object as accessible as a free-standing sculpture, a good deal of skill and experience is required to balance all the factors affecting the proper assessment of the risk involved with the separating of individual elements to access the rusting cramps. The eventual decision is very often based upon the concept that it is impossible to treat the offending fixings satisfactorily *in situ*.

Similarly, the reduction or elimination of environmental factors affecting an object or structure may be possible but reliable information concerning both the nature and rate of deterioration symptomatic of the effects of the environment to be modified must be fully understood before any such interventions are designed. It has become common practice, for example, for church monuments that are being affected by the ingress of rising or penetrating moisture to be dismantled and reconstructed, isolated from the sources of such ingress by a lead damp-proof membrane. During this operation it is always the case that any ferrous fixings are replaced with those of a more suitable material as already described. Indeed, apart from those monuments that are constructed of stone types most susceptible to salt-laden moisture damage and have been most severely exposed to moisture ingress, it is usually the expansion of the ferrous fixings and the resultant material damage and loss of structural integrity that prompts the remedial intervention in the first place. However while there are undoubtedly many cases where this type of intervention is fully justified it is imperative that the analysis of the risks involved is performed by suitably experienced persons with access to as much data on the past condition of the monument as possible. Unless the monument is deemed to have reached a critical state then the risks of removal damage coupled with the loss of important archaeological information may well militate against such an interventionist approach. In such a case a regime of first aid repairs as necessary coupled with the implementation of situation monitoring on agreed baselines may be the most responsible way forward. This approach allows for a more informed intervention at a later date as necessary.

Our approach to the assessment of the risks involved with the interventions to the Inigo Jones Gateway may be seen as analogous to these situations. The information gained from the visual survey of the structure provided a good indication of the current condition overall and this in turn provided a reasonable basis for the design for the treatment of the exposed stone surfaces *in situ*. The lack of suitable covering for the pediment roof was also an obvious area for remedial intervention. This left the question of the embedded ferrous fixings. On this area our assessment was that

Figure 4 Directional magnetometer probe developed for the Inigo Jones Gateway project. (English Heritage Photo Library)

Figure 5 Cramp with modified anode system and single reference cell. (English Heritage Photo Library)

traditional dismantling and removal had the potential to cause far too great a level of damage to the original historic material. We would also find it very difficult to calculate just how much of the original stone would be beyond repair and sensible reuse and therefore the programming and budgeting of such a programme would be difficult. We therefore decided that the fixings would need to be treated *in situ*.

Naturally, an important element of this thesis was BCRT's belief that the cramps could be both successfully located and accessed for treatment while remaining embedded within the masonry. The method of treatment could be developed in such a way that its application would be non-destructive to the surrounding masonry in both the short and long term.

Initial location surveys were carried out by GB Geotechnics of Cambridge[2] who used impulse radar to locate the fixings and to provide a better idea of the nature of the internal construction of the gateway. With this survey to hand Taywood Engineering[3], the research arm of Taylor Woodrow Construction, were commissioned to develop a system of remote installation for the buried cramps. The parameters for access to the fixings were set at a surface excavation diameter of 10 mm ($^3/_8$ ins) or less with a working depth of 250mm (10 ins). Once developed in the laboratory the Taywood system was tested on site and a pilot ICCP cell was connected to trial the feasibility of the system. While the application systems worked effectively, the location of the fixings proved rather more difficult than had been

expected. A further combined radar and cover meter (magnetometer) survey refined the locations to some extent, but it eventually proved necessary to develop a unique wand-type magnetometer probe to enable near-miss entry holes to be used for successful location of the metal surfaces of the fixings (Fig 4). It had proved essential in the location and access exercises to combine the survey techniques and findings with the experience of masonry practice to obtain best results. Even with this system it was recognised that there would exist within the Gateway metal elements, often relating to previous repair episodes, that would either intentionally or unintentionally be excluded from the ICCP installation. Therefore a further development of the ICCP design, this time carried out by Rowan Technologies[4], converted the original distributed anode system to a localised anode one, thereby avoiding the danger of induced corrosion of unconnected metal by stray current (Fig 5). The system also allows other metal fixings to be added to the circuit at any point in the future should evidence of expansion problems surface. The performance of the ICCP is monitored via data loggers situated at the transformer rectifier control panel within Chiswick House.

The ICCP installation was part of a supporting programme of conservation repair for the gateway, including cleaning, stone piecing, mortar repair, shelter coating and the provision of a new lead roof.

This project has enabled English Heritage to break new ground in several important areas in the

field of public monument conservation. It has enabled us to develop and demonstrate a practical method of ICCP installation via keyhole surgery for masonry structures. We have been able to confirm that such a system prevents any further corrosion of cramps in damp masonry. We have also been able to refine a package of non-destructive survey techniques to locate such fixings, and we have been able to introduce sufficient technologies to enable the system's performance to be monitored remotely.

There are naturally many avenues for further development of ICCP in the field of monument conservation but we feel that, while not suggesting that this is a method which has universal application, our project at Chiswick House has demonstrated that it does have very real potential in certain areas where alternative methods would prove unnecessarily interventionist.

Full technical details of the project have been published in *English Heritage Research Transactions Volume 1: Metals* (1998), ISBN 1-873936-62-1.

ENDNOTES

1. Made for the Earl of Middlesex and erected along the Kings Road at Beaufort House, Chelsea in 1621, the Gateway was given to Lord Burlington for his gardens at Chiswick by Sir Hans Sloane in 1738. The structure is one of only seven authenticated buildings surviving designed by Inigo Jones (1573–1652).

2. G B Geotechnics Ltd, Downing Park, Swaffham Bulbeck, Cambridge, CB5 0NB. Tel.: 01223 812464, Fax: 01223 812462.
3. Taywood Engineering Ltd, Taywood House, 345 Ruislip Road, Southhall, Middlesex, UB1 2QX. Tel.: 020 8578 2366 Fax: 020 8575 4956.
4. Rowan Technologies Ltd, Carrington Business Park, Carrington, Manchester M31 4ZU. Tel.: 0161 775 4648 Fax: 0161 776 4518.

REFERENCES

Berkeley K G C and Pathmanaban S, 1990 *Cathodic Protection of reinforcement steel in Concrete,* London, Butterworths.
British Standards Institution, 1991a BS 5493, Appendix G: *Code of practice for protective coating of iron and steel structures against corrosion,* London, British Standards Institution.
British Standards Institution, 1991b BS 7361: Part 1: *Cathodic Protection: Part 1. Code of Practice for land and marine applications,* London, British Standards Institution.

AUTHOR

Bill Martin trained as a stone conservator and ran his own studio for nine years before becoming Conservation Officer at the Council for the Care of Churches. His responsibilities at English Heritage, where he is senior architectural conservator in the Building Conservation and Research Team, include research into masonry consolidants, the decay and conservation of historic tile pavements and the conservation of architectural metalwork.

20 The Albert Memorial

Saved but not restored

Alasdair Glass

English Heritage
23 Savile Row,
London W1X 1AB, UK
Tel.: 0207 973 3083
Fax: 0207 973 3000
alasdair.glass@english-heritage.org.uk

Abstract

The Albert Memorial has been repaired and conserved but not fully restored. The inherent defects of its original construction have been rectified and it has been made maintainable for the first time. The detrimental artistic and technical effects of previous interventions have been rectified. Its architectural coherence and richness have been recovered and a balanced colouration and the sense of preciousness regained. The legibility of its didactic elements has been restored. The Memorial is nearer to Scott's intentions than at any time since 1914.

Key words

Albert Memorial, victorian, monument, craftsmanship, restoration, George Gilbert Scott, conservation

The unexpected death of Albert, Prince Consort, in 1861 at the early age of 42 led to an outpouring of national remorse at not having appreciated him sufficiently during his lifetime. A subscription was raised to erect a suitable memorial to his memory and Parliament added a substantial sum. After initial ideas for a gigantic obelisk had fortunately been abandoned, seven architects were invited to submit designs. George Gilbert Scott's design was the only gothic one submitted. It is the epitome of the gothic revival and a most effective marriage of architecture and the decorative and fine arts (Fig 1).

Scott's inspiration was not actual medieval buildings, but shrines and reliquaries, which are of course often miniature buildings. His design for the *Memorial* was therefore jewellery on a gigantic scale. Scott said he was aiming at the effect of 'preciousness'. While at the lower levels he clearly delighted in the natural qualities of the materials he used, stone, marble and granite; at high level he was aiming at the effect of chased and gilt silver, regardless of the variety of materials actually used. Originally he had wanted to use marble and bronze for the canopy and spire but was obliged for budgetary reasons to use stone and lead cladding on iron.

Unfortunately the *Memorial* is not jewellery but a building exposed to the London climate. The most significant defect in its construction was that the leadwork was not fabricated in a way which allowed it to accommodate thermal movement. The leadwork rapidly split, allowing water to penetrate and attack the iron core, which rusted, expanded and increased the cracking. Nothing would stop this vicious circle of decay except the complete removal

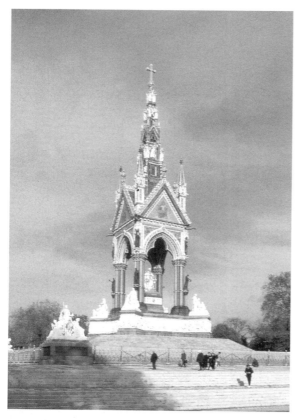

Figure 1 The *Albert Memorial*, after repair, November 1998. (English Heritage Photo Library)

Figure 2 The *Albert Memorial*, before repair, October 1994: the head of *Albert*. (English Heritage Photo Library)

of the leadwork and refixing in a manner which would allow for thermal movement.

The brief for the repair and conservation of the *Memorial* was almost as simple as that for its original design, to do 'all work necessary to ensure structural and aesthetic integrity and to facilitate maintenance', not to restore it fully to a state of pristine glory which it never enjoyed, which would have added at least 50% to the cost even if it were practical. It was intended to undertake all work which would be required within 60 years and that all more than superficial work should last for at least 60 years. The amount of work done at various levels was also conditioned by their relative visibility and future accessibility.

The contentious area is, of course, the extent of work necessary to ensure aesthetic integrity. In determining this the basic principles of minimum intervention, maximum retention and reversibility have been observed. There was also concern that

the didactic purpose of the *Memorial* should also be maintained and enhanced, particularly in respect of the programme sculpture. Although the *Memorial* is essentially a single-period building, it was desirable not to obscure the evidence of its subsequent history unnecessarily.

As well as understanding Scott's original intentions, it is necessary to understand the history of subsequent interventions to understand the current intervention. In particular, in 1915 the gilding was stripped from the statue and pedestal of the Prince Consort and from the cuprous statuary and foliage of the canopy and spire. The statue of the Prince Consort was given a black lanolin treatment (Fig 2) but the foliage and lesser statuary were left to turn green, completely altering the colour balance of the *Memorial* and staining the stone and marble below. Most of the gilded ornamentation of both lead and stonework was left to continue to weather but the gilded beading on the lead tiles of the main roof was stripped, as was the stone foliage in the main capitals, arches and gables. In the 1950s there was some regilding of the face of the main arches and of the stone pinnacles.

Polychromy was a major element of the original design. This largely survives in the variety of paving stones and granites, the 'jewels' of various materials and the glass cloisonné and mosaics, simulating enamel (Fig 3), and has been revived by cleaning and, in the case of the railings, by repainting.

Deciding on the extent of regilding has been the most difficult area. The deliberate blackening of the undercut gilded stone foliage in imitation of niello

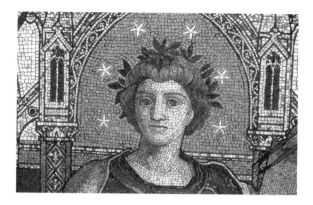

Figure 3 The *Albert Memorial*, during repair, June 1998: detail of the head of *Architecture* mosaic. (English Heritage Photo Library)

has largely survived as has the blackening of the ungilded areas of leadwork. The approach to regilding different materials and different degrees of weathering had to be consistent. It was easy to conclude that the correct finish for the bronze foliage and sculpture, from both the aesthetic and technical standpoint, was to regild it. Conversely, it was undesirable to regild more stonework than was absolutely necessary, to avoid reinstating an impervious surface treatment on a porous material. The weathered stone surface was still durable and most of the carved detail was still legible after cleaning. However it was no longer the ideal surface for durable regilding, to achieve which would have required either redressing Farmer and Brindley's splendid carving or flushing it up.

For the main arches, it was essential to give them sufficient apparent substance and to devise a frame for the mosaic spandrels consistent with the top chord formed by the mosaic inscription. The inner beak moulding around the spandrels was regilded and, after trials, the foliage of the arch face only, the vertical at the angles and the central bosses were regilded.

On the main pinnacles, the granite angle shafts and cleaned stone arrises provided sufficient definition of the architectural form. However, the patchy effect of the weathered gilded panels which obscured the detail was ameliorated by some touching in with yellow ochre gilding size and a small amount of regilding.

Gilding contributed nothing to the durability of the leadwork. The discovery that the surviving gilding on the leadwork could be cleaned by pulse

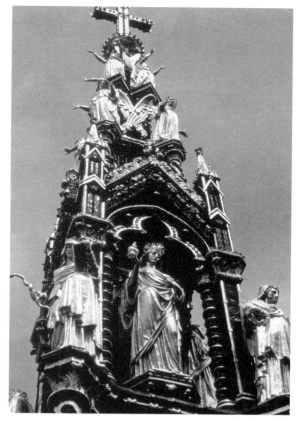

Figure 4 The *Albert Memorial*, during repair, June 1998: looking up the spire to the cross from the level of the Virtues on the south side. (English Heritage Photo Library)

laser and so become visible again and able to be consolidated was crucial, as it allowed an approach consistent with that for the stonework.

The leadwork was only regilded where necessary to clarify the architectural elements or to maintain the balance with the regilded bronze foliage and statues and the gold mosaics. It was therefore largely confined to architectural mouldings and defining the structure of column shafts, capitals and bases, impost blocks, pedestals and corbel brackets. Interestingly, Scott originally intended that the sculptures on the spire should only be partly gilded, as can be seen on the original plaster model on display in the Victoria & Albert Museum. When they were in place he realised that this produced an unfortunate effect but also, once they were fully gilded, that additional gilding was needed on the leadwork (Fig 4). It is evident from the shadow lines

Figure 5 The *Albert Memorial*, during repair, May 1998: the cross after restoration. (English Heritage Photo Library)

Figure 6 The *Albert Memorial*, during repair, August 1998: working on the newly gilded *Albert*. (English Heritage Photo Library)

that some of the gilding was done when the statues were already in place.

This puritan approach to regilding was relaxed at certain points where full regilding would have the maximum visual effect. The finials of the stone pinnacles and the lead clad finials of the main gable have been completely regilded and the blackening of the background repainted. The original lead on iron cross and orb were shot from the top of the *Memorial* by an over-enthusiastic anti-aircraft gunner in 1940. The replacements installed in 1955 were simple unadorned bronze castings. They have been retained but ornamented and gilded to match the appearance of the originals (Fig 5). The cross has also been correctly orientated north-south rather than east-west like a church, which is how it was placed in 1955, and the 1.5m (5 ft) of column omitted below the orb was restored using the

original lead on iron technique, but with joints formed in the same way as on the original leadwork which has been redetailed.

The statue of *Albert* has been regilded as he was originally (Fig 6). He is portrayed in the iconography of a Christian saint and martyr, carrying as his attribute the catalogue of the Great Exhibition of 1851. As the dedicatee of the shrine it is natural he should appear as the most precious object. This was deliberately emphasised by not gilding the eight statues of the *Greater Sciences* which are symmetrically disposed around his head. Scott had originally intended these to be of marble. When they were changed to what was discovered in the course of the work to be brass rather than bronze, they were given a varnish treatment which failed rapidly and was not renewed, as it was disliked for its glossiness. The *Sciences* have now been cleaned, patinated and waxed (Fig 7).

The lower tier of *Sciences* stand on stub columns attached to the main column clusters by ornamental bronze bands. These have been cleaned, patinated and partly gilded as they were originally. However, the bronze foliage forming the capitals of the stub columns has not been regilded. Being at low level they are readily legible and regilding them would be a solecism when the Darley Dale sandstone capitals of the columns have not been so treated.

The pedestal of the statue of *Albert* has a band of marble containing enamel escutcheons set into and flanked by carved panels, completing the heraldic ensemble. The panels have been regilded as they

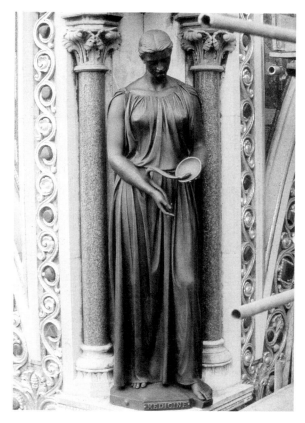

Figure 7 The *Albert Memorial*, during repair, June 1998: the restored statue of *Medicine*, in the *Greater Sciences*. (English Heritage Photo Library)

Figure 8 The *Albert Memorial*, after repair, November 1998: *Phidias*, detail from the Parnassus frieze. (English Heritage Photo Library)

were originally, to ensure the legibility of the heraldry and to provide a sufficiently rich visual support to the regilded statue.

The marble sculpture, the *Industries* and *Continents* groups and the frieze of the world's greatest artists are the major component of the *Memorial*'s didactic purpose. They accounted for a third of the original cost but only a 30th of the cost of the current work. The frieze is the highest accessible level. Scott described it as the soul of the *Memorial*. Nearly all the figures are named individuals and those whose appearance was known are readily recognisable portraits (Fig 8). The marble sculpture is work of great quality but was not displayed in a controlled museum environment. Cleaning revealed the beauty of the material and restored the three-dimensional quality of the groupings. Missing elements are well recorded and there has been

restoration in the past. Missing items have been restored: fingers and toes, attributes and instruments on the frieze, weapons and other artefacts on the *Continent* groups (Fig 9).

The elaborate wrought- and cast-iron gates between the bases of the *Continent* groups were not designed by Scott until 1870 but they are a major element of the completed *Memorial*. Since 1901 they were painted black but they have been repainted in their original russet colour, simulating bronze and complementing the Ross of Mull granite on the *Continent* bases. As originally they have also been massively gilded to restore the balance between the levels of the *Memorial*.

The *Albert Memorial* is very much the inspiration of a single mind, a piece of Wagnerian total art even if the music is frozen. Scott was fortunate in being able to realise his vision, despite answering to a

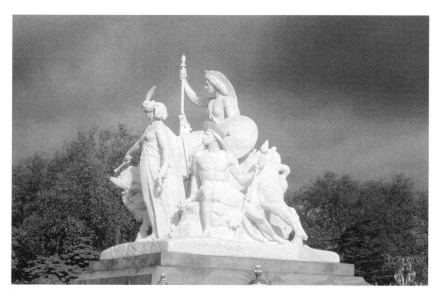

Figure 9 The *Albert Memorial*, after repair, November 1998: *America*, detail from the *Continents* group. (English Heritage Photo Library)

committee and suffering constant uninvited interventions. The project team was anxious to ensure that the conservation of the *Memorial* did not become a camel designed by a committee. As the intention was neither simply conserving the remaining fabric nor restoring it to its original appearance, it was inevitable that decisions would have to be taken on architectural design as well as technical and historical grounds.

The Department of the Environment decided that there should not be a steering committee of the great and the good. English Heritage set up a *Quality Board* which included members of staff not directly connected with the project to ensure it was meeting its conservation objectives. English Heritage's London Advisory Committee also visited the site twice at determining moments. The difficulty was to ensure that the whole *Memorial* looked right from below and at a distance, when it could only be seen in detail close up on the level.

The inherent defects of the original construction of the *Memorial* were compounded by the difficulty of maintaining it with the available technology. Facilitating maintenance was part of the original brief for the project, even before the introduction of the Construction Design and Management

Regulations made safe maintenance part of the brief for all large projects. Measures have been taken to allow modern access technology to be employed without risk of damage to the *Memorial*. A costed maintenance schedule has been prepared for the next 30 years, at which time it is intended the *Memorial* should receive a half-life inspection from a light scaffolding which would allow minor repairs to be done.

If the *Albert Memorial* is understood and appreciated it will continue to be valued and never again be allowed to fall into the state of disrepair which led it to being declared a Building at Risk in 1993. Regrettably, English Heritage's proposals for a permanent exhibition under the terrace on the south side of the *Memorial*, giving public access to the dramatic brick vaults under it, were not supported by the Heritage Lottery Fund. The demand from the public remains and the income would have paid for the future maintenance and security of the *Memorial*.

CONCLUSION

The architectural achievement of the project is to have reached and applied consistently a reasoned synthesis of the potentially conflicting artistic,

technical and financial constraints. The synthesis has been informed by a knowledge and understanding of Scott's original intentions and the subsequent history of the *Memorial*. While its original appearance has not been fully restored, its meaning and its power to communicate have been so treated.

ACKNOWLEDGMENTS

Client
 English Heritage Major Projects
Project Managers
 Osprey Project Management Ltd
Architects
 Peter Inskip and Peter Jenkins Architects
Structural Engineers
 The Morton Partnership
Quantity Surveyors
 Dearle and Henderson Consulting
Main Contractor
 John Mowlem Construction plc
Ironwork
 DGT Fabrications Ltd
Leadwork
 Eura Conservation Ltd
Bronze foliage
 Dorothea Restorations Ltd
Bronze sculpture
 Andy Mitchell
Stone and Marble
 Nimbus Conservation ltd
Mosaics
 Trevor Caley Associates
Steps and Terraces
 PAYE Stonework and Restoration Ltd
Railings and gates
 Paul Dennis and Sons Ltd
Enamel Escutcheons
 Plowden and Smith

REFERENCES

anonymous, 1872 *Handbook to the Prince Consort National Memorial*, London, John Murray.

Bayley S, 1981 *The Albert Memorial. The monument in its social and architectural context*, London, Scolar Press.

Darby E and Smith N, 1983 *The Cult of the Prince Consort*, New Haven and London, Yale University Press.

Sheppard F H W (ed), 1975 *Survey of London, vol 38, The Museums Area of South Kensington and Westminster*, London, Athlone Press.

Stamp G (ed), 1995 *Personal and Professional Recollections by Sir George Gilbert Scott*, Stamford, Paul Watkins.

The Victorian Society, 1993 *Save Albert. A Conference on the History, Present State and Future of the Albert Memorial*, London, The Victorian Society.

AUTHOR

Alasdair Glass is an architect who has specialised in building conservation throughout his career, initially in the private sector but mainly in public service. For 1987–91 he was Project Manager for the Albert Memorial, and responsible for the management of the London statues and monuments on behalf of the Department of the Environment. He was English Heritage Project Director for the Albert Memorial for 1994–98. He is a Fellow of the Society of Antiquaries and a committee member of the Association for Studies in the Conservation of Historic Buildings.

Part 5

The Future of Public Monuments

21 Sculpture and the afterlife

Benedict Read

Department of Fine Art
University of Leeds
Leeds LS2 9JT, UK
Tel.: 0113 233 5265
Fax: 0113 245 1977
b.w.read@leeds.ac.uk

Abstract

The title of this paper should probably, more properly, be 'Sculpture and *its* afterlife', by which is meant aspects of the fate of sculpture, including whether the artist can do anything to affect this, or whether there are too many other threats to its survival. This paper is about the ideology of survival and what provisions, if any, artists can make to ensure the continuity of existence of their work and its reputation.

Key words

Sculpture, monuments, survival, threats to art, changes in public opinion

Henry Moore went to considerable lengths to ensure the proper overseeing of his work and reputation after his death by setting up the Henry Moore Foundation. But he is in many ways a much more interesting sculptor than he is given credit for, certainly more interesting than some of his defenders and detractors alike allow him to have been. His attitude to materials is fascinating, and much more complex than perhaps is realised. In the second half of his career he worked in clay, terracotta, plaster and wax to an extraordinary extent, not just simply in preparation for bronze production but for the materials' own sakes. If you read carefully between the lines it is clear that he prepared maquettes in these materials even for some of the larger carvings of the 1930s, when he featured as one of the champions of 'Truth to Material'. His attitude to bronze was positively enthusiastic, illustrated by the interesting comment he made when asked how many casts he liked to have made: 'Well it varies according to the size of the sculpture and *what*

demand there might be for it' (author's italics). Another telling comment on the appeal of bronze came from Barbara Hepworth, famous likewise as a direct carver: 'all our original carvings have, in 45 years, been biffed, banged, bruised, broken and boiled so that they are cracked'.

At Moore's death he instructed his Foundation that no more casts should be made of his works. This is usually taken as a reference to Rodin's work which, because Rodin left the copyright in reproducing his work to the Rodin Museum, has led, until recently, to a succession of posthumous castings which have occasionally created whole collections of Rodin's work. There is not usually a problem with these, as they are generally recognisable from their patination as posthumous work, and as long as the viewer appreciates that what he or she is looking at replicates the original form of the work, but that it may not be entirely in an original (or originally derived) condition, then there is no question of being misled. There were of course plenty of

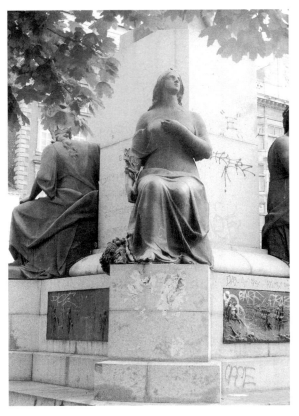

Figure 1 *Wellington Memorial*, Piccadilly Gardens, Manchester (1856, Matthew Noble). (Benedict Read)

'original' replicas of Rodin's work made during his lifetime; the *Age of Bronze* recently acquired by the City Art Gallery in Leeds is one of these, and the fact that it had been made (and remade, since the patron's wife did not like the patination of the first version they were offered) by Rodin for the Beckett family of Leeds, was a crucial factor in obtaining National Heritage Memorial Fund support for its acquisition. If it had been any old version, especially a posthumous cast, the attitude of the Fund would probably have questioned supporting the acquisition of a work of which versions are already to be found in other public galleries in the country.

The situation with Moore's work was maybe slightly different. For his great *UNESCO Reclining Figure* of 1957–58 he made a number of studies and variants, amounting to 22 related works, and from these, in his own lifetime, at least 261 bronze casts were made, 32 of these over five feet (1.6 m) high, and marketed. Similarly with the *Upright Motives*, the most famous of which is probably the so-called

Glenkiln Cross, there are at least 131 original, autograph versions in different sizes. Moore certainly kept what one might call 'master' versions, in bronze and plaster, and these have obviously been invaluable when works have been vandalised and were able to be restored.

Casual (as opposed to deliberate) vandalism is always a hazard and need not necessarily be intended to be destructive. This applies particularly to public sculpture: Matthew Noble's *Wellington Memorial* in Piccadilly Gardens, Manchester, is regularly adorned with graffiti, referring either to local football loyalties or what may be, shall we say, consciousness-enhanced popular culture (Fig 1). Marochetti's *Wellington* on Woodhouse Moor in Leeds has been subjected to a programme of polychrome painting of the bronze surfaces that would have done credit to the 1996 *Colour in Sculpture* exhibition at the Henry Moore Institute in the city: red, white, gold and blue, all except the latter carefully disposed over original details of the figure (Fig 2). The blue was used to add something to the front of the figure which one student of mine described as 'Italian swagger'. The proximity of the statue in this state to the studio premises of the Fine Art Department of the University of Leeds is wholly coincidental.

Lough's *Admiral Collingwood* at Tynemouth is a huge work, suitably designed at a scale to dominate the view out to and in from the sea, as was only appropriate for this local naval hero. It must have seemed similarly fitting to commemorate a more modern heroic local entity, as can be seen by the large graffitied initials NUFC (Newcastle United Football Club). Even Gormley's larger still *Angel of the North* is not immune to carrying this message, witness the adornment of the statue with a suitably enlarged number 9 football shirt with SHEARER on it, prior to the FA Cup Final in which Newcastle played. Not that it did the team any good, as it happened; they lost 2-0. That there is nevertheless an understanding of the function of the public memorial statue, even in the minds of those who deface them, is evident in the graffiti on the base of Behnes' *Peel* in Peel Park, Bradford: someone had written up 'Nasir is my hero', echoing the sentiment of heroic commemmoration that caused Peel's statue to be set up in the first place.

Just as Henry Moore has made provision for the future of his reputation by leaving a collection of his works in the hands of a Foundation, so too in the nineteenth century sculptors attempted to ensure

their ideological survival by this means. The widow of Lough, whose *Collingwood* is mentioned above, left his original plaster models to the city of Newcastle-upon-Tyne, his home town. They were joined by those of Matthew Noble and originally formed a collection of over 364 works, housed in Elswick Hall in the city. About 10 or so of these survive now in the Armstrong Museum of Engineering, the rest are rumoured to have formed part of the ballast of the urban motorway, in the construction of which 1960s Newcastle took such pride. John Henry Foley, the most highly regarded sculptor of mid nineteenth-century Britain, left his plaster models to the Royal Dublin Society where a number survive to this day. One senses that to some extent they do these things better on the continent. Ary Scheffer portrayed Marie d'Orleans sculpting in her studio in 1838, and her models survive in the Scheffer Museum, Dordrecht. In Austria, on the outskirts of Vienna, one can visit the Hanak Museum, where the works of the early twentieth-century sculptor Josef Hanak are preserved with others by Siegfried Charoux.

There could be much more serious threats to the afterlife of sculpture: Acts of God, for instance, as in the painting by Frans Pourbus of *The Flight into Egypt* of 1564 in a church in Ghent, which shows a classical statue exploding into pieces as the Holy Family pass; this apparently is a story told in *The Golden Legend* or the Apocrypha. The fire that burnt down the Sydenham Crystal Palace in 1936 destroyed a vast collection of plaster casts of sculpture, a veritable museum of the history of European sculpture, with works from antiquity, the Middle Ages, the Renaissance, up to the nineteenth century. Simple old age can get the better of material with a limited shelf-life; the screen at Lubeck Cathedral in Germany with its painted wooden sculpture by Bernt Notke has survived remarkably well considering the fragility of its constituent elements and the good intentions of centuries of conservators, but even today, with all our contemporary skills, the torso of the Crucified Christ has still lost a chunk of the gesso that originally lay between the wood and the paint. The godly, too, in their enthusiasms, can play havoc with sculpture, as in the wonderful remains of the stone sculpted decoration inside the Lady Chapel at Ely Cathedral of *c* 1335–53 (Fig 3); sufficient traces of the original coloured paintwork remain, but not the heads of the figures which were smashed off in a frenzy of Protestant zealotry.

Figure 2 *Wellington*, Woodhouse Moor, Leeds (1854, Baron Marochetti). (Benedict Read)

Human violence, channelled through official justification to the status of war, need have no respect for the work of art: photographs of the centre of Rotterdam, shortly after the Germans had bombed it in May 1940, show scarcely a single structure standing. Somehow, though, de Keyser's commemorative bronze figure of *Erasmus* of 1618-21 survived (Fig 4) and it has since been repositioned outside the restored structure of the medieval parish church of St Laurence, two survivors (just) brought together by their shared trauma. This particular physical fate of the city led to the commissioning after the war of Zadkine's *Rotterdam Memorial* of 1953. This work has been criticised for being ostensibly over-emotional, crudely sentimental and so on, but anyone who has ever seen the photographs mentioned above will understand only too well the extent to which the work bears witness to the suffering and destruction. Of course in the Second World War such devastation cannot fairly be attributed to one side only: there is to this day no

Figure 3 Detail of carving in the Lady Chapel, Ely Cathedral, c 1335-53. (Benedict Read)

Figure 4 *Erasmus Memorial*, Grotekerkplein, Rotterdam (1618-21, de Keyser). (Benedict Read)

trace remaining of Reinhold Begas' *Kaiser Wilhelm Denkmal* of 1892–97, originally outside the Schloss in Berlin due to Allied bombing. It is nonetheless a pity from the point of view of sculptural history, as it seems, from surviving photographs, that Begas' statue could have some connection with Thomas Brock's *Queen Victoria Memorial* outside Buckingham Palace in London of 1901–23, but this can only be a matter of surmise without the physical substance to prove it, or not. Finally, and ironically, some sculpture survived because of war. The sculpture adorning the archaic temple of Athena on the Athenian Acropolis only survived, admittedly in fragmentary form, because it was buried underground after the Acropolis was sacked during the Persian invasion of Greece in the fifth century BC.

Major political changes will self-evidently place sculpture with any sort of political identity at risk. It would be interesting to know how many of those closely involved with sculpture felt at least a twinge of horror when, as a result of the sweeping political

changes affecting the Soviet Union recently, the first symbol of the old order to go was the statue of the founder of the Soviet secret police. Art-political correctness might not have allowed any regret on stylistic grounds. But then the same sentiment led to the melting down of the 'degenerate' *War Memorial* of 1927 by Ernst Barlach, suspended in space in the Cathedral of Gustrow in Germany. Luckily for us all, another cast had been made and an exact replica could be made when the cultural situation changed. Certain symbols of English hegemony have been affected in Ireland: Foley's bronze figures of the *Earl of Carlisle* and *Viscount Gough* in Dublin were found unacceptable by certain nationalists and so had to be brought down. Apparently the Irish did not do it themselves; they brought the French plastic bombers who, being French and thus perhaps more sympathetic to art, carefully wrapped the explosive round the legs of the works and thus literally brought them down to earth without substantial destruction, and both monuments were preserved in the Board

of Works stores at Kilmainham Hospital on the outskirts of Dublin.

Deliberate theft can influence sculpture's afterlife. Derwent Wood's bronze *Atalanta* at one time stood on Chelsea Embankment in London, set up as a memorial to the sculptor by the Chelsea Arts Club. The first time it was sawn off at the ankles it was at least found in a scrap metal yard before being melted down, the second time unfortunately not. Still, my recounting of this story did once have a beneficial result, and the Rodin *Age of Bronze* ended up in Leeds. Changes of ownership affect sculpture. The Henry Moore *Sundial*, originally made for a specific site in London for Times Newspapers, now belongs to the Banque Lambert in Belgium. Barbara Hepworth's *Meridian* of 1958-59 was originally an integral part of the decoration of State House, Holborn, in London, the wall against which it was sited being built higher to make the work, according to the artist, 'look perfect'. Now, who knows where it is, the building has been demolished and the work belongs to the Pepsi-Cola Corporation. One should note here the almost total ineffectiveness of current legislation relating to the listing of sculpture that is part of a building. You could have a series of masterworks of sculpture and paintings that are integral to the design of a building, but if the architecture is not of enough merit to be listed grade II* or grade I, then tough luck to the artworks, however major, even if they are literally cemented in to the structure. The horrendous goings-on at the Time-Life building in Bond Street, London demonstrated this: the Moore carvings attached to the wall were safe (ironically enough because the planners originally insisted that they should be cemented in, as opposed to the proposal of the sculptor and architect to have them on spindles, so that they could revolve). These are safe, but the Moore *Reclining Figure* bronze commissioned to go on the balcony behind them can legally be removed, because it is not fixed, as can the huge Ben Nicholson painting in the stairwell of the building, which was painted to hang there and which functions as a mural decoration, but which because it is not technically painted directly on to the wall, cannot be constituted as part of the original building. [Since the conference, the legislation referred to here has been confirmed and enforced to preserve fittings in certain cases, like the Time Life examples cited here.]

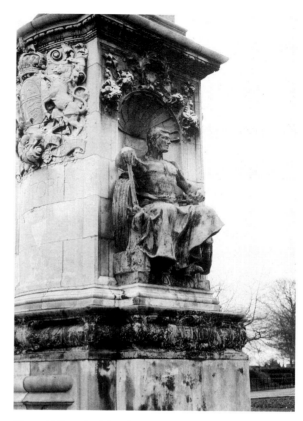

Figure 5 Detail of the *Queen Victoria Memorial*, showing *Industry*, Woodhouse Moor, Leeds (1905, Sir George Frampton). (Benedict Read)

Other changes in ownership can be construed as survival-friendly. The *Venus de Milo*, to take an obvious example, originally from the Greek island of Melos, is now secure in the Louvre, rather than having been ground up for mortar or chipped up for stone as might have happened if it had stayed in its original site. Certainly it lost a couple of arms before it was removed. Gibson's *Tinted Venus* is now a treasure of the National Museums and Galleries on Merseyside, but it seems it may have undergone a number of changes to its original colouring while still in private ownership before its relatively recent entering into the conservational security of a public collection.

A more serious threat to the afterlife of sculpture, not always recognised, is that posed by apathy or agnosticism, an attitude of not caring or not appreciating the sculpture's proper value. Sir George Frampton's *Queen Victoria Memorial* in Leeds was originally unveiled in Victoria Square outside the Town Hall in 1905. It is a substantial work, consisting

of a large bronze figure of the queen on a high pedestal, with large bronze supporting figures representing *Peace* and *Industry* on either side (Fig 5). In the 1930s, in order to make a car park in front of the Town Hall, the statue was moved to Woodhouse Moor, a park on the way out of the city. One morning not so long ago, a student working on a PhD on Frampton was coming into town on a bus past the statue. He saw to his horror that the figure of *Industry* had fallen from its platform and was lying on the ground. He dutifully reported this to the curators of the city's sculptor before retiring to bed to recover from the shock. It transpired that what someone had tried to do was climb up the monument, possibly aiming for the figure of the queen at the top (she has been subject to intermittent decoration by the Master of the Traffic Cone). Unfortunately what the climber did not realise was that *Industry* was not actually fixed in any way to the base, so down had come climber, *Industry* and all. There was blood all over the sculpture (on enquiry the disinterested police had not registered any fatality or near-fatality in the area) which was severely damaged by denting and cracking. The city's political authorities were reluctant to take any responsibility, then or now, for the proper maintenance of their civic sculpture (see the case of the polychrome *Wellington* above). The damaged figure eventually had a refuge found for it, but since then, for all the efforts of the curatorial staff, no provision has been made by the political authority to look after it, let alone have *Industry* repaired and reinstated (but see also Taylor & Sportun, this volume). This is not just the prerogative of the Industrial North: the University of Cambridge has banished its tribute in statue form to its one-time Chancellor, *Prince Albert*, (by Foley), originally in the main entrance hall of the Fitzwilliam Museum, to an exterior site where the marble is apparently gradually weathering away.

In addition to apathy or agnosticism threatening the survival of sculpture, there is the added problem of what can be described as ideological political correctness. Was Begas' *Wilhelm I* actually annihilated, or was it, like the eighteenth-century Schloss in Berlin, damaged and then deliberately not restored to the point of demolition? It is fairly certain that much of the work executed between 1933 and 1945 by Hitler's 'favourite sculptor', Arno Breker, does exist somewhere but it is not on general view.

On a less politically contentious note, G F Watts' *Lord Lothian Memorial* in the church at Blickling, in Norfolk, a magnificent and rare example of the artist's unique carving style, was subject to deposits of bat droppings from the roof above until a solution to this problem was found that was fair to both bats and church monuments-. There are other aspects of ideological discrimination that put at risk the survival of sculpture, whole careers, whole oeuvres that are not on view because they do not fit into certain conceptions of the canon of art. Karel Vogel's *Boy* was shown at the Battersea Park sculpture exhibition of 1960, one of the series of major sculpture exhibitions sponsored by the London County Council. But where is it now? Who knows about Karel Vogel apart from a very few scholars of post-war sculpture in Britain?

In spite of apathy, ignorance, political correctness, a multitude of potential threats, some works do quietly, almost invisibly survive. Few people seem to notice the public statue of *Cobden* in Camden Town, London, dating from 1868, by the Wills Brothers (who they?) (Fig 6). But *Cobden* has been remarked on by two commentators in recent years, and what commentators. He featured in a recent lecture by one of the major British sculptors of this century, Sir Anthony Caro. And he was the subject of a late poem by the principal champion of modernist sculpture in this country, Herbert Read:

> COBDEN imperturbably stone
> divides the flow of Camden traffic
> frock-coated elevated stiff alone
> - it is an academic trick
> (petrification of the flesh
> facade of an impassive mind)
>
> Collisions happen in the milling mesh
> to which we humans are consigned
> but COBDEN neither sees nor feels
> our common fate
> nor hears the rumble of the wheels
> early or late.

If there can be safety in near oblivion, there can also be proper measures taken by moving work out of harm's way. There is a famous photograph by Robert Doisneau called *Venus prise à la gorge* in which four burly French workman are attempting to move a large Maillol bronze in the Tuileries Gardens, Paris. The conservators in the audience may be

shocked not so much by two of them grasping her naked breasts but by the fact they were not wearing gloves! Matthew Cotes Wyatt's colossal bronze equestrian statue of the *Duke of Wellington* of 1846, originally placed on top of the Wellington Arch at Hyde Park Corner, was threatened with the melting pot when the arch was moved in 1883. Luckily the Army who had paid for it put in a claim, they were assured they could have it back as long as they took it away, and it survives to this day at its alternative site at Caesar's Camp, Aldershot. One of Eric Gill's major public works, his *Leeds War Memorial*, was originally installed on the outside of Alfred Waterhouse's Great Hall of the University. The controversy over this work, commemorating the war dead of the city of Leeds by a representation of *Christ Driving the Money-Changers from the Temple*, with the money-changers dressed in contemporary clothing, led to frequent calls for its removal and destruction. It was eventually moved, but to an inside location, where it survives today, though not without occasional threat. A postgraduate student of the Leeds Fine Art Department was once caught about to stick a huge notice about a forthcoming conference onto the Gill with heavy-duty adhesive tape. When challenged, he said: 'Oh, is that a work of art, I never knew'.

In India there were a large number of public sculptures put up by the British while they were in control of the sub-continent. A very large proportion of these still survive, though not necessarily in their original positions. Foley's two great equestrian figures of *Outram* and *Hardinge* originally stood on the main public space of the city, the Maidan. *Outram* still survives, with many of Calcutta's British public statues, in the grounds of the residence of a leading local government figure. *Hardinge*, his twin, was shipped back to this country by the widow of a descendant of Hardinge's and installed in her garden. Frampton's *Queen Victoria* in Calcutta is still *in situ* in front of the Victoria Memorial Museum where it is apparently treated as a cult figure by the local inhabitants, a fate rather more respectable than what has happened to Frampton's *Victoria* in Leeds. Similar treatment can be found in other ex-imperial locations. Not all the British statues in Dublin have been blown up. Foley's *Prince Albert* was moved inside the secure fencing of a government building, while Watts' *Physical Energy*, a version of which was

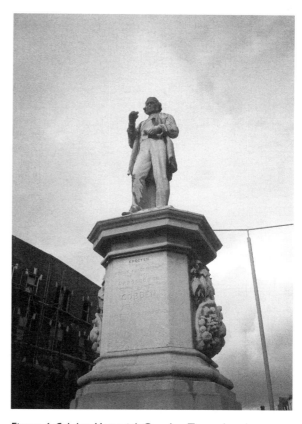

Figure 6 *Cobden Memorial*, Camden Town, London (1868, The Wills Brothers). (Benedict Read)

put up in Southern Rhodesia in commemoration of Cecil Rhodes, survives in store in Harare.

In dealing with sculpture, particularly outdoor work, one can be haunted by the lines of the Latin poet Horace, championing the written word: 'exegi monumentum aere perennius' ('I have set up a monument more enduring than bronze'). Obviously a case can be made for this argument, but then in his days they did not have the benefit of the UKIC, English Heritage, let alone the PMSA. We will show them!

AUTHOR

Benedict Read is Chair of the Public Monuments and Sculpture Association (PMSA) and Lecturer in the Fine Art Department at the University of Leeds. He is the author of *Victorian Sculpture* (1982), and of other works on painting and sculpture from 1840 to the present day.

22 Conservation of monuments: Where are we going?

Roberto Nardi

Centro di Conservazione
Archeologica,
Convento di San Nicola
02020 Belmonte in Sabina (Rieti)
Italy
Tel.: +39 0765 7714521
Fax: +39 0765 7714522
ccanet@tin.it

Abstract

The end of the millennium and the beginning of another is an opportunity to reflect upon the state of our profession: the conservation of our cultural patrimony. This paper looks at the experiences of the Centro di Conservazione Archeologica (CCA), a private company, active for 15 years on public commissions in the conservation of monuments and archaeological sites.

Initially, the work of CCA was devoted solely to restoration/conservation, with the use of so-called 'modern' techniques and materials having a significant impact on the original fabric. Today, the materials and techniques used are almost exclusively traditional (in the historic sense) and have minimal impact on the monument. In addition, our present sphere of activity is much wider and, alongside actual conservation work, we are asked to carry out documentation, training courses, maintenance and public information initiatives.

Thus we recognise that our profession has finally abandoned the 'restoration' approach for a new path in the direction of preventive conservation.

Key words

Maintenance, training, information, preventive conservation, planning, conservation/protection

The end of one millennium and the beginning of the next is an opportunity to reflect upon the state of our profession: the conservation of our cultural patrimony. This paper looks at the experiences of the Centro di Conservazione Archeologica (CCA) over the last 15 years in conserving monuments and archaeological sites.

As a private company, CCA has tried, on the one hand, to develop methodological approaches that would lead to qualitative improvement in its work, while responding, on the other hand, to the demands of the market. Today, in taking stock of the past 15 years, it is these interventions that give us a real picture of the facts.

Our professional itinerary began in the late 1970s and early 1980s when the focus was exclusively on 'restoration', both in training and in day-to-day work. Most of us were trained in Italy in restoration

institutes, and once we were professionals we became 'restorers', with our first jobs being 'restoration' treatments. Our culture and professional preparation were characterized by a series of technological certainties, our tools were infallible formulas, super-modern treatments and magical products.

The relationship between operator and monument was always a one-way street. By and large, the restorer knew what to do even before encountering the monument; at best there might be an adjustment in the level of treatment or in the application of one slightly different product to another. In the more fortunate cases, the choice of treatment was influenced by the types of material and the state of decay of the artefact's surface. The results were treatments that had a major impact on the monument. **The restoration did not conserve, but transformed.**

Then, in the first half of the 1980s, a slow but steady change began to occur. There were several possible reasons for this:

- a maturing process linked to the ongoing debate in Italy about *restoration* versus *conservation* and to more frequent exchanges on the international level;
- requests coming from the political sector urging increased interventions in the area of the built urban heritage;
- the arrival on the market of new forms of professional organisations, such as private companies, mostly composed of recent graduates who were always ready to question a principle or technique;
- the experience of difficulties and failures and, above all, the courage to admit them and talk about them.

At that time, the activity of CCA was entirely devoted to restoration, with the use of so-called 'modern' techniques and materials which had a significant impact on the original. It is hardly worth giving examples of monuments treated with this approach, as each of us could supply a long list from experience. Even documentation was not called for, or was not included in the product requested.

The first tangible sign of change arrived after the failures and difficulties encountered during treatments of large-scale monuments, which were in serious states of decay and exposed to a highly polluted urban environment. Under these conditions, the methodologies used up to that time were found to be totally inadequate, making it necessary to start a new process of study, focused on the monuments themselves. Thus new techniques for reading the monuments were delivered, marked by a technical-conservation style which was also historical and humanistic.

People began to read the signs of decay of materials; a technique for recording these traces was developed; 'topographic maps' were created, the study of which helped in interpreting the deterioration of surfaces, understanding the mechanisms of decay and planning the corrective measures needed to prevent the repetition of these mechanisms. At the same time, there was more emphasis on the archaeological and historical study of the monuments in order to understand their materials and construction techniques, to identify the signs of use and maintenance; to study phases of neglect, the stratigraphy of burial and cases of re-use. In short, all this allowed the monument to introduce itself and to suggest the 'cures' it would find compatible. The monument came to be treated not like a mute and shapeless mass of degraded materials, but as an intelligent machine having a high cultural content and, above all, having a great desire to convey this message, historical, spiritual, technological, artistic, that it contained. This was the case with the conservation of the Arch of Septimus Severus (Fig 1) and the temple of Vespasian in the Roman Forum, and the Stadium of Domitian and the Crypta Balbi in Rome. These considerations filled the 1980s, and entered our treatment methodology definitively. They also appeared in the headings of state budgets, thus being officially recognised and requested by the commissioners.

The relationship between operator and monument was now completely overturned; no longer a one-way street, leading from operator and colliding with the monument, it now went both ways. **This intervention did not transform but conserves.**

While these views and practices monopolized professional debate and practice in the field, some new objectives appeared timidly on the horizon. These new causes for reflection first seemed to be accidental episodes but slowly gained ground with

Figure 1 Rome, Arch of Septimus Severus. The state of ten-year old conservation treatments was checked in 1996 on the surfaces of the monument. The limewash used as a sacrificial layer was found to have worked well, proving the validity of the theory 'soft treatment today, but constant maintenance tomorrow'.

Figure 2 Rome, Atrium of the Capitoline Museum. The Atrium was conserved in 1990–93 with an intervention planned with a long-term maintenance programme. The programme is still continuing, demonstrating how efficient constant maintenance is in terms of damage prevention and costs.

the dynamics of future interventions. The issues were planning of treatments and post-treatment maintenance of monuments.

Whereas planning was essentially covered by site experience, as in the case of the Arch of Septimus Severus and the Stadium of Domitian, and where maintenance was basically a theoretical intuition and not regular praxis, the project, complete with future protection measures (both active and passive) was at the base of interventions performed from 1990 to 1996, at the atrium of the Capitoline Museum in Rome, at the Bath House in Masada, at the rural church of Sant'Andrea Priu in Sardinia and at the Baths of the Cisiarii in Ostia.

The relationship between operator and monument was further modified, or amplified: no longer a one-way street, leading from the operator and colliding with the monument, and no longer focusing exclusively on the conservation of material and cultural values, but extending to the future protection of the results achieved.

Information comes from the monument, and the conservator studies and processes this in order to produce a treatment plan that returns to the monument in the form of materials that are stabilised, maintained and protected in the years to come. The result is always intervention with low impact on the monument but with an expectation of lasting time. **The treatment did not transform, but conserved and maintained**.

And just when we thought we had finally codified and defined our fields of professional activity, new

Figure 3 Masada, Israel. The Great Bath House. More than half a million people visited the conservation work 'live', and special structures were built to welcome and guide the public on the site.

Figure 5 Zippori, Israel. Conservation of the floor mosaics in the Building of the Nile. Consolidation techniques are based mainly on lime mortars. Superficial consolidation is carried out using liquid hydraulic mortar.

requirements slowly made themselves felt, until they, too, entered and expanded our field of actions. Here the issues were initiatives organised to foster public information and professional training of conservation personnel.

The first initiative was in 1984, when CCA opened the site of the Arch of Septimus Severus to delegates of the ICCROM General Assembly. This positive experience was kept on the back-burner until 1990 when, during the work on the atrium of the Capitoline Museum, CCA set up a site that was entirely open to the public for three years (Fig 2). Since that time, more than a million visitors have been able to watch CCA operations 'live', for instance at the Western

Palace and the Bath House of Masada (3), during work in the villas of the Nile and Bird and Fish at Zippori (Figs 4, 5 and 6), again in Israel, or at the Baths of the Cisiarii and Piazzale delle Corporazioni, at Ostia Antica (Fig 7).

As for training, all that had to be done was simply to respond to pressing demands from the field. Inevitably, during and after every intervention, we found ourselves faced with the incapacity on the part of local authorities not only to continue on their own in the direction indicated, but also to maintain what had been accomplished so far. Funds for

Figure 4 Zippori, Israel. Conservation of the floor mosaics in the Building of the Nile. All technical operations are carried out on site, using traditional materials and techniques and respecting the historical content of the monuments.

Figure 6 Zippori, Israel. The Building of the Nile. Keeping the public informed is the most efficient way of showing how fragile our cultural heritage is and how delicate and time-consuming its conservation can be. By maintaining such regular information campaigns a new generation of conservation-sensitive users of monuments and sites will be educated.

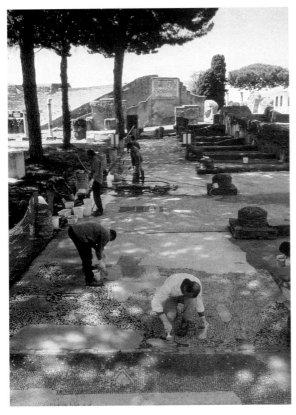

Figure 7 Ostia Antica, Piazzale delle Corporazioni. Maintenance of mosaic floors, keeping fragile artefacts intact with limited time and cost.

Figure 8 Side, Turkey. Training allows long-term archaeological programmes to be carried out. Preventive conservation is the most important aspect of conservation work today.

Once again, the duties of the conservator expand even further, to include information of the public and training of conservation technicians. Our interventions today are aimed at the conservation of the monuments, their future maintenance, transmission to the public of cultural and technical values of the monuments and training of future generations of conservator-restorers.

CONCLUSION

Public information is currently highly popular: not only has it become an integral part of all our interventions, but also has been codified in a recent European summit (Summit Europeo, Pavia, February 1998) as a fundamental part of the profession of conservator-restorer. In particular, Article 6 mentions 'the assurance of an appropriate balance of integrated theoretical and practical teaching, as well as the teaching of strategies for communication in the education and training of the conservator-restorer' and Article 13 states 'the provision of appropriate resources to ensure improved communication between professionals, the public and the decision makers'.

training were requested, but were refused, with the lack of appropriate facilities given as a reason. This was not even specialised training, but basic training; the teaching of field practices which are often closer to common sense and to familiarity with the site and the monuments than to techniques of restoration or conservation. These are simple solutions that, with a good knowledge of traditional techniques and materials, can prevent greater damage in the vast majority of cases, as well as practices of control and daily care that only personnel in place can carry out, and which almost always are enough to guarantee the future maintenance of monuments and sites (Fig 8). CCA have tried to convey this in courses organised by UNESCO in Peru, or by the ICCROM PREMA programme in Africa, in Ostia at courses organised by the Regions of Lazio and Sardinia, and in Israel at courses organised by the Antiquities Authority and the National Parks Authority.

Fifteen years ago the activity (and budget) of a private company such as CCA was entirely dedicated to restoration. Today, things are quite different. Restoration is still present; other activities are present to a significant degree, ie documentation (now at the foundation of every conservation treatment), maintenance, conservation and protection, planning and training.

This last point has assumed such importance in our programmes that CCA has decided to set up new headquarters, dedicated to offering monthly courses at basic level of specialization, intended for technicians of archaeological sites and monuments. In these courses, the basic elements in preventive conservation are to be taught: documentation, survey and condition assessment, teamwork, analysis and problem-solving, strategic priorities (building priorities), final reporting, communication, teaching skills, use of traditional techniques and materials, first aid (during excavation and otherwise), maintenance techniques, protection techniques (reburial, wall capping etc).

The principal characteristic of restoration, which occupied us full-time 15 years ago, is that it is an activity directed toward the artefact with a short-term impact. Instead, the characteristic of all the activities we are engaged in today (conservation, documentation, maintenance, planning, information and training) is that they are indirect activities with a long-term impact on the artefacts. This means that what we are doing today is more likely to last because it anticipates today and protects tomorrow. **This is called preventive conservation.**

Permit me to close on a note of optimism: if this is what we are being asked to be (and being paid for) today, it means that not only our profession but also the market are finally ripe for preventive conservation.

REFERENCES

Albini R, Costanzi Cobau A and Zizola C, 1996 Ostia Antica. La conservazione dei mosaici delle Terme dei Cisiarii: I risultati, in *Proceedings of the Third Conference of AISCOM*, Bordighera, Rome.

Melucco A, Nardi R and de Guichen G, 1990 Conservation of archaeological mosaics: the state of the problem in the light of a recent international course, in *Proceedings of the Triennial International Meeting on Conservation of Mosaics*, Palencia.

Nardi R, 1986 Conservation of the Arch of Septimus Severus: work in progress, in *Proceedings of IIC 11th International Congress*, Bologna.

Nardi R, 1988 Il Tempo di Vespasiano: un palinsesto nella storia del Foro Romano, in *Rendiconti della Pontificia Accademia di Archeologia*, **LX**.

Nardi R, 1992 Planning as a means of preventive conservation, in *Proceedings of the ARAAFU Conference Conservation Restauration des Biens Culterels*, Paris.

Nardi R, 1995 Open-heart restoration: raising the awareness of the public, in *ICOM-CC Newsletter*.

Nardi R, 1996 The conservation of the atrium of the Capitoline Museum, in *Proceedings of the ICOM Triennial Meeting*, Edinburgh.

Nardi R, 1997 Conservation: a direct route to the protection and study of monuments, in Lindley p (ed), *Sculpture and Conservation: Preservation or Interference?*, Aldershot, Scolar Press.

La Rocca E and Nardi R, 1994 Preventive conservation and restoration: a matter of costs, IIC Triennial meeting, Ottawa.

AUTHOR

Roberto Nardi took his degree in archaeology at the University of Rome and a certificate in conservation at the Instituto Centrale del Restauro. Since 1982 he has been Director of the Centro di Conservazione Archeologica (CCA), in charge of many conservation projects, including the conservation of the Arch of Septimus Severus and the Temple of Vespasian in the Roman Forum, the Crypta Balbi, the Stadium of Domitian, the Atrium of the Capitoline Museum and the Great Bath House at Masada, Israel. He runs a training centre in preventive conservation in a sixteenth-century convent near Rome.

23 Commissioning public sculpture in historic Lincoln
A proposal for the millennium

Vincent Shacklock

The School of Art and Design
De Montfort University
Wordsworth Street, Lincoln LN2 1PF, UK
Tel.: 01522 895118, Fax: 01522 895119
vshacklock@dmu.ac.uk

Abstract

In April 1998 the *City of Sculpture* project was launched aimed at securing sufficient public sculpture to enhance Lincoln. Probable sites include Minster Green, Steep Hill, the Temple Gardens, the Arboretum and the small squares and open spaces which ventilate the close urban grain of historic Lincoln. This paper comments on the selection of sites, preparing a brief and choosing the right artist; questions of appropriateness, artistic freedom, selection judgements, the role of 'experts'; processes and safeguards for securing public acceptance and encouraging involvement; and quality, maintenance, security and durability.

Key words

Sculpture, Lincoln, historic areas, commissioning of public art

INTRODUCTION

Lincoln is a city of outstanding architectural and historic interest. Its partially-surviving Roman street plan and above-ground archaeology remain to offer an understanding of the scale and importance of the Lindum Colonia. In its size, setting and materials the cathedral (Fig 1) is a powerful testimony to Lincoln's status from the eleventh century. Its physical grace speaks of the imagination of the clergy, builders and artists who drove its construction, while the skill of craftsmen is evident in its decoration and detail. The cathedral is one of Britain's greatest in its prominence, form and silhouette. Even the nearby castle, itself a notable

Figure 1 Lincoln Cathedral, West Front, c1075, c1145, c1240, and later. (Lincoln City Council)

monument of Norman origin, is overwhelmed by the presence of this great church.

Founded by the Romans to guard a gap in the Lincolnshire Edge, the settlement spread downhill to the River Witham. The city has benefited from architectural commissions undertaken by Carr (1723–1807), Smirke (1781–1867), Blomfield (1856–1942), G G Scott (1880–1960) including his first important church, G F Bodley (1827–1907), Temple Moore (1856–1920) and Pugin (1812–52), while the city's arboretum is by the skilled hand of Edward Milner (1819–84). Some unfortunate town planning decisions from the 1960s aside, Lincoln has the townscape and historical architecture to complement its great cathedral.

THE *CITY OF SCULPTURE*

A small but determined group in Lincoln is driving a bold idea to attract public sculpture to the city so that it might one day boast another distinguishing quality; contemporary public sculpture which enhances local pride, cultural development and attracts visitors.

In April 1998 the *City of Sculpture* Project was launched, aimed at commissioning or purchasing public sculpture for Lincoln. A partnership comprising the city and county councils, two local arts trusts, the Dean and Chapter, the Society of Arts and De Montfort University has begun work on a plan which will see sculptures installed at various locations. Minster Green, the Castle and Steep Hill, Temple Gardens and the Arboretum and the small squares and open spaces which ventilate the close urban grain of historic Lincoln are being assessed for their capacity to accept sculpture alongside the retail squares, business parks and neighbourhood centres. Even in a city of relatively tight urban form, the historic quarter is interspersed with substantial open spaces of one sort or another, providing good opportunities for well-chosen artists.

The *City of Sculpture* partners believe that the initiative can benefit Lincoln's economic, cultural and historic character but the complexity of sculpture provision on a city-wide scale is daunting. Issues with which the group are currently wrestling include:

- impact on the character and appearance of listed buildings, groups and spaces
- how to collaborate with planners, architects and engineers
- how to interest the public
- the balance of small and large, intimate and

Figure 2 A powerful tribute in bronze to *Lord Tennyson* (1903) by G F Watts on Minster Green. (De Montfort University (DMU))

prominent sites
- how to select artists and prepare briefs
- when to seek the views of 'experts'
- maintenance, security and durability
- when to employ temporary installations.

Lincoln's *City of Sculpture* project also has a broad ambition. First to give residents, of all ages and groups, the opportunity to engage in a far greater sense of artistic endeavour than is currently possible. Second, to identify Lincoln with a strong artistic dimension which supports and influences economic and cultural development.

EXISTING SCULPTURE IN LINCOLN

Standing on Minster Green is a powerful bronze *Lord Tennyson* (1903) (Fig 2), a native of Lincolnshire, by G F Watts (1817–1904). Watts, the foremost symbolist painter and sculptor of his day,

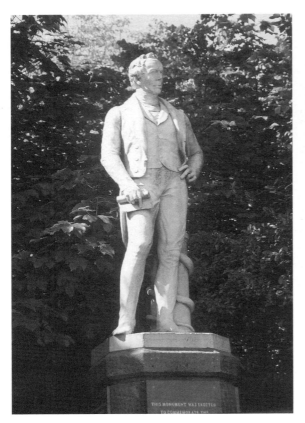

Figure 3 *Dr Charlesworth* (1853) by Thomas Milnes. (DMU)

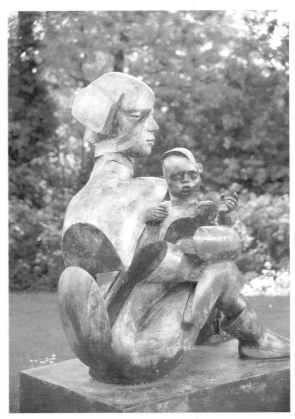

Figure 4 Glyn Williams' *Mother and Child,* acquired 1995, has been placed in the grounds of Dr. Charlesworth's former mental institution. Williams requested that his work be placed not before the large formal building, but in the shadow of a tree on the fringe where it works so much better. (DMU)

provided his services free to honour the memory of the poet laureate who had been his close friend. This affection may be evident in the composition, particularly the long coat and floppy hat. The medical practitioner, Dr Charlesworth (Fig 3), promoter of a more humane approach to mental illness, is celebrated through a statue placed in a garden south of the hospital that he founded. Thomas Milnes (1813–88) completed the work in 1853. The Temple Gardens, located south of the Bishops' Palace, takes its name from the small early nineteenth-century temple modelled on the Choragic Monument of Thrasyllus, perched on top of which sits the mythical Greek figure of *Niobe* in white limestone (sculptor unknown) weeping at the tragic demise of her children.

Prominent among recent acquisitions are works by Glyn Williams and Michael Sandle. Williams' *Mother and Child* (1995) (Figure 4) has been placed within the ample grounds of Dr Charlesworth's

former mental institution, its precise siting selected by the sculptor to avoid an uncomfortable formal relationship with the very large building. Instead, *Mother and Child* stands in the shadow of a tree on the fringe where it works so much better, the visitor coming upon it almost by accident, the pleasure heightened by this surprise.

In 1996 Sandle's powerful and provocative *Mighty Blow for Freedom* (Fig 5) was lent to Lincoln and placed in Temple Gardens within sight of De Montfort's School of Art and Design where he is professor of sculpture. The placing here engages the visitor approaching from Broadgate in the visual interplay of horizontal elements which make up the Lincoln hillside: the great mass of the cathedral at high level, the striking remains of the Bishops'

Figure 5 Michael Sandle's *Mighty Blow for Freedom* placed in Temple Gardens alongside the Usher Gallery within sight of De Montfort University's School of Art and Design at which he is professor of sculpture. (DMU)

Palace lying just beneath and the substantial green swathes of Temple Gardens providing the underframe. Reginald Blomfield was appointed by the city fathers to design and build the Usher Gallery within these gardens in the late 1920s. It is a strong composition, well detailed with swagged bucrania in a pseudo frieze, and commandingly placed below the Bishops' Palace (see Pevsner 1989, 479–91). Elsewhere in Lincoln is a 1913 statue of *Bishop Edward King* by W B Richmond (1842–1921) with an inscription by Eric Gill (1882–1940), and several memorials, plaques and numerous carved embellishments to nineteenth-century shops, banks and industrial buildings.

The cathedral can be seen as an individual sculpture and as a building with much external figurative and decorative carving, particularly rich in Romanesque and Gothic sculpture, particularly the West Front's Romanesque frieze. The frieze is a unique collection of 17 carved panels, generally considered to have been carved *c* 1140 under the bishopric of Alexander 'The Magnificent' (Zarnecki 1988, Kahn 1992). Running the width of the Norman West Front they display scenes from the Old and New Testaments. Under a conservation programme begun in the 1980s the panels are gradually being cleaned, inspected and removed to the workshops

for stabilization (see Baily 1997, Beadman & Scarrow 1998). The grave condition of those already removed has led to a series of decisions which suggest that few, if any, of the panels will remain on the building at the end of the programme early in the 21st century. New panels carved by distinguished craftspeople are slowly being inserted as replacements, details lost from the originals being carved as they may originally have appeared.

The debate over these decisions has been full but the gallery-displayed originals and the newly-carved replacements will be of enormous interest. Indeed the amount of cathedral architectural and sculptural ornament lying in store awaiting a suitable gallery is quite remarkable. This includes three valuable and beautiful fragments of Norman relief sculpture thought to belong to the campaign of sculptural decoration of the West Front under Bishop Alexander (Pevsner 1989, 479–91). It is understood that some 50 or more sculptures and fragments may at some future date join the Romanesque frieze panels on permanent display.

DEVELOPING A PROGRAMME

Lincoln's public sculpture is well-placed and warmly appreciated and the compact nature of the historic

quarter, together with the intimate relationship between buildings and spaces, encourages the view that an additional dozen or so contemporary sculpture installations would have a dramatic effect (see Noszlopy 1988, Cavanagh 1997). The *City of Sculpture* project aims to go about this in a socially-inclusive manner, reflecting the diversity of the partners' interests. The aim is for both prominent and intimate sites, small- and large-scale sculpture, temporary and permanent installations, national and local artists. Community initiatives will be fostered and learning opportunities provided in the county's schools with public lectures and events. Strong though the collective will is, there is an acknowledgment of the need to learn from others. Lincoln's exuberance over this new concept is not so intoxicating as to encourage a headlong dash for commissions and purchases uninformed by successes (and failures) elsewhere.

Fortunately, more guidance can be drawn from experiences elsewhere in the United Kingdom than would have been the case a few years ago. Successful projects abound, including the early sculpture trails at the Forest of Dean and Grizedale and the recent Sustrans bicycle route, the remarkable success of garden festivals in promoting the public sculpture in urban 'green' settings, the Yorkshire Sculpture Park at Bretton Hall Park and the sculpture initiatives implemented with skill and imagination at Birmingham Centenary Square, Cardiff Bay, Swindon, Sheffield and elsewhere. There are also noteworthy blockbuster commissions such as David Mach's *Train* (1997) in Darlington and Antony Gormley's *Angel of the North* (1997) overlooking the A1 at Gateshead, both of which have gained fame and a certain notoriety by virtue of their scale.

Lottery funding has, of course, provided an enormous increase in the amount of new work commissioned and installed nationwide but availability of funds is only part of the process. The large-scale public sculptures in the north east were only possible because of a 15-year process of building up officer and council support via the regional arts boards in a series of smaller commissions, artist residencies, schools projects and various grassroots community initiatives. Gateshead Riverside Sculpture Park and Grizedale, for example, are the tangible results of such enduring commitment. Lincoln has had some success developing public interest

but true confidence and commitment will be necessary if teachers, communities, officials and specialists are to secure continued public funding and work successfully in good times and bad.

There are numerous ways of commissioning and acquiring sculptures; almost as many processes as the range of work: individual wealthy patrons, corporate sponsors, public bodies, committees of various sorts, commissioning agencies, open competitions, limited competitions and gifts and purchases on the open market. Artists' opinions about commissions are often overlooked and opportunities lost to inform the process by exchange of ideas and assumptions, but there is no point in setting artists of vastly different reputation against one another in competition. Where a decision is taken to approach a number of established sculptors for a complicated commission, it is unreasonable to expect drawings or maquettes without them receiving a fee. Preliminary ideas can lead to a shortlist where each candidate is invited to undertake a significant amount of work for a fee. The fact that many artists are less well-off should never be a justification for securing their input on the cheap.

Sculptures confront us, they inhabit our space. Paintings, by contrast, transport us immediately into other realms. This notion places responsibilities on the sculptor and the sculpture, but most of all it places massive responsibility on the initiators. The selection of too many sites or some which are inappropriate can cause individuals to feel that their environment has been violated, or to question the value of modern sculpture, or to withdraw support for public sculpture as a whole. In the context of Lincoln's historic core, the controversy which could arise through inappropriate siting, scale or artistic message could be very damaging.

Temporary installations have great value for a complex project like Lincoln's. Excellent sites not available in the longer term can be put to use, affording the artist a chance to experiment in concept, materials or technique in ways which might not otherwise have been possible or appropriate. The time-limited nature of an installation can reduce the potential for hostile reaction to a particular site or the sculpture placed in it. If, on the other hand, a sculpture is loved and lost, the sense of loss can heighten interest in the next round of commissions promoting public dialogue and interest.

Figure 6 *Ships Vents* in a small courtyard of the Lincoln County Hospital, drawn to the attention of the *City of Sculpture* project by a hospital visitor who found these bright, primary-coloured ships' vents such an enjoyable surprise. (Lincoln County Hospital)

Figure 7 *The Jazz Player* by Richard Thornton. Installed recently and much enjoyed by passing pedestrians. (DMU)

Temporary projects can help present the city as a dynamic and colourful complex of activity. All this has to be balanced against the actual and perceived additional cost of temporary work. Fund-raisers, supporters and, most importantly, the client or client group, may sense they are not making an investment in durable art and find little solace in the knowledge that their temporary installation will be well-documented prior to removal.

Public acceptance is critical to limit vandalism, justify maintenance and sustain long-term commitment to local arts policies. One recent scheme in a small area of London allowed residents to nominate those artists whose work they would like to see permanently sited in their streets. The selected artists were matched to locations and the works commissioned. All this was admirably open

and transparent but its application on a city-wide scale would be rather restrictive. Enlightened private patronage, the use of informed panels and selections by representative groups have a role if balance and variety are to be achieved. Above all, the target should be quality. Without commissions which permit artistic flair, which welcome interpretation, and without a measure of artists of national distinction, the adventure as a whole will be lacking.

The mood of the city has reacted well to the idea and recent months have seen an increasing interest in public sculpture and some positive actions to introduce sculpture. Some residents have drawn attention to existing sculptures in semi-private grounds or otherwise hidden locations: *Ships Vents* (Figure 6) in an enclosed, quiet courtyard of the County Hospital is an example. In addition, there have been suggestions and requests for particular

commissions or purchases. A tribute to the life and work of Diana, Princess of Wales, may be funded in the form of a water-based sculpture. The recent arrival of *The Jazz Player* by Richard Thornton is the first of a three-part installation of the artist's work in the business fringe of the town centre. The first commission in stone is about to be awarded for siting in a new shopping square. Several sculptures by Michael Kenny RA will shortly be on show at two Lincoln Art School sites and in the Cathedral cloisters as part of a tour of the artist's work. The *City of Sculpture* project is barely at the starting blocks but the news has already created a buzz of interest and a keenness to engage. The local newspaper has fuelled interest with coverage of the project's vision and objectives and kept interest going with vox pops which, fortunately, have revealed a reasonable measure of public support.

SCULPTURE IN THE HISTORIC QUARTER

Lincoln's historic centre is protected legally as an area of archaeological and architectural importance. Challenging and provocative contemporary art placed here could easily become a target for severe criticism. It may be argued that a more conservative and traditional programme of sculpture would be appropriate the closer one is to the Cathedral. Indeed, the argument might be put that the historic core is already such a distinguished and visually pleasing place that there is no justification for the importation of public art, contemporary or otherwise, and the major investment should be channelled to modern residential, industrial and commercial areas. There is great benefit to be gained from identifying areas outside the historic city which will accommodate and benefit from installations but the historic core should not be seen as off-limits. It is entirely feasible to expect well-chosen sculpture to complement, and itself benefit from, historic settings. The argument rests on similar reasoning to that relating to the insertion of well-designed contemporary architecture in sensitive historic settings.

CONCLUSIONS

Four issues are worth noting in conclusion. The first is that durability is essential. Even a temporary installation has an intended lifespan which it must survive in good health and appearance. At the first sign of its decay under site-stress its days should be considered over and it should be removed. The passing public cannot be expected to guess or remember what is intended to appear worn-out and any installations of this sort are a target for cynicism and vandalism, the enemies of public art. If it is intended to be permanent it must be designed, fabricated and assembled to see out 75 years or more.

The second is that there must be public understanding, support and, if possible, affection for the project and the individual sculptures. Engagement of the public is essential, whether in management of the city-wide concept, identification of some sites, choice of artists, commentary on briefs or just the chance to express and record their views. A public which understands the artistic concept, or can interpret the physical form, warms to its texture, derives local meaning or comes to believe that it has wider cultural value will be more willing to sustain a commitment to sculpture and allow public spending on its management and continuation.

The third is that artists and administrators have to find ways of integrating the sculpture formally, and in subject matter, to the context of each site. The tendency to parachute art in has to be controlled, though not necessarily prohibited altogether. Finally, in introducing sculpture and monuments to public space we must aim for quality in all respects. There is the risk that this will be perceived as an elitist pursuit with an inevitable tendency to move toward the 'safe', established or high-profile artist. They can be local or national, young or old but they must be the best in their category by whatever methods of selection is devised; they must enjoy excellent vision; and they must be given adequate resources.

There should be confidence to include some of the outstanding open spaces of the historic core and smaller, more intimate sites within the close urban fabric of places such as Steep Hill, Michaelgate, Bailgate and High Street. Impact on the character of historic buildings, groups and spaces should be accepted in the knowledge that the excellence of brief, commission, and execution will lead to outcomes of exceptional quality. This is not necessarily a view which will be carried through to the end, but if it is, and if the partnership secures work of outstanding quality, there will be a small

contribution to the stock of public monuments which the historians and conservators two hundred years from now may meet to discuss and debate.

REFERENCES

Baily J, 1997, The bureaucratic tendency: polemic reflections on the control of conservation work, with reference to the Romanesque frieze at Lincoln Cathedral, in Lindley p (ed), *Sculpture Conservation: Preservation or Interference?*, Aldershot, Scolar Press, 15–20.

Beadman K and Scarrow J, 1998, Cleaning Lincoln Cathedral's Romanesque Frieze, in *The Journal of Architectural Conservation*, 4:2, 39–53.

Cavanagh T, 1997, *Public Sculpture of Liverpool*, Liverpool, Liverpool University Press.

Kahn D (ed), 1992 *The Romanesque Frieze and its Spectator*, London, Harvey Miller.

Noszlopy G T, 1988, *Public Sculpture of Birmingham including Sutton Coldfield*, Liverpool, Liverpool University Press.

Pevsner N and Harris J, 1989 *Buildings of England, Lincolnshire*, London, Penguin Books.

Zarnecki G, 1988 *Romanesque Lincoln, The Sculpture of the Cathedral*, Lincoln, Honeywood Press.

ACKNOWLEDGEMENTS

The author acknowledges advice given by Ann Elliot, Gary Power and Dr John Lord in the preparation of this paper.

AUTHOR

Professor Vincent Shacklock is Head of De Montfort University's School of Art and Design at Lincoln (since 1995) and Director of the Centre for Conservation Studies at Leicester (since 1993). He worked in local government and private practice as a town planner and urban designer before moving to higher education. In recent years his teaching and research has been in conservation with publications including fire safety in cathedrals, conservation law and the management of historic property and gardens in Italy.

24 That sacred turf

War memorial gardens as theatres of war (and peace)

Paul Gough

Faculty of Art, Media and Design
University of the West of England
Clanage Road, Bower Ashton
Bristol, BS3 2JT, UK
Tel.: 0117 966 0222 ext 4270
paul.gough@uwe.ac.uk

Abstract

This paper examines the idea of garden spaces and planting regimes as a form of natural 'anti-monument'. Drawing upon examples from Gallipoli in Turkey and Caen in Northern France the paper looks at how design teams are beginning to rely less on stone and cast bronze in preference to symbolic planting schemes that require the pilgrim-visitor to enter into a discursive, theatrical space. In these spaces the dramaturgical is prioritized over the purely visual in challenging and novel ways. The chapter also reflects on the political and symbolic potency of the floral tribute suggesting that the direction and protocol of official mourning in the aftermath of the death of Diana, Princess of Wales, in 1997 was influenced by these private and transient memorials.

Key words

War memorials, battlefield parks, symbolic trees, Commonwealth War Graves Commission, Gallipoli

'There had been problems with the planting. The grass at the cemetery was French grass, and it seemed to her of the coarser type, inappropriate for British soldiers to lie beneath. Her campaign over this with the Commission led nowhere. So one spring she took out a small spade and a square yard of English turf kept damp in a plastic bag. After dark she dug out the offending French grass and relaid the softer English turf, patting it into place, then stamping it in. She was pleased with her work, and the next year, as she approached the grave, saw no indication of her mending. But when she knelt, she realised that her work had been undone: the French grass was back again.' (Barnes 1996, 36–7)

The redoubtable Miss Moss (of Julian Barnes' short story *Evermore*) was never to find satisfaction with the foreign planting schemes of the Commonwealth War Graves Cemeteries in France. Her frequent attempts to personalize the graveside environment of her brother's stone were annually frustrated by the strict procedures of official protocol which meant that Miss Moss had to resign herself to alien turf and 'dusty geraniums'. Barnes' story brings out some of the key issues in the tensions between a public and private agenda of grief. How, in the face of the vast monuments and cemeteries of the battlefields, could an individual mourner hope to personalize the symbolism of commemoration? What role might plants, shrubs and trees play in opening

up the processes of remembrance? And, thirdly, could these arboreal devices act as metaphors for collaboration and interaction in the future design of new commemorative landscapes?

This paper will attempt to answer these questions, and in doing so will examine three case studies. Firstly, a memorial park on the Somme battlefield in northern France, secondly, a consecrated landscape on the beachhead at Gallipoli in Turkey and third, a newly-designed commemorative landscape in Normandy. In the process of exploring these landscapes the paper will concentrate on the role that trees, shrubs and plants can play in both extending and critiquing the language of monumentalism. It will also reflect on the current debates on the role played by memorials in asserting ideas of national identity and social memory.

Our exploration begins in north-east France, in a landscape that has been given a number of extraordinary and evocative titles: The Killing Fields, The Dying Zone, The Dead Ground, the Silent Cities. (Hurst 1929, Coombs 1983, Slowe & Richards 1986, Middlebrook & Middlebrook 1991). Yet this landscape is only two hours by car from England. During the Great War it was within earshot of London, families took picnics at Beachy Head to the accompaniment of the great artillery barrages on the Western Front.

At first sight the Somme has little in common with the other great funerary landscapes of the world; the Valley of the Kings in Thebes, or the buried city of Pompeii. The Somme is a prosperous and comfortable agricultural zone. The villages are compact and well-kept. In 1916 British soldiers who were sent there to prepare for the Great Push described it as resembling Salisbury Plain with its long views, gently sloping downlands, many copses and small woods.

After the war, in the 1920s and 1930s, artists flocked to the old battlefields to record the painstaking restoration process as each building, irrespective of its original architectural merit, was returned to its pre-war state. Artists besieged the authorities for sketching permits. At the Royal College of Art, London, Professor William Rothenstein (himself an Official War Artist) despatched his students to the old front line to paint and draw the picturesque ruination of Picardy and Artois. One artist wrote that it was crucial that he made the trip because he had missed out on seeing the aftermath

of the terrible earthquake at Messina in 1908.[1] In her 1919–20 folio of Western Front drawings, artist Olive Mudie-Cook made one with the title *A Modern Pompeii*. [2]

The artists had to work quickly. The programme of restoration was impressive and resolute. It was, though, a process of replication rather than innovation. George Steiner has described this perfection of renewal as having little more than a 'lacquered depth' resulting in an obsession with the literal (Steiner 1971, 51). In some of the smaller Belgian villages, such as Passchendaele which was totally obliterated in the war, it is as if the buildings have been borrowed from a Wild West movie, comprising a frontage and little else, just a few props and supports to lend a sense of community and architectural continuity. Despite its antique appearance, one travel writer has written, the city of Ypres is actually more recent than Milton Keynes (Fountain 1998, 8).

In his book on the Great War, Paul Fussell remarks on the difficulties in recovering a feeling for the actualities of the trench war (Fussell 1975, 36). Entrenchment, he argues, has long been a dead metaphor. Nowhere is this more true than on the deserted agricultural plains of the Somme. It takes a giant leap of the imagination to reconnect this vast space with the teeming industrialized territory occupied by the rival armies in 1916.

From contemporary film and photographs we know that for tens of miles the French landscape sustained a huge and complex supply line that required a massive logistics effort, hundreds of vehicles, thousands of men in supply depots, rail links, shipping lines, armament factories all working to maintain a handful of men holding a shallow ditch in the ground. The ditches, though, are still there. In some places, such as at Vimy Ridge, they have been preserved in concrete as a permanent marker to that most temporary existence (Fig 1).

But even where they have been ploughed over, the disturbed chalk still marks out the line of the former trenches, zig-zagging and weaving crazily across the gently sloping downland. At each ploughing the earth coughs up more of its iron lode, encrusted shells are heaped up at cross-roads to await collection by itinerant bomb-disposal squads. Scattered in the fields is the archaeological proof of the conflict: lead shrapnel balls, fragments of rusted

Figure I Preserved trenches, Vimy Memorial Park, France. (Paul Gough)

shell casing, a crust of clavicle or rib bone, lengths of grotesquely twisted barbed wire. Historians speak of the importance of 'walking the ground' in gaining a true feel for battle terrain and its related fieldcraft. For others, the process of scouring the freshly ploughed fields of the Somme is to try to unite the volume of memory with today's actualities. It is, though, an almost unbridgeable chasm. As James Mayo has observed of ancient battlefields, 'place and event have been tied, but little more' (Mayo 1988, 148).

There is then a restrained drama in this historicized landscape. The scattered metal fragments are potent scenic props on this stage. But the true players in this theatre of war are the monuments. Much has been written on the symbolic role and social value of war memorials. For over fifty years the gigantic stone piles dotted across the Western Front and throughout Europe have been regarded with awe and deep respect. Despite their absurd size, the arches, gateways and towers designed and built by the Allied side were revered for their restrained neo-classical style and their subtle use of materials and scale. In the past ten years though, architectural and cultural historians have questioned the authority of the victors' monument.

The debate has been particularly energetic in post-unified Germany. By reflecting on the nation's fascist past and the rhetoric of military commemoration, artists and historians such as Martin Brozsat have argued that monuments do little but 'coarsen' historical understanding, rather than clarify meaning they bury events 'beneath layers of national myth' (Brozsat in Young 1990, 53).

Many commentators have pointed to the ideological function of the war memorial as 'something constructed *after* the event which it celebrates or indicates... it entails an interpretation of the event which those who come later are called upon to accredit.' (Van Den Abeele 1994, 265). James Young has argued that many war memorials are little more than the 'locus for self aggrandising national memory' (Young 1990, 52). Artists such as the Critical Art Ensemble use the Internet to actively critique our cultural assumptions about the status of monuments;

> Monuments are the means to forgetfulness. Memory dissipates in their shadow. We shall never forget. We will always forget. The monument does not protect its slaves from repetition. In fact, it ensures repetition. The classical ghettos of Derry and Palestine are the products of forgetfulness. (Buchler & Papastergiadis 1996, 23).

The last decade has seen the rise of the counter- or anti-memorial. Such artists as Jochen and Esther Gerz have argued and built interactive monuments that invite (indeed require) a public response, however contentious, and an active participation in its making, however critical of the larger cause. The resulting artworks are the antithesis of the grandiose ennobling stone and bronze monuments of the public domain. They are often crudely constructed, modestly located and, above all, do not alleviate a sense of guilt. This point is recognised by James Young when he writes that conventional memorials dissipate the weight of national memory and in so doing these 'monuments may relieve viewers of their memory-burden' (Young 1990, 57).

There is, though, little physical relief from the monuments on the Somme. As if to compensate for the fragmented evidence in the surrounding fields, memorials such as the Thiepval Arch and the Menin Gate are immense, solid objects. They speak of immutability, permanence and continuity of belief; everything that the infantryman's life was not. Not only is the Thiepval Memorial to the Missing of the Somme 'unmissable', writes Geoff Dyer, 'it is also, strangely and appropriately, unphotographable. No photograph can convey its scale, its balance, its overwhelming effect on the senses' (Dyer 1994, 126).

Everything seems to be exaggerated; the huge stone wreaths, the acres of carved names, the piling up of the arches, the way it dominates every vista on the battlefield. In this highly charged rhetorical space there is little room for personal negotiation; the spectator remains firmly on the outside looking in or, more often, up (Harbison 1991, Winter 1995).

To complement the emotional intensity of these architectural colossi, several fragments of the battlescape have been set aside as memorial gardens or peace parks. A good example of the former can be found near the village of Serre on the Somme. The Sheffield Memorial Park is a tract of ground that has been periodically decorated with successive waves of commemorative icons. Although this, and similar, tracts of 'consecrated' land conform to the dominant rhetoric of the victors' monument, these spaces offer a very different sensory and spatial experience and, as such, are sensitive, negotiable spaces in which interaction and participation are premised over the gigantism of many war memorials. In this way they can be regarded as a form, albeit modest, of 'counter-monument'.

The Park sits on the northern sector of the old battlefield at Serre. One of its perimeter edges is formed by the line of a British trench that was the startline for troops from northern England. The park is littered with official memorial architecture; a formal gateway; an arch that helps to announce the space while also declaring it a place of reverence and designated memory, and a tract of conifer trees that both projects the symbolism of regeneration, while providing an uncluttered ground plane that makes it easy to read the cratered surface of the old battlefield.

Over the decades, these official signifiers have been supplemented by markers of local, individual memory: brass plaques hammered into the conifer trees (Fig 2), a cross placed by a bereaved relative and the annual offerings of poppy wreaths. More recently, a memorial wall has been sited at the corner of the wood. It follows the shallow line of trenches from which the doomed Accrington Pals advanced onto the German lines. It is a curious construction, half wall, half ruin. Visually it is reminiscent of the thousands of ruins caused by the siege warfare along this front. Symbolically, it may suggest that this is only a fragment of a building, that this is a job only half done. Its material construction is especially important, as the bricks were made in

Figure 2 Tree Plaque, Sheffield Memorial Park, The Somme, France. (Paul Gough)

Accrington and bought over to France for this specific purpose (Middlebrook & Middlebrook 1991, 74–5). As we shall see, this habit of sending native stones, plants, trees and even soil to distant battlefields is a feature of many commemorative gardens in France. It is part of the complex fetishism of remembrance which is best served by transient natural forms rather than fixed architectural emblems.

Aesthetically, the fragment of brick wall at Serre has upset the designed relationship between the neo-classical archway and the preserved battle space. But, in such rhetorically charged spaces, aesthetics count for little. Sheffield Memorial Park has been reappropriated by a memory-interest group, as have many new sites in this part of France.[3] The brick fragment is evidence of a continued need to extend the iconography of mourning and to localise (and so rejuvenate) memory, instead of accepting grief as something national and abstract.

The Memorial Park is a piece of theatre, but one in which the memorial furnishings are props that only seem to accentuate the emptiness of the surrounding landscape. This notion of emptiness seems crucial to our understanding of the impact of many Great War memorials. After all, the 'first and best known' marker of martial memory, the Cenotaph in Whitehall, London, was designed as an empty tomb, dedicated to the honour of those buried elsewhere (Greenberg 1989, 5). The Somme landscape is a place emptied of its military occupancy but still saturated with its memory. It is, as one writer in the war put it, 'not empty at all, rather full of emptiness' (Farrer 1918, 55).

Just as the Cenotaph remains largely invisible for 364 days of the year so the Sheffield Memorial Park becomes truly activated when swarming with visitors. Occasionally, the park is inundated with British schoolchildren. Their teachers line the children in single file along the shallow trenches while relating the history of the space. The talk is bought to an abrupt end when the teacher blows hard on a whistle to mark the moment when the Pals battalions 'jumped the bags'.

The preserved battle gardens of the Western Front might almost have been expressly designed for this purpose. A favourite ploy of the battlefield tour guides at Vimy Ridge memorial park is to divide a coachload of pilgrims and line them up on either side of the craters that once divided the two front lines. In pakkamacs and golfing caps they stand in mute rows just yards apart. Many commentators despise this form of vicarious entertainment. 'It is the contemporary visitor's duty to resist the "ease" of imaginary projection,' argues George Van Den Abbeele, we must 'remain acutely aware of the gap between what is there, and what is not there (or there no longer)' (Van Den Abeele 1994, 271). Yet, despite its fraudulence, the physical act might help us appreciate the absurd compression of space on the 1917 battlefield, and gauge something of the sense of exposure experienced by men once they left the relative security of the trench world.

A way of contextualizing the symbolic power of plants and trees in commemorative environments was seen in a cartoon in the satirical press recently (*Private Eye*, undated). It depicted an accident or a scene of disaster. Three figures clutching bouquets were trying to push their way through the crowd. One of them was shouting 'Stand back, we've got the floral tributes!'.

The floral tribute acts as an initial marker to more formal and solid modes of memory. Cut flowers, wreaths and paper poppies allow anyone to participate in the public process of grieving. This was exemplified in the aftermath of the death of Diana, Princess of Wales, when the streets of Imperial and governmental London relinquished some of their vested authority. Normally, one can trace the routeways of civic power across central London to Whitehall by plotting a line through the statues and memorial architecture that are the 'public face of our national culture' (Rutherford 1997,11). In stone and bronze they are the powerpoints on an imperial and royal circuit board. But, as we know, the funeral route had to be extended to encompass the crowds and to accommodate the volume of grief. It had to allow both spatial and symbolic respect for the acres of flowers spreading from the emotional pressure points, like a floral aneurysm, at St James Palace and Clarence House. It was extraordinary that the symbols of transience and ephemerality; balloons, candles, cut flowers wrapped in paper, messages and poems pinned to trees, should so divert the momentum of official protocol.

Our appreciation of the symbolic value of flowers is very sophisticated. It spans a spectrum of symbolism from the rose (the classical icon of nurtured grief) to its opposite, the poppy, symbol of unpredictable growth, ephemerality and the sleep of reason. On distant battlefields the symbolic value of certain flowers has become part of a complex process of nationalism and emotional jurisdiction (Gough 1996a).

In Western Turkey, on the old battlefields of Gallipoli, there are 31 small Commonwealth War Graves Cemeteries. Despite poor drainage, insecure ground and occasional bush fires they survive the hostile climate and are tended with the customary care of the War Graves Commission. There have been some concessions to the conditions and to the social environment: high perimeter walls and deep, stone lined ha-has protect the lawns from animals and ensure adequate drainage. Many cemeteries have a single stone screen-wall which bears the cross of sacrifice in relief, as opposed to a free standing cross found in Christian countries. However, to the frustration of some Australian veterans most of the plants in the cemeteries are indigenous to Turkey. In the 1930s Commission horticulturists attempted to acclimatize over 100 different types of eucalyptus, but only succeeded in developing a robust strain for the lower slopes (Longworth 1967, 114).

Why should veterans show such frustration ? Partly it would seem, because the process of planting was an essential part of their grieving process. It was a process that was, and indeed still is, collaborative and inclusive. As early as 1915 the Commission had put in place a scheme to plant home-grown maple seeds on Canadian graves in France and Belgium. That same year the Australian wattle had been planted around Anzac graves in Turkey and cuttings

of olearia and other native seedlings had been shipped over from New Zealand. In cemeteries with Chinese or Indian graves the Commission had to ensure that only plants considered sacred and appropriate for commemoration were planted. Indians, for example, regard iris, marigolds and cypresses as suitable (op cit, 74).

Unlike the grand monuments on the Western Front, the rhetoric of commemoration in Gallipoli is best conveyed through its planting regimes. In one of the war cemeteries stands a lone tree planted by a bereaved father. Bought over from Manchester, it is reputedly the only English oak on the peninsula. It has an unofficial presence within the strict regime and protocol of the cemetery.

The story of the Lone Pine is further evidence of the symbolic potency of particular trees. At the height of the battles in mid-1915 the Allies chose to name a Turkish strongpoint after a solitary dwarf pine that dominated the horizon above the beach-heads (Moorehead 1956, 198). After the war, Australians clearing the battlefield found the stump of the pine in a trench. A number of seeds were retrieved and sent to Australia where they were planted in the grounds of the National War Memorial in Canberra. One tree grew and flourished, bearing seeds that were replanted at other symbolic locations in Australia. Then, in a reversal of the original idea, seeds were sent back to Gallipoli and planted in the presumed location of the original tree. The Turkish tree from those seeds survived a terrible scrub fire that ravaged the Anzac battlefields in 1994.

Surprising as it at may seem, there is nothing unique about the Australian seed exchange. Last year a team of Bristol-based Great War enthusiasts re-planted a tree on the site of The Lone Tree which played a crucial part as a gathering spot and a datum point during the Battle of Loos. The ridges of Gallipoli are strewn with conifers planted by the Returned Servicemen's League and other ex-service organisations.

The British reserve a special veneration for the few trees that survived the war. In a memorial park on the Somme stands the Danger Tree or Tree of Death which acted as a landmark in the centre of no-man's-land. The tree is long dead. It is now a petrified stalk held in position in a barrel of cement but that makes it no less popular as an icon for battlefield tourists.

Further south, in the middle of Delville Wood, is a hornbeam that is reckoned to be the only tree in the wood to have survived the terrible bombardments of 1916. Despite a shrapnel filled trunk it thrives and is the focus of near-devotional attention. A large stone marker proclaims its unique status (Middlebrook & Middlebrook 1991, 167).

It would be easy to put this down to a bizarre mix of arboreal sentimentality and regimental ritual. But (as Joseph Beuys and Ian Hamilton Finlay have constantly reminded us) tree-planting is a political act. And, to return to my theatre analogy, on some old battlegrounds trees and shrubs are more than just stage scenery. After the fire in Gallipoli the Turkish authorities cleared the entire battlefield area; many commemorative trees were chopped down, War Graves Commission planting schemes were threatened and new shrubs and conifers were planted by the Turkish military. A compromise was agreed, but the tensions are still evident. The argument centres on who controls memory. After all, the campaign in the Dardanelles was won by the Turkish army and the modern Islamic state was forged on these precipitous ridges (Gough 1996a, 76).

These tensions have been exacerbated by a recent wave of statues installed by the Turkish authorities. This new generation of memorials takes the form of giant striding figures, cast in bronze and mounted on imposing pedestals. They make a strange and uncomfortable contrast to the restrained and rather discordant neo-classical architecture of the Allied war cemeteries. They stand yards apart contesting control of ridge lines and once important vantage points, 'parallel monologues, acting as if the other were not present' (Ayliffe *et al.* 1991, 174).

So what have we understood by these strange horticultural games being played out between Turkey, Australia, northern Europe and South Africa?

Firstly, for those of us who know anything about the highly ritualised mythologizing of the Great War, the trans-continental seed exchange is typical of the veneration afforded certain icons from that period. In his book on the Canadian response to the memory of the war, Jonathan Vance lists the merchandise in stone fragments, shards of stained glass and other relics of the Western Front that found their way back to Canada (Vance 1997, 70–71).

Secondly, we must appreciate the symbolic value of tree planting. In many Great War battlefields

Figure 3 General View, 'The Fountain' Canadian Memorial Garden, Caen, France. (Paul Gough)

individual trees planted by bereaved relatives help offset the formal planting of commission cemeteries and add an idiosyncratic, subjectivized contribution to the highly charged rhetoric of official mourning.

And, thirdly, arboreal intervention seems to have allowed the many Dominion countries a continuing role on the European battlefields of the Great War. The role is not a static role centred on repairing masonry and building new museums, but an evolving, transformative role channelled through plant life. Perhaps also, the trees and shrubs are crucial metaphors for those Dominion countries (particularly Australia and French-Canada) who are in the difficult and lengthy process of re-negotiating their relationship with Britain.

The final case study is a memorial garden near Caen, in Normandy. It was designed by a team of students and staff from a Canadian University in an open competition. The brief was to design a garden that would make use of the valley and steep walls

immediately beneath the huge museum of *le memorial*. It is intended that the museum will be ringed by gardens designed (and funded) by each of the nations whose armies liberated the city in 1944 (Gough 1998, 212).

The most ambitious garden has been built by American veterans' organisations. It takes the form of a walk culminating in a vast pool, which then forms a continuous flow of water. Whereas there is something faintly sci-fi about the futuristic curves of the pool, the waterfall space is earthed in the spirit of seed and soil exchange that we have seen so often in memorial gardens. Each of the military units from the Normandy campaign has contributed a stone, a plaque, tablet or painted rock to create a synthesis of trophy room and fireside hearth.

The Canadian garden, by contrast, plays a much more subtle, but very demanding game. In effect the designers have used the topography of the valley to suggest a particular journey across water and land. This is not a garden at all; it is a provocative piece of landscape theatre which conflates a spatial symbolism with a temporal concept. The space has been designed to mimic the Canadian soldier's progress during the Second World War as he moves from home earth, across water, through a period of exposure and hazard, up an arduous, often disorientating climb, to the final breach in a seemingly solid defensive wall. The progress culminates in the pristine lawn (the ultimate symbol of horticultural supremacy) on the plateau above the valley sides (Fig 3).

The journey begins with water. Another Canadian memorial (this time in Green Park, London) also uses an unceasing flow of water to suggest cleansing and regeneration. In Green Park the water is studded with bronze maple leaves: at Caen the pool is inscribed with a Latin text: 'Nulla Dies Umquam Memori Vos Eximet Aero' (*no day will erase your generation from our memory*). Is it too fanciful to suggest that the pool acts as a metaphor for the Atlantic crossing, a point somehow reinforced by the grid-like structure of the slabs which seem to echo the longitude and latitude lines of admiralty charts (Gough 1996b)?

The second episode is the zig-zag path that makes a slow ascent of the steep valley side. Here, we are confronted by a steep wilderness of thick, prairie grass. But the grass changes colour and texture rather abruptly. A broad swathe some ten

metres wide is planted with brown grass, while either side the grass grows in rich green clumps. The effect is rather disquieting: it is as if a broad band of the hillside has been scorched, leaving nothing but burnt plants. In addition, the tufts are knitted into the soil by a cellular plastic webbing that resembles a thin veneer of skin flowing over the hillside. These associations have caused considerable unrest among the gardens' critics. Veterans' organisations have objected to the symbolic inference that this part of the garden represents the fate of so many Canadian soldiers in the campaign to liberate Europe (Fig 4).

This garden takes us into a new and very different landscape of commemoration. The burnt grass, the exaggerated awkwardness of the zig-zag slope and the oppressive weight of the concrete wall above make this a rather provocative design. It does not offer the solace and reverence of some of the other funerary terrains we have examined. If anything, it extends the vicarious role of the battlefield pilgrim, but in an uncomfortable, perhaps rather unyielding fashion.

This paper has argued that an understanding of the symbolic and metaphorical role of plants, trees and shrubs in a commemorative space is crucial in extending and opening out the process of remembrance. Plant life has a natural cycle of growth, fertility, decay and death which is assiduously avoided in the conventional iconography of martial memory. Plant life rarely has the permanence suggested by hewn rock and cast metals. Nor do trees and shrubs (however well tended) offer the illusion of permanence. Lewis Mumford astutely argued that 'stone gives a false sense of continuity, and a deceptive assurance of life' (Mumford in Young 1990, 53). Remembrance gardens, battlefield sites and symbolic plantings allow a much needed interaction and participation. Even the greatest of the post-war monument builders recognised the power of the unbuilt space of the battlefield. In 1917 Edwin Lutyens described to his wife the strange charisma of the military cemeteries, before (somewhat inevitably) dedicating himself to the great task of solidifying memory in solid metal:

The graveyards, haphazard from the needs of much to do and little time for thought. And then a ribbon of isolated graves like a milky way across miles of country where men were tucked in where they fell. Ribbons of little crosses each

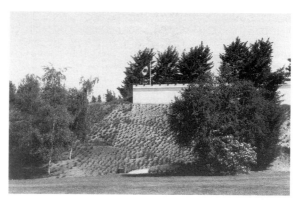

Figure 4 General view 'The Climb' Canadian Memorial Garden, Caen, France. (Paul Gough)

touching each across a cemetery, set in a wilderness of annuals and where one sort of flower is grown the effect is charming, easy and oh so pathetic. One thinks for the moment no other monument is needed. Evanescent but for the moment is almost perfect and how misleading to surmise in this emotion and how some love to sermonise. But the only monument can be one in which the endeavour is sincere to make such monument permanent – a solid ball of bronze! (Percy & Ridley 1985, 349)

ACKNOWLEDGEMENTS

The fieldwork for this paper was made possible by research grants from the Faculty of Art, Media and Design at the University of the West of England, Bristol. The author is also indebted to Professor Terry Copp, Wilfred Laurier University, Canada for his generous support during his research in Caen, France.

ENDNOTES

1 See artists file no. 346/7 part I, Department of Art, Imperial War Museum, London.
2 Portfolio held in The Liddle Collection, Leeds University.
3 On the old Somme battlefield, for example, there is a newly installed obelisk purchased and dedicated by Ulstermen to commemorate the Ulster Division attack on 1st July 1916.

REFERENCES

Ayliffe R, Dubin M and Gawthorp J, 1991 *Turkey: The Rough Guide*, London, Harrap Columbus.

Barnes J, 1996 *Evermore*, London, Penguin.

Brozsat M, 1988 A controversy about the historicisation of National Socialism, in *Yad Vashem Studies*, **19**, 1–47.

Critical Art Ensemble, 1996 in *Ambient Fears* (eds) Buchler P and Papastergiadis N, London, River Orams, 22–30.

Coombs R, 1983 *Before Endeavours Fade*, London, After the Battle.

Dyer G, 1994 *The Missing of the Somme*, London, Penguin.

Farrer R, 1918 *The Void of War*, London, Constable.

Fountain N, 1998 Fields forever England, in *The Guardian*, 9 May, 8–9.

Fussell P, 1975 *The Great War and Modern Memory*, Oxford, Oxford University Press.

Gough P, 1996a Conifers and commemoration: The politics and protocol of planting, in *Landscape Research*, **21**:1, 73–87.

Gough P, 1996b Canada Conflict and Commemoration: An appraisal of the new Canadian War Memorial, in *Canadian Military History*, **5**:1, 26–34.

Gough P, 1998 War memorial gardens as dramaturgical space' in *International Journal of Heritage Studies*, **3**:4, 199–220.

Greenberg A, 1989 Lutyens's Cenotaph, in *Journal for the Society of Architectural History*, **XLVIII**, 5–23.

Harbison R, 1991 *The Built, the Unbuilt and the Unbuildable*, London, Thames & Hudson.

Hurst S, 1929 *The Silent Cities*, London, Methuen.

Longworth P, 1967 *The Unending Vigil*, London, Secker & Warburg.

Mayo J M, 1988 *War Memorials as Political Landscape*, New York, Praeger.

Middlebrook M and Middlebrook M, 1991 *The Somme Battlefields*, London, Viking.

Moorehead A, 1956 *Gallipoli*, London, Hamish Hamilton.

Mumford L, 1938 *The Culture of Cities*, New York, Scribners.

Percy C and Ridley J (eds), 1985 *The Letters of Edwin Lutyens to his Wife Lady Emily*, London, Collins.

Rutherford J, 1997 *Forever England: Reflections on Masculinity and Empire*, London, Lawrence & Wishart.

Slowe P and Woods R, 1986 *Fields of Death: Battle Scenes and the First World War*, London, Hale.

Steiner G, 1971 *In Bluebeard's Castle* London, Faber.

Van Den Abeelle G, 1994 Armored Sights/Sites blindes, in Diller E & Scofidio R (eds), *Back to the front: Tourisms of War*, FRAC Basse Normandie and Princeton University Press, 220–276.

Vance J, 1997 *Death so Noble: Memory, Meaning and the First World War*, Vancouver, UBC Press.

Winter J, 1995 *Sites of Memory, Sites of Mourning*, Cambridge, Cambridge University Press.

Young J, 1990 The counter-monument: memory against itself in Germany today, in *Art and the Public Sphere*, (ed) Mitchell WJT, Chicago, Chicago University Press, 49–78.

AUTHOR

Paul Gough is a painter, broadcaster and writer. He studied painting at Wolverhampton Polytechnic and at the Royal College of Art, London and holds a PhD on First World War art. His large-scale history paintings are in many private and public collections, including the Imperial War Museum London. His recent research covers the aesthetics of conflict, landscapes of dereliction and the iconography of commemoration. He has published widely and given conference papers on a range of related topics. He is Associate Dean in the Faculty of Art, Media and Design at the University of the West of England, Bristol.

Afterwords

Closing remarks, 22nd May 1998, and questions / comments from the floor

John Fidler

Head of Building Conservation
and Research
English Heritage
23 Savile Row, London, UK
Tel.: 020 7973 3000 Fax: 020 7973 3001
john.fidler@english-heritage.org.uk

INTRODUCTION

The month of May 1998 has been a pertinent and useful time to hold this Monuments and the Millennium conference. On Tuesday 19th May, the day before the start of this event, Sir Jocelyn Stevens, the Chairman of English Heritage, launched another English Heritage initiative called 'Buildings at Risk', which features a published national register of Grade I and II* statutory listed buildings which are imperilled by redundancy, neglect and decay. Of interest to us and on top of the list of notable London public monuments which sadly feature in this register, as noted by the London Evening Standard newspaper, is the Wellington Arch at Hyde Park Corner which is currently owned by the Department of Culture, Media and Sport.

Sir Jocelyn was therefore rather diplomatic in his welcoming remarks to Mark Fisher, the Arts Minister, on Wednesday when he opened our conference, as there were no references in his speech to that particular subject. Even government departments charged with the protection of public monuments, it seems, have difficulties with historic structures in their care which top the 'endangered species' list.[1] There never was a better time to air these issues, to share common problems and agree best practice solutions to save public monuments for current enjoyment and that of posterity.

As many speakers and delegates have said in the course of this conference, the current out-pouring of interest in public monuments has been connected with similar previous times of celebration and of memorial. The recent anniversaries of the wars of the twentieth century, the pathos of seeing the shrinking number of survivors gathering at their monuments at memorial services, is tangible proof of the place of monuments in the public heart. But neglect, vandalism and decay are on the increase, for want of charity, of responsible ownership and for want of resources and management.

Monuments also suffer from well-meaning but ill-advised repairs and treatments, besides the effects of time and nature and now need defined standards of care and maintenance if they are to survive into the future.

REVIEW OF THE CONFERENCE PROGRAMME

As far as the conference programme has been concerned, the speakers' papers were presented in purposeful themed groupings. We have had excellent shared debates on what constitutes a public monument, whether its monumental qualities are affected by or related to public spaces, ownership, ideas or material reality. We discussed typologies and inventories and, particularly important, reflected on the types of records and access to them that might be necessary to help with the maintenance of monuments in the future.

This morning, on the final day 22nd May 1998, we had case studies from the field which showed, in several cases, the delicate balance and sensitivities involved in trying to preserve the patination of the past and yet reflect the original designer's intent, where that was possible to ascertain. This afternoon,

discussions focused on the future of public monuments, questions of tenure, patronage and management.

Some of our discussions focused on the philosophical and political issues of ownership, current and historical ownership of sites and context, questions of the artist's intent and debate ranging from the technical aspects of this subject, the preservation of the maximum amount of original fabric, to the preservation of the maximum amount of material integrity and of artist's intent. This was seen by many here as a black and white, good or bad discussion, whereas I would see a palette, a range of responses that we could use for particular circumstances given effective quality of research in the first place.

In my view, there is certainly a need for more inter-disciplinary working and an enhanced level of dialogue between the different professions present today. One of the exciting aspects of this conference has been that it has brought together a very particular and wide-ranging group of expertise in this country for the first time.

So far as technical issues are concerned, we have been hearing about more sensitive, cost-effective methods for cleaning and coating, enhanced levels of training for efficient maintenance and, on the research and development side, about the pioneering use of cathodic protection systems such as that at Inigo Jones' Gateway, the first use of cathodic protection for dispersed metal cramps in masonry in the United Kingdom. Our Irish colleague and speaker David Slattery, I believe, was the first architect internationally to employ cathodic protection on a historic building, on Government Buildings, Dublin. More recently, speaker Ingval Maxwell of Historic Scotland was involved in the use of the technique on a twentieth-century steel-framed and stone-clad building for the Scottish Office. So now we are starting to see the developing use of this exciting new preventative maintenance system by public bodies throughout the British Isles and in Ireland.

I, for one, was very heartened to hear the excellent paper from our friends in Liverpool, from the National Museums and Galleries on Merseyside, on the limitations of laser cleaning technology. In some quarters, laser cleaning has been seen as the ubiquitous panacea for all soiling and patination ills. But the paper gave us instead an objective view of

the way that the sensitivities of all kinds of remedial techniques can be scientifically assessed. The paper's conclusions will undoubtedly now inform all our future work in this field.

Elsewhere in the conference, Andrew Naylor and Bill Martin reminded us in their separate presentations that, as far as metals conservation is concerned, most of the pioneering theoretical and scientific work in the field is relatively recent when compared with the libraries of books we have to use on the preservation of stonework, for example. The techniques of conservation for historic architectural or monumental metalwork are now shifting away from wholesale replacement with new material towards its long-term preservation and retention in situ in various ways. It is understandable, therefore, that we are still debating questions of protection and maintenance for metal-based objects. There is still a need for a good deal of research in this area to catch up with our colleagues who have been working on stone for so many years.

For me, one of the most exciting groups of papers at the conference has been on educational and marketing techniques for raising public awareness, given by our colleagues from Australia and the United States of America. There is certainly a need here to tap into a groundswell of public interest and concern for public monuments in Britain: a challenge for us in the months and years ahead.

THE WAY AHEAD

As to the future: we have evidently enjoyed the multi-disciplinary nature of this conference and that collaborative working spirit should be fostered and maintained, if at all possible. There is certainly a synergy to be gained from the dialogue, communication and joint action between the kind of public, voluntary and charitable bodies we have assembled here.

Perhaps we should have also invited along the British Government's Arts Councils, the sponsors of new public works of art; the Urban Design Group and the Royal Town Planning Institute for their interests in civic placement of works of art; town centre managers and the English Historic Towns Forum for their concern for town centre management, vandalism and tourism; and the Royal Fine Art Commission[2] for its interest in the artistic

quality and siting of nationally important works of public art?

Rosemary Macqueen, one of the delegates from Westminster City Planning Department, was very heartened to hear many of the discussions elucidated this week, as her authority suffers the burden of most of the demands and pressures for new public sculpture in its open spaces. Her Works of Art Committee has to sit twice a month to consider proposals and, at the moment, most of the design ideas are for animal sculpture, memorials to the animals who worked hard in the world wars, elephants, dogs, horses and so on, hardly the most edifying of tasks considering the memorial topics of the recent past! Her Council would, I am sure, appreciate more published guidance in the field on all the topics discussed over the last few days.

There may well therefore be a need for some sort of standing committee, formed on the basis of the groups and individuals attending this conference, to take matters forward in a spirit of national and international cooperation. Between public authorities, private concerns and professional groupings of various sorts, the opening dialogue we have established here could be fostered for future collective benefit.

To address our speakers: I would like them to leave this conference reflecting on their papers and speeches in the light of the other presentations, and to review them in the context of three basic questions. What lessons can we learn for our own papers and for the conference findings as a whole, from the lessons from the past? What lessons can we learn from good practice today? What action needs to be taken now to improve matters for the future?

Armed with their papers and with the conference proceedings, we can start to look to the political arena to develop resources for further action. There is certainly a need for more published information in the field. We do not even know which of each other's publications exist (the small leaflets display stand outside the conference hall has been an eye-opener for many of us!). We need standards, protocols, guidance for the lay-person and the expert. Our work has just begun.

These are just some brief thoughts that have started to surface in my mind over this three-day event. I am sure that there are other ideas and suggestions delegates might have or comments

they would like to make. So I would now like to open a discussion to the floor. If anyone would like to make a comment, or suggest a course of action, I am sure that the organising committee and the other organisations attending here would be quite willing to consider them and take them on board.

QUESTIONS/COMMENTS FROM THE FLOOR

Q1 Jo Darke (PMSA)
You were suggesting inviting other bodies to join in continuing discussions on public monuments and I suggest that you add an architectural input from the Royal Institute of British Architects (RIBA). I think it is extremely important, from the experience of the Public Monuments and Sculpture Association, that sculpture and commemorative monuments are integrally attached to their structures from an aesthetic perspective. I do not think we can really allow architects to get away with ignoring sculpture any longer.

A1 John Fidler
Thank you, point taken.

Q2 Ian Leith (Chairman, PMSA National Recording Project)
The United Kingdom's Department for Culture, Media and Sport has recently started the process of statutorily listing post-war sculpture, but has declined to protect sculpture attached to unlistable structures. What sort of future provision might be made to protect, for example, the unique 1951 set of nine figures by Siegfried Charoux displayed on two levels on the Walbrook frontage of St. Swithun's House, St. Swithun's Lane in the City of London? They are noted as of merit in Nikolaus Pevsner's *The Buildings of England* volume but are vulnerable to the whims of the owners since they have subsequently been refused listed status. What is the legal outcome of the precedent-making application to remove sculptural embellishments from the Time Life building in Bond Street, London?

A2 John Fidler
I am not sure I can answer these questions until some recent case law is resolved. For those at the conference who are unfamiliar with the English planning law situation, I should remind the audience

that there have recently been some doubts expressed about the statutory protection of contemporary internal and/or external works of art when fixed to listed historic buildings. Claims have been made that the artwork can be legally parted from the building which they originally adorned and be sold off.

The Time Life building, on the corner of Conduit Street and Old Bond Street in the City of Westminster, is a case in point. It is statutorily protected as a listed building of special architectural or historic interest. It was built in 1952–3 to the designs of M Rosenauer and various interior designers under the supervision of Sir Hugh Casson and Misha Black. On its external terrace are four abstract panel murals by Ben Nicholson and a reclining bronze figure by Henry Moore. Internally the building is further decorated by an iron sculpture by Geoffrey Clarke and a gilt clock by R & C Ironside.

An application was made to remove the very fine works of art from the building when the lease-holder wished to part with the property and dispose of the art separately. The local planning authority objected but lost the first public enquiry into the matter. The case raises a series of issues around what constitutes the integrity and special interest of listed buildings adorned with works of art (here the artwork was originally commissioned independently of the building but was installed at the time of its opening).

The works of art were subsequently removed and the planning authority eventually served a listed building enforcement notice to require their return to the building. Recently, a second public inquiry has been fought by the local council and a decision from the Secretary of State is due this summer. [3] So we shall have to wait and see.

For its own part, English Heritage advises the Arts Minister at the Department for Culture, Media and Sport in relation to the statutory listing of public sculpture and memorials. The total inventory of listed buildings and structures in England is now heading towards a total of six hundred thousand entries (around 5% of the total building stock) but revisions and additions to the list on the basis of themed studies are ongoing.

Conference delegates may be interested to know that as of the week of 15th May 1998 there are about three thousand different forms of memorials and monuments on the statutory list representing 0.5% of the total stock. It is quite difficult to interrogate the computer precisely on numbers because an entry defined as a war memorial might actually be a stained glass window in an historic building, but there seem to be about three thousand listed memorials or monuments of various kinds.

English Heritage's policy on recommending monuments for listing is that, when the Royal Commission on Historical Monuments for England (RCHME) [4] and the Imperial War Museum inventory (previously described at this conference) is complete, we shall look again to see if the national list needs to be revised in whole or part.

Q3 Unidentified delegate
I would like to support the notion of getting people from different disciplines together to form a professional interest group. This is the first meeting that I have been to, since one I attended in Melbourne several years ago, where there were artists, conservators, public art managers, architects, all together in one room, talking about their own perspectives on these issues. I know I have never been to such a meeting in the USA, as we all seem to have our own professional societies; the conservators go to their meetings, the architects, the artists, the public art managers go to theirs. We hardly even read each other's literature. We are all off in our own little worlds and I think we can all learn a lot more from getting together through meetings like this.

A3 John Fidler
Thank you.

Q4 Glen Wharton
I very much enjoyed having a chance to hear what everyone else is doing, primarily with my colleagues in the United Kingdom. However, as wonderful as the town meeting was that Save Outdoor Sculpture! sponsored that we heard about, I want to point out that within this auditorium we are all of the same skin colour. If we are truly living in a diverse multi-cultural society in which we are trying to get as much support for a significant but perhaps often little-known topic, I think we need to broaden our support (on both sides of the pond).

A4(a) Susan K Nicholls

What we are finding from our SOS! database is that, despite the large number of monuments we were spotting, and despite the large number of people for whom the sculptures are meaningful, we still have a dearth of inputs and interest in significant areas of the country. I think Glen's point is a good one. It is one area that we at SOS! will be beginning to address in some way, whether it is through local discussions or projects.

A4(b) John Fidler

The ethnic bias in this room is particularly noticeable. I think the May 1998 voting and discussions in Northern Ireland are looking at that same cultural issue but from a political and religious angle, we are all for inclusion and need to engage in dialogue. Thank you for that point.

Well, I think that we have talked ourselves out of time. Please rest assured that the organising committee will be getting together and trying to put together some ideas and action based on what we have discussed here today and we shall make those decisions known to you all in the fullness of time.

VOTES OF THANKS

As chairman of the last session of this conference, I would like to thank Robert White, the Chairman of the United Kingdom Institute for Conservation (UKIC), for coming along and getting the entire Monuments and the Millennium show on the road. It was very good of him to come down from Lincoln during his busy UKIC year. He was very supportive at a strategic level for what UKIC's Stone and Metals conservation sections have been doing, working with English Heritage and that is much appreciated.

Sir Jocelyn Stevens loves these kinds of events, because he is always among friends! He had a great time, he told me, and thanks you all for your attendance and interest. The Arts Minister, Mark Fisher, clearly enjoyed himself too because he talked for about twenty minutes longer than his civil servant minders had told us he would and set a precedent for the rest of the conference! He only required but five lines of briefing notes, so he was obviously talking from the heart and with a great deal of background knowledge and experience that was appreciated by the conference. Perhaps we can look to give him and

his successors in office sight of the findings of this conference, some time in the near future?

I would like to thank the session chairmen for all their efforts in keeping us to time and place during the last few days. Jonathan Ashley-Smith of the Victoria & Albert Museum; Julian Litten, who wears many representative hats but this week here for the Friends of Kensal Green Cemetery; Colin Schlapobersky for UKIC; and Ian Leith representing the PMSA; thank you very much, your skills were much appreciated.

We have had thirty one speakers and tour guides helping to make this a very special event and I am especially thankful and grateful to those who have come a very long distance from overseas to be with us this week. You have helped to make this conference a truly international event and you have brought a great deal of experience with you to share for our collective benefit. Thank you.

I need also to thank our student helpers this week, Zoe Allen, Katherine Morris, Adeline Walkner and Jamie McCarthy. We have tried to keep them terribly busy, so that is why they have been looking a little worn-out today! They have staffed our conference reception desks. They have acted as messengers and they have operated our roving microphones. We are very pleased that they have been able to be with us. We hope that they have got something out of the conference in terms of taking notes and listening to what has been going on, as well as working with us. And I hope they have had time to challenge some of the speakers' views in the tea-time sessions too!

From the Victoria & Albert Museum: Richard Cook has been a marvellous ally, providing us with access and general support where the front hall staff sometimes could not. Christina in the Education Department and our audio-visual technician at the back of the hall have also helped smooth our paths. Thank you very much for your support.

Ladies and gentlemen, it is customary on these occasions also to thank our sponsors, modest as their impact has been on your lives. It is important that we recognise the fact that various publishers, companies and public authorities have contributed towards the conference costs and we are very grateful for their support.

For the Organising Committee, I should mention everyone that has been involved. For the UKIC

Stone and Metal conservation sections, Colin Schlapobersky, Russell Turner and Angus Lawrence have more than pulled their weight for UKIC. They are all very busy conservators in private practice, with little free time on their hands. But they have worked very hard to make this conference a beneficial occasion. Thanks very much, chaps.

Jo Darke for the Public Monuments and Sculpture Association (PMSA) has come to all our committee meetings and organised the entire tour agenda, guides and tour logistics and for that we are also extremely grateful.

From English Heritage, Jeanne Marie Teutonico has directed all our activities from Head Office, assisted by Suzie Zumpe on the front desk, with Sasha Chapman and David Mason. Although we are employed by the public service to deliver this kind of educational outreach activity, in association with other bodies, my staff have very busy professional lives in addition to this kind of work, so I am particularly grateful to and proud of them for their efforts. Well done, team!

Finally, I want to thank you, the audience. With speakers and delegates, we have totalled a conference audience of about a hundred and forty strong. You have been attentive, curious, patient and kind, and so, on behalf of the Organising Committee, I hope that you have found the conference both interesting and stimulating. We trust that you will go on from here with a renewed sense of purpose and determination in your lives. We have made many new friends and colleagues world-wide through this occasion and that is something special to be fostered and appreciated. For 'Monuments and the Millennium', to conclude this conference and to paraphrase Churchill's now very corny old phrase, this is not the beginning of the end, it is the end of the beginning. Thanks very much and good afternoon.

ENDNOTES

1 The Wellington Arch was built in 1864 as an ornamental entrance to Hyde Park, celebrating the Duke of Wellington's victories over the French and it was moved to its present site in 1883. In 1912, the statue of Wellington was replaced by Adrian Jones's moving statue of the Angel of Peace alighting on a Chariot of War. The structure now includes a vent exhaust duct from the nearby transport routes and was used until recently at ground level as a Royal Parks Police Station. After the conference, later in 1998, the Wellington Arch and many other public monuments and statues then in the care of the Department for Culture, Media and Sport were transferred to English Heritage. Condition assessments were undertaken of the new additions to English Heritage's estate and a major works programme was prepared during 1999 to make the Wellington Arch safe and to restore it to its former glory.

2 The UK government subsequently decided to abolish the Royal Fine Art Commission (RFAC) by September 1999 and set up in its stead a new public body with broader terms of reference called the Commission for Architecture and the Built Environment (CABE). Initially run as a private company limited by guarantee with the Secretary of State for Culture, Media and Sport as sole shareholder, CABE will ultimately be given powers through primary legislation when parliamentary time permits.

3 The Secretary of State's decision was given after the conference, on 17th August 1998, upholding Westminster Council's enforcement notice and dismissing the appeal. The decision, which validated the Council's contention that the works of art were integral to the building as demonstrated by both the method and purpose of their original attachment, has not been subsequently challenged in the courts and the return of the artwork is expected.

4 The Royal Commission on Historical Monuments for England was merged into English Heritage (the Historic Buildings and Monuments Commission for England) on 1st April 1999.